THE *Queer* SIXTIES

THE *Queer* SIXTIES

edited by
PATRICIA JULIANA SMITH

ROUTLEDGE
NEW YORK AND LONDON

The author gratefully acknowledges permission to reprint previously published materials.

"Liberalism, Libido, Liberation: Baldwin's *Another Country*" by William A. Cohen is reprinted from *Genders* 12, pp. 1–21. © 1991 by the University of Texas Press. All rights reserved.

"You Don't Have to Say You Love Me" by Patricia Juliana Smith is reprinted from *Camp Grounds: Style and Homosexuality,* edited by David Bergman. (Amherst: The University of Massachusetts Press, 1993). © 1993 by the University of Massachusetts Press.

Published in 1999 by
Routledge
29 West 35th Street
New York, NY 10001

Published in Great Britain by
Routledge
11 New Fetter Lane
London EC4P 4EE

Library of Congress Cataloging-in-Publication Data

The queer sixties / edited by Patricia Juliana Smith.
 p. cm.
 Includes bibliographical references and index.
 ISBN 0-415-92168-6 (acid-free paper). – ISBN 0-415-92169-4
(pbk. : acid-free paper)
 1. Gays' writings, American–History and criticism. 2. American literature–20th century–History and criticism. 3. English literature–20th century–History and criticism. 4. Homosexuality–United States–History–20th century. 5. Homosexuality–Great Britain–History–20th century. 6. Gays' writings, English–History and criticism. 7. Lesbians in literature. 8. Gay men in literature. 9. Nineteen sixties. I. Smith, Patricia Juliana. II. Title: Queer 60s.
PS153.G38Q44 1999
810.9'920664–dc21 99-13788
 CIP

To Lillian Faderman, the Mother of Us All

CONTENTS

ACKNOWLEDGMENTS

SINCE I FIRST conceived the idea of this book in 1994, I have accumulated a number of debts of gratitude, many of which are long overdue. My first and largest debt is to the contributors, particularly those who have entrusted me with their essays from the very beginning of this project, for their positively saint-like patience and support over the course of four years, three states, and, all told, seven changes of residence. They are all to be commended for their extraordinary kindness, consideration, and collegiality.

My thanks are also extended to my sister Kate Lanehart, who provided space and shelter in her home in Rosebud, Texas, where I completed one of the more crucial stages of the editorial process. The University of California at Los Angeles (UCLA) Department of English staff, particularly Jeanette Gilkison, Rick Fagin, and Nora Elias, have been of tremendous help in making sure that all the various mailings this work entailed got to their intended destinations. Dear friends and colleagues, including Blake Allmendinger, David Bergman, Joe Bristow, Helen Deutsch, Lowell Gallagher, Deborah Garfield, Bill James, Jayne Lewis, Arthur Little, and Judith Rosen, all provided key suggestions and sanity-saving cheerfulness. Colleen Jaurretche, Anne Mellor, Tim Murphy, Michael North, and Tom Wortham provided much needed encouragement and support.

The dedication of this book is the acknowledgment of my indebtedness over many years to Lillian Faderman. I was fortunate to be one of her graduate students during her stay as visiting professor at UCLA in the early 1990s. She did much to facilitate my transition from directionless graduate student to queer critic, beginning with my first major paper presentation and culminating in the publication of *Lesbian Panic*. She has done so with characteristic altruism and modesty. For this I am most grateful to her, as I am for her courage and pioneering efforts in blazing the trail so many of us have since followed.

INTRODUCTION

■

ICONS AND ICONOCLASTS
Figments of Sixties Queer Culture

Patricia Juliana Smith

The Sixties: A Ghost Story

Over the three decades that have ensued since the much-vaunted cultural and social revolutions of the 1960s, numerous aspects of that decade have periodically returned to haunt our perceptions and sensibilities, so much so that during the mid-1980s, a waggish slogan appeared on bumper stickers, lapel buttons, and graffiti throughout the county: LSD = Let the Sixties Die. However, like a revenant, the sixties may well be dead yet continue to revisit us. We need only look to the past few years of the mid-1990s to see this, and the evidence is virtually unavoidable. The mass media have appropriated the semiotics of the sixties to serve as the means for a variety of ends, even some quite apparently at odds with the values of the decade. For example, 1960s popular music is used to advertise everything from antacids to fast food, while retro-sixties fashions make themselves visible on college campuses. The arts and artists of the sixties have also been rediscovered: the Beatles sold more copies of their recordings in 1996 than they did in any year while they were still actively performing. Related to these manifestations of appreciation and curiosity—if not outright nostalgia—is the recent upsurge in academic interest about this quasi-legendary decade. The past several years have seen numerous scholarly reevaluations of what the 1960s meant and how the issues and events of the period continue to make themselves felt in current political debates and social mores; indeed, in response to the growing number of academic studies in this area, a 1996 issue of *Lingua Franca* featured a cover story asking, "Who Owns the Sixties?"[1]

Of course, one cannot own a ghost. By implying even the possibility of some sort of intellectual proprietorship, the question becomes a dubious one, yet one that requires a response, if not a direct answer. To seek the reason for this renewed interest on the part of diverse groups and individuals—including many not yet born in the 1960s—would require volumes. One response, however, is that ghosts are said to return and haunt because they have unfinished business with us (a matter that will be considered subsequently). The question also suggests, by assuming "ownership," that there is one, holistic notion of the sixties, as if the zeitgeist of the decade were not a confluence of

diverse individuals, groups, and social and historical conditions. Perhaps there were numerous ideas of the sixties, according to the particular moment in time or the viewpoint of the individual perceptor. Nonetheless, even when such diversity is considered in academic discourse, it is clear that one group— queers, or homosexuals as they were then called—surely does not own the sixties, for it is usually assumed, if we are to believe what we are told and read, that the decade's sexual liberation was *hetero*sexual liberation.[2]

xii
∎
Patricia
Juliana
Smith

Another facet of the "ownership" issue involves the claims staked by various academic disciplines. It would also seem, if one examines the current proliferation of scholarly texts focusing on the sixties, that the topic is the province of the social sciences; to date, few texts are written from the perspective of the literary or cultural critic. Those that have been produced, moreover, present a decidedly heterocentric bias.[3] This is not to say that there are no studies on the 1960s written from a queer perspective, but those that do exist are social histories rather than studies of cultural production.[4] The purpose of *The Queer Sixties,* then, is to fill a gap, not only in queer studies, but in academic studies of the 1960s as well. Going against the grain, it proposes a new and different means of looking at the queer cultural and subcultural expression of the decade, which culminated in the closet doors swinging open, dramatically and irrevocably.

A Short Queer History of the 1960s

The Queer Sixties is, most emphatically, not a social history. This has already been done—and done well—by gay and lesbian social historians. Rather, it is a collection of essays by fourteen scholars, all trained as literary critics, who employ the methodologies of textual criticism to "read" the queer iconography implicit in a variety of art forms arising from the zeitgeist of the 1960s, including fiction, drama, the visual arts, film, popular music, and, in some cases, cultural personae.[5] But while the intention here is not to provide a social history, the essays need to be read in the context of the years immediately preceding perhaps the two most dramatic events in the history of homosexuals in Great Britain and United States. In both nations, the end of World War II and the ensuing Cold War precipitated, as lesbian historian Emily Hamer has observed, "a time of increased conservatism on many fronts, although there is no consensus about why this was so."[6] One facet of this conservatism was the growing legal prosecution of homosexuality, among other forms of so-called deviance. At the same time, a number of "homophile" organizations seeking to end legal prohibitions and to educate the public about homosexuality (particularly the Mattachine Society and the Daughters of Bilitis in the United States, and the Homosexual Law Reform Society and the Minorities Research Group in Britain) came to life. By the time the 1960s were at their height, changing social mores in Britain brought about legal change. In the wake of the 1963 Profumo sex scandal, which brought down the ruling Conservative Party, Harold Wilson's Labour government enacted sweeping legislative and social reforms. Working from the premise that the most civilized and enlightened society is a permissive one, Parliament effectively diluted government powers of film and stage censorship. The 1967 Sexual Offences Act decriminalized homosexual acts between consenting adult men (a full ten years after the government-commissioned Wolfenden Committee's report first proposed this change) and, in effect, repealed the

repressive Labouchère Amendment to the Criminal Law Amendment Act of 1885, the very law that had resulted in the imprisonment of Oscar Wilde.[7]

In the United States, however, prohibitions against homosexual activities were a matter of state and local, rather than national, law. Thus, no such national legal reform was possible—nor would American public opinion, either then or now, permit such change. Instead, the climactic point of homosexual history in the United States was a public disturbance. On the evening of Friday, June 27, 1969, the New York Police Department raided the Stonewall Inn, a gay bar on Christopher Street in New York City's Greenwich Village. Such raids on gay bars were hardly uncommon; indeed, they were part and parcel of the routine of queer life in the fifties and sixties. This time, however, the patrons' response was atypical; drag queens, butch lesbians, and queers of all varieties fought back, and the rioting continued over the entire weekend. The event is popularly regarded as the flashpoint—the originary moment—of the American Gay Liberation movement of the 1970s.

Queer culture did not, however, begin with these dramatic moments in time; rather, it had flourished in both nations with an elaborate and highly developed sensibility, a subcultural vernacular and semiotic system, and cultic veneration of certain figures. These are the stories *The Queer Sixties* intends to tell.

Figments and Fragments: The Sixties and the Queer Imagination

I have quite deliberately chosen the word "figments" to denote the icons examined in this volume. Homosexuality, even now, but more so in the 1960s, exists in heterocentric perceptions as an unrealistic mode of being, one that can be readily ignored or dismissed, as would the purely imaginary.[8] Moreover, when social dictates force homosexuality into the realm of covert desires and activities, the development of an aura of mystery and fantasy is almost inescapable. Thus, if the queer imaginary is a highly developed one, it is not without reason; the imagination can easily take control where no overt expression is allowed, and in such a context, the need for icons is a tremendous one. The queer cultic iconicity of each "figment" is based, in great part, on the particular pull it exerted on both the individual and collective queer imaginaries in the 1960s and thereafter; in effect, such attraction depends on the queer audience being able to discern sympathetic attributes in each that, in a period in which homosexuality remained for the most part legally and socially proscribed, were not readily apprehended by mainstream audiences.[9] This is, I would argue, most obvious in the subcultural or pop cultural "figments" the volume presents; but, as the essays by Jennifer A. Rich and William Scroggie indicate, even works that explicitly presented homosexual possibilities to a mainstream audience, such as *The Children's Hour* and *The Boys in the Band,* were originally, and have remained, susceptible to very different readings from queer audiences.

"Figment," in addition, alliteratively suggests "fragment," and fragmentation plays a significant role in the shape of this volume. The ideal for a collection of essays is that taken together, all should present a closely united whole; that all the pieces should, somehow, mirror one another while affirming a central axiom. As this volume focuses on artists and works that went against the grain of what was considered the norm, so this collection, to some

extent, does likewise. This is not to say that certain essays are not directly related to others. The linkages between lesbian pulp fictions and their gay male counterparts, for example, or those among Joe Orton, Dusty Springfield, and John Lennon in the context of the British Mod youth culture of "Swinging London" are obvious; the connection between Andy Warhol and Valerie Solanas goes without saying. The correlation between the Los Angeles of Christopher Isherwood and that of John Rechy and Jim Morrison is perhaps less obvious, as may be the other linkages between the various artists and texts that confronted and affronted mainstream sensibilities. They are, nonetheless, present and pertinent. This volume exists, then, not as a tightly woven fabric, but rather as a mosaic; each essay is a discrete entity, yet when all are placed in juxtaposition with one another, a pattern appears.

I would argue, moreover, that this mosaic-like portrait is an appropriate one, inasmuch as it represents the conditions in which much of the queer, cult-like veneration of icons took shape in the 1960s. The need for cult figures—the obscure objects of admiration, identification, and desire—arises, like most such devotions, in great part from feelings of alienation. While the overturn of established norms seemed to have become an everyday event by the time the sixties were at their height, these "happenings" at best only marginally included or formally acknowledged queers, whose own "revolution" was, for the moment, still deferred. "The sixties," as they are presently configured in the mainstream collective unconscious of Anglo-American culture, provide the backdrop for the essays in this collection; but those sixties "belonged"—and still do "belong"—to someone else.

This is not to deny the efforts of certain extraordinary individuals and groups—some of whom are commemorated in these essays—but the deeds that brought about Stonewall in the United States and the decriminalization of male homosexuality in Great Britain were, in reality, the actions of the brave and the few. For most ordinary queers, the 1960s were spent in the closet—in isolation, fear, and repression—and, accordingly, in the fragmented, and often not completely coherent, half-life of "all the sad young men" and "odd girls out," to use the code words of pulp fictions. At a time when the risks of publicly acknowledging one's homosexuality were too great for the average queer to venture, what brought such individuals together, at least ostensibly, was frequently a common interest in, or devotion to, a cult object. That the group that was gathered at the Stonewall Inn on the evening of the riots was comprised in great part of drag queens coming together to mourn the passing of their icon Judy Garland is, I would argue, hardly accidental.[10] The police raid was nothing new; on this particular occasion, however, it added an insufferable level of insult to injury. It is not egregious hyperbole to posit that, in the queer imaginary, the raid constituted a sacrilege—the violation of a gathering of the devout. Accordingly, we must not readily dismiss the cult of the icon or the iconoclast as mere personal obsession or camp frivolity—as if camp, as many of the essays here argue, were not, in and of itself, terribly serious—even dangerous. Nor should we underestimate the power of such veneration to effect social change.

Icons and Iconoclasts:
A Means of Measuring Our Pain

Each essay in this volume is, in a sense, a "case study"—a term ironically appropriate for a decade in which homosexuals were still regarded as "cases" requiring psychoanalytic study—of a particular cultural phenomenon or figure that, since manifesting in the context of the 1960s, has taken on iconic status among queer audiences; that is to say, one that has become the object of queer cultic devotion. The iconicity of each work or artist is, however, inextricably linked with—and undoubtedly the result of—an (initially) iconoclastic quality. That these entities evoke a response of affection, identification, and admiration from a devoted queer audience or following arises, almost inevitably, from the presence in each of characteristics that were, in their time, implicitly or explicitly contrary to societal and cultural ideals and sexual mores in a manner resonant with queer sensibility—even if, in some cases, the artists or their production (e.g., John Lennon and Jim Morrison) were "queer" only in the generic sense of being deviant from the larger cultural norm. This phenomenon inscribes two separate, but linked, artistic paradoxes: first, that a particular and marginalized audience might perceive a given work or figure in a manner vastly different from the perceptions of a "mainstream" audience or even the artist him- or herself; and, second, that that which shatters or overturns the earlier ideal stands to become the new ideal.

In 1970, after his attempted break from the burdens of life as a sixties icon, John Lennon sought to disabuse us of our need for the various gods we have created. In the song "God" (in which he exhorts, in the course of a litany of contemporary icons, "Don't believe in the Beatles"), Lennon proposes that "God is a concept by which we measure our pain."[11] It is not too much of a stretch to suggest that this is true, not only of religious deities, but of subcultural icons as well, for even the linguistic terms by which we describe them have religious origins. "Icon" (in its purest sense meaning merely "image" and now widely used to connote an object of devotion) retains an earlier meaning as the graphic representation of divine or saintly figures, such as those of the Eastern Orthodox churches. "Iconoclast" (literally, "image breaker") is a term used in contemporary discourse to describe anyone whose ideas or actions have the effect of threatening cherished traditions (or merely the status quo); similarly, it has its origins in ecclesiastical history, referring to the followers of Leo the Isaurian in ninth-century Byzantium, who took much too literally the Old Testament prohibition of the worship of graven images. Through an ironic twist in semantics, these particular zealots, like their sixteenth-century Protestant counterparts, destroyed art in their religious zeal, in the very same spirit that suppressed the works of many of the "iconoclastic" artists examined here; and, as a further irony, such historical iconoclasm was committed in order to annihilate the worship of "false" gods.

The worship of idols—of "false" gods—is, I would suggest, an integral part of queer culture, particularly in times when homosexuality is most severely proscribed. Although there are notable exceptions, organized religion has, in most instances, treated homosexuals as absolute and irredeemable pariahs. Shunned by mainstream religious devotees and—by implied extension—their "true" deity, queers (often with an ample dose of

self-parodic irony) have developed their own counterdeities, who function either as the singular object of devotion or as part of an eclectic pantheon. It is not for nought that Maria Callas, one of the more conspicuous objects of gay male opera queen worship, was called "La Divina," or, for that matter, that the original Italian meaning of "diva," the term applied to Callas and her ilk, is literally "goddess."[12] Cultic fascination with, and obsessive devotion to, a distant public figure is generally dismissed by the "serious" and "adult" (i.e., straight) world as frivolous and infantile—in much the same manner as homosexuality is frequently dismissed.[13] To return to Lennon's definition of God, underlying this ostensibly absurd, excessive, sentimental, and even pathological veneration is a very real element of extraordinary pain, the pain of social and religious ostracism for which, one is told, the "real" deity feels revulsion rather than compassion. Thus, the queer icon—who, whether personally queer or not, has either suffered greatly and rebounded, defied traditional mores continually and unapologetically, or both—becomes the larger-than-life measure of the particular and often invisible pain of the obscure and ordinary gay or lesbian individual.

It follows, then, that identification with the admired object plays a significant role in the individual modeling and self-perception of the queer individual and functions as well as the embodiment of an all-too-common dilemma of homosexual life, that of unfulfilled—and unfulfillable—erotic desire. In a perceptive retrospective essay on the career of Dusty Springfield, Stacey D'Erasmo argued that Springfield's public personae raised "that quintessentially queer question: do you want to be her or have her?"[14] I agree completely; and, as the question is indeed a quintessential one for queers, it is applicable to queer icons in general, as implied by many of the essays in this collection.

Let us consider, for example, Andy Warhol, arguably one of the most extraordinary queer icons. In the 1960s, Pop Art, a movement almost inextricably associated with camp (and thus, queer sensibility) reached its height. Beyond a doubt, the most prominent figure of the New York Pop Art scene was Andy Warhol, an artist whose very name is almost synonymous with 1960s iconography. His mass-produced and recurring visual images of animate and inanimate cultural icons have come, for many, to emblematize (if not subvert, iconoclastically and ironically) the very essence of the decade's consumerism and materialism. The great icon maker of the 1960s also performed a major feat of self-creation; his public image, which Kelly Cresap calls a "naïf-trickster persona," infuriated and alienated many among the self-impressed intelligentsia of the art world. As Cresap argues, this "dumb and dumber" affectation was a clever machination that allowed Warhol access to the mass media and to celebrity status that otherwise would have eluded him as a marginalized, "swish" gay man. Indeed, it might be seen as an alternative—and highly original—means of what we now call "coming out." In examining Warhol's "dumb blond" personae, Cresap evaluates the artist's role in shaping subversive queer culture and semiotics and considers the extent to which the persona of the harmless "fairy"/naïf has become itself an icon of queer camp performance.

Andy Warhol (almost) died for *someone's* "sins"; but just *whose* sins—and *what* sins—is not necessarily clear. His camp strategies and performances, like those of other artists discussed here, might well be regarded as a means of

having it both ways: seemingly affirming a specific (straight, patriotic, bourgeois) message to the mainstream audience while denying, through ironic overkill, that affirmative gesture in the eyes of another (that is, queer) audience. Camp, accordingly, is perhaps just another twist of the old appearances-versus-reality trope. Still, no artist or performer possesses absolute control over audience perceptions, and when, as in the case of Valerie Solanas, the artist has so completely blurred the lines of demarcation between the real and the imaginary that she cannot see the difference, camp and performance have the potentially lethal ability to spin completely out of control. One of the most extreme figures on the periphery of the Warhol circle, Solanas was herself a would-be icon who performed the role of iconoclast—vis-à-vis the decade's great icon/icon maker—much too literally. An unsuccessful playwright, Solanas is best remembered for her putatively revolutionary act of attempting to assassinate Warhol—who was an unlikely and unwitting scapegoat for the wrongs of patriarchal society—just two days, by strange coincidence, before the assassination of Robert F. Kennedy. Prior to the shooting, Solanas had gained a certain notoriety for her pamphlet, *SCUM Manifesto* (the acronym standing for "Society for Cutting Up Men." Laura Winkiel, employing the concepts of contemporary performance theory, demystifies *SCUM Manifesto* and the murder attempt. Her argument suggests that we read Solanas's pamphlet as an elaborately hyperbolic, neo-Swiftian satire on gender roles. Many of Solanas's contemporaries, however, took the document at face value and—regardless of the author's actual intentions (for perhaps her only real wish was to become famous and, in a perverse twist of the Warholian dictum, to have her fifteen minutes of limelight)—adopted it as a foundational text of radical lesbian separatism. As such, it has attained a curious iconic status of its own, as it continues to resonate to this day in the antiporn, antisex feminism of individuals such as Andrea Dworkin and Catherine MacKinnon. For the Solanas devotee—and truly, they do exist—she stands as a radical, lesbian, martyr heroine who, through being incarcerated and institutionalized, suffered for her struggles against the patriarchy, regardless of the facts of the matter. It is also perversely fitting that Solanas, by means of the film *I Shot Andy Warhol,* has posthumously achieved the iconicity for which she was, in life, literally ready to kill. In examining the multifarious psychological and political implications of Solanas's "performances," Winkiel confronts the terrifying possibility that some of the more extreme forms of lesbian feminism over the past quarter-century may have been the result of the rejection of queer camp sensibility—and thus, an absolute case of what might be called irony failure—on the part of those who have since "performed" lesbianism solely as a political gesture rather than a sexual desire.

At the same time when Warhol was making a mark on international cultural consciousness, the "Permissive Society" and youth culture of Great Britain produced a number of disparate iconoclasts who have long been icons to queer audiences and, ironically, martyrs as well. The enfant terrible of 1960s British drama, Joe Orton, was an iconoclast in a number of senses, from his notorious conviction and imprisonment for subversively "vandalizing" images in library books to his plays affronting middle-class sensibilities. His theater works stripped bare—at times, literally—the icons of the crepuscular British Empire; yet, simultaneously, his self-fashioned public image, as

Francesca Coppa demonstrates, was the embodiment of a new gay icon, a nascent mode of youthful, "masculine" queer sensibility and discourse. This new ideal would soon eclipse an older, "effeminate" model and would have significant ramifications for gay culture in the 1970s, which some critics would subsequently find highly problematic. At the same time, this "new attitude" indirectly led to Orton's undoing, for if Andy Warhol *almost* died for *someone's* sins, Joe Orton actually did so. Focusing on 1967 as a crucial year in British queer cultural history, Coppa provocatively juxtaposes two events—legislative reform and Orton's brutal murder. Not only was Kenneth Halliwell, Orton's lover and murderer, a jealous, frustrated writer aggravated by his partner's success, he was also, to a great extent, a personification of the "old homo" stereotype, being ill-prepared for the changes, whether legal or stylistic, that Orton had come to symbolize. In destroying Orton, however, Halliwell ironically fixed his victim's place as an enduring queer martyr/icon.

It is also ironic that while the old "queeny" homosexual icon fell into decline as the youth culture advanced, the drag queen found a curious female analogue in the "Mod" youth culture that swept Britain and the world at the midpoint of the decade. Rock star Dusty Springfield, as I argue in my own essay, created a decidedly queer persona while achieving popular success in a trendy milieu in which lesbianism, lacking the criminal status and thus the glamour of male homosexuality, remained invisible and unfashionable. Utilizing the tactics of camp, she adopted more visible (and modish) marginalized identities by "becoming" a gay man in drag (or, conversely, a *female* female impersonator) visually and a black woman vocally. In this manner she pushed accepted notions of femininity to absurd extremes and thus, even if unwittingly, subverted the iconography of what it means to look like—and be—a "girl." The year 1968, a crucial year for political upheaval and for many of the artists and works in this volume (e.g., Andy Warhol and Valerie Solanas, *The Boys in the Band, Myra Breckinridge*), was a watershed year for Springfield as well. While it saw her artistic high point with the release of her critically acclaimed album, *Dusty in Memphis,* it also marked the beginning of the end of her career. The camp masquerade that brought her popularity—a curious lesbian simulacrum of a "girl"—ultimately served a young queer woman even less well than it did the superannuated "old homos" from whom she appropriated it. Despite her courageous, if quixotic, 1970 "coming out" statement, there was no place for Springfield in the highly politicized ethos of lesbian-feminism then fulminating, and the rock music world had no place for a "dyke." The 1970s found Springfield professionally and personally in decline, a veritable pop pariah, forgotten by all but a few die-hard queer admirers. Springfield would seem to embody the prototypical qualities of the icon/martyr who suffers and rebounds, and the 1980s and 1990s have seen the canonization of "St. Dusty." The very elements of her persona that proved her undoing subsequently—and ironically—had, by the 1980s, made her a venerated icon of a newer, more inclusive queer sensibility.

The Beatles were, of course, the quintessential icons of 1960s youth culture; yet to "queer" the Beatles, even now, might strike some as outrageous. To dismiss this possibility is, however, to overlook the fact that the Beatles' public image was the craftily fabricated brainchild of their closeted gay manager, Brian Epstein.[15] Ann Shillinglaw's provocative analysis of the Beatles' films demonstrates the extent to which this image was constructed

around a seemingly asexual male homosociality, underscored by the deployment of queer camp encoding, particularly on the part of John Lennon. The nature of the relationship between Epstein and Lennon has long been the subject of speculation (and a recent film), as has been Lennon's sexuality. While making no attempt to arrive at any conclusion about the strictly personal issues involved in this seemingly unresolvable controversy, Shillinglaw provides considerable insight into Lennon's "queer" sensibility, revising our perceptions of the Beatles' cultural legacy and illuminating the manner in which their nonthreatening modes of gender bending indirectly contributed to a greater social acceptance of queerness.

If the artists and performers discussed thus far seem to fall into a pattern of the trend-setting defier of tradition qua scapegoat, the "L.A. section" of this volume presents two very different and unlike (if not unlikely) sorts of queer sixties icons/iconoclasts—as, perhaps, befits the unique conditions of life on the margins in southern California. In the first instance, the 1960s found Christopher Isherwood, a representative of an older mode of British queer culture, transplanted to Los Angeles, the city that for many emblematizes the ultimate American multicultural utopia—or dystopia. As the Modernist chronicler of the homosexual demimonde of prewar Berlin, Isherwood had become, by the 1960s, a gay icon in his own right. His 1964 novel, *A Single Man,* provides a view of the conditions of queer life in yet another city that has historically drawn outsiders of all sorts from every corner of the globe. As Joseph Bristow observes, Isherwood's middle-aged protagonist, like Isherwood himself, has left behind what he saw as the dying tradition of England and envisions southern California—both literally and metaphorically—as a site in which "gay male desire is an indirectly acknowledged component of a diversifying West Coast culture gradually coming to terms with questions of sexual, ethnic, and generational difference." If this image of Los Angeles seems fantastically utopian, one need only remember that both the author and his character had emigrated from a society in which male homosexual acts were still criminal. Moreover, the very multiplicity and lack of homogeneity that has always bestowed this dualistic iconic status on Los Angeles has also made its queer life unique—indeed, possible. In the context of a nascent cultural diversity influenced by early 1960s liberalism and the civil rights movement, gayness could, ideally, be seen as just another form of otherness, analogous in many ways to the protagonist's "Englishness." In this manner, Bristow suggests, Isherwood was able to imagine the possibility of gay life treated with dignity; one might go so far as to say that Isherwood actually achieved this, and in doing so achieved a sort of queer iconicity without martyrdom, perhaps simply by "getting away with it." Isherwood's protagonist, however, is neither so daring nor so fortunate; bereaved by the death of a lover he cannot mourn publicly, George is a type of the suffering queer "saint" isolated by the dominant culture, albeit one who strives for survival rather than immolation.

Isherwood's California dream was, however, only one side of the story, only one facet of Los Angeles queer culture. John Rechy's *City of Night,* published a year before *A Single Man,* portrays another Los Angeles, the demimonde inhabited by male hustlers and drag queens. In examining the iconography and culture of this sexual underworld, Ricardo Ortíz provocatively connects the gender roles, posturings, and attitudes of Rechy's hustlers

with the sexual and gender ambiguities that mark the performance and lyrics of rock star Jim Morrison, surely one of the most prominent subcultural iconoclasts—and icons—of the 1960s. Ortíz has collected numerous observations from a wide variety of sources that suggest that Morrison was influenced, at least indirectly, by Rechy's novel; indeed, Morrison resignifies the novel's title in the lyrics of "L.A. Woman." The purpose of Ortíz's essay is not to "out" Morrison—which, as he asserts, would be a futile, indeed pointless, task. Rather, as the essay on John Lennon also posits, one need not be queer to have—or to utilize—queer sensibility. Accordingly, Ortíz demonstrates another aspect of Los Angeles's cultural multiplicity in which queerness could, potentially, become yet one more "otherness" in its pop culture melting pot, much as it does in Isherwood's view.

Designs for Living:
Textual Images, Iconic Types,
and the Creation of Queer Identity

Thus far, we have only considered how particular public figures have functioned as icons, in the sense of a secular pantheon, for their queer audiences. An equally powerful force in the creation of icons is surely that of representation through various media, including fiction, drama, and film. For a significant portion of the audience that consumes and subsumes visual and textual representations, the narratives and images they perceive are mimetic and therefore offer models and patterns for their own lives. For the isolated or semi-isolated gay or lesbian individual who is bereft, for the most part, of a larger and viable queer community—as most were in the 1960s and many are still today—texts or films that represent a relatively unambiguous representation of queerness provide, for better or worse, paradigms for identity. Recently, I had a conversation with a lesbian activist, now middle-aged, whom I had assumed to be a paragon of "political correctness." I was therefore rather amazed to hear her recall—*with great fondness*—her experience, while still a "baby dyke," of seeing the 1968 film, *The Killing of Sister George,* in a theater somewhere in the American Midwest, in spite of what many would now consider its outrageously grotesque and unflattering representations of lesbian characters. The over-the-top characterizations did not matter; what did matter, she told me, was her realization that other women shared the desires she felt, that she was neither unique nor alone in this world. Angela Weir and Elizabeth Wilson, in assessing the value of pulp fictions, suggest this was a relatively common phenomenon: "To lose oneself in these narratives was to participate more fully in a total lesbian alternative world than was ever possible. . . . In this fantasy world work, home—and, indeed, everything about "everyday life"—were subordinated to the fierce dictates of sexual desire."[16] Unrealistic escapism this well may be; but such a vicarious sense of community, as offered by texts and films, not only has the power to make an isolated, marginalized life livable for many, but also provides the idea of just what queer identity might be when no more tangible models are available. In this manner, a number of works provided the character type as icon while functioning as a sort of subcultural conduct guide. That this is so—and that there were, as lesbian author Maureen Duffy articulated in 1966, "dozens of ways of being queer and you have to find what your kind is"— may well be seen in two of the works previously discussed.[17] Christopher Ish-

erwood, for example, creates a homosexual Everyman whose most notable quality is his ordinariness and whose social isolation is, accordingly, an ironic indictment of the proponents of mainstream mores who would denounce his "otherness." Conversely, as Ricardo Ortíz demonstrates, John Rechy's *City of Night* established certain very different types—the hustler, the drag queen—as iconic in the popular imaginary, to the extent that the former became the prototype even for the ostensibly straight and utterly iconoclastic rock icon.

Arguably, pulp fictions, the most marginalized (and, perhaps, maligned) texts of 1960s queer culture, were for many the most influential form of subcultural "instruction." Created originally to provide titillation just short of outright pornography for, presumably, a heterosexual male audience, pulps were marketed in a manner that underscored their less-than-respectable status: on the back racks of drugstores, in bus stations and sleazy newsstands, and so on. Marginal as they were in terms of social acceptability—and, in most cases, literary quality—pulps nevertheless were often the *only* source of gay or lesbian representation available to many queer subcultural readerships at the beginning of the decade. Thus, the pulps played a significant, if ambiguous and unheralded, role in the shaping of queer identity and self-consciousness—and, accordingly, in the formation of a subcultural iconography of queer semiotics. Even as these texts were instrumental in creating certain stereotypes (or, conversely, archetypes) of queerness, which were often internalized and made iconic—for better or worse—by the gay and lesbian audiences, their very lack of respectability allowed them to perform the iconoclastic function of presenting, if only obliquely, subversively positive images.

By and large, the picture of queer life that the pulps painted was not a "gay" (i.e., happy) one: it was a twilight world in which "sad young men" and "odd girls out" pursued their doom even as they pursued their forbidden passions. The (stereo)typical scenario ran, as David Bergman writes: "Boy meets boy. Boy dies." Yvonne C. Keller, in turn, illustrates that in lesbian pulps, the plot, while still stereotypical, was a bit more complex: Butch meets femme; femme is "rescued" from "unnatural passions" by boy (i.e., she is reheterosexualized); butch dies grotesquely. Despite these narrative limitations, queer readers nonetheless found positive uses for the pulps, which at that time were often the only readily accessible texts to call homosexuality by name and to present forthrightly many of the social problems affecting most gays and lesbians. Keller demonstrates that although a number of "literary" novels of the late fifties and early sixties featured lesbian plots, their characters were generally socially privileged, middle-class, discreet, and above all else, closeted; their lesbianism was implied but never named. In effect, "literary" novels attempted to normalize lesbians, while the pulps confronted—albeit in a sensationalized manner—the ostracism and prejudice most lesbians faced routinely. In spite of plot restrictions, moreover, the authors of lesbian pulps managed to convey positive images of queer characters and their relationships—even as they dispatched them to their perdition—that were then not found elsewhere.

Similarly, in his exploration of gay male pulps, David Bergman relates how in the sixties, even in advance of post-Stonewall consciousness, certain pulps became vehicles for the concept that "gay is good." Whether an ambitious pseudo-pastoral romance like *The Song of the Loon* or a hastily contrived

potboiler like *The Man from C.A.M.P.*, these fictions rejected bourgeois morality and affirmed a gay lifestyle outside the bounds of heterosexual expectations. As such, they functioned as a considerable, if generally uncredited, aspect of the groundwork of Gay Liberation movements that would come to the fore in the 1970s and subsequent decades.

Now, in the 1990s, reproductions of pulp fiction covers proliferate as camp collectibles—greeting cards, clocks, refrigerator magnets, and the like—are found wherever queer-oriented shops find a clientele. This, in and of itself, bears witness to the manner in which the pulps have, perhaps ironically, achieved a wry iconic status: embarrassing to (yet enjoyed by) the more conventional queers of the 1950s and 1960s and often rejected and abhorred by many of the more earnest liberationists and critics of the 1970s and 1980s, the pulps, by means of their very iconoclasm, have become in their own way the camp objects of cult appreciation.

It would be wrong to assume that the 1960s texts and films that were influential in the creation of queer typology and iconography were all subcultural or marginal. During the 1960s, gay and lesbian characters and situations became increasingly evident, albeit often sensationally so, in mainstream cultural production. The longest section of this volume is devoted to a number of works that drew considerable attention from the mass media and reached audiences well beyond their queer cult followers. Although some of these works strike more recent queer critics and audiences as superannuated or hopelessly retrograde, their iconic status yet attains—an effect, no doubt of their once-iconoclastic character. Each, in its way, achieved a familiarity, celebrity, or notoriety that has allowed it to contribute—for better or worse—to the manner in which queers are perceived by the straight majority.

The Children's Hour, William Wyler's cinematic adaptation of Lillian Hellman's 1934 play, was the first film to address homosexuality and yet evade censorship in the wake of the relaxation of the Hays Code, which had determined "acceptable" motion picture content since 1935. Hellman's play was based on an early nineteenth-century legal case arising from a school-girl's allegations of homoerotic conduct between two schoolmistresses, which resulted in the closing of their school. The play itself had faced hostility and censorship, but by the time it reached the screen in 1961, its critics found the film "old fashioned" in its treatment of the subject matter, a view shared by many subsequent gay and lesbian critics. In this manner, we begin to see how rapidly and profoundly public opinion about homosexuals and homosexuality changed in the course of the decade, as is evinced by later works and the manner in which they were received. Jennifer A. Rich challenges these easy dismissals by earlier critics and the perceptions of audiences then and now. That *The Children's Hour* could suggest lesbianism at all was surely an act of iconoclasm in the context of early 1960s American social mores, yet the parameters of its acceptability are based on a *suggestion* of lesbianism, presumably a false one, rather than an actual *representation* of lesbianism. In effect, lesbianism would seem to be a thing of which one could be accused rather than a thing in and of itself, as far as the film is concerned. Rich, however, argues that we need to reconsider the deeper implications of this film; through her analysis of protagonist Martha Wright, she questions the prevailing assumption that the student's accusation is necessarily a *false* one and elucidates the underlying issues of lesbian identity that the film implicitly raises.

As the decade progressed, gay and lesbian identity became increasing imbricated in the issues of other marginalized groups. By the time James Baldwin published *Another Country* in 1962, the African-American novelist was already established and acclaimed in the literary world, well on his way to the iconic status he would eventually attain. Thus, although his critics found it difficult to accept this representation of race and sexuality in contemporary America, which was, according to William A. Cohen, "too ready to endorse alternative, bohemian—especially homosexual—lifestyles," they were also unable to dismiss it. Cohen's essay explores the intersections of race, gender, sexuality, and power relations in Baldwin's novel, and it delineates the manner in which the author's affirmation of the individual—regardless of his or her socially encoded otherness—broke new ground in creating cultural acceptance and understanding of these issues.

Baldwin's reputation in the larger (i.e., straight) literary world allowed him access to an audience that might otherwise have turned a deaf ear to the issues of sexuality and race that permeate his novels and essays. Indeed, by the mid-sixties, a number of gay authors had attained, not only visibility, but also a sort of media celebrity, the most notable being Truman Capote, one of the most obvious gay figures of his day. In 1966, at the height of his fame, Capote published *In Cold Blood,* the narrative of two mass murderers, their crime, their flight, and their homosocial—if not homoerotic—relationship, and a work described as the "first non-fiction novel." Blake Allmendinger contextualizes *In Cold Blood* within the tradition of male same-sex relationships in American literature, particularly the Western. As in traditional Westerns, Capote's male pair, bonded across "cowboy-Indian" racial lines, reinscribes the masculine-feminine gender role dichotomies conventionally assigned in such configurations and is suggestive of the protagonists' internalizations of these stereotypes. Setting the stage by observing some of the gender constructs implicit in the most familiar and best-loved Westerns (such as *The Virginian* and *Shane*) that "confuse and . . . clarify the Western hero's own sexuality," Allmendinger sees Capote's novel as an updated Western in which the gay author represents his protagonists as "modern-day outlaws," an appropriate metaphor for gay male identity in the 1960s; indeed, it goes without saying that the cowboy, while on the one hand, the paragon of American machismo, has also long been an iconographic type in the creation of gay male identity.

The end of the sixties saw a greater level of explicitness in mainstream representations of homosexuality. In the short season between decriminalization in Britain and the Stonewall Riots, a number of works, including Quentin Crisp's unabashed autobiography, *The Naked Civil Servant,* and Frank Marcus's play, *The Killing of Sister George,* shocked and titillated vast audiences. Even more notorious, perhaps, were Mart Crowley's *The Boys in the Band* and Gore Vidal's outrageous satire, *Myra Breckinridge.* The overwhelming changes in gay signification and consciousness at the end of the decade are dramatically illustrated by the history of *The Boys in the Band,* which delineates the often campy and bitchy interactions of a group of gay men at a birthday party. When the play debuted in 1968, it was originally lauded as a breakthrough in the representation of homosexuality; yet, by the early 1970s, it was widely blasted for its self-loathing gay characters, who comprise a panoply of old types and stereotypes, particularly that of the "sad

homo." William Scroggie provides a cogent reconsideration of the play, seeing it as a reflection of the medical discourses on homosexuality prevalent in the 1960s and of mass media reactions to the topic. Because of its notoriety, *The Boys in the Band* had a considerable, if short-lived, influence on public perceptions of gay men; that it might be seen as an example of social realism, moreover, undoubtedly gave greater "authenticity" to its characterizations in the minds of a straight audience. Thirty years on, it is perhaps best seen as a "period piece," one that has lost its power to shock. Its characters, however, remain with us as a group of 1960s "ghosts," for the legacy of the "unhappy homo" has never entirely departed.

While Crowley's realism provided a provocative simulacrum of gay identity to the American public, a wildly fantastic contemporary novel wielded a far greater ability to shock and offend the straight mind. Gore Vidal's thoroughly iconoclastic *Myra Breckinridge* provides a seemingly apocalyptic—and thus appropriate—end to pre-Stonewall queer culture. The whole range of queerness was thrust upon the mainstream in this elaborate and outrageous camp deconstruction of everything middle-class America has traditionally held dear. One early critic saw it as a sure sign that society was changing; and, indeed, it was. As if to confirm that life imitates art, this ferocious satire of American sexual and material mores (relating the *bildung* of Hollywood transsexual Myron/Myra) so shocked the public that it quickly became a best-seller and was adapted for film. Douglas Eisner cites the novel's climactic rape scene (in which the postoperative Myra, who has assumed as her personal mission "to recreate the sexes," sodomizes—by means of a dildo—an imbecilic young stud who embodies all that American heterosexual masculinity stands for, including repressed homosexuality) as emblematic of social and aesthetic change. Indeed, one might see Myra as the fictional embodiment of much that Valerie Solanas proposed in *SCUM Manifesto*. In Vidal's hands, the camp aesthetic, which he used in this text as a new mode for the public (as opposed to strictly subcultural) representation of homosexuality, is fused with the then-growing social awareness of the relationship between gender, sexuality, and power. That such relationships exist—and that *Myra Breckinridge* gained such an extensive (if, ostensibly, offended) audience—leads one to conclude, as a final thought on the queer 1960s, that sexual pathology is, after all, as American as apple pie.

Taking Care of [Unfinished] Business

I began this Introduction by calling the 1960s a ghost story. This volume, as I see it, is an album of queer "ghosts"; the artists and works examined here may seem, to many, remote and only tangentially connected to the brave new world of the 1990s, where "alternative sexualities," as we now call them, are visibly represented in the media and where we might even imagine at times that queerness has actually become fashionable, if not respectable. Our ghosts may, in many cases, seem little more than camp reminders of the bad old days—for one doubts that very many gays and lesbians would like to return to the sort of queer life that then existed—yet I would argue that we cannot dismiss them quite so easily. If we are indeed "haunted," it is because our ghosts have unfinished business with us—and we, with them.

It is clear that the sixties encompassed some of the watershed events of queer history, without which the Gay and Lesbian Liberation movements of

the 1960s could not have taken shape. But certain nagging elements of queer life in the 1990s suggest that the more things change, the more they stay the same. Three decades after decriminalization in Great Britain, social prejudice against homosexuality remains rife, as demonstrated by the virulent debates in the House of Lords against lowering the age of consent for sexual acts between men; that reform in this area was blocked by such an antiquated institution has simply engrained the existing double standard more deeply. In the United States, even three decades after Stonewall, homosexual acts remain criminal in many state and local jurisdictions; we need only look to the debacle involving the status of gays in the military issue or the legal efforts to prevent same-sex marriage, an institution that has not even come into being, to understand the depth of prejudice and hatred, a situation that, in many cases, has hardly improved since the 1960s.

The sixties marked the beginning of our "revolution," just as it did the revolutions of many other maligned groups. But lest we delude ourselves by signs in popular culture or academic discourse that this revolution was a long-ago event that we need not think about any more because it has nothing to do with our lives here and now, let us try to remember what a famous homosexual philosopher said regarding such tendencies: that those who forget their past are doomed to repeat it. It is in that spirit that I present the essays collected in *The Queer Sixties*, that we might not forget what the queer culture of that decade meant—and continues to mean.

Notes

1. *Lingua Franca,* Rick Perlstein. "Who Owns the Sixties: The Opening of a Scholarly Generation Gap." *Lingua Franca,* 6, no. 4 (May–June 1996): 30–37.

2. I am playing here with the shifting semantics of gay and lesbian identity, in which word usage is often overdetermined. The word *queer,* while now often used as an all-encompassing term for gays, lesbians, bisexuals, transsexuals, transgendered persons, and almost anyone else who is not quite straight, was commonly used as a pejorative term in the 1960s. Conversely, *homosexual* was then considered a "proper" and relatively polite term, although it is now rejected by many to whom it applies as a label redolent of medical sexology and, consequently, pathology. The whole spectrum of terms applied to individuals who are erotically attracted to the same sex is employed in this volume, whether according to the usage of the 1960s or the present day, and should be read according to the context in which they appear.

3. See, for example, Patricia Waugh, *The Harvest of the Sixties: English Literature and Its Background 1960 to 1990* (London: Oxford University Press, 1995); and Neil Nehring, *Flowers in the Dustbin: Culture, Anarchy, and Postwar England* (Ann Arbor: University of Michigan Press, 1993).

4. Among the most notable and commendable of these social histories are John D'Emilio, *Sexual Politics, Sexual Communities: The Making of a Homosexual Minority in the United States 1940–1970* (Chicago: University of Chicago Press, 1983); Martin B. Duberman, Martha Vicinus, and George Chauncey, eds., *Hidden from History* (New York: Meridian, 1989); Alice Echols, *Daring to Be Bad: Radical Feminism in America 1967–1975* (Minneapolis: University of Minnesota Press, 1989); Lillian Faderman, *Odd Girls and Twilight Lovers: A History of Lesbian Life in Twentieth-Century America* (New York: Columbia University Press, 1991); Emily Hamer, *Britannia's Glory: A History of Twentieth-Century Lesbians* (London: Cassell, 1996); Alan Sinfield, *Literature, Politics, and Culture in Postwar Britain* (Berkeley: University of California Press, 1989); Jeffrey Weeks, *Sex, Politics and Society: The Regulation of Sexuality since 1800,* 2nd ed. (London: Longman, 1989). While not necessarily focused on the 1960s in particular, each of these works addresses at some length the issues of the decade from a queer perspective.

5. Many of the essays collected here employ this methodology, which was pioneered by British scholars in the humanities and is often termed British Cultural Studies. For an explanation of this methodology, see Graeme Turner, *British Cultural Studies: An Introduction* (Boston: Unwin Hyman, 1990).

6. Hamer, *Britannia's Glory,* 144.

7. For an extensive history of British legislation regarding homosexuality, see Weeks, *Sex, Politics and Society.* It is worth noting that female homosexuality, while socially and culturally proscribed in Britain, was never illegal. On the social conditions of lesbianism in Britain, see, in particular, Hamer, *Britannia's Glory.*

8. Several major critical works have dealt significantly (if not always directly) with the queer imaginary and its manifestations in cultural contexts as well as queer fixations on particular icons. The most notable of these are Terry Castle, *The Apparitional Lesbian: Female Homosexuality and Modern Culture* (New York: Columbia University Press, 1993); Wayne Koestenbaum, *The Queen's Throat: Opera, Homosexuality, and the Mystery of Desire* (New York: Poseidon, 1993); Eve Kosofsky Sedgwick, *Epistemology of the Closet* (Berkeley and Los Angeles: University of California Press, 1990), and Eve Kosofsky Sedgwick, *Tendencies* (Durham, N.C.: Duke University Press, 1993). While I do not cite any of them directly in this chapter, I am nonetheless deeply indebted to the ideas presented in all these works in shaping my argument.

9. For an extensive study of such attraction and discernment on the part of a gay male subcultural audience in the case of a particular icon, Judy Garland, see Richard Dyer, *Heavenly Bodies: Film Stars and Society* (New York: St. Martin's, 1986), 141–94.

10. For an illustrative—and extraordinarily campy—anecdote linking Judy Garland's funeral and the Stonewall Riots, see Martin B. Duberman, *Stonewall* (New York: Dutton, 1993), 190–91.

11. John Lennon, "God," *John Lennon/Plastic Ono Band,* (EMI Records, 1970).

12. On Callas worship among gay men, see Koestenbaum, *The Queen's Throat,* esp. 134–52.

13. On this perceived infantilism and its application to the seemingly abject nature of fan cultism, see Castle, *The Apparitional Lesbian,* esp. 200–203.

14. Stacey D'Erasmo, "Beginning with Dusty," *Village Voice,* 40, no. 35 (29 August 1995): 67.

15. After Epstein's death, his public image underwent an appalling eclipse and he was consequently viewed as a "sad homo" or a tragic queen who had loved the Beatles (particularly John Lennon) pathetically and unrequitedly. Moreover, although he virtually created the world's most successful rock group, it was widely (if rather inaccurately) perceived that, ultimately, he had ill-served his protégés' business interests. Accordingly, his death (the result of a possibly accidental drug overdose) has long been interpreted as a suicide in response to his growing loss of control over Lennon and the other Beatles. Recent attempts have been made to acknowledge Epstein's contributions to British arts and culture and to establish him as a queer hero in his own right. (Once again, the icon maker/martyr traits are apparent.) For new insights into Epstein's life and career, see Martin Lewis's "New Companion Narrative" to the reissued edition of Epstein's autobiography, *A Cellarful of Noise* (New York: Pocket Books, 1998), 1–45.

16. Angela Weir and Elizabeth Wilson, "The Greyhound Bus Station in the Evolution of Lesbian Popular Culture," in *New Lesbian Criticism: Literary and Cultural Readings,* ed. Sally Munt (New York: Columbia University Press, 1992), 95.

17. Maureen Duffy, *The Microcosm* (London: Virago, 1989), 273.

PULP POLITICS
Strategies of Vision in Pro-Lesbian Pulp Novels, 1955–1965

Yvonne Keller

DESPITE THE ADVANCES in gay community formation encouraged by the dislocations of World War II, for lesbians, the 1950s and early 1960s in the United States were a difficult time. Dominant culture sought a return to a mythical pre-War, pre-Depression "normality," visioned in ideologically conservative terms in which "men were men and women were housewives" (Whitfield 43). This, alongside increased public discourse on homosexuality as a psychological disease and the Cold War notion that homosexuals were a pressing political threat, made the fifties, as Lillian Faderman writes, "perhaps the worst time in history for women to love women" (*Odd Girls* 157). Despite their benign *Father Knows Best* image, the 1950s and early 1960s were, to some extent, an age of paranoia, fed by deep fears of the bomb and communism. Both assuaging and mirroring such anxieties was a general atmosphere of voyeurism; for example, in popular culture Hugh Hefner began *Playboy*—displaying scantily clad women for the man who looks—and James Bond's "license to look" (at women) was more important to the success of the Ian Fleming thrillers than his license to kill (Denning 102). On a political front, visual technologies of spying and surveillance dominated public life and discourse as the Julius and Ethel Rosenberg and Alger Hiss spy trials threatened every all-American boy's (and girl's) presumed innocence. Indeed two potent American fears—fear of the communist conspiracy and the fear that a member of one's family might be homosexual—were linked in the perceived threat that homosexuals could be blackmailed into becoming communist spies (Epstein; Whitfield 43). As a result, even extremely closeted homosexuals and lesbians were barred or dismissed from federal jobs and the military; the Federal Bureau of Investigation (FBI) began broad surveillance of homophile organizations and gay gathering places; and urban police heightened their harassment of homosexual citizens (D'Emilio 60).

Given the fierce public disapproval of homosexuality, lesbian representation was scarce and lesbians of the time repeatedly attest to the frustration of their desire for such images in popular culture. In every public art, lesbianism was invisible: the Hays Code banned the depiction of homosexuality in Hollywood films; the nascent television industry never showed recognizable

homosexuals; and mainstream New York book publishers offered only a trickle of covertly lesbian literary texts. Outside the pathological images proffered by psychiatry and occasional scandal magazine articles that capitalized on the fear of homosexuality, lesbian pulp novels were the only medium that afforded a large stock of these images. Marked by their explicitly lesbian, sensationalized covers, which advertised "twilight women," "forbidden love," or the "limbo of lesbianism," these books were mass-market, cheaply made paperbacks with lesbian themes. The genre of lesbian pulp novels came into existence thanks to the "paperback revolution" begun by Pocket Books, which in 1941 greatly increased its distribution channels, and thus sales.[1] Book outlets—mostly bookstores—had numbered around 1,000 before World War II, but Pocket Books's new use of newspaper distribution outlets such as newsstands and grocery store racks created an impressive 100,000 outlets for cheap paperbacks. Pocket Books's success was imitated by many other mainstream East Coast presses, notably Fawcett, Beacon, and Midland-Tower, which promoted paperback originals of genres such as Westerns, mysteries, thrillers, and, most important for my focus here, lesbian pulps, with astonishing success.

These new mechanisms of distribution meant, in essence, that more books with lesbian themes were cheaply and widely available during this time than at any previous time in U.S. history. While their existence is only briefly noted in a few publishing histories, millions of lesbian-centered texts were bought during this time. Tereska Torres's *Women's Barracks* (1950), for example, a story of a houseful of French women living in England during World War II, quickly sold over 1 million copies; by 1968, over 3 million copies had been printed (Adams 259, 273), and as of 1975 it ranked as the 244th best-selling American novel (Hackett 16). Even Radclyffe Hall's lesbian classic, *The Well of Loneliness,* when reissued as a lesbian pulp complete with a sensationalist cover that proclaimed in large, red type: "Why can't I be normal?" achieved sales of over 100,000 copies a year.[2] Claire Morgan's 1952 *The Price of Salt,* a tale of two women who fall in love in New York City, had sold over a half-million copies by 1958, and by 1963, the *Ladder* estimated that there were over 1 million copies in print (Highsmith, pbk. cover; "Crosscurrents" 14). Given that best-selling hardcover novels in the 1950s sold an average of 30,000 copies and the sales of typical trade hardcovers today can be as little as 5,000 copies the first year, these figures are extremely high. Clearly, the publishers had a new, successful genre on their hands.

Lesbian pulps thrived from 1950 to 1965. The genre began with the publication of *Women's Barracks* in 1950, followed in 1952 by Vin Packer's best-seller *Spring Fire,* a story of love between two midwestern sorority sisters. These two relatively unhomophobic books, both written by women (one of whom described herself as a lesbian), made publishers aware of a potentially large market that was (at least at first) assumed to consist of heterosexual men. This belief led to the publication of many poorly written, fast-paced tales involving frequent sex and written from a male point of view, a kind of lesbian pulp that I call "virile adventures." In contrast, my focus here is pro-lesbian pulps—a subset of lesbian pulps, often written by lesbians, with generally more positive lesbian representation—which were published in quantity only toward the end of the 1950s. Ann Bannon's famous Beebo Brinker

series, for example, is a series of six books featuring the same characters, published between 1957 and 1962, and Randy Salem's ten books appeared between 1959 and 1965. After 1965, however, what some called "the golden age" of lesbian paperbacks was over: mainstream publishers no longer published lesbian pulps because of the changing times and the increased incorporation of lesbian themes either in fiction of more established literary quality or in the new openly pornographic fiction published by small, opportunistic, nonmainstream presses.[3]

Clearly lesbian pulps flourished largely because of the publishing industry's ability to make money from homosexual themes, but there are other reasons as well. First was the form: true, pulp novels made money, but they were a devalued form of writing; and few of their editors were concerned about their content. Second was gender: the lesbians depicted were still women—which meant, to more men than just Hugh Hefner, that they were still sexually available to men and, moreover, nonthreatening to depict (to heterosexual men, of course); not coincidentally, fewer pulp novels were published with gay male themes. Third was the use of vision: voyeurism in particular worked as a form of pleasure and reassurance over anxieties about social hierarchies; it reinstated the power of men over the objects of their gaze. While looking/surveillance was a precipitate of the culture at large and expected for novels with sexual adventures, it also provided narrative structures in which to "show" lesbians and often placed a man in the scene with the two women. While he exists as an assumed reader/audience when not explicitly in the narrative, more often he is a real character in the novel, as the man who always gets the girl—at least, the most feminine girl—in the end.

While existing as a technology of power within the larger culture and within representation, voyeurism was also a technology of power in the realm of lesbians' lived experience. For example, lesbian bars from the forties to the early sixties were subject to quite blatant heterosexual tourism. In their history of the lesbian community in Buffalo, New York, Elizabeth Kennedy and Madeline Davis write that "most bars . . . had straight observers. Lesbians used humor to deal with the inevitable objectification and were successful at deflecting the tension" (62). They go on to quote an interviewee, a lesbian, who says, "back then you had an awful lot of your soldiers, sailors, straights come in, it was like going to the zoo and seeing the monkeys dance" (62). Lesbian-designed strategies for engaging with vision, in fiction and in life, were thus both necessary and difficult.

What were embattled lesbian readers to do, given their strong desire for lesbian representation and the inevitable proximity of voyeurism and homophobia in the only readily available books with lesbian themes? They did the only thing they could—they compromised and turned a blind eye, so to speak, to the homophobic looking relations installed in these texts. For example, when, at the end of the 1950s, a group of American, white, middle-class lesbian readers assembled a bibliography of lesbian titles, called simply *Checklist 1960,* they were "not averse" to the representation of frequent sex in the novels they listed, but rather developed a special designation for the books that incorporated frequent sex without a "reasonably well written story":

[I]f the story is just a peg on which to hang up a lot of poorly written, gamy erotic episodes, with no literary value, and just evasive enough to keep the printer out of jail, then we have given it short shrift with the abbreviation "scv"—which cryptic letters are editorial shorthand for "Short Course in Voyeurism"—and have been the basis of a lot of jokes in the tedious business of passing reviews around the editorial staff. (Bradley and Damon, *Checklist 1960* 5)

The "scv" label seems to mean: do not bother to read this book; it borders on pornography and is not for "us." Though critical, the editors do not keep "scv" books out of their bibliography, saying "we shan't spoil your fun" (5). This reluctance to judge, plus the scarcity of lesbian fiction overall, precluded their rejection of these books. Voyeurism in some form pervaded so many lesbian novels—since the majority were lesbian pulps—that it could not serve as an effective basis of exclusion. In *Checklist 1960,* of all the novels listed, over thirty-five lesbian pulp novels were given the highest rating as "of considerable value"; of the total, thirty-eight were rated "scv," all of which were lesbian pulps.

The editors of *Checklist 1960,* like many lesbian readers of the time, were caught in a bind. On the one hand they felt discomfort at the evident repeated proximity of the two concepts of voyeurism and lesbianism in their book list. They write: "the paperback originals reek with drooling voyeuristic stripteases about lesbians, for the sake of men who like to enjoy pipe-dreams about lesbians making love, and about some Big Handsome Hero who eventually converts the girls to 'normality' with some secret formula of caresses" (Bradley and Damon, *Checklist 1960* 52). On the other hand, in their desire for representation, they collected and read any books with lesbian themes, despite homophobia and voyeurism. Most lesbian pulps were virile adventures aimed at a male readership, but there were also, beginning in the late 1950s, a subset of pro-lesbian pulps, the set of books most often written by lesbians and characterized by the most positive lesbian representation. Like the editors of the *Checklist,* lesbian writers who wrote lesbian pulps were caught in a similar bind: they wanted to write about lesbians, which the genre encouraged, but they were also compelled to conform to generic imperatives such as homophobia, sexism, frequent and gratuitous sex, voyeurism, male-centeredness, and sad endings—typically, ones in which the lesbians do not end up happily together. Using an exemplary novel of the genre, Randy Salem's *Man among Women,* this essay analyzes the representation of voyeurism in pro-lesbian pulps to argue that these pulp novels resisted and subverted the publishers' (and readers') expectations of how voyeurism should be treated in the genre. I conclude by suggesting that the genre's openness about lesbianism, even though often voyeuristic and homophobic, opened up an important space in public discourse because it allowed more articulation of lesbian issues than the few literary novels with lesbian themes existent at the time.

Subversion in Pro-Lesbian Pulps:
Randy Salem's *Man among Women*

Given the context of a homophobic, male-oriented genre, pro-lesbian authors themselves have asserted (sometimes in the pages of the lesbian peri-

odical of the time, the *Ladder,* but also in a post-Stonewall context) their desire to improve the inaccurate and sensationalized depiction of lesbians that the virile adventures created. These authors were typically more invested in creating positive lesbian representation than other lesbian pulp authors, often because they themselves were bisexual or lesbian. In 1989, pro-lesbian pulp author Valerie Taylor describes the late fifties:

> There was suddenly a plethora of [gay novels] on sale in drugstores and bookstores, and most were absolute trash—many written by men who had never knowingly spoken to a lesbian. . . . I wanted to make some money, of course, but I also thought that we should have some stories about real people—women who had jobs, families, faults, talents, friends, problems; not just erotic mannequins. ("Those Wonderful" 1)

These authors' desire to write *against* the genre's norms also constituted a refusal of cultural norms: lesbianism as sick, immoral, or criminal. The writers tried to show "real," "true" depictions of normal, "well-adjusted" lesbians to the public (Bradley, "Those Wonderful" 4; Christian, "Those Wonderful" 4). However, publishers imposed strict limits on what they could do. Although Paula Christian claims that she "got away with quite a bit" (*Amanda* 1), March Hastings tells of the basic limits: "[My editor said:] 'The heroines cannot end up happily together. . . . It's against the moral code.'. . . I heard conviction here, not to be argued, not to be negotiated" ("Those Wonderful" 8). While these authors' intentions, stated many years after the books were published, may be skewed in order to please a gay audience, their consistency invites belief. Overall, the multiple instances of tempered idealism, self-doubt, and self-censorship that are manifest in the encounters described between lesbian writers and their publishers support a reading of these texts as contested, contradictory sites of self-representation. Overall, lesbian authors' impulses to self-representation correlate with markedly more positive lesbian representation in their books.

Unlike post-Stonewall lesbian fiction today or literary fiction at the time, pro-lesbian pulps are fully immersed within, and indeed obligated to attend to, the discourse of voyeurism because of the constraints of their mass-market cultural form. Lesbian authors of lesbian pulps must have each taken a "short course in voyeurism" themselves to publish successfully in the genre. How did they implement that knowledge? How did they navigate the simultaneous generic mandates for overt lesbianism and objectifying imagery while still portraying well-adjusted, perhaps even happy, women? In contrast to contemporaneous literary fiction, which rarely and only covertly addressed lesbian themes, pro-lesbian pulp writers could write openly about lesbian heroines, lesbian bars, and, to a lesser extent, cultural structures of homophobia. However, again in contrast to literary fiction, homophobia, racism, and sexism were also expected to be more overt in their texts. Despite their location in the middle of a homophobic discourse, pro-lesbian pulp novels resisted the legacy of this genre. Their authors' tactics often resulted in obvious contradictions within the texts, such as perfectly content lesbians who suddenly commit suicide or marry men at the very end of the book. From today's point of view, these efforts at resistance may well seem like

failures—their overall homophobia is easily recognizable. Nonetheless, pro-lesbian pulp writers did resist, and they did so in a genre that gave them more possibilities for openness about lesbian issues than the more elite work of literary lesbian writers of the time.

The pro-lesbian pulp genre is comprised of almost 100 novels by over fifteen different authors.[4] Their authors implemented three strategies in reaction to the conventional voyeurism of the genre: refusal to acknowledge its existence in their writing, appropriation, and subversion. In deploying the first, and least utilized, technique, refusal, some writers managed to ignore the constraints of a sexy/erotic adventure tradition while still achieving publication within the genre. The paradigmatic example here is Valerie Taylor, whose Erika Frohmann series, in books like *A World without Men* and *Journey to Fulfillment,* successfully avoided sensationalism and extraneous sex scenes and worked to normalize, humanize, and desensationalize the lesbian characters while keeping them central to each story. The second strategy, deployed in books like Ann Bannon's *I Am a Woman,* embraces looking relations but does so in a female-centered context that reverses who looks and the meaning of the look. Randy Salem's *Man among Women* is representative of the third strategy, subversion. Her novel is the most self-contradictory of these three types, in that it accommodates the genre's insistence on a male voyeurism but resists the male power that traditionally accompanies it.

Randy Salem is one of the five or six pro-lesbian pulp authors most highly regarded by the *Ladder* and its readers, and, according to Barbara Grier, the woman behind this pseudonym is a lesbian (1991 interview). Her work covers a wide range of texts, from *Chris,* an entertaining lesbian love story that remains sellable today (and indeed was republished by a lesbian press in the 1980s), to titles like *The Unfortunate Flesh* and *Tender Torment,* which are more like virile adventures. Her *Man among Women* (1960) is a useful and typical example of a pro-lesbian pulp because it conforms in part to generic constraints but nevertheless represents lesbians positively. Narrative voyeurism is both encouraged and subverted in this book; often the male protagonist is allowed to look at lesbians but always with painful consequences, from jealousy to physical pain due to a fall after watching. In short, the text is simultaneously voyeuristic and antivoyeuristic.

Because of its history of engagement with issues of vision that also are central to these books, this essay in part uses film criticism to analyze the written text. For example, in *Man among Women,* Ralph, a photojournalist and thus a kind of voyeur by profession, is the hero of the book and narrates the story.[5] This structure of seeing the world through Ralph's eyes offers the reader an easily recognizable place of identification with the feelings, power, and gaze of the white, male protagonist. In her well-known article, "Visual Pleasure and Narrative Cinema," Laura Mulvey makes the identification between protagonist, spectator (reader), and vision explicit: "As the spectator identifies with the main male protagonist, he projects his look onto that of his like, his screen surrogate, so that the power of the male protagonist as he controls events coincides with the active power of the erotic look, both giving a satisfying sense of omnipotence" (34). Mulvey here also draws our attention to the issue of power, arguing for the identification of the spectator with the male protagonist, and thus with his sense of power. Randy Salem's work, I will argue, grants maleness as the gender of the look but aims to separate this

look from what Mulvey calls "active power" or "omnipotence." Thus, Ralph can look, but his look carries no power.

The book's story is simple: boy meets girl but girl is already with girl, boy waits for girl, boy gets girl. Using a common pulp tactic, heterosexual sex starts the book, which is set in the "exotic" locale of the Bahamas. A sensitive, likable, handsome young man on foreign assignment who is bored by his overly efficient fiancée back home, Ralph finds a beautiful woman named Alison on a deserted tropical island, which is completely inaccessible except with scuba equipment due to a ring of coral circling the island. They make love, swim, and eat raw seafood in an extended romantic idyll, yet Alison remains reticent, elusive about her past or future and mysteriously distant. Though the book tells the story of Ralph staying close to Alison and eventually winning her, the story emphasizes lesbian, not heterosexual, primary relationships, and this early sex is the book's only heterosexual lovemaking. Ralph in fact spends most of the book ancillary to, and jealous of, a successful lesbian relationship. The narrative depicts Alison and her lover, Maxine, showing their devotion to each other as well as their group of lesbian friends, who are working together to create an all-lesbian resort on the same tropical island where Ralph and Alison met. The lesbian relationship is not permitted to be seen as too wholesome, however—Maxine is also Alison's aunt. In addition, Maxine serves as the guardian of Alison's fortune until she turns twenty-one ("in a year or two"), and the narrative implies that Maxine's use of Alison's fortune to establish the resort might be more in the aunt's interest than the niece's.

While voyeurism occurs throughout *Man among Women,* it especially pervades two scenes in which Ralph sees Alison and Maxine having sex. In the first scene, after Ralph and Alison return from the island, Maxine and Alison pay the hotel manager to make sure Ralph drinks too much liquor so that he will pass out and wake the next morning to find Alison irrecoverably gone. Instead, Ralph drunkenly talks the maid into giving him the dinner the women had ordered from room service, and when they neglect to answer his knock, he pushes his way into the room. Salem writes:

> As he catapulted headfirst into the room, his eyes riveted on the bed. The two women lying together on it—naked and locked in a close embrace—struggled apart, wide-eyed in horror and shock.
> One of them was Alison. (43)

This scene also constitutes the teaser page at the front of the book, evidence of the publisher's belief in voyeurism (and lesbianism) as an effective hook. But after a single additional sentence that describes Maxine, Ralph and the readers are cut off from further sights because the chapter immediately ends. Ralph has finally been rendered unconscious by the alcohol. The next day, unable to even think the word *lesbian,* he acknowledges that Alison "is a. . . ." Realizing that he has a challenger, he asserts that he can win Alison away since he "knows firsthand" her "deep and fiery need for the male" (45). In this scene, Ralph's loss of consciousness—accompanied by a loss of sight— effectively halts the structural power of his looking.

Sight is crucial to the narrative's progression. Maxine believes Ralph has "seen more than he should," and decides she wants him under her

control. Jealous of him, she also cannot allow him to use his knowledge of the couple's lesbianism against them since their group is composed of well-known, wealthy women whose plans for a lesbian resort would be a perfect topic for the scandal magazines. Thus, after Ralph again tracks them down, Maxine decides to keep him close at hand and, since he has (conveniently) been robbed, she is able to keep him financially dependent on them:

> [S]uddenly he knew what was expected of him. He shrugged.
> "I'm willing to do whatever I can for you both."
> Alison grinned with obvious amusement. Maxine nodded at the acceptance of her terms. (54)

After this, Ralph is kept under surveillance, his maleness used to prop up the legitimacy of their business negotiations. He is given food, clothes, shelter, and cigarettes, but no money, symbolizing Maxine's continued control over his life. While these are putatively Maxine's terms, they also give Ralph what he then most wants, access to Alison. With Ralph as a disempowered adjunct, manifest control and power are thus kept by the women for most of the book.

Whereas Ralph's invasion of Maxine and Alison's hotel room allows him sight but also knocks him out, the second voyeuristic episode, which is the only scene of lesbian lovemaking described in the book, is similarly double-edged, allowing Ralph to look, but at the expense of realizing his own inadequacy. The scene occurs after Ralph has agreed to help the women set up the all-lesbian resort in the hopes that his extended proximity will allow him to win Alison back. Angry that Maxine and Alison were retiring to their hotel room (undoubtedly to make love) after a day in which he and Alison had become closer, Ralph decides to "throw away all scruples" and take a look at them, since he has to "know what he is fighting." Voyeurism is here redoubled through fantasy and memory, as Ralph "pictur[es] what might be happening between the two women now that they were alone. With terrible vividness, he recalled the image of them naked together at the hotel" (93). He is portrayed as desiring to own Alison:

> There was no doubt in his mind that Maxine was even now preparing to possess the girl. *His* girl. . . . He had a sudden impulse to whirl around and bash down the door of the room. He wanted to do violence, to smash forever all the bonds between them. . . . He meant to get a look at them—at any cost. (93–94)

Note here that the narrative answer to Ralph's desire to smash lesbian bonds is to *look*. He finds a neighboring terrace, and "disgusted, yet hypnotically fascinated, he watched, dreading to see, yet not daring to leave" (94). Ralph here is the ideal relay figure for the voyeuristic look. Fear and pleasure mix as he looks at the women. He is fascinated yet disgusted; he watches, he dreads, yet he does not dare leave, preoccupied as he is with "demystifying the mystery" of woman, in Mulvey's terms (35).

The scene emphasizes, not the objects of the look (Maxine and Alison), but Ralph's reactions as a voyeur; the reader watches him watch them. Ralph is fascinated, yet looking hurts: "Blinded by emotions of loss and grief, over-

whelmed by a murderous rage, he rushed in a daze from the terrace" (95). He is so shaken that "[h]e wanted to forget what he had seen. He wanted to erase it so completely that he would never recall it again." Paradoxically, his structural and cultural position as viewer is so painful that it has given him a desire *not* to see. The reader as relayed voyeur "sees" even less, since out of the episode's nineteen paragraphs, only four describe the women. In the end, this scene, which constitutes the most extended and dramatic episode of voyeurism in the book, depicts more the cost of Ralph's sight than sex between women or any pleasure in watching.

Looking results in pain, but also knowledge. Curiously, this knowledge is all about Maxine, not about Alison—all about identification, rather than desire. In a fashion typical of lesbian pulps, the older, "real" lesbian functions as a "male" antagonist for the hero, whereas Alison, the "woman" (read: straight woman) is the "prize," someone without agency of her own. The back cover confirms, even proclaims, this structure: "Calling into play all the masculine weapons he possesses—and he has many—Ralph engages in all-out war with striking Maxine Carpentier, with Alison's body the prize." Maxine is an adversary with whom Ralph identifies—she is powerful, knowledgeable, and desires Alison just as he does. He concludes, despite his own blinding homophobia, that she is a worthy opponent.

> Maxine had been to him a creature to be pitied, one of life's misfits who had temporarily captured Alison through sheer accident. And just what was she now? Not pitiable, certainly. And certainly not someone to be lightly dismissed. She was a creature of power—a formidable enemy who could do anything he could do. Differently, perhaps, but maybe better. She was a person who knew more about Alison, more about pleasing her, more about teasing her, than he would be able to know for many a year. . . . [He wondered] if he really had a chance against Maxine after all. (95–96)

While lesbian lovemaking skills are not infrequently figured as threatening in pulp novels, the actual fact that Maxine *can* make love better than Ralph can is *not* the usual assessment of male heroes. His spying here renders Ralph figuratively impotent. His (in)sight in part becomes punishment—knowledge that a man, privileged by a sexist homophobic culture, does not (want to) know. Ralph sees what his culture tells him is impossible: not only is the male not the hero, not the love of the beloved, but he is an inferior lover. This rupture in the sanctioned formula must, of course, be recontained, with Ralph winning the woman by the end of the book.

The text offers a third scene about sight, though one completely lacking in sex, that perhaps says the most of any scene about this period's view of voyeurism. It is the only incident, significantly, that Ralph himself notes as voyeuristic, and the results are again painful for him. While waiting to pick up Alison and her friends from a Greta Garbo film (the book's most noticeable such subcultural clue), Maxine takes Ralph for a ride in her convertible. Maxine is in a good mood and chats with him about her favorite subject:

> "[Alison's] plenty stubborn, all right," she said. The affection she had for the girl was obvious in her tone and in the soft lines around her eyes. . . .

Ralph listened to her as she spoke at length about Alison. She spoke with such evident relish and openness that one might have thought they were mother and daughter. It made Ralph distinctly uncomfortable. He felt like a Peeping Tom treated to a keyhole view. He wanted to shut Maxine up, to shout her down with the side of Alison he knew, that he alone knew. Miserably he realized that Maxine would not talk so freely if she considered him any kind of threat. (129)

In this passage again Ralph "peeps" yet deeply regrets seeing (actually, only hearing) what men are supposed to want to see. While he feels as if Maxine is offering him the sexual thrill of a "keyhole view," in fact she is feeling open and generous and is simply talking about her lover's personality. The two are not hidden in a hotel room or having sex as in previous scenes; only in his rendering of the situation is this voyeurism. Yet this culturally sanctioned "treat" called voyeurism is not palatable. Ralph feels like a Peeping Tom in part because he is in love with Alison himself and cannot bear to hear of her intimacy with someone else, but also because Salem here mocks the male (reader's) desire to see lesbians having sex by showing the love as "normal" and the looking as "perversion." The available conceptual frame to understand the women's love is twisted so that an "open" display of the fact still makes Ralph feel like a voyeur. The text criticizes voyeurism as the culturally normative mode of understanding lesbianism. In other words, the link between lesbianism and voyeurism here is so strong and automatic that the mere image of a lesbian couple—structurally—makes a voyeur out of the nearest straight man. Alternately, the connection can only be figured as non-gay, as a mother-daughter bond—evidently, the only other possible way to understand such "evident relish" and *"openness"* in the affection between two women. The culture mandates that either lesbians are not really lesbians or they are sexual objects whose role is to satisfy the owners of the gaze. There is no possible community-sanctioned place for them to even inhabit, other than within a male-controlled economy of sex. It is, therefore, no wonder that their main form of representation is in pulp novels and no wonder that they need a remote island.[6]

Lesbian Bars as Racial Sights/Sites: Hierarchies of Looking

Representations of the lesbian bar, the only public lesbian space available in the culture, is standard in lesbian pulps. In most lesbian pulp novels, heterosexual looks control even that space, which is typically figured as one of heterosexual tourism. Virile adventures might show the lesbian bar from the point of view of a heterosexual couple that is there for a "thrill." Pro-lesbian pulps construct bar scenes that often refuse this normative structuring, recreating the bar as a lesbian-centered, liberating space despite occasional heterosexual patrons. Salem's bar in the Bahamas is an enjoyable space where lesbians can dance, flirt, and talk with each other, despite a heterosexual presence. But the refusal of male voyeurism exacts a toll—apparently, if lesbians are no longer to be the object of the gaze, the power vacuum must be filled, in this case by creating black people as spectacle instead.

In *Man among Women*'s bar scene, lesbians, all of whom are wealthy and white, are in control of their own territory. While they are planning the

resort, Alison, Maxine, their lesbian friends, and Ralph spend time in a tropical "closed" town in the Bahamas only for the very rich—idle white tourists, not rich natives, despite its location. Alison, her friends, and Ralph go to a local bar that is mostly gay. Here Ralph, our supposedly masculine, strong hero, is in fact a "kept man," who is taken along only as nominal heterosexual cover for the women. When Ralph realizes that the bar is really more lesbian than not, "He sighed and leaned back in the chair, his high spirits beginning to fade" (77). Ralph's gaze lacks an object or desire and the reader is given no images of him looking at lesbians. Rather, we see looks between and among lesbians. While Ralph gives up and leans back in his chair, Alison, in a similar but opposing motion, "lean[s] forward eagerly and her eyes were amused" (77–78). The lesbian gaze is valorized as Alison looks, trying to pick a likely woman out of the crowd for her friend Judy to approach.

In the beginning of this scene, Salem switches the location of spectacle from (white) lesbians to (heterosexual) blacks. Apparently to do something so daring as depict one group appropriating the white male look and refusing to function as its object, one must refocus the power of that look onto another Other: hierarchical looking relations must have an outlet. As they first enter the bar, Salem describes at length three "Negroes" with bongos in the center of the bar, with a fourth on a reed instrument, playing music. The beat gets louder and more intense as a "barefooted Negress" "pad[s]" out into the spotlight and dances in an erotically charged manner. The narrative animalizes and primitivizes the Bahamians with stereotyped racist, sexist, and colonialist images. For example, the woman dances with "thighs flexed, ribs heaving and breasts hanging naked. Her stark white eyeballs rolled upward as her frenzy mounted" (77). In *Man among Women,* the hierarchical look is displaced onto a convenient Other—the natives of the Bahamas. In racist fashion, Salem "softens" the blow to straight American (white) male readers caused by (white) lesbian rejection of the gaze by thrusting black people as spectacle onto the stage, thus creating a new and reassuringly familiar—also exotic and erotic—Other. As Judith Mayne writes about a film that works similarly, "The racial stereotype appears when the sexual hierarchy of the look is deflected or otherwise problematized."[7] Thus, Salem's move toward increased racial objectification works in two ways: to reassure the reader that the basic structures of dominant power remain intact, and, concomitantly, to allow subversive, unobjectified images of a different "Other"—in this case, lesbians. The problems with, and futility of, reinforcing oppressive structures in one place while trying to break them in another are manifest.

The racist mechanism of the look is supported by other, more obvious racist assumptions. The natives of the Bahamas are consistently portrayed as inferior and as "types" rather than people. Whether the maid, the manager of the hotel, or the policeman, all are either subservient, docile, feminized, wily, and money hungry or alien and eroticized. Alison and Maxine have an American black man working for them named Noah, who is portrayed as a domesticated Other; the epitome of the physically powerful, helpful servant, he is a noble, selfless, asexual, Uncle Tom figure. Nonverbal, gentle, and patient, his is a masculinity domesticated for white female use. Alison explains Noah to Ralph in a way that establishes his—and her—historically unchanged (and implicitly unchangeable), structural positions: "Noah is our man of all work. So was his father. We used to have lots of servants—but not

anymore" (56). He does traditionally masculine tasks for the lesbian group, such as drive the boat. American maleness in the sense of sexuality, however, is defined as white, in that white males are sexual and have agency whereas black men are helps or hindrances only. Noah's blackness renders him "not male" in a culturally useful or privileged sense. For example:

> [Ralph] felt a nudge at his back and turned to see Noah beside him, leading the dog on a chain. "You go with the lady," he said to Ralph, and nodded toward Maxine, walking ahead of them.
> Ralph was about to refuse, but Alison . . . smiled in agreement. "He's right," she said. "Maxine shouldn't go ahead unescorted." (69–70)

Thus, the black man knows, not only his place, but Ralph's: Noah cannot be the (white, middle-class) "man" who should escort Maxine (neither can Alison). Noah knows that Ralph, even though despised by, and despising of, Maxine, can and should escort her. This repetitive fixing of structural positions reassures the white, male reader that the dominant cultural structures are or will be reasserted by the novel's end, as indeed they are.

The character of Noah is profoundly racist, yet in this lesbian text his character is the only male needed for the heroines to succeed, unlike other men such as Ralph or their gay male friends. According to the narrative, Noah provides the strength, the nonthreatening and domesticated maleness, needed to carry through the dream of a lesbian-only resort. Finally, by his name and captaining of the boat, he recalls the biblical Noah and his ark. In a twist on that narrative, the new Noah's purpose is not heterosexuality incarnate in saving two (male and female) of each creature and not to start his own clan (having no desire or independent agency); rather, he serves as a midwife. His function is to land white lesbians on their own island, presumably to start the lesbian community anew.

Man among Women's Conventional Ending: Male Sight Restored

Just as sight is diverted to benefit the women in the bar, the three scenes analyzed here show voyeurism as evident, yet twisted to benefit the women. In the first, Ralph blacks out; in the second, he feels inferior; and the third, he wants not to have seen at all. In all three and for most of the narrative, Ralph suffers because of what he has seen, as opposed to feeling omnipotent. In the last episode of the book, however, Ralph becomes for the first time a culturally "successful" distanced observer, in that his sight is aligned with power instead of pain. The ending leaves Alison injured but safe and calling Ralph "darling"; Ralph having saved, and probably won, his girl; and Maxine surely dead, having chosen to give her own life to divert a barracuda that attacked Alison. Though successful, Ralph's viewing activity is the only "action" this passive hero takes to get the girl.

At the beginning of this final scene, Maxine, Alison, and Ralph are diving to film the easiest way through the coral reef that circles the island so that the film can serve as a guide to wreckers who will bomb the coral to allow boats to approach. Ralph had made vague plans to kidnap Alison on this trip but Maxine thwarted him by coming along (there is no indication that Alison would have consented; she has not grown noticeably less enamored of Max-

ine or more enamored of Ralph). This sequence initially depicts Alison and Maxine as swimming together, and Ralph as separate, distanced from the couple by his camera (150). Through Ralph's investment in photographing the sea, the text uses vision to distance him from the action and he forgets everything except his own ability to see. The camera—a device for looking and, in fact, for eternalizing looking—marks the reinstatement of the male look as powerful, not coincidentally in an event that occurs alongside the obligatory heterosexual ending. This scene recalls the beginning of the book, which also depicts Ralph as a professional underwater photographer. Ralph had initially remained in the Bahamas longer than expected because he had not yet managed to photograph one of the sea's predators. At the end of the book, suddenly, Ralph sees exactly his desire, in the form of a barracuda, through his viewfinder: "This was what he had been after. What a brute!" (150). Immersed in his work, Ralph had wrongly thought that the other fish appeared riled due to a recent tropical storm, not a barracuda. His mistake deepens since he does not, even now, take cognizance of the possible danger—he is too enthralled by the opportunity of shooting his prey (thus, with vision as shot, as gunshot, and as power).

Even after the barracuda snaps up a fish only a yard above Alison's shoulder, Ralph remains absorbed in filming his beloved (the barracuda? Alison?) rather than saving her.

> In his excitement, Ralph moved nearer, hoping for a close-up of the slanting head, the vicious teeth protruding from the lower jaw. The barracuda was floating just above the women with an ominous placidity that was like the lull before the storm. As if by telepathy, Ralph realized the sinister intent just a split second before it happened—and by then it was too late. (151)

Salem makes Ralph part of the sea, aligning him "telepathically" with the barracuda. While my rendering clearly shows Ralph's guilt in Alison's wounding, Salem is more subtle: the text scripts an ambivalent, ambiguous scene that can be read by both her audiences, straight male and lesbian, with some degree of pleasure (and displeasure).

Because of its underwater setting and the rendering of the sea as an extension of Ralph (doing his tacit bidding, as it were), the scene seems a dream world, a fantasy in which Ralph finally gets what he wants: punishment for Maxine (and, incidentally, Alison, who is severely hurt), and Alison without her lover and thus free to be with him. Maxine and Ralph realize that only one of them can take Alison to safety while the other one must act as decoy, luring the barracuda away and in the process certainly dying. Since they are described as "equally" good swimmers, and both love Alison, this decision is left up to Alison. Curiously, this is the "woman's" only moment of agency—bleeding, in shock, unable to talk since they are all underwater, she first looks deeply at Maxine and smiles, and then turns and puts her arms around Ralph for him to carry her. The text leaves unclear the question of whether Alison knows she is sending Maxine to her death and showing a suddenly long-term preference for Ralph. Thus, even as Ralph "wins" his girl, the text grants agency to everyone and everything but the man—to Alison, Maxine, and even the barracuda.

Thus, with the exception of the final scene, Randy Salem twists a generic convention to refuse the man the pleasures and power of the male gaze. Each moment of voyeurism becomes, not a moment of control over/desire for the object seen, but of actual exclusion and forced impotence. Voyeurism is not simply about lust or objectification—rather it means pain, unwanted knowledge, looking without pleasure or power—the impotent theater viewer or reader is thrust back in his seat, being separated from the power of the gaze. Despite substantial concessions to a heterosexual male audience, *Man among Women* shows the structure of a system of looking and its costs, and it begins to dismantle voyeurism as an uncontested place of power for straight men.

The white, middle-class lesbians who commented on *Man among Women* when it first came out had contradictory responses to the book. In the *Ladder*, in June 1961, Barbara Grier calls it "superior," a "top-notch Lesbian paperback," despite a "surprisingly . . . male oriented" story ("Lesbiana" 22). A review in *Checklist Supplement 1961* offers split opinions: "Editors disagree; some liked this, some said 'scv and gaah at that.' Read it yourself, if you can stand it" (Bradley and Damon 26). "Scv," as the reader will recall, stands for "short course in voyeurism"; "gaah" evidently is an expression of disgust. The conflicted nature of the opinion here, in labeling a title both "superior" and "scv," points to the text's central contradictions. Leaving aside the death of the "real" lesbian, which readers might well have acknowledged as a necessity of the genre, male-centeredness and scenes of the hero looking at lesbians are countered by an in-depth depiction of a supportive lesbian community, positive gay characters, and a strong, loving, long-term lesbian relationship.

Perhaps what Randy Salem has accomplished here is a simple publishing trade-off: she was allowed to depict a strong community of lesbians if she made the central character a male who got his girl in the end. Though I have not discussed this community here, the book depicts a likable set of non-homophobic lesbians, all of whom seem reasonably contented in their gayness, including a friendly doctor who lost her practice because of her lesbianism and an elite, upper-class woman who is Maxine's lawyer, some of whom are coupled, and some single. The book looks ahead to the utopian and science fiction literature of 1970s lesbian feminism, envisioning the surprisingly utopian in lesbian literature: the separatism and protected space of a lesbian-only resort.[8] The book also resists homophobic generic constraints by refusing to sensationalize lesbian lives.

Readerly Ambivalence and Multiple Identifications

How might a lesbian reader negotiate the complex set of identifications and desires proffered in *Man among Women*? What are the relations between reader and text? Many feminist and queer film critics since Mulvey have convincingly critiqued her position and have insisted on multiple points of identification and a desire for a range of spectatorial subject positions.[9] Similarly, feminist literary, reader-oriented, and especially reader-response critics, as well as some film critics, have convincingly argued for versions of a "wary," "resistant," or "perverse" reading position for the reader/viewer, allowing her or him flexibility in negotiating the ideologically hostile text or the text in which a certain subject position remains consistently invisible.[10] Lesbian pulp novels, especially the virile adventures but also, to a lesser degree, the pro-

lesbian pulps, are so unsubtle that they initially beg for a strict Mulveyan reading, which would see these books as locking the male reader into a voyeuristic, sadistic position and the viewed woman as stuck in the position of sexual object; they are all too obviously products of a dominant ideology. What I find especially useful when looking at pro-lesbian pulps, therefore, is to keep both Mulvey's idea and the multiple, actual possible identifications simultaneously in mind.

In "Desire in Narrative," Teresa de Lauretis confirms the complexity of possible identifications for women as well as the different modes of identification: "Clearly, as least for women spectators, we cannot assume identification to be single or simple. For one thing, identification is itself a movement, a subject-process, a relation: the identification (of oneself) with something other (than oneself)" (*Alice Doesn't* 141). A multiplicity and complexity of identifications for lesbians are thrown into relief in an early scene on Maxine's boat. First, the scene sets up the reader to identify with male voyeurism: "Ralph decided to remain silent and stay where he was so that he could watch them." Second, taking up a position opposed to the first, the reader is also allowed to identify with the women being watched: "The fingers caressed Alison's cheek and then slipped around to the back of her slim neck. Alison looked up at Maxine and smiled tenderly." Here one can identify with Ralph's, Alison's, or Maxine's desire. Third, in the text's clearest encapsulation of its dictate that voyeurism causes pain, one can identify with the action—the punishment for looking:

> Ralph could not take his eyes from Maxine's hand. He wanted to break it off at the wrist. . . . In his anger he half arose. As a wave careened the boat, his feet slid out from under him on the slippery deck and he crashed over the edge and down to the duckboards below, landing with a thud on his back. A wild pain tore through him. (62–63)

This third identification is not with a character, but with the sequence itself. The pleasure for a lesbian reader is ambivalent; she simultaneously likes being able to see what Ralph sees *and* likes the serious pounding Salem inflicts on him for daring to see it.

Though a lesbian reader may enjoy Salem's trouncing of the male gaze, the text also implicates her in the mechanisms of sight. Torn between different identifications, she will tend to vacillate between wanting to halt Ralph's invasive looking for the sake of the women's privacy (identification with lesbian characters), pleasure in a punishing feminist fantasy where a voyeur gets what he deserves (identification with the action), and wanting to encourage Ralph's voyeurism so that she can watch the progress of the story (identification with Ralph, but also with the lesbian characters). A lesbian reader of Salem's narrative must align herself with Ralph's eyes, if not his motives—a perspective that channels, simultaneously, voyeurism, Ralph's love for Alison, and the lesbian reader's independent desire to see lesbian representation. For example, in one scene we are told, "They clung ecstatically and Maxine whispered words into the girl's ear that did not reach Ralph" (95). If he does not hear them, neither do we—and "we" do want to hear them, even if we do not particularly want them heard by Ralph. The lesbian reader is thus complicit. Despite this possible complicity with voyeurism, the choice to read

pro-lesbian pulps, it must be remembered, was made in a cultural context in which these books were some of the only, and definitely some of the most positive, representations of lesbianism available. As Bertha Harris writes, in defense of her enjoyment of lesbian pulps, in an article on lesbian literature: "when you are starving, a soda cracker will do" (51). Though probably few wanted a short course in voyeurism, many were eager for a short course in lesbianism. The proximity between the two, in sum, was fraught, yet could not be ignored.

A lesbian reader's ambivalent and complex reactions can be clarified through comparison with Kobena Mercer's thoughtful reconsideration of his reaction as a black gay man to Robert Mapplethorpe's photos of black gay men in his essay, "Skin Head Sex Thing: Racial Difference and the Homoerotic Imaginary." Mercer argues that Mapplethorpe's photos possess undecidability:

> [T]he difficult and troublesome question raised by Mapplethorpe's black male nudes—do they reinforce or undermine racist myths about black sexuality?—is strictly unanswerable, since his aesthetic strategy makes an unequivocal yes/no response impossible. This is because the image throws the question back to the spectator, for whom its undecidability is experienced precisely as the unsettling shock effect. (*Welcome* 192)

Whereas Mapplethorpe's images remain undecidable and polyvalent, and in this way shocking, the pro-lesbian pulps' images of lesbians are predominantly polyvalent and predictable. That is to say, they are decidedly polyvalent, yet already "decided" in favor of the hegemonic. The form so embraces the dominant ideology that discordant images are either hidden or, even when obvious, overpowered by the weight of the popular form. Instead of a crafted polyvalence that grates and demands attention, this is a polyvalence buried under stereotype and poor writing. Pro-lesbian pulps as a result are often *both* homophobic *and* not homophobic, for example regularly calling the same lesbian heroines "strange and twisted" in one paragraph and "noble and beautiful" in the next.

If the Mapplethorpe photos and the pulp texts are differently polyvalent, the reactions of the viewer/reader to each are similar in their polyvalence. Mercer elaborates a theory of readerly ambivalence that stresses the importance of context, writing of the complex set of feelings he experiences when he admits both identification with, and desire for, the black gay men in the photos of this white gay artist. He writes:

> [S]haring the same desire to look as the author-agent of the gaze, I would actually occupy the position that I said [in previous work] was that of the "white male subject.". . . I would say that my ambivalent positioning as a black gay male reader stemmed from the way in which I inhabited two contradictory identifications at one and the same time. ("Skin" 180)

Thus Mercer identifies simultaneously with the (white) gaze (of desire) and the gay black men being (objectified and) imaged. Similarly, in the case of *Man*

against Women, the lesbian reader sees the object, lesbians, through a straight male gaze, which offers her an ambivalent, contradictory set of locations for identification, desire, and objectification.

Mercer has an advantage over 1950s pulp readers because he knows more about the artist than lesbian readers knew about Salem; in fact, attention to the specific authorial location (Mapplethorpe as gay, white, and male) is crucial to how Mercer revisions and revalorizes the photos of which he had previously been so critical. Mercer is ambivalent about identifying with the photographer, while Salem's readers could not know the gender or sexual orientation, much less race, of this pseudonymous author. Mercer experiences identification with or desire for on two levels: with the photographer and with the black men photographed. The lesbian reader has three levels from which to identify—with the lesbian couple, with the male protagonist, or with the pseudonymous author. These sometimes irreconcilable multiplicities may account for the book's "scv-yet-superior" rating in the *Checklist*. In the end, neither Mercer nor the lesbian reader identifies with the *subject position* of Mapplethorpe or Ralph, only with their *desire*. The white male is, in each case, the most readily available point of entry to their own desire; thus, identification does not necessarily mean identity—though sharing a location can mean complicity. The difficulty, or even impossibility, of disentangling this complicity between lesbianism, voyeurism, and homophobia may be one reason why lesbian pulps have been generally ignored in contemporary lesbian literary scholarship.[11]

Conclusions: Pro-Lesbian Pulps as Lesbian Literature, or, The Advantages of the Obvious

What the pro-lesbian pulps offered at their best was a restructuring or deflection of prevalent cultural representational norms; in this case, the expectation of voyeurism. Some work, like Valerie Taylor's, showed that a text published within the pulp genre could contain an openly lesbian story about realistic lesbians without incorporating voyeurism into the text. Other work, like Ann Bannon's, seeks, not to refuse voyeuristic sight, but to harness it to a pro-lesbian agenda, thus appropriating some of its cultural power. Salem's text in the end disempowers the heterosexual male gaze, despite representing the voyeurism expected of the genre. In this way, pro-lesbian pulps begin to rework the structures of sight through refusal, escape, or refiguration so as to make a space for lesbian representation—and lesbian readers—other than the pre-established one.

Feminist film critic Carol Clover, in an article on slasher films, argues that the same characteristics that make these films "lowbrow" also allow them to better bring to the surface the structures of the surrounding society. She writes, "[T]he qualities that locate the slasher film outside the usual aesthetic system . . . are the very qualities that make it such a transparent source for (sub)cultural studies toward sex and gender in particular[,] . . . giv[ing] us a clearer picture . . . than do the legitimate products of the better studios" (188). By analogy, I would argue that the "low-brow" lesbian pulps display the very mechanics that structure society, as opposed to ignoring or simply incorporating them. Lesbian pulps are blatant about power, voyeurism, racism, and homophobia. The ideology is so obvious that it may have

allowed lesbian readers of the time to see the structures of heterosexism instead of simply internalizing them. The pro-lesbian pulp subgenre, specifically, also begins to undermine these oppressive structures, by offering spaces, moments, and even whole stories with incipiently pro-lesbian representation.

In contrast to the era's literary lesbian novels, the fact that pro-lesbian pulps, following the lead of Radclyffe Hall's *Well of Loneliness,* named, confronted—and sometimes acceded to—dominant structure, also gave lesbian readers of the time more of a language with which to name their oppression. Unfortunately, literary novels that eschewed the depiction of voyeurism altogether often also were unable to name homophobia. The literary novels with lesbian themes of the fifties and early sixties faced a different set of cultural and "generic" constraints than did their pulp counterparts. Generally, these texts, such as those by May Sarton, Mary Renault, Rosamond Lehmann, or Brigid Brophy, were made antihomophobic through the normalizing and humanizing of the presence of a lesbian character in the text. Thus, while literary novels do not have obviously voyeuristic scenes (voyeurism generally is seen as tied more closely to pornography than "high-brow" literature), I want to look briefly at what they lose by this omission.

May Sarton's *The Small Room* (1961; rpt. 1976) narrates the lives of a lesbian couple on a New England college campus, one a professor and the other a wealthy trustee, as a normal and accepted part of campus life. However, their status as lesbians is barely discussed by any of the characters themselves, including the couple, except for the general rumor that a specific professor has power because she is "Olive Hunt's pet" and a quick defense: "It happens to be a real relationship. The fact is that they love each other and have done so for twenty years. Beyond our recognition of that fact . . . it is none of our damned business" (151–52). Although lesbians are allowed in this world, then, the word *lesbian* is never mentioned and homophobia, by which I mean any idea of structural oppression, is never raised. It is none of polite (middle-class, white) society's business—and thus, a sort of knowing silence becomes the best for which a lesbian (reader) can hope. This mode of literary representation argues for an acceptance of lesbianism through a discourse of normality that works to make gayness a topic it is best to notice but never discuss. In her review of *The Small Room* in October 1961, Barbara Grier praises exactly this invisible presence: "Without exception this is the very best novel yet written using the device of introducing in a wholly natural manner a major lesbian love affair treated in a completely frank, sympathetic, offhand, and unconcerned way" ("Lesbiana" 24). Yet the representation of lesbianism here is severely limited. Though these women are characters with depth and their love for each other is discernible, the most concrete evidence of their relationship is the fact that they call each other "darling." On the other hand, they are represented arguing, they never touch each other, and by the end of the book their twenty-year relationship appears doomed. Homophobia is not even possible as an idea in this text. In other words, the fact of lesbianism *is* in the text, but with a closet around it. It is, both to the reader and to the other characters in the book , a "spectacle of the closet," as Eve Sedgwick puts it in her discussion of Proust—a closet that is known and seen, though not discussed. Another definition of closet, indeed, is, a very "small room."

This pattern is repeated with variations in almost all of the few British and American literary novels with lesbian themes printed in the first half of the twentieth century. In Rosamond Lehmann's beautifully written *Dusty Answer* (1927), the focus on the loved one is clear but the sexual dimension of the love is so unspoken that the reader can only intuit it from vague, amorphous hints. Brigid Brophy's *The King of a Rainy Country* (1957), similarly, logically implies, though never asserts, the lesbian orientation of her protagonist, Susan, while she lives (though does not sleep) with her "boyfriend," Neale. Susan never admits explicitly to falling in love with the older opera singer, Helen, or to physical desire at all—other than her vivid memory of one kiss with another girl when she was in boarding school, which was powerful enough to send her and Neale to Italy on a quest for the kissed one. The unnamed quality of Susan's lesbianism produces a strange compromise—lesbianism is not vilified, but also *not quite there*. Helen dies suddenly, before Susan is able to tell her of her love. Lesbianism as invisible presence also structures Mary Renault's *The Friendly Young Ladies* (1945), in which the lesbianism of the young couple living on a houseboat is either completely assumed as natural by the characters (and, therefore, there is no need to speak of it) or, paradoxically, it is completely unknown to the people who know or visit them (and, therefore, equally unspeakable). In either case, it is never a subject for discussion, except indirectly. It is not insignificant, however, that in the denouement, the protagonist leaves her long-term lover for a man. In sum, the best way to handle one's lesbianism is through silence, and the best way to depict it as an author is, as the character in Sarton's book stated, through initial acknowledgment followed by silence.

The depiction of a lesbian in Mary McCarthy's *The Group* (1963), the most recently published book, is refreshingly different in that it both utilizes this typical trajectory and then cleverly explodes it by having the fact of Lakey's lesbianism prove crucial to the plot. While the well-known heterosexuality of its author probably helped assure this book's welcome, *The Group* was the only one of the literary novels with lesbian themes of this time period to attain best-selling status; it was second on the fiction best-seller list for 1963, with more than 3 million copies sold by 1977. Lakey is the most beautiful, sensitive, and intelligent of the group of elite college friends, yet she is also an elusive presence, off in Europe for most of the narrative while the others live their lives more domestically, in both the national and home-centered meanings of the term. For most of the book, the reader knows Lakey only as a "wonderfully romantic" heroine, as Catharine Stimpson asserts (253)—her lesbianism is invisible, more hidden than that of any of the characters in the other literary novels discussed here. But after Lakey returns from Europe in the company of a baroness, confirming her lesbian status, her friends from college, Stimpson concludes, "[find] encounters with her awkwardly enigmatic and strange; strangely and enigmatically awkward" (254), (in an accurate description of this sort of "acknowledging silence"). At the very end, the villain, a man who in the first chapter married one of the eight friends, who has just committed suicide because of him, is punished because of the threat that Lakey's lesbianism poses. Thus, in the final lines of the novel the (heterosexual or gay) reader's sympathies are suddenly aligned entirely with Lakey's ability to use her lesbianism to hurt an arrogant, cruel man; in order for a semblance of justice to occur in the ending, we must throw in our sympathies

with, not just Lakey, but Lakey's lesbianism. *The Group*'s "time-bomb" approach to typical literary lesbian representation was unique, and it exploits and exposes the narrative conventions of the day.

While lesbian readers have traditionally welcomed literature that discusses lesbianism, however subtly, the rare literary novel that allows its characters to discuss lesbianism as an issue and openly name what we recognize today as homophobia receives rave reviews from lesbian readers. The most famous of these by far is Radclyffe Hall's *The Well of Loneliness* (1928). Despite a homophobia recognized by numerous lesbian literary critics, the directness with which Hall discussed both lesbianism (though focusing on the identity, and never the actual sex act) and homophobia caused her book to be banned in England and made it a best-seller elsewhere.[12] In the obviousness of their depiction of lesbianism and homophobia, pro-lesbian pulps in fact follow the tradition of *The Well of Loneliness* more successfully than do most fifties and early sixties literary novels with lesbian themes.

Thus, pro-lesbian pulps constitute—along with literary fiction, nascent homophile organizations, and the public space of gay bars—the beginnings of a readily available representation of lesbian community and resistance that was soon to erupt to a new level with the 1969 Stonewall riots and their aftermath. The pulps' homophobia induced many lesbians to feel their sexual orientation was morally wrong, diseased, or criminal, and it caused some to refuse the label of lesbianism altogether. Like *The Well of Loneliness,* the pulps offered lesbians not just a representation of lesbians, but a vocabulary with which to begin to resist dominant ideologies and the idea of a public lesbian culture—a lesbian community. Valerie Seymour's salon in *The Well of Loneliness* is a crucial symbol of community, as is Salem's lesbian-only island—each revealing a possibility of lesbian community not present in the books by Sarton, Renault, Lehmann, or Brophy. Despite, and in some ways because of, the voyeurism in their texts, Salem and other pro-lesbian pulp authors achieve what Sarton and others like her cannot—widespread distribution and high sales; a depiction of a degree of lesbian intimacy, sexuality, and community; an obviousness about homophobic structures; and, not least, a simple power to use the word *lesbian* frequently in print. Surely, if historical importance is one measure of a book's inclusion in a lesbian canon or literary tradition, pro-lesbian pulps, despite their characteristic homophobia and voyeurism, belong alongside literary counterparts, whose lesbian representation was usually more opaque.

Notes

1. On the paperback revolution, see Davis 16–47, Bonn 25–64.

2. Sales figures for Radclyffe Hall's book according to Una Troubridge (cited in Newton 9).

3. For the phrase "golden age," see Naiad Press, inside cover, *Three Women,* by March Hastings. Since Naiad is run by Barbara Grier, I presume she is behind this naming. Kate Adams also uses this phrase. For a contemporaneous summary of the lesbian pulp phenomenon, see Barbara Grier, "The Lesbian Paperback."

4. The most well known authors are: Ann Bannon, Sloane Britain, Paula Christian, Joan Ellis, March Hastings, Marjorie Lee, Della Martin, Rea Michaels, Claire Morgan [pseudonym of Patricia Highsmith], Vin Packer, Randy Salem, Artemis Smith, Valerie Taylor, Tereska Torres, and Shirley Verel. Of these, Bannon,

Christian, Hastings, Morgan, Salem, Taylor, and Verel have all been republished by feminist, lesbian, or even (in the case of Bannon) mainstream presses.

5. On the voyeurism of photojournalism, see Stam and Pearson (197).

6. See Zimmerman (*Safe Sea* 124–26) on the resonance of islands as a space of community in the recent lesbian literary imagination.

7. Here Mayne discusses Dorothy Arzner, one of the very few women to have succeeded as a director during the studio era of classic Hollywood. Mayne shows how Arzner's film, *Dance, Girl, Dance,* makes remarkably similar moves to those I have delineated in Salem's text. *Dance, Girl, Dance* is the film that feminist film theorists privilege because it is the one classic Hollywood film where a woman character returns the male look. Arzner's lesbianism, which is alleged by Mayne, may not be insignificant here ("Lesbian Looks" 125).

8. On feminist science fiction and utopian literature, see for example Crowder, Zimmerman (*Safe Sea*).

9. Judith Mayne's both/and approach is especially helpful: her vision of lesbian spectatorship insists, on the one hand, that "all spectatorship is potentially contradictory," while remembering the importance of "a gay component in everything that involves identification," that is to say, gayness is important in the text, in the reader, and in the writer ("Discussions," 136). For a brief overview of the work done since Laura Mulvey's analysis, see Modleski (esp. 62–70 and 73 n.23). See also the anthologies edited by Doane, Erens, and Penley, as well as hooks (115–31) and Wallace.

10. See Schweickart; Kennard; Flynn and Schweickart; hooks (115–31); Bobo; Nataf; Zimmerman ("Perverse Reading"); Fetterley.

11. Important exceptions include Zimmerman (*Safe Sea*), Faderman (*Odd Girls* 147; *Surpassing* 355), Hamer, Weir and Wilson, Barale ("When Jack Blinks"), Penn, Yusba ("Odd Girls"; "Twilight Tales"), Walters, Lynch, and Grier ("Lesbian Paperback").

12. See Esther Newton's summary of Hall's critics in her argument to reclaim Hall's book.

References

Adams, Kate. "Making the World Safe for the Missionary Position: Images of the Lesbian in Post–World War II America." In *Lesbian Texts and Contexts,* ed. Karla Jay and Joanne Glasgow. New York: New York University Press, 1990.

Bannon, Ann. *Beebo Brinker.* Greenwich, Conn.: Fawcett, 1962. Rpt. Tallahassee, Fla.: Naiad Press, 1986.

———. *I Am a Woman.* Greenwich, Conn.: Fawcett Publications, 1959. Rpt. 1962. Rpt. Tallahassee, Fla.: Naiad Press, 1986.

———. *Journey to a Woman.* Greenwich, Conn.: Fawcett Gold Medal, 1960.

———. *The Marriage.* Greenwich, Conn.: Fawcett Gold Medal, 1960.

———. *Odd Girl Out.* Greenwich, Conn.: Fawcett Publications, 1957.

———. "Readers Respond" (column). *The Ladder,* 5, no. 10 (October 1960): 25.

———. *Woman in the Shadows.* Greenwich, Conn.: Fawcett Gold Medal, 1959.

Barale, Michèle Aina. "Below the Belt: (Un)Covering *The Well of Loneliness.*" In *Inside/Out: Lesbian Theories, Gay Theories,* ed. Diana Fuss, 235–58. New York: Routledge, 1991.

———. "When Jack Blinks: Si(gh)ting Gay Desire in Ann Bannon's *Beebo Brinker.*" In *The Lesbian and Gay Studies Reader,* ed. Henry Abelove, Michèle Aina Barale, and David M. Halperin, 604–15. New York: Routledge, 1993.

Bobo, Jacqueline. "*The Color Purple:* Black Women as Cultural Readers." In *Female Spectators Looking at Film and Television,* ed. E. Deirdre Pribram. London and New York: Verso, 1988.

Bonn, Thomas L. *UnderCover: An Illustrated History of American Mass Market Paperbacks*. New York: Penguin, 1982.

Bradley, Marion Zimmer. "Those Wonderful Lesbian Pulps: A Roundtable Discussion." Ed. Eric Garber. *San Francisco Bay Area Gay and Lesbian Historical Society Newsletter*, 4, no. 4 (Summer 1989): 1.

Bradley, Marion Zimmer, and Gene Damon (pseudonym of Barbara Grier). *Checklist 1960: A Complete, Cumulative Checklist of Lesbian, Variant, and Homosexual Fiction, in English, or Available in English Translation, with Supplements of Related Material, for the Use of Collectors, Students and Librarians*. Rochester, Tex.: Self-published by Marion Zimmer Bradley, 1960.

———. *Checklist Supplement 1961: An Additional Listing of Lesbian, Variant and Homosexual Fiction, and Selected Non-Fiction, in English or Available in Translation, for the Use of Collectors, Students and Librarians; Intended to Supplement the Lists Presented in The Complete Cumulative Checklist, 1960*. Rochester, Tex.: Self-published by Marion Zimmer Bradley, 1961.

Brophy, Brigid. *The King of a Rainy Country*. New York: Alfred A. Knopf, 1957.

Christian, Paula. *Amanda*. With Introduction. Belmont, 1965. Rpt. New Milford, Conn.: Timely Books, 1981.

———. "Those Wonderful Lesbian Pulps: A Roundtable Discussion." Ed. Eric Garber. *San Francisco Bay Area Gay and Lesbian Historical Society Newsletter*, 4, no. 4 (Summer 1989): 1.

Clover, Carol J. "Her Body, Himself: Gender in the Slasher Film: The Cinefantastic and Varieties of Horror." *Representations*, 20 (Fall 1987): 187–228.

"Cross-Currents." *The Ladder*, 7, no. 7 (April 1963).

Crowder, Diane Griffin. "Separatism and Feminist Utopian Fiction." In *Sexual Practice, Textual Theory: Lesbian Cultural Criticism*, ed. Susan J. Wolfe and Julia Penelope, 237–50. Cambridge and Oxford: Blackwell Publishers, 1993.

Davis, Kenneth C. *Two-Bit Culture: The Paperbacking of America*. Boston: Houghton, 1984.

Davis, Madeline D., and Elizabeth Lapovsky Kennedy. *Boots of Leather, Slippers of Gold: The History of a Lesbian Community*. New York: Routledge, 1993.

de Lauretis, Teresa. *Alice Doesn't: Feminism, Semiotics, Cinema*. Bloomington: Indiana University Press, 1984.

———. "Film and the Visible." In *How Do I Look? Queer Film and Video*, ed. Bad Object-Choices, 223–63. Seattle: Bay Press, 1991.

D'Emilio, John. *Making Trouble: Essays on Gay History, Politics, and the University*. New York: Routledge, 1992.

Denning, Michael. *Cover Stories: Narrative and Ideology in the British Spy Thriller*. London: Routledge, 1987.

Doane, Mary Ann, Patricia Mellencamp, and Linda Williams, eds. *Re-Vision: Essays in Feminist Film Criticism*. Los Angeles: University Publications of America, 1984.

Epstein, Barbara. "Anti-Communism, Homophobia, and the Construction of Masculinity in the Postwar U.S." *Critical Sociology*, 20, no. 3 (1994): 21–44.

Erens, Patricia, ed. *Issues in Feminist Film Criticism*. Bloomington: Indiana University Press, 1990.

Faderman, Lillian. *Odd Girls and Twilight Lovers: A History of Lesbian Life in Twentieth-Century America*. New York: Columbia University Press, 1991.

———. *Surpassing the Love of Men: Romantic Friendship and Love between Women from the Renaissance to the Present*. New York: Morrow, 1981.

Fetterley, Judith. *The Resisting Reader: A Feminist Approach to American Fiction*. Bloomington: Indiana University Press, 1977.

Flynn, Elizabeth, and Patrocinio P. Schweickart, eds. *Gender and Reading: Essays on Readers, Texts, and Contexts*. Baltimore and London: Johns Hopkins University Press, 1986.

Garber, Eric, ed. "Those Wonderful Lesbian Pulps: A Roundtable Discussion." *San Francisco Bay Area Gay and Lesbian Historical Society Newsletter,* 4, no. 4 (Summer 1989): 1.

———. "Those Wonderful Lesbian Pulps, Part II." *San Francisco Bay Area Gay and Lesbian Historical Society Newsletter,* 4, no. 5 (Fall 1989): 7–8.

Grier, Barbara. Author interview. July 27 and 28, 1991.

———. "Lesbiana." *The Ladder,* 6, no. 1 (October 1961).

———. "Lesbiana." *The Ladder,* 5, no. 9 (June 1961): 22.

———. *The Lesbian in Literature.* 1967. 3rd ed. Tallahassee, Fla.: Naiad Press, 1981.

———. "The Lesbian Paperback." In *The Lesbian's Home Journal: Stories from the Ladder,* ed. Barbara Grier and Coletta Reid, 313–26. Baltimore: Diana Press, 1976. [Orig. pub. in *Tangents,* 1, no. 9 (June 1966) under pseudonym of Gene Damon.]

Hackett, Alice Payne and James Henry Burke. *Eighty Years of Bestsellers: 1895–1975.* New York: Bowker, 1977.

Hall, Radclyffe. *The Well of Loneliness.* 1928. Rpt. New York: Permabooks/Doubleday. 1st Permabooks ed., 1951. 8th ed., 1954.

Hamer, Diane. "'I Am a Woman': Ann Bannon and the Writing of Lesbian Identity in the 1950s." In *Lesbian and Gay Writing,* ed. Mark Lilly. New York: Macmillan, 1990.

Harris, Bertha. "The Lesbian in Literature: Or, Is There Life on Mars?" In *The Universities and the Gay Experience: Proceedings of the Conference Sponsored by the Women and Men of the Gay Academic Union November 23 and 24, 1973,* 45–52. New York, Gay Academic Union, 1974.

Hastings, March. "Those Wonderful Lesbian Pulps, Part II." Ed. Eric Garber. *San Francisco Bay Area Gay and Lesbian Historical Society Newsletter,* 4, no. 5 (Fall 1989): 7–8.

———. *Three Women.* Tallahassee, Fla.: Naiad Press, 1989.

Highsmith, Patricia. *The Price of Salt.* 1952. Rpt. New York: Bantam Books, 1958.

hooks, bell. *Black Looks: Race and Representation.* Boston: South End Press, 1992.

Kennard, Jean E. "Ourself behind Ourself: A Theory for Lesbian Readers." In *Gender and Reading: Essays on Readers, Texts, and Contexts,* ed. Elizabeth Schweickart and Patrocinio P. Schweickart, 63–82. Baltimore, Md., and London: Johns Hopkins University Press, 1986.

Lehmann, Rosamond. *Dusty Answer.* London: Reynal and Hitchcock; New York: Holt, 1927. Rpt. New York: Harcourt Brace Jovanovich, 1975.

Lynch, Lee. "Cruising the Libraries." In *Lesbian Texts and Contexts,* ed. Karla Jay and Joanne Glasgow, 39–48. New York: New York University Press, 1989.

Mayne, Judith. "Discussion" accompanying "Lesbian Looks: Dorothy Arzner and Female Authorship." In *How Do I Look? Queer Film and Video,* ed. Bad Object-Choices, 135–44. Seattle, Wash.: Bay Press, 1991.

———. "Lesbian Looks: Dorothy Arzner and Female Authorship." In *How Do I Look? Queer Film and Video,* ed. Bad Object-Choices, 103–35. Seattle, Wash.: Bay Press, 1991.

McCarthy, Mary. *The Group.* U.K. New York: Harcourt, Brace and World, 1963. Rpt. New York: Signet, 1964. Rpt. Middlesex, U.K.: Penguin Books, 1964.

Mercer, Kobena. "Skin Head Sex Thing: Racial Difference and the Homoerotic Imaginary." In *How Do I Look? Queer Film and Video,* ed. Bad Object-Choices, 162–222. Seattle, Wash.: Bay Press, 1991.

———. *Welcome to the Jungle: New Positions in Black Cultural Studies.* New York and London: Routledge, 1994.

Modleski, Tania. "Hitchcock, Feminism, and the Patriarchal Unconscious." In *Issues in Feminist Film Criticism,* ed. Patricia Erens, 58–74. Bloomington: Indiana University Press, 1990.

Morgan, Claire [pseudonym of Patricia Highsmith]. *The Price of Salt*. Afterword by the author. New York: Coward McCann, 1952. Rpt. New York, Bantam, 1953. Rpt. Tallahassee, Fla.: Naiad Press, 1984.

Mulvey, Laura. "Visual Pleasure and Narrative Cinema." In *Issues in Feminist Film Criticism,* ed. Patricia Erens, 28–40. Bloomington: Indiana University Press, 1990. [Orig. printed in *Screen,* 16, no. 3 (Autumn 1975).]

Nataf, Z. Isiling. "Black Lesbian Spectatorship and Pleasure in Popular Cinema." In *A Queer Romance: Lesbians, Gay Men, and Popular Culture,* ed. Paul Burston and Colin Richardson, 57–80. London and New York: Routledge, 1995.

Newton, Esther. "The Mythic Mannish Lesbian." In *The Lesbian Issue: Essays from Signs,* ed. Estelle B. Freedman, Barbara C. Gelpi, Susan L. Johnson, and Kathleen M. Weston. Chicago: University of Chicago Press, 1984.

Packer, Vin. *Spring Fire*. Greenwich, Conn.: Fawcett Gold Medal, 1952.

Penley, Constance, ed. *Feminism and Film Theory*. New York: Routledge, 1988.

Penn, Donna. "The Sexualized Woman: The Lesbian, the Prostitute, and the Containment of Female Sexuality in Postwar America." In *Women and Gender in Postwar America, 1945–1960,* ed. Joanne Meyerowitz, 358–81. Philadelphia: Temple University Press, 1994.

Renault, Mary. *The Friendly Young Ladies*. New York: Pantheon Books, 1984. [Original pub as *The Middle Mist*. New York: William Morrow and Co., 1945.]

Salem , Randy. *Baby Face*. New York: Softcover, 1964.

——. *Chris*. New York: Beacon Books, 1959. Rpt. Tallahassee, Fla.: Naiad Press, 1984.

——. *The Free Love Virgin*. North Hollywood, Calif.: Brandon Books, 1964.

——. *Honeysuckle*. New York: Midwood Tower, 1963.

——. *Man among Women*. New York: Beacon Books, 1960.

——. *The Sex Between*. New York: Midwood Tower, 1962.

——. *Sex in the Shadows*. New York: Softcover Library, 1965.

——. *The Soft Skin*. New York: Midwood Tower, 1962.

——. *Tender Torment*. New York: Midwood Tower, 1962.

——. *The Unfortunate Flesh*. New York: Midwood Tower, 1961.

Sarton, May. *The Small Room*. 1961. Rpt. New York and London: W. W. Norton and Co. 1976.

Schweickart, Patrocinio P. "Reading Ourselves: Toward a Feminist Theory of Reading." In *Gender and Reading: Essays on Readers, Texts, and Contexts,* ed. Elizabeth Schweickart and Patrocinio P. Schweickart, 31–62. Baltimore, Md., and London: Johns Hopkins University Press, 1986.

Stam, Robert, and Roberta Pearson. "Hitchcock's *Rear Window:* Reflexivity and the Critique of Voyeurism." In *A Hitchcock Reader,* ed. Marshall Deutelbaum and Leland Poague, 193–206. Ames: Iowa State University Press, 1986.

Stimpson, Catharine. "Zero Degree Deviancy: The Lesbian Novel in English." *Writing and Sexual Difference,* ed. Elizabeth Abel, 243–59. Chicago: University of Chicago Press, 1982.

Taylor, Valerie. *Beans and Rice*. Tallahassee, Fla.: Naiad, 1989.

——. "Five Minority Groups in Relation to Contemporary Fiction." *The Ladder,* 5, no. 4 (January 1961).

——. *The Girls in 3-B*. Greenwich, Conn.: Fawcett Crest, 1959.

——. *Journey to Fulfillment*. New York: Midwood Tower, 1964. Rpt. Tallahassee, Fla.: Naiad Press, 1982.

——. *Return to Lesbos*. Midwood Tower, 1963. Rpt. Tallahassee, Fla.: Naiad Press, 1982.

——. "Saturday Conversation." *The Ladder,* 9, no. 9 (June 1965): 9–11.

——. *Stranger on Lesbos*. Greenwich, Conn.: Fawcett Crest, 1960.

———. "Those Wonderful Lesbian Pulps: A Roundtable Discussion." Ed. Eric Garber, *San Francisco Bay Area Gay and Lesbian Historical Society Newsletter,* 4, no. 4 (Summer 1989).

———. *Unlike Others.* New York: Midwood Tower, 1963.

———. *Whisper Their Love.* Greenwich, Conn.: Fawcett Crest, 1957.

———. *A World without Men.* New York: Midwood Tower, 1963. Rpt. Tallahassee, Fla.: Naiad Press, 1982.

Torres, Tereska. *Women's Barracks.* Greenwich, Conn.: Fawcett, 1950. Rpt. New York: Dell, 1968.

Wallace, Michele. "Race, Gender, and Psychoanalysis in Forties Film: *Lost Boundaries, Home of the Brave,* and *The Quiet One.*" In *Black American Cinema,* ed. Manthia Diawara, 257–71. New York: Routledge, 1993.

Walters, Suzanna Danuta. "As Her Hand Crept Slowly up Her Thigh: Ann Bannon and the Politics of Pulp." *Social Text: Theory/Culture/Ideology 23,* 8, no. 2 (1989): 83–101.

Weir, Angela, and Elizabeth Wilson. "The Greyhound Bus Station in the Evolution of Lesbian Popular Culture." In *New Lesbian Criticism: Literary and Cultural Readings,* ed. Sally Munt, 95–114. New York: Columbia University Press, 1992.

Whitfield, Stephen J. *The Culture of the Cold War.* Baltimore, Md.: Johns Hopkins University Press, 1991.

Yusba, Roberta. Participant at panel, "Building Community, Finding Love: Lesbian Bar Culture Since the Forties." 1985 National Women's Studies Association Annual Conference. Seattle, Wash. VHS video published by National Women's Studies Association, 7100 Baltimore Avenue, Suite 500, College Park, Md., 20940; 301/403-0525.

———. "Odd Girls and Strange Sisters: Lesbian Pulps Novels of the '50s." *Out/Look,* 12 (Spring 1991): 34–37.

———. "Twilight Tales: Lesbian Pulps 1950–1960." *On Our Backs,* Summer 1985, 30.

Zimmerman, Bonnie. "Perverse Reading: The Lesbian Appropriation of Literature." In *Sexual Practice, Textual Theory: Lesbian Cultural Criticism,* ed. Susan J. Wolfe and Julia Penelope, 135–49. Cambridge and Oxford: Blackwell Publishers, 1993.

———. *The Safe Sea of Women: Lesbian Fiction 1969–1989.* Boston: Beacon Press, 1990.

2
■

THE CULTURAL WORK
OF SIXTIES GAY PULP FICTION

David Bergman

FOR QUITE SOME TIME I imagined that all pre-Stonewall novels followed an unbroken formula: boy meets boy, boy dies. The famous novels of that period—Gore Vidal's *The Pillar and the City* (1948), James Baldwin's *Giovanni's Room* (1956), and even John Rechy's *City of Night* (1963)—paint a grim picture of the homosexual: a life that was furtive and dangerous, even when not deadly. I had the impression that gay fiction through the sixties had not progressed beyond the gay books of the thirties and forties, the work Samuel Steward described as "a sad and sorry thing." Steward blames it on "A firm named Greenberg," all of whose novels "ended unhappily with the homosexual 'hero' committing suicide or being killed in some way; thus sin was punished and middle-class virtue triumphed" (107).

I have learned, however, to be skeptical of such simple schematizing. A quick check of the facts would show that Greenberg published *The Better Angel* (1933), the first gay novel with a happy ending, and Foreman Brown, who wrote the book under the name of Richard Meeker, told me that he received no pressure from Greenberg to alter the novel's positive conclusion. Nonetheless, the impression that gay fiction uniformly contained negative representations of homosexuality is longstanding. In 1955, David L. Freeman complained in *One,* the pioneering homophile journal, that "contemporary literature by and about homosexuals . . . almost without exception . . . is morbid, bohemian, introverted, unrealistically romantic and perverted" (quoted in Austen 147). In a recent interview, the cultural critic Michael Bronski summarizes pre-Stonewall fiction as "Young Boy Comes to New York, Meets People in the Theater, Gets Fucked Over, and Then Commits Suicide" (quoted in Rowe 58).

If such a state of affairs were true—and I hope to show that it is only partially so—this did not stop gay men from reading gay novels and plays. Richard Dyer recalls:

> I thought I virtually was Geoff in *A Taste of Honey* and David in *Giovanni's Room* (even though I was neither working class nor American), but it

was more longing I felt towards Gaylord Le Claire in *Maybe—Tomorrow* [Jay Little's 1952 soft-core erotic novel], a wish that I could be him and have him with his "earnest face and handsome physique." And I took on board the two main messages of the type—that to be homosexual was both irremediably sad and overwhelmingly desirable. (73)

The sadness and desire of gay writing may have seemed knotted together, but their effects were very different. In fact, readers like Dyer identified with the sadness and became alienated from the joy of their desiring. Dyer's formulation suggests the pressures that have distorted gay cultural history. First, because the forces of identification with negative stereotypes are stronger than the forces of erotic attraction, gay readers recall more vividly what was "irremediably sad" than what was "overwhelmingly desirable." Second, class prejudice obscures the positive images of pulp fiction. *A Taste of Honey* and *Giovanni's Room* are respectable literary works, whereas *Maybe—Tomorrow* is undisputed pulp. Dyer may be able to identify with working-class characters, but he cannot approve of subliterary fiction. He was not alone. Similar class prejudices have affected the evaluation of lesbian fiction. As Angela Weir and Elizabeth Wilson note:

> *Then* [Ann Bannon and Valerie Taylor] were something forbidden not only by the wider society, but by one's own (sixties) standards of what was artistically worthy and important; *now* they have become prime sites for an excavation of lesbian culture. . . . So deeply ingrained, however, were prejudices about "high art" and "low culture" in that now distant period that Ann Bannon and the rest were automatically consigned to the category of libidinised trash. (96)

What lesbian scholars—not only Weir and Wilson, but also Diane Hamer, Suzanna Danuta Walters, and Blanche Weisen Cook—have performed with such success, excavating their "libidinised trash" in order to find "prime sites" for minority culture, gay male critics have been less involved in doing.

I do not wish to deny the prevalence in pulp fiction of the homophobic stereotype of the homosexual as "sad young man." The homophobic undercurrents in these works can be explained in any number of ways. First, the owners of most of the pulp-publishing firms were heterosexual (Rowe 56). Their understanding of gay men and lesbians was limited to the commercial potential of their target audience. Second, gay men were not always the authors of gay pulp fiction. Larry Townsend reports that among the authors were women who had switched to writing gay books when they recognized that it was a relatively lucrative market (Towsend, personal communications). The result, as Daniel Harris has amusingly demonstrated, was that the mechanics of sex often were rather vaguely represented (19). He singles out *Queer Daddy* (1965) as a particularly funny example, which describes sex between a transvestite nanny (Lena) and the father who employs him in the following heated, but fuzzy, terms:

> [Lena] wanted to scream, wanted to seize, wanted to cast himself into the flames of satiation. . . . Like a kitten kiss, he touched the warm, soft

round of flesh and the world exploded. Lena clutched his mouth to keep from screaming. The convulsions rolled and hammered and squeezed his body and he could not voluntarily move. He knew what he was doing, what was cascading over the pink warm body, and the shock of ecstasy made movement impossible. In his excruciating expenditure, he straightened and arched and it no longer mattered that he had raised away from the suddenly moving body on the bed. (80–81)

The vagueness of this sexual act does not entirely justify Harris's conclusion that "the turgid periphrasis of this amorphous rhetoric served a utilitarian function, that of self-censorship" (19). Harris fails to note that the author of *Queer Daddy* is Helene Morgan, a pseudonym, of course, but one that might hide the identity of a woman writer rather than a man. Both the fuzziness of the mechanics of gay sex and the bodice-ripping rhetoric of the passage strongly suggest that the author was not so much homophobic as ignorant, perhaps a woman applying formulas from heterosexual to homosexual pulp.

What is surprising, however, is how often these books evaded the homophobic ethos of the time. Harris points out how "guiltlessly gay sex is described" in the mimeographed pornographic pamphlets of the fifties—precursors in a way of the 'zines of today (19). In his analysis of the bookcovers of the sixties, Dyer finds it "particularly striking" that the pictures of sad young men that graced the front of many books did not represent "the often far more upbeat and positive text inside, where the ecstasy of homosexual love, the unfairness of social attitudes, and the fun of camp culture are all to varying degrees suggested" (86). I want to explore the "far more upbeat and positive text" that has often been hidden, not only by the covers depicting sad young men, but also in gay accounts of gay fiction. I want to follow up on Lars Eighner's observation about pre-Stonewall writing: "If you looked at anything that was gay-positive in those days, it was porn" (quoted in Rowe 108).

Eighner himself is an interesting case of how gay writing and political activism are linked. A well-established pornographer—among his many works is *Elements of Arousal: How to Write and Sell Gay Men's Erotica* (1994)—Eighner is perhaps better known for his memoir *Travels with Lisbeth* (1993), an account of being homeless for three years. He began writing gay "stuff just as [he] heard of Stonewall" for underground and hippie publications in Austin, Texas. He used the pseudonym "Larry Nadir," his code name from his student radical days when he was a member of Students for a Democratic Society (SDS). As Larry Nadir, he tried to arouse a concern for gay rights in SDS, but to no avail. These student radicals took the Stalinist line that "homosexuality is a bourgeois disorder." "Maybe you can do something for us if you stay in the closet, but you can't advance in the party under these circumstances," they told Eighner (in Rowe 106). The only place where he could gain a positive sense of being gay was in the gay pornography of the times. In Eighner's account, there is a striking dialectic: pornography motivates him to political action as the student radical "Larry Nadir," and then he uses the name "Larry Nadir" as the pseudonym for his first gay pieces. What could Eighner have been reading? Could any of the gay erotica of the sixties perform the radical cultural work Eighner suggests it performed on his consciousness?

The Song of the Loon

The most popular and important book of gay erotica in the sixties was Richard Amory's *The Song of the Loon* (1966), which was followed by *Song of Aaron* (1967) and *Listen, the Loon Sings* (1968). We cannot tell now how many copies of the book sold—clearly in the tens of thousands—but it was so popular that in 1970, a full-length, faithful screen adaption was released, making it the only gay erotic novel of the period so honored. According to Larry Townsend, Amory was a high-school English teacher, and quite a lot of *The Song of the Loon* is didactic, starting with the title page (personal communication). It tells us that the work is "a pastoral in five books and an interlude"; the characters have nothing to do with native Americans but are drawn from "certain very European characters from the novels of Jorge de Montemayor and Gaspar Gil Polo." The author has taken the stock characters of the pastoral romance, he tells us, and has merely "painted them a gay aesthetic red and transplanted them to the American wilderness." With a schoolmarmish severity, Amory warns that "anyone who wishes to read other intentions into these characterizations is willfully misunderstanding the nature of the pastoral genre" (iv).

We should take Amory's warnings to heart or else we are likely to confuse his campiness for racism. For example, his American Indians speak in the stilted English of the Hollywood Western. They are all strong, brave, and fleet of foot, unrealistically idealized. That is the nature of pastoral conventions, and his white men also speak in a manner that is part boys' book folksiness and oracular high-mindedness. Yet despite the potential campiness of these pasteboard Indians and trappers, *The Song of the Loon* is essentially a serious work (more's the pity, since additional humor might have improved it). In the end, it is too solemn and awkward for its own good, as if through a gawky yoking of André Gide and Louis L'Amour.

In his warning not to "misunderstand the nature of the pastoral genre," Amory alerts us to the politics and history of the genre, which are discussed at some length in Gregory Woods's *A History of Gay Literature*. By distancing *The Song of the Loon* from the realistic novel, Amory removed it from such generally homophobic genres of gay pulp novels as the medical study or the sociological tract, which came to prominence following the Supreme Court decisions that obscenity is writing "without redeeming social value." By casting erotic descriptions as either medical or sociological studies, which construed homosexuality as either social deviance or mental disease, pulp publishers were able to circumvent the law. For example, in *Satyriasis: A Study of Male Nymphomania* (1966), Franklin S. Klaf, M.D., offers, according to the backcover, a "brilliant and informative new study of excessive male desire" and a bibliography for future reference. *The Different and the Damned: The Homosexual in a Heterosexual Society* (1968), by Anonymous, a self-confessed "demonoid," recounts in breathless surges the author's cruel fate of following his "one thirst[:] . . . seeking out the beautiful young males among the humanoids. And seducing them!" (20). The Introduction, penned by a concerned, but compassionate, heterosexual, speaks of *The Different and the Damned* as "a completely sincere and brutally candid account . . . of the problems and prejudices a homosexual encounters" providing "a thought-provoking view" (6). Not only did the pastoral mode push *The Song of the Loon* far from these dreary pseudo-scientific works, but it freed Amory from the worst of all the

genres of gay writing—the problem novel, which, for all its good intentions, is among the most maudlin and condescending of forms.

If the pastoral romance distanced *The Song of the Loon* from certain distasteful pulp genres, it also linked it to the classical tradition of idealized male-male sexuality. The connection to this Greek ideal is underscored when the two main characters, Ephraim and Cyrus—after a day of target shooting, swimming, and lovemaking—discuss *The Iliad*. "When I first read the *Iliad*—I'll never forget the experience," Cyrus contends with studied awkwardness, "I think it was then that I first came to some knowledge about myself. Achilles and Patroclus—epic lovers—how I welcomed them!" (51) Not to be outdone, Ephraim recalls that as "a student filled with Greek and Latin," he first fell in love with a boy with whom he read everything, "Homer, Plato, to Petronius, Montaigne" (51). As James Gifford has shown in *Dayneford's Library,* this sort of reading list is a well-established gesture of gay and Dayneford's proto-gay literature (2).

Moreover, casting *The Song of the Loon* as a pastoral romance allowed Amory to go beyond the psychological limits of his audience and explore attitudes about sexuality that were, perhaps, not common even within the gay populations. The Native Americans who belong to the Loon Society, a brotherhood of men loving men, do not seem at all to suffer from self-hatred, guilt, social ostracism, or other symptoms of internalized homophobia that many gay men of the sixties bore. As a pastoral, *The Song of the Loon* had license to depict a psychological and sexual freedom that did not, and probably still does not, exist.

Daniel Harris criticizes *The Song of the Loon* on much the same grounds as *Queer Daddy*. While he admits that in the former work one can visualize the sex scene, he asserts that "the underlying assumption shaping the author's description of sex remains the same—that intercourse causes a form of temporary madness, an ecstatic swoon that triggers an automatic shutdown in the amount of information the reader is permitted to receive" (20). Although Harris is correct in saying that the sex scenes in *The Song of the Loon* are highly ecstatic, he is wrong to impute the sublimity of the rhetoric to any residual self-censureship on Amory's part. Amory wants to emphasize, not the mechanics of sexual intercourse, but the transformative nature of lovemaking. Lovemaking is a form of "temporary madness" in the same sense in which the Greeks regarded it as a divine inspiration. *The Song of the Loon* rejects the split between sex and love, between the physical and the spiritual. Indeed, one of the themes of the book is that such a split is a result of internalized self-hatred and is symptomatic of severe psychological damage. Amory intends not to shut down sexual information, but to open sexual experience to a larger consciousness and, in so doing, he refutes those who would reduce same-sex relations to the merely physical, a homophobic strategy perhaps even more common then than it is now.

Indeed, at the time, *The Song of the Loon* was a groundbreaker specifically because of its sexual explicitness. Writing in 1971, John Murphy cites *The Song of the Loon* for its power to make gay men feel comfortable with their bodies and with lovemaking.

Richard Amory's series of *Loon* books are representative of this new wave of sexually explicit books in their detailed descriptions of sex be-

tween men. They are atypical, however, in the good humor and relaxed sensibility that makes them less morbid than most pornography. . . . One wonders why this positive attitude toward physical homosexuality has been primarily found in pornography until now. (57)

While revisionist historians may find the novel's depictions of sexual acts deficient by today's standards, in its day, they were a model of explicitness.

Like pastoral romances in general, *The Song of the Loon* is both rather simple in structure and complex in detail. *The Song of the Loon* recounts a journey—Ephraim MacIver's journey to understanding, accepting, and loving, not only himself as a gay man, but also others as gay men.

In the first part of the novel Ephraim travels to see Bear-who-dreams, a wise shaman and leader of the Loon Society, an organization of men-desiring-men. He has been instructed to go to Bear-who-dreams by Ixtlil Cuauhti, one of the elders of the Loon Society. The elder had nursed Ephraim after he was injured in a frontier town where he came in pursuit of his friend Montgomery, with whom he had a violent, one-sided, drunken, and unloving sexual relationship. Although Montgomery came to the Northwest to lose Ephraim in the wilderness, he is now looking for him, having joined forces with the evil Mr. Calvin (the symbolic significance of the name should speak for itself), a missionary dedicated to stamping out same-sex intercourse among the natives. One thread of this novel describes how Calvin becomes enamored by Montgomery and, in the crucible of that passion, alchemizes their homophobic self-hatred into gay love.

While still on his journey to find Bear-who-dreams, Ephraim next meets Cyrus Wheelwright, a giant backwoodsman, who has learned the American Indian language and has become initiated into the Loon Society. The two men fall in love, but Ephraim, who is uncertain whether he has gotten over his emotional involvement with Montgomery, leaves to continue his journey to Bear-who-dreams.

Eventually Ephraim does meet up with Bear-who-dreams, and the two have sex. One of the notable aspects of *The Song of the Loon* is its advocacy of intergenerational sex. Desire is not limited to the young and beautiful. Ephraim poses two questions to Bear-who-dreams: first, with whom should he partner since he has fallen in love with so many men who want to live with him, and, second, is Ephraim free of his self-hating love for Montgomery? To answer these questions, Bear-who-dreams gives Ephraim a drug. In the resultant hallucinatory Spirit Quest, Ephraim experiences almost being killed by Montgomery but is saved by Cyrus. Thus, his questions are answered.

In an interview, Michael Bronski told Michael Rowe:

> I would argue that . . . there were two messages we received after gay liberation happened, one message was that it was okay to get fucked, which was not true before. . . . And the second one that you could actually love yourself. You didn't have to go after straight "trade." You could go after another gay man." (62)

If what Bronski says is true, *The Song of the Loon* would force us either to revise our notions about when gay liberation began or look to see how these notions were planted prior to the movement.

Clearly, the plot of *The Song of the Loon* continually argues, not only for the erotic attraction of gay man for gay man—as in sex between members of the Loon Society—but for rejecting sex with men who do not accept their same-sex orientation. The relationship between Ephraim and Montgomery is, from the outset, viewed as destructive and unworthy because the latter refuses to accept his same-sex desires. One of Ephraim's lovers, Singing Heron, tells Ephraim that he is looking for a lover "who walks proudly and with strength in the sun, who draws strength from the earth, as do the cedar and the Douglas fir; one who can love others because he can love himself. . . . There are such men . . . and you will know many of them soon" (12). Similarly, one member of the Loon Society argues that sex with ostensibly straight men is "worse than slavery." "What you want me to do [by having sex with a straight man] is to lower myself, to make myself less than a man—a tiny animal without pride. I will not sell my pride and decency" (28).

In addition, *The Song of the Loon* regards receptive anal intercourse as the symbolic enactment of sexual self-acceptance and a rejection of the puritanical and sexist attitudes that abjectify the anus and feminize passivity. While visiting Bear-who-dreams, Ephraim meets Tlasohkah, and together they watch a ceremony in which two men have anal intercourse before the Loon Society. Tlasohkah explains to Ephraim that such a public display "is not often done . . . unless two people wish to make a more public declaration of their love" (105). Ephraim finds it "shocking and . . . beautiful," and later he asks Tlasohkah to initiate him into the mysteries of both the anal receptor and penetrator roles, albeit in a more private setting. Mutuality, however, is not an explicit goal in *The Song of the Loon*—Amory does not wish to stigmatize anyone who prefers one role to the other—but it shows that the most "manly" of men may not be averse to being anally penetrated.

The hardest lesson that Ephraim needs to learn in the Way of the Loon is that a committed relationship does not entail monogamy. In fact, monogamy is rejected as a possessive, selfish, and destructive aspect of Judeo-Christian culture. Singing Heron tells Ephraim at the beginning of the novel:

> You suffer from the white man's disease, the proud man's disease, the sickness of the Missionary way. It is called jealousy but sometimes I think it is called selfishness. . . . If I love one man, can I not love another at the same time? If one man has filled my heart with love, can I not share it with another? If I make love to you, that does not mean that I love another less. I do not want to own you as I would a puppy—that isn't love, Ephraim. (16)

When Singing Heron sends Ephraim on to see Bear-who-dreams, Ephraim asks if they can be "partners." Singing Heron answers that such a partnership is possible only if Ephraim alters his attitude toward monogamy: "you *must* know our ways, and you must have known love from many people" (34). At the end of the novel, when Ephraim is partnered with Cyrus, he still feels caught between his desire for many men and his belief that he should be monogamous with Cyrus. It is Cyrus who insists that while he is trading furs at Fort Vancouver, Ephraim should return to Bear-who-dreams and his followers. "Ah, Ephraim," Cyrus tells him, "We all want to love and to be loved,

deeply, meaningfully, as you and I love each other; but we also . . . want to explore, to push ourselves outward, to find newness" (187). Amory is the advocate neither for indiscriminate sexual abandon nor for a pseudo-marital gay monogamy. Quite clearly he believes that gay men must forge their own kind of committed relationships, in which their long-term companionship is coupled with sexual nonexclusivity.

In *The Song of the Loon*, Amory seems socially remarkably ahead of his time—or perhaps we underestimate the awareness of pre-Stonewall gay men. Indeed, the work seems more closely related to the Radical Fairies than *The Boys in the Band*. The novel ends with neither drunkenness nor suicide, but with its highly masculine heroes united in a loving, ongoing relationship in which the sexual roles are fluid and mutual. Amory refuses to separate physical love from spiritual love. He is unwilling to see gay relationships as in any way less than heterosexual relationships, but he does see them as organized in the same way—or at least, he hopes they will not be similarly organized. Amory urges us, through his pastoral shepherds (dressed in this masquerade as American Indians), to cure ourselves of "the sickness of the Missionary way" (97).

Although *The Song of the Loon* is atypical of most pulp fiction in its literary aspirations and its sense of literary history, it is not unusual in its desire to break with the stereotypical treatment of gay men and its attempt to articulate a different discourse on homosexuality. It may be useful to compare *The Song of the Loon* with a trilogy of novels, also published in 1966, that follow the adventures of Jackie Holmes, the "man from C.A.M.P."

The Man from C.A.M.P.

Don Holliday, the author of the Jackie Holmes series, has no literary pretensions. The novels are clearly cobbled together very quickly, with whatever shortcuts were necessary to meet the contract requirements. I suspect that *Color Him Gay,* the second novel in the series, was running a bit short as, without any preparation, Jackie is thrown into a reverie about past assignments and twenty pages (76–98) are lifted from the first volume verbatim. In the final installment of the series, *The Watercress File,* the first forty-two pages of the novel are a repeat of the first forty-nine pages of *The Man from C.A.M.P.,* except that Ted Summers is renamed Rex Winter in *The Watercress File.* In fact, the editing is so rushed that occasionally "Summers" was not consistently changed to "Winter" in the later text (see p. 36).

Despite the frequent incoherence of the narratives, the novels' political message, as embodied in the notion of C.A.M.P., is quite clear. The fullest description of C.A.M.P., an acronym whose meaning is, toyingly, never explained, appears in *Color Him Gay.* The rock star Dingo Stark, whose name recalls Ringo Starr but whose character seems modeled on Mick Jagger, is being blackmailed by Brothers United To Crush Homosexuals (B.U.T.C.H.) because, between the ages of fifteen and seventeen, he had had a homosexual relationship with a neighborhood boy. Jackie explains the purpose of C.A.M.P. to Stark, who now considers himself a heterosexual:

> It's an international, underground organization dedicated to the advancement and the protection of homosexuals. . . . C.A.M.P. has

numerous sections that deal with every aspect of homosexuality. Some
of them work to improve the legal situation, others work in the medical
and social fields, among others. . . . [H]omosexuals are frequently the
victims of unscrupulous people, ranging from small time roughnecks
who make a sport of queer hunting . . . to blackmailers and sometimes
worse. There's little police protection for the homosexual—remember
he's technically outside the law anyway. That's where I come in. My
section works as a police agency for homosexuals everywhere, when-
ever needed. (*Color Him Gay* 18–19)

David
Bergman

Of course, C.A.M.P. is fantasy, although in Los Angeles in the late sixties
and early seventies there was an organization called H.E.L.P. that had the
same aims as C.A.M.P. and provided a multifaceted support system for
the gay community (Rowe 331). What I find remarkable is the unapologetic
way in which Holmes discusses gay people. C.A.M.P. serves, not only to
protect, but also to advance gay people. While not rejecting straight people,
it asserts that gays must look out for each other in a hostile, dominant
culture. As Rich, Jackie's assistant, tells a friend, "It gives me a feeling of wor-
thiness to work toward a day when our kind of life and love will not only not
be laughed at, but will have its rightful respect in the world" (*Man from
C.A.M.P.* 141).

The Man from C.A.M.P. is clearly a parody of the popular television
show of the day, *The Man from U.N.C.L.E.,* which in turn spun off from the
James Bond craze. James Bond and *The Man from U.N.C.L.E.* were centered
on hypermasculine, heterosexual heroes. Jackie Holmes, whose name recalls
the porn star John Holmes, stands in contrast to these figures. Small, weak-
looking, and effeminate, Jackie makes quite a show of his fay ways. Yet the
novels go to considerable pains to indicate that Jackie, although he never dis-
owns his effeminacy, is performing it as well. In the first and last of the novels
he teams up with ostensibly straight agents, who are at first made uncomfort-
able by having to work with him. With a sort of sadistic glee, Jackie poses
all the more because it so disturbs his colleague. Repeatedly we are told that
although Jackie might look weak, "his body was one of wiry strength, com-
bined with speed and agility. . . . He could run with the speed of a gazelle,
and out-fight opponents twice his own weight" (*Man from C.A.M.P.* 28). But as
a secret agent, he does not want to advertise these abilities; in fact, "his
appearance of helplessness had served to his advantage countless times" (28).
Jackie, in short, is like his miniature poodle, Sophie—harmless looking but
"trained to kill" (43).

At the conclusion of the books, Jackie not only wins the respect of the
straight agents by his fearlessness, physical prowess, and cool resourceful-
ness, he also lands them in bed. Indeed, C.A.M.P. has awarded him a
wooden phallus where he puts a notch for each of the heterosexual agents he
has anally penetrated, and the statue is covered with grooves.

That the climax of the novel is the metaphorical "notching" of straight
people is not entirely a sign that the novel embraces the homophobic attitude
that one should "go after straight 'trade,'" to use Michael Bronski's term
(quoted in Rowe 62). They dramatize the novels' premise that all people are
bisexual; orientation is not fixed, although it is sometimes hard to budge. As

Jackie explains to Dingo Stark in a didactic moment, "many authorities think that everyone remains more or less bisexual, but that the conditioning in our society prohibits the average adult from practising or even recognizing his homosexual urges" (*Color Him Gay* 22). Sex with Jackie thus does not transform straight men; rather, it opens them to the full range of their sexual options.

Much has been written about how the politics of sexual identity reinforces the gay/straight division, which the dominant society needs to maintain rigid gender patterns. Less has been said about the uneasiness that gay writers felt about erecting the gay/straight dichotomy or of the politics that made such a division appear necessary at the time, but even a work as quickly written and decidedly trivial as *The Man from C.A.M.P.* exhibits uneasiness about the virtue of an exclusively same-sex orientation even as it insists on it. Series author Don Holliday understood that an exclusively homosexual orientation contradicted his own assertions of the inherent bisexuality of human beings. Nevertheless, in a brief episode he explains why he felt a need for gay men, at least certain gay men, to remain free of any sexual contact with women. During the period in which C.A.M.P. is torn by a series of security breaches, Jackie warns one agent. "We have no room in the organization for ambi-sextrous [*sic*] types," he tells him, "Some of our people have been converts, admittedly. But we have to be very sure they'll not change their minds or turn butch or something" (144). Jackie's concern mirrors in fictional terms an anxiety afloat within the nascent gay and lesbian communities. As gay men and lesbians began to be aware of themselves as a community—a community under attack from the police, from blackmailers, from the business and religious communities—they also needed to assure themselves of the solidarity and loyalty of those with whom they worked. The hostility toward bisexuality—"ambi-sextrous types," to use Holliday's wording—grew out of a need to be assured that colleagues would not betray each other under pressure. The gay writers of pre-Stonewall gay fiction do not deny the queer identity, by which I mean an identity marked by fluid object choice—indeed, they are very alert to the mobility of sexual feelings— but they try to freeze sexual object choice. In dividing the world between straight and gay, they are motivated, not by a failure to theorize alternative positions, but by the need to establish loyal allies in a highly polarized environment. Sexual exclusiveness gave substance to political, emotional, and social solidarity at a time when many felt they could afford no fence-sitters. Part of the political work of these books was to reinforce the need for readers to decide on which side they stood, even as such books as *The Man from C.A.M.P.* continually show the arbitrariness of homo/heterosexual boundaries.

Realities of Gay Publishing

In order to put in perspective the impact that gay pulp fiction may have had, we need to understand how widely it was distributed. Trade books were distributed through bookstores, and gay-positive books, or even gay-themed books, had trouble getting into "respectable" outlets. For example, although John Rechy's 1963 novel, *City of Night,* sold a reported 65,000 copies in hardback, in 1978—some fifteen years later—when his *Sexual Outlaw*

appeared, his publisher could place the book in only two cities in the Southeast, as the chain stores refused to carry it. Unlike trade books, pulp books and pornography were handled by magazine distributors, which had entirely different distribution networks and thus, in many ways, brought gay pornography to remote corners of America. Instead of being sold in bookstores, pulp was sold at bus stations and cigar stores and off magazine racks. Jonathan Williams, the poet and publisher, reports that such "one-handed classix" as Louis Stout's *Long Time Coming* and the Loon Trilogy had "warmed the hearts of thousands in places like Statesville, North Carolina, when only the seamy news stands on the town square affords the crumbs of literacy" (171).

It is hard to say how much these books circulated. Williams says that the Loon Trilogy "is pretty jolly, particularly if read aloyd [*sic*]," and my impression is that often these books were read to amuse and excite groups of young men. They were also passed among one-handed readers in a daisy chain of masturbators. In any case, we know that they reached a wide spectrum of readers, as well-educated writers were as interested in them as sweaty teenage boys. *The Song of the Loon* is quite self-consciously literary, and Samuel Steward, who penned the Phil Andros series, was a professor of English as well as a member of the Gertrude Stein–Alice B. Toklas circle. Even such an unadulterated work of pulp as Edwin Fey's *Summer in Sodom* (1965) occasionally takes a peculiarly high-brow turn, as when one young man asks his friend as they flee from knife-wielding criminals, "Was that really a dagger I saw before me?" (150) It seems an unlikely place for an allusion to *Macbeth,* but Fey seems reasonably confident that a large proportion of his readership is educated enough to appreciate the campy humor. What such an example suggests is that both better-educated and less-educated gay readers came together in the reading of pulp.

Yet class did make a difference. Douglas Dean, who wrote several books for Greenleaf, complained about being considered a pornographer by gay readers who rejected such fiction:

> Many men who might enjoy writing of a higher level don't purchase or read books which . . . they have already classified in advance as "dirty."
>
> Well, don't misunderstand me, I'm not a snob, I have nothing against pornography, *per se*. The fuck books have their place. But what I'm saying is—there should be a place in the gay man's library for *both* kinds of books. (16)

Perhaps the first public meeting to discuss gay literature occurred a little less than a year after Stonewall when, under the auspice of the Society for Individual Rights (SIR), Phil Andros, Dirk Vanden, and Richard Amory spoke in San Francisco to about two hundred men. The event was reported in the *Advocate* by Larry Townsend. What is striking about this article is its engagement with the politics of gay liberation. According to Townsend:

> Those of us who are gay, who write stories about gay people, directed toward a basically gay readership are rapidly approaching a new self-realization, as well as an equally new awareness of our social responsi-

bilities. As in any social movement, whether it be revolutionary or—like ours—an attempt to bring about necessary humanistic changes within the framework of the existing culture, writers must form an integral part of the movement's core. It was toward these ends that SIR held its symposium. (19)

Douglas Dean, Phil Andros, Dirk Vanden, and Richard Amory all complained about the niche that had been created for their work, which locked them into a particular style. Townsend points out that:

> because of the difficulties in persuading standard publishers to produce books with frankly homosexual themes, most have us have been forced into the "adult" or "porno" market. None of us are [*sic*] overly pleased with this as it restricts our range of expression. As Dirk Vanden noted, we are limited to an exposition of 50,000 to 65,000 words—too short for proper development of characters and plot, especially when it is necessary to devote approximately 20 per cent of our text to "hots" (sex). (19)

Through the sixties, two publishers were known for producing gay pulp fiction. On the West Coast the major publisher was Greenleaf, which brought out *The Song of the Loon* and whose most important editor was a woman, Ginger Sisson. On the East Coast the major publisher was The Guild Press, headed by H. Lynn Womack. Greenleaf did not concentrate exclusively on gay works, but the Guild Press did, and it may well have been the first gay-owned publishing house dedicated to publishing gay materials.

Womack is a strange and mysterious figure in gay history. Newspaper accounts of him—and his frequent arrests and legal battles made him a recurrent name in the papers—could not resist describing him. An albino weighing 240 pounds, he was a striking figure. A former George Washington University philosophy professor, he had taken over the Guild Press in the early fifties when it published *Grecian Guild Pictorial,* whose motto, "Art—Body-building—Health," was emblazoned on the covers. By the sixties, Womack published at least ten magazines in addition to hardcover and paperback books. Jackie Hatton has called it an "empire," but it was a small and fragile one. H. Valentine Hooven claims that his "shabby business practices . . . and incautious advertising methods . . . eventually did him in," but the real culprit seems to have been the Richard Nixon administration's need to placate the moral right (106). I do not mean to suggest that Womack's business practices were anything but shabby, but the government did not close the business down because he was in the habit of not paying authors.

Womack was an artful dodger of financial and legal problems. According to the *Washington Post* (8 July 1971, C20), he evaded criminal charges in 1969 when he was found "not guilty for reasons of insanity." In fact, Womack was in the habit of committing himself to St. Elizabeth's Hospital, the Washington, D.C., psychiatric facility where Ezra Pound was once a patient, to avoid prosecution and bill collectors (Preston 12).

Samuel Steward's account of dealing with Womack gives a feel for his tactics as a businessman:

> One of the older homosexual presses which had been weaseling its way carefully between the markers was the Guild Press, presided over by a jolly rotundity who had been in trouble with the law before. . . . [H]e ran his press with the insouciance that Leigh Hunt had shown a century and a half before, when he continued literary work while in prison.
>
> A New York bookseller put me in touch with this Jolly Roger. . . . A contract was signed over a pittance, galleys were read in 1966, and [I]— now in California—waited breathlessly for [my] book to appear.
>
> It didn't. Dead silence from Jolly Roger in Washington. No response to a dozen letters, the runaround on phone calls. Three years went by. [I] later learned the J.R. had run out of money and couldn't pay the binder.
>
> There were many confusions over the book. J. Brian in San Francisco brought out a paperback edition; then the hardcover edition was remaindered as soon as it appeared, and a sleazy three-volume paperback set with dreadful pictures was produced by the Jolly Roger's press without [my] name anywhere to be seen. (116)

To call Womack's practices sleazy is perhaps to put too fine a point on them.

From the outset, Womack seems to have had a larger political agenda than simply making money from publishing. In August 1958, the Grecian Guild held a convention in New Orleans, which was presided over by the Reverend Thorman Alderson, a young Episcopal minister, who, under the guise of attacking puritanism seems to cast a wider net without ever speaking overtly of homosexuality. "Where you find the body neglected, despised or considered an object of shame, there you have puritanism. Where you find human emotions beaten down, stifled or scorned as a sign of weakness, there you have puritanism" (quoted in Denneny). For Michael Denneny, the Grecian Guild "should be looked at again, as one of the earliest homophile organizations and one with perhaps as much historical consequence as Mattachine." Indeed, as several scholars have pointed out, the Mattachine Society could claim only 230 members in 1960, whereas the Guild Press could boast of 40,000 subscribers (Hatton 16). In Womack's 1971 trial, David R. Hurles, the limber author of *Auto-Fellatio and Masturbation,* one of the books seized by the government as obscene—a man, it should be noted, who not only could fellate himself, but could also take pictures of himself in the act—testified that his volume had sold 80,000 copies at the then-high price of $7.50 a copy (*Washington Post,* 21 July 1971, C9). Clearly Womack and the Guild Press books reached a large population, at least in comparison to gay organizations. Womack printed, without charge, all the materials used in the 1973 campaign to have the American Psychiatric Association remove homosexuality as a psychiatric disease. After reviewing the material in the Womack Archives at Cornell University, which includes "subscriptions to homophile journals, evidence of anti–Vietnam War activism, articles supporting gay rights, personal letters of support for gay men in jail and the service, and evidence of gay networking on an international scale," Jackie Hatton concluded that "Womack's business constituted a conscious challenge to the political, legal and social discrimination against homosexuals in this period" (18–19).

Perhaps Womack's most important achievement was winning a 1962 Supreme Court decision. According to Hatton, "This case was extremely significant in that it asserted that there was such a thing as homosexual identity, and that homosexuals had a right (within the limits of censorship laws) to express that sexual identity" (20). The decision required that postal inspectors judge gay materials by the same standards used for heterosexual materials. Freedom from discrimination from the post office was especially important to Womack since he was not only a publisher but the owner of the Guild Book Service, which, he claimed, was the "oldest gay book service in the world" (Hatton 28). Thus, by winning such an important victory, Womack was able to keep spinning yet one more thread to connect gay people together throughout the country.

In 1969, Womack published an anonymously written work entitled *The Team* in a series called Classics of the Homosexual Underground, which in length and format recalls the mimeographed pornographic pamphlets of the fifties. *The Team* is a novella of absolutely no literary, social, or psychological value, a fact that the anonymous Introduction, which I assume was written by Womack himself, makes clear enough:

> The very fact that the given allegedly obscene work arouses sexual stimulation and has the sole object as its function and result, does not and should not mean that the work is undesirable or unacceptable or to be outlawed. For we still harken back to the truth that human sexuality and depictions of it are decent and homorable, not to be surpressed because they represent that which is both natural and good. (11)

Nevertheless, just to play it safe, the Introduction claims that pornography "suggest[s] social injustices that need correcting" and that such works "always had [*sic*] something important to say about the human condition, even while they also aroused, titillated and stirred the human imagination, the sexual fantasy, the erotic appetite" (14).

Womack was not alone in combining pornography and liberation, although the mix was a highly controversial one. As Marc Stein has shown, Philadelphia's Janus Society, a sixties homophile organization, raised money and consciousness through its magazine *DRUM,* whose aim was "putting 'sex' back into 'homosexual'" and "producing a magazine geared to the homosexual as an individual who is something other than an abused ever-sinned-against outcast" (quoted in Stein 74). Even at the time, Clark Polak, the editor of *DRUM,* saw a connection between the work of the Janus Society and Womack's Guild Press, and he wrote an article for the first anniversary issue titled, "The Story behind Physique Photography," which discusses Guild Press at some length.

The test of these political forces is in their effect on the consciousness of gay men growing up in the general society. Writing in 1971, John Murphy recalls:

> The first pornography I encountered was on the racks in the back of a seamy little drugstore in Washington, D.C. The magazines were primitive compared to what may be purchased today. . . . But when

I was in high school, these were dangerous, forbidden, exciting and disturbing. . . . [T]hey awakened something I had never before experienced. This was my first glimpse of the world that has been created to service—and exploit—the homosexual. (56)

Although Murphy is "infuriated" by the exploitation, he nevertheless acknowledges the power these works had in awakening, not only his sexual desires, but also his awareness as a gay man. As Jackie Hatton has argued, the value of gay pornography is that it "constructs a discourse which is just as much about the *right to be homosexual and the shape of a distinct gay culture, as it is about sexual desire or sexual politics*" (13; Hatton's italics).

References

Amory, Richard. *The Song of the Loon.* San Diego, Calif.: Greenleaf Classics, 1966.

Anonymous. *The Different and the Damned: The Homosexual in a Heterosexual Society.* San Diego, Calif.: Publishing Export Company, 1968.

Anonymous. *The Team.* Classics of the Homosexual Underground. Washington, D.C.: Guild Press, 1969.

Austen, Roger. *Playing the Game: The Homosexual Novel in America.* Indianapolis, Ind.: Bobbs-Merrill, 1977.

Dean, Douglas. "Fuck Books or Gay Literature." *Vector,* May 1973, 16.

De Montemayor, Jorge, and Gaspar Gil Polo. *Diana.* Foundations of the Novel. Ed. Josephine Grieder. New York: Garland, 1973.

Denneny, Michael [as Mingus]. "Through the Looking Glass." *Night and Day,* 7–13 July 1986.

Dyer, Richard. *The Matter of Images: Essays on Representation.* London and New York: Routledge, 1993.

Fey, Edwin. *Summer in Sodom.* New York: Paperback Library, 1965. First edition, Argyle Books, 1964.

Gifford, James. *Dayneford's Library: American Homosexual Writing, 1900–1913.* Amherst: University of Massachusetts Press, 1995.

Harris, Daniel. "Transformations in Gay Male Porn." *Harvard Gay and Lesbian Review,* 3, no. 3 (Summer 1996): 18–22.

Hatton, Jackie. "The Pornographic Empire of H. Lynn Womack: Gay Political Discourse and Popular Culture 1955–1970." *THRESHOLDS: Viewing Culture,* 7 (Spring 1993): 9–32.

Holliday, Don. *Color Him Gay.* San Diego, Calif.: Corinth Press, 1966.

——. *The Man from C.A.M.P.* San Diego, Calif.: Corinth Press, 1966.

——. *The Watercress File.* San Diego, Calif.: Corinth Press, 1966.

Hooven, F. Valentine, III. *Beefcake: The Muscle Magazines of America 1950–1970.* Cologne, Germany: Benedikt Verlag, 1995.

Klaf, Franklin S. *Satyriasis: A Study of Male Nymphomania.* New York: Lancer Books, 1966.

Morgan, Helene. *Queer Daddy.* San Diego, Calif.: Satan Press, 1965.

Murphy, John. *Homosexual Liberation.* New York: Praeger, 1971.

Preston, John. Introduction to *$tud,* by Phil Andros. Boston: Perineum Press, 1982.

Rowe, Michael, ed. *Writing below the Belt: Conversations with Erotic Authors.* New York: Richard Kasak Books, 1995.

Stein, Marc. "Sex Politics in the City of Sisterly and Brotherly Love." *Radical History Review,* 59 (Spring 1994): 60–93.

Steward, Samuel M. *Chapters from an Autobiography.* San Francisco: Grey Fox Press, 1981.

Townsend, Larry. "Plight of Gay Novelists." *Advocate,* 19 August–1 September 1970, 19.

Weir, Angela, and Elizabeth Wilson. "The Greyhound Bus Station in the Evolution of Lesbian Popular Culture." In *New Lesbian Criticism: Literary and Cultural Readings,* ed. Sally Munt, 95–113. New York: Columbia University Press, 1992.

Williams, Jonathan. "The Moon Pool and Others." *Little Caesar,* 12, 169–74.

Woods, Gregory. *A History of Gay Literature: The Male Tradition.* New Haven, Conn.: Yale University Press, 1998.

3
■

NEW YORK SCHOOL'S "OUT"
Andy Warhol Presents Dumb and Dumber

Kelly Cresap

It took intelligent people years to appreciate the abstract expressionist school and I suppose it's hard for intellectuals to think of me as art. I've never been touched by a painting. I don't want to think. —ANDY WARHOL[1]

THE NAÏF-TRICKSTER PERSONA fashioned by Andy Warhol provides a crucial paradigm of 1960s queer visibility.[2] Andy was audaciously swish by the standards of the time, and yet his public demeanor suggests that naïveté was perhaps a more favored "orientation" for him than homosexuality. He cultivated an affectless dumb-blonde persona, spoke in a reticent, gee-whiz manner, responded with an indiscriminate "Yes" or "I don't know" in interviews, and asked associates for ideas of what to paint. So compelling was his impersonation of someone whose ignorance extended across entire epistemological spheres—politics, civic duty, social breeding, language ability, even basic motor skills—that people were more or less obliged to accept the impersonation as the legitimate article. Warhol's naïf self-presentation may be seen as an intricately coded surrogate for coming out as a gay man, a step he did not make, even well after Stonewall and the advent of identity politics. His strategic, though not entirely self-conscious mimings of ignorance and immaturity helped him to confront, cope with, manage, articulate, and also deny the complex implications of his queer sexuality. His extraordinary ability to deploy cognitive refusal lies at the core of his provocations in the realms of both Pop and queer culture. Warhol's steadfastly maintained swish/naïf performance exists simultaneously as an inverted parody of New York School decorum and ideology; as a critically enabling force for the contemporary gay and lesbian movement; and also, paradoxically, as a default system that permitted Warhol to employ de-gaying tactics and the rhetoric of homophobia when he found it expedient. Never fully reducible to an opposition between pro- and anti-gay components, Warhol's sixties persona reveals "queer naïveté" as a chameleonic performative mode, one that continues to inform present-day Pop and queer practices.

Toying with the Artist-Savants

The emergence of abstract art is one sign that there are still men able to assert feeling in the world. —ROBERT MOTHERWELL[3]

I don't have strong feelings on anything. —WARHOL[4]



44

Kelly
Cresap

Warhol demonstrates how the practice of "cultivating naïveté" promotes an incipiently queer agenda by exposing the dynamics of an entrenched masculinist regime of knowledge.[5] In a culture where reason and masculinity are stereotypically linked, a man playing a naïf provides a potential critique, not only of what is meant by mental competence, but also of male potency, even as he exposes himself to attack along these same lines. Warhol's pose of naïveté gives a farcical turn to the intertwined machismo and savantism that helped to legitimize the first bona fide homegrown art movement in the United States. His "unfeeling, unthinking" stance constitutes a sacrilegious inversion of principles central to the New York School, which is more famously known as the Abstract-Expressionist movement.

Members of the New York School invested the realm of art with tremendous feeling and expressed the highest aspirations for painting as a mode of philosophy. The movement's intellectualism, as well as its notorious machismo, may be seen in terms of an effort to transform the feminine-identified act of painting into an endeavor virile and robust enough to qualify as a valid pursuit for red-blooded, heterosexual American males. Attending lectures at the Eighth-Street Artist's Club and engaging in verbal or physical brawls at the nearby Cedar Tavern became ways of establishing artistic credentials in the movement. The influential critics Clement Greenberg and Harold Rosenberg, using masculinist and nationalistic terms to champion the new American painters, greatly reinforced the movement's aura of intellectual machismo.[6] Their attempts to "vindicate" art as a male domain could not have come at a more opportune moment. As Jonathan Katz wrote, "America has a history of suspicion with regard to its artists and their manliness, and perhaps never more so than in the early 1950s when the rest of America was rolling up its shirtsleeves and getting down to work to defeat Communism."[7] Given the kinds of brawny cultural self-confidence displayed in the United States during and following World War II, it may come as no surprise that art would be newly stigmatized as an effete and emasculating activity and a pursuit not befitting real men. A certain defensive logic belies Motherwell's insistence that "the emergence of abstract art is one sign that there are still men able to assert feeling in the world." His statement helps to safeguard an obverse proposition—that the emergence of abstract art was one sign that those who were able to assert feeling were *still men*.

Despite its antiacademic bias, Abstract-Expressionism developed a reputation as a *thinking man's* movement; concomitantly, membership fees rose astronomically for women and effeminate men.[8] Dore Ashton's biography of the New York School recounts the somewhat fraught courtship that developed between artists and intellectuals as they attempted to find common cause in the movement. Speakers who were invited to the Artist's Club sometimes met with scoffery from the membership, but their presence was still regarded as vital. Ashton shows how artists used the club, not only to build a visible, fraternal gathering-place, but also

to confirm their widening audience among the educated strata of the society and to establish the visual artist as a member of the intelligentsia on equal footing with writers and composers. No amount of nostalgic disclaiming can disguise the interest the visual artists displayed in attracting the other intellectuals to their bailiwick, and putting them in their place, so to speak. It was with considerable pride that they scheduled such speakers as Hannah Arendt, Lionel Abel, and E. E. Cummings. Though David Hare or Ad Reinhardt, or sometimes de Kooning, would occasionally heckle the august intellectuals who appeared Friday nights at the Club, they were the first to encourage invitations to poets, philosophers, psychiatrists, and critics.[9]

Among the many outspoken voices at the club, Willem de Kooning's carried an unusual weight of authority. The art world in the fifties continued to draw sustenance from the myth of "loft-rat" cosmopolitanism established in de Kooning's early career.[10] Among the mannerisms venerated in this myth were the ability to sound well-read but not bookish or academic and to wear workingman's garb and provide an air of brave poverty even if money was no longer a problem.

Both the intellectualism and the machismo associated with Abstract-Expressionism helped to establish the movement's famous "heroic" stature; this heroism, in turn, became used to create a perceptual distance between New York School artists and the millions of newly enleisured Americans who were turning to painting as a form of "cheap psychotherapy" or home entertainment.[11] Popular-press accounts collaborated in widening this gap; *Life* magazine, for instance, alternated between generating a cult atmosphere around figures like Jackson Pollock and satirizing the implicitly female legion of "peasant-class" painters who were merely "fillers-inners of numbered pictures."[12]

As nonprofessional painters with the stature of Winston Churchill advocated a "splash and wallop" painting style that sounded remarkably close to the working methods of the Abstract-Expressionists, apologists for the New York School found themselves increasingly hard-pressed to delineate the movement's claims for distinction.[13] They characteristically used continental philosophy as collateral in this effort, and their writings made painting sound more and more like philosophy. Ann Gibson has shown how, in spite of Abstract-Expressionism's contrarian emphasis on individual autonomy and its refusal of interpretive systems, the movement relied heavily on a "network of guiding philosophies," among them Jungian psychology, New Criticism, Russian Formalism, and Existentialism.[14] Ashton's account describes how a quasi-philosophical language of anxiety and alienation (drawn from Jean-Paul Sartre), of authenticity (Martin Heidegger), and of notions of the Sublime (borrowed from a heavily Dionysianized Friedrich Nietzsche), became ritual in art journals, lectures, and symposiums following the war, even carrying over from club events to Cedar Tavern discussions (178–87). Such language, which was employed far more impressionistically than rigorously, helped to provide ballast to artists who were casting about for a sustaining myth in an increasingly consumer-based nation.[15] The intellectuality of postwar art discourse came as a natural outgrowth of the backgrounds and inclinations of many of its artists and writers, yet it also

involved a protection-society air of defensiveness. Just as earlier one had "needed" Sigmund Freud in order to appreciate the surrealists, so now one also somehow "needed" Nietzsche, Carl Jung, Heidegger, Sartre, Franz Kafka, and the poetry of angst in order to properly appreciate Abstract-Expressionism.

One of the great affronts of Pop Art, then, was that it no longer "needed" high-modernist philosophy and poetry; even its nomenclature conveyed an indifference toward this tradition. As Allan Kaprow writes: "the word *pop* summoned up at once a native innocence and a deep fear of preoccupation with matters of so-called weight and thought. The whole notion of 'popularity' was (and is) patently anti-European in this sense and anti-intellectual as well."[16] The enlarged comic strips, ubiquitous logos, and name-brand products featured in Pop Art seemed to suspend, even to ridicule, imperatives toward pensiveness and the discerning critical eye. Artists themselves specifically disavowed the twin agenda of *gravitas* and *cogito* that underpinned modernist criticism and art. In Gene Swenson's 1963–1964 *ARTnews* interviews on the question, "What Is Pop Art?" painter Roy Lichtenstein labeled himself "anti-contemplative, anti-nuance . . . and anti all of those brilliant ideas of preceding movements which everyone understands so thoroughly." Painter Robert Indiana professed an aversion toward the high angst quotient of the earlier dadaist movement; he declared that Pop was not to be confused with "any neo-dada anti-art manifestation," on the grounds that "its participants are not intellectual, social and artistic malcontents with furrowed brows and fur-lined skulls."[17]

Warhol's stance was more radically unsettling than these, since he not only advocated an anticontemplative, anti-angst position but acted it out on a daily basis. A quality of self-absorbed naïveté traceable to his early childhood became a self-consciously cultivated aspect of his post-1962 Pop persona.[18] With his trademark silver-blond wig and cool, expressionless gaze, Andy was seen as the very physical embodiment of Pop, and he became the favorite bête noire of New York School artists, who found their own work eclipsed by the upstart movement. His habit of looking and behaving like an idiot in public exacerbated the offense of canvases whose content was itself regarded by many as egregiously idiotic. In his Warhol biography, Victor Bockris writes:

> With his dumb-blond image and, as it seemed to many, his dumb paintings, Andy became the number-one target for anybody who wanted to attack pop art, particularly among the first- and second-generation abstract expressionists and their followers. Reviewers in that camp called Warhol's work, among other things, a "vacuous fraud."[19]

Warhol played the role of "vacuous fraud" to the hilt, performing a series of ruses or "dupes" on the ground rules of the previous artistic dispensation. Whereas late-modernist art was promoted as a strenuous, "heroic" undertaking, Warhol proclaimed how easy and fun painting was. He offered an across-the-boards "dumbed-down" makeover of the ideals of late modernism, substituting surface for depth, mechanism for aura, repetition for uniqueness, self-promotion for asceticism, collaboration for autonomy, dissemblance for authenticity, and exultant consumerism for critical negation.

When interviewers asked him to account for his intentions, he tended to answer, "I don't know," or to treat the Q-and-A process as a joke:

Q: Do you think pop art is—
A: No.
Q: What?
A: No.
Q: Do you think pop art is—
A: No. No, I don't.[20]

However, the term "vacuous fraud" must also be seen as a double-edged euphemism. Immediately after meeting the artist in the mid-sixties, Francis Sedgwick, father of Factory superstar Edie Sedgwick, said of Warhol, "Why, the guy's a screaming fag."[21] That this epithet was not stated publicly by the Abstract-Expressionists did not mean they failed to share the sentiment.[22] Charges of vacuity and fraudulence delivered the same message in a more back-handed, estimable fashion. The terms decorously insinuated Warhol's basic lack of substance, heft, thinking power, authenticity; in a word, of manhood.

At the same time, Warhol himself, who was unusually skilled at manipulating his public image, may be said to have collaborated in drawing the "lesser" charge.[23] My impression is that, given the pre-Stonewall mentality in which he was raised and the coolness with which his overtly homoerotic art of the fifties was received, Warhol discerned that the role of "vacuous fraud" would take him much further in life than that of "known homosexual." He characteristically used the former role as a smoke screen for the latter. A logic of reaction-formation may be said to underpin both the intellectual self-image promoted by the New York School and the naïf self-image promoted by Warhol. Members of the New York School maintained a front of savantism and machismo as a method of guaranteeing that they were still "real men" in spite of being deep-feeling painters; Warhol found refuge in the persona of "empty-headed trickster" as a means of guarding against his being read too quickly, or too exclusively, as a screaming fag.

Artful Dodgers

Pop came along and said to a lot of people for whom the whole modern aesthetic is just too difficult and too devoid of fun, it said to all these people, anything goes. It released them from a certain kind of seriousness, a certain kind of solemnity, but I think, as an artistic statement, as an artistic vision, it's totally facetious. —HILTON KRAMER[24]

Oh, you might think, "Oh, here's this nice little boy who is very naive, and he dresses like a hick from Pennsylvania, and he acts sort of sickly and naively, and he doesn't know what the score is." Well, he did. But he was always involved with it on the level of a game or play. And this was very important to him. I mean, he couldn't understand why people were taking things so seriously, or why people had to be so . . . a drama. He loved the theatre.
—ALFRED C. WALTERS,
RECALLING HIS MEETINGS WITH
WARHOL IN THE MID-1950S[25]

The "adorability" factor that Warhol had played up while establishing his commercial art career in the 1950s, and which had elicited nicknames such as "Raggedy Andy" and "Andy Paperbag," all but disappeared after his initial Pop success.[26] As an art-world insider, he no longer had to rely on the latter-day Horatio Alger act that had sustained him in his move from Pittsburgh to New York City. His wigs, dark glasses, and blank expressions gave a remote celebrity chic to his physical appearance; his artistic output—particularly the jarring, grotesque *Death and Disaster* paintings, exhibited first in 1962—dealt a decisive blow to the "cute-Andy" image held by those who had known him in the fifties and earlier. The naïf persona that survived this transition made an impression whose startling incongruity persists to the present day.

Of all the naïf-trickster social styles to emerge during the 1960s, Warhol's remains the most enigmatic and fecund. The decade witnessed recurrent efforts to confront, thwart, confound, and otherwise de-ideologize the workings of entrenched regimes of knowledge (parental, cultural, commercial, academic, military, bureaucratic). Such efforts gave rise to a host of well-publicized naïf-trickster types: the Merry Pranksters led by Ken Kesey, the Haight Ashbury–based flower children, the new transcendentalists in the Krishna/Whole Earth/Zen meditation movement, and the Yippies led by Jerry Rubin and Abbie Hoffman. If these genealogically related anti-Establishment collectives seem more quintessentially sixties in spirit than Warhol's example, it is partly because their influence has not extended as potently beyond the decade. Despite the liberatory energies they unleashed, they lacked the urbane complexity and eerie clairvoyance that has sustained the Warhol mystique into the nineties. The Prankster, flower child, transcendental meditation (TM), and Yippie movements carry a strong Rousseauistic yearning for a pre-Industrial age, and they posit a naturalistic critique of advanced Western capitalism that is, finally, more antimodern than postmodern in outlook. Warhol, by contrast, holds the ambiguous distinction of being the world's first naïf of eminence successfully to "cross" (or, more accurately, to double-cross) the Modernist divide.[27] He did not, in fact, possess the gift of second sight, nor was he ever in complete control of his public image; but in the trickster tradition of bringing chaos and discord, today he is both celebrated and deplored in ways that other figures from the sixties are not.

The audacity of Warhol's position in the sixties is thrown into relief by the examples set by his immediate artistic predecessors, Robert Rauschenberg and Jasper Johns. Rauschenberg and Johns established a significant precedent for Warhol—a precedent that, in retrospect, is also significant for its tameness. As breakaway artists from the waning New York School tradition, and as lovers who carried on a closeted six-year relationship, Rauschenberg and Johns showed partial allegiances both to a previous era's codes of "urban cowboy" masculinity and savantism as well as to emerging postmodern codes of gender blurring and hipster naïveté.[28] The two artists provided a heavily coded critique of Abstract-Expressionism while still adhering to many of the movement's articles of faith. Their maneuverings amounted to a kind of epistemological shell game in which the contraband elements of queerness and naïveté shuttle among a host of disguises. Kenneth Silver's essay, "Modes of Disclosure," shows how their work both "embraces and betrays" Abstract-Expressionism; both parodies the movement's machismo

and at the same time stops short of constituting gay art.[29] Silver offers an astute reading of the specifically queer contradictions the two artists maintained: Rauschenberg and Johns suppressed the fact that they had supported themselves by doing commercial window display work and yet snubbed Warhol for having supported himself this way; they ridiculed the swagger and "ballsiness" of Abstract-Expressionism but nevertheless kept Warhol at a distance because they found him too "swish."

Silver concludes his essay by celebrating the "free play of gender, sexuality, and class signification" he sees as Warhol's "special field of knowledge" (202). However, a subsequent look at this field of knowledge shows that it, too, is riddled with queer contradictions. Warhol played the epistemological shell game with alternate stakes, making a shrewd diversion out of his apparent *lack* of knowledge. He promoted the commercialness of his work while suppressing the fact that he had been formally trained in the field of commercial art at Carnegie Tech; he kept the press and public guessing by providing falsified and inconsistent biographical data about himself; and he played up the "swish" aspect of his persona and pursued numerous infatuations with men while still maintaining the air of someone who did not know the first thing about sex.

THE DOCUMENTARY *Painters Painting* offers glimpses of this shell game in progress. Made by the artists' agent, Emile de Antonio, in 1970, it preserves evidence of Rauschenberg, Johns, and Warhol's restless impatience with the kind of male-gendered authority and high seriousness that was considered de rigueur for an artist's image.[30] The studio segments proceed for the most part straightforwardly, the artists interviewed (New York School affiliates Hans Hofmann, Barnett Newman, Robert Motherwell, Willem de Kooning, Kenneth Noland, and Helen Frankenthaler, among others) speaking and gesturing no less deliberately and rationally than the critics (Clement Greenberg, Thomas Hess, Hilton Kramer). A certain old-world astringency and unimpeachable reasonableness governs both the content and style of a majority of the interviews.[31]

The segments with Rauschenberg, Johns, and Warhol mark an important departure from this protocol. Rauschenberg and Johns both make attempts to inject the interview format with irony. Rauschenberg alternates between a thoroughly engrossed, brow-furrowed intentness and a winsomely cheerful demeanor that emerges almost like a protest against the other mode. He grins boyishly while describing how he erased a drawing by de Kooning. At other times he smiles inconsequentially, with a defensive shyness, as if the deliberation of his spoken response worked at cross-purposes with an impulse to lighten or josh the interview process.

Johns also seems to catch himself in the act of taking the interview too seriously. At inexplicable moments he erupts in a peremptory laughter, as if to introduce levity by sheer force. At one point he grows particularly morose while speaking about his early work, but then confesses he "became perhaps too serious about what [he] did," and laughs as if in conspiracy against his younger self. He finds great amusement in recounting the story behind his bronze-painted beer cans or in telling about how his aunt once wrote him to announce how proud she was of his respect for the American flag. During another reply he dryly interjects, "I will of course tell lies here." At other

times, the source of humor is unclear, as if he were entertaining a private joke; or an initial outbreak of laughter clears the way for an extended solemn reply. He openly mocks de Antonio's question, "What about Dada?" when he responds, "'What about Dada?' What kind of question is that: 'What about Dada?'" and proceeds to laugh uproariously. Having made this trickster maneuver, he then capitulates to expectation, providing an elaborate anecdotal account of his work's relation to that of Marcel Duchamp.

Johns and Rauschenberg stage jocular protests against interview convention while still couching their responses in a fundamental seriousness. By contrast, Warhol mounts a full-scale send-up, providing a theatrical example of the "total facetiousness" that Hilton Kramer described as the bane of Pop Art. Warhol's trickster performance in *Painters Painting* maintains a virtuosic seamlessness, like a joke that never announces itself as such by arriving at a punchline.

The artist brings his assistant Brigid Polk to the interview and casts her as its tacit authority. (The main prerequisite for becoming one of Warhol's assistants was hanging out at his studio, a multipurpose loft space known as The Factory. Although Polk's father was president of the Hearst Corporation, her fame at the Factory stemmed from her avid use of amphetamines.) With his private tape recorder running, Warhol deflects questions to Polk and to de Antonio, alternating his microphone between the two of them even when *he* is doing the talking. His verbal responses consistently debunk the interview genre's underlying pledges to offer reliable and revealing information and show glimpses of a personable, knowable individual. His rumpled, antistentorian delivery itself communicates the antithesis of what is meant by the phrase "weight of authority"; and yet, paradoxically, his low-voiced, nasal monotone and lack of animation give him a prepossessing air of intellectuality. Warhol dodges the first question, concerning his origins as an artist, by claiming that de Antonio "made" him a painter and then asserting that he learned about art through listening to de Antonio's gossip: "You used to gossip about the art people, and, uh—uh, that's how I found out about art" (119). Besides revealing a spuriously nonheroic provenance for his career, Warhol's comment damages the illusion of documentary objectivity—the pretense (upheld by the other interviewees) that de Antonio has no history of personal involvement with the artists he has selected to film.

Warhol's next maneuver is to cast doubt on whether he has an artistic career at all. He flouts the notion of artistic autonomy by insisting that Polk has been doing his paintings for the past three years. When she claims that in fact a certain "Mr. Goldman" is responsible for the paintings, Warhol, sounding like one of Twain's "innocents abroad," says "But Mr. Goldman's dead." Continuing to emphasize his own supposedly "blasé-faire" role at the Factory, his commentary turns circumlocutory and tautological, achieving a whimsicality worthy of Lewis Carroll: "The reason we can say Brigid does it is because I haven't done any for three years. So, when the papers say that Brigid's done all my pictures, Brigid can say she does all my pictures, which she can say because we haven't done any." Warhol goes on to characterize silkscreening as an effortless process about which he knows next to nothing: "Oh I just, uh, found a picture and, uh, gave it to the man, and he made a print, and I just took it and began printing . . . And then they came out all different because I guess I didn't know how to really screen." Asked about his

photomat portrait of Ethel Scull, Andy says, "It was just so much fun to do." He estimates he was paid $700 for the work, and, when challenged on this amount, takes refuge in "I don't know" and "I'm not sure." Asked why he chose to paint an electric chair, he responds with an alarming matter-of-factness: "Oh well—that was the time I think they were, they stopped, uh, killing people in the electric chairs. Wasn't it or before? So, I thought it was an old, uh, image, so that would be nice too."

Warhol's replies seem calculated to offend through their very inoffensiveness: "I just took it and began printing"; they were "just so much fun to do"; I thought the electric chair image "would be nice." In Warholian parlance, words like "just," "fun," and "nice" simultaneously convey innocuous pleasantness, an infantile level of maturity, and an inability or unwillingness to engage in thought. In the way he consciously overrides commonly accepted notions about the difficulty, seriousness, sacrifice, and profundity involved in making art, his utterances—in spite of his deadpan delivery—spring out of the documentary context like coiled jack-in-the-boxes.

The filmmakers chose not to include one exchange that shows Warhol at a revealingly queer moment. The printed text indicates that de Antonio asked Warhol what he thought of the show recently curated by Henry Geldzahler for the Metropolitan Museum (the Met):

> DE ANTONIO: Were there any people in Henry's show whose work you didn't like?
> WARHOL: Oh, no. I like everything.
> DE ANTONIO: What did you like best about the show?
> WARHOL: I never did see the show.
> DE ANTONIO: You never went?
> WARHOL: I went to the opening, but I didn't go inside. I pretended to be Mrs. Geldzahler and invited everybody in. I just stayed on the stairs and didn't go in. So I never did see it.[32]

Here Warhol's naïf performance makes a brief foray into the realm of explicitly queer masquerade. The artist permits a glimpse of himself in imaginary drag as the curator's wife, a matronly hostess welcoming visitors to the show. The joke acquires greater resonance through the fact that Geldzahler was gay and one of Warhol's closest confidants in the early sixties. Although they were not physically involved, they developed a trust and comradery with each other that gave their friendship some of the outward signs of a successful marriage. In spite of this, the moment in the interview is so fleeting, and so embedded in the larger context of Warhol's otherwise not-explicitly-gay performance, that the cross-dressing display flickers on and off almost subliminally. Gay readers are left to pick up on the reference as connoting gayness; audiences not so inclined are left to read the confession as merely another of his juvenile pranks—Andy playing dress-up with his parents' clothes, for instance; Andy mocking the Met. Here, as elsewhere in his career, Warhol's queer performance takes place under the protective aegis of his naïf-trickster performance.

Playing Dumb about Being Gay

We passed a bridge every day and underneath were used prophylactics. I'd always wonder out loud to everybody what they were, and they'd laugh.
—WARHOL DESCRIBING HIS HIGH SCHOOL
DAYS IN *PHILOSOPHY* (22)

52
■
Kelly
Cresap

Paradoxically, it was not until after Warhol found effective disguises for his gayness that he became a trenchant force in gay politics. Warhol's Pop breakthrough in the early sixties is entirely imbricated with his ability to make his gay intentions illegible to the public at large. The Bockris biography indicates that the reception of his exhibit of frankly homosexual "Drawings for a Boy-Book" in 1956 came as a bitter object lesson about the constraints within which he had to work in order to gain attention in the world of fine art (84). Not incidentally, 1956 was also the year he underwent plastic surgery on his nose, an operation that brought disappointingly minor results; and the year in which, after extended travels with Charles Lisanby, he complained that he had "gone around the world with a boy and not even received one kiss."[33] At no point in Warhol's career did his work stop being gay, but by the early sixties it had undergone a major camouflage operation, as did Warhol himself in relation to it.

Certain elements of Warhol's output have become almost canonical symbols of sixties gay culture: the silkscreens of Elvis and Troy Donahue (1962–1964); the New York World's Fair mural of *Thirteen Most Wanted Men* (1964); the films *Sleep* (1963), *Blow-Job* (1963), *My Hustler* (1965), *Lonesome Cowboys* (1967), and *Flesh* (1968); and, more generally, the Factory's endless promotion of camp taste and drag culture. The films in particular still retain their startling homoerotic impact. Their gayness inheres, not only in their worshipful display of the male physique and their flirtation with same-sex attraction, but in their mesmeric allure, their moments of high bitchiness, their transmogrificatory relation to mainstream Hollywood film, and their outrageous lack of outrage toward the acts and images they depict. Further, Warhol's establishing of a safe harbor for drag queens at the Factory must be seen as a critically enabling stage in the history of drag liberation and of the Stonewall Rebellion itself.

To argue that this body of gay sixties work also performs maneuvers of gay avoidance or removal on Warhol's part will perhaps invite charges of ingratitude, pettifoggery, or twenty-twenty hindsight. My purpose in making the case is not to distribute Gay Lib bonus-and-demerit points, but to examine a structure of behavior that continues to inform contemporary social and political practice. The Warhol who presides over and disseminates such a wealth of homophile material in the sixties is also supremely adroit at omitting incontrovertible evidence about his own desires. His career is a classic illustration of Eve Kosofsky Sedgwick's recurrent postulate about how the codes of gay "knowingness" are imbricated with codes of gay deniability.[34] Simultaneously, Warhol carries the mantle of being the most notoriously swish and notoriously naïve member of the New York artistic elite. As a homosexual artist making insurgent raids on a heavily guarded macho terrain, Warhol relies on "unwittingness" as his most valuable defense—a qual-

ity capable of charming friends and baffling enemies, and a form of damage control taken out against the more scandalous implications of his work.

One of Warhol's tactics is to find cunning refuge in the very Popism of his Pop images, to hide himself in an audience of millions. Elvis and Troy radiate international box-office appeal, which diverts attention away from the specific attractions they held for the man who silkscreened them. These "star attractions" are further distanced from the realm of homoerotic self-disclosure by the boy-girl logic Warhol promotes through finding female counterparts both for his male film idols (Marilyn, Natalie, Liz, Jackie) as well as for his own public appearances (Superstars Edie, Ultra, Viva).

By way of a double-entendre, Warhol's "most wanted men" ask to be scrutinized and pursued, not only by the FBI and "concerned" citizens, but also by gay men savvy enough to get the joke; and yet all these audiences are conceived impersonally, demographically: the mural depicts the popularly and generically *most* wanted men, not necessarily the men most wanted *by* Warhol. This logic of "mass mediation" filters through the more explicitly homoerotic film material: everybody, and therefore not *particularly* Warhol, is wild about Paul America in *My Hustler;* Tom Hompertz, the angelic blond in *Lonesome Cowboys;* and Joe Dallesandro in *Flesh* and *Trash*. The desires displayed by the title characters in *Lonesome Cowboys* are not shared by the film's producer in a way that is palpable or verifiable. Warhol, like the filmmaker John Waters, secures a place for himself as (to use Eve Sedgwick's terms) the "ubiquitous but invisible, and consequently disembodied, source" of what his films depict.[35]

Warhol becomes the impresario or meta-agent whose films confer queer desire onto others while he maintains a scrupulously guarded position of plausible deniability. Unlike underground filmmaker Jack Smith, Warhol chooses not to implicate his own bodily presence by joining his casts onscreen. His claim to having no feelings whatsoever (the ultimately unconvincing stratagem of a delicate mama's boy) conveniently helps him to sidestep the question of whether his artistic output ever records *his* feelings.[36] No one would mistake the "my" in *My Hustler* as denoting Warhol; the word's usage here exists in diametric relation to its usage in the title of Jasper Johns's painting "In Memory of My Feelings—Frank O'Hara" (1961). Andy's pretense of having not only no feelings but no memory ("My mind is like a tape recorder with one button—Erase") amounts to a backhanded form of political self-exemption.[37] Having no feelings or memory precludes having any *gay* feelings or memory. Concomitantly, having a naïf public persona furnishes Warhol with a ready alibi of naughty-boy "innocence"—the impression that he was compelled to such images and narratives out of childish curiosity rather than adult arousal; that he was drawn to a realm he could always, if challenged, claim not to understand. Transforming the open secret of his gay sexuality into a personal playground, Warhol manages during the sixties to be both outrageously, notoriously gay as well as to carry himself with an air of someone who has no inkling of what he is doing. Warhol's flamboyant artistic output, his cryptic authorial presence, and the series of dislinkages he creates between them—all of these elements are both enacted and corroborated through the logic of naïf-trickster performance.

As Warhol's career migrates from painting and filmmaking to the realm of publishing, his now-you-see-it, now-you-don't relation to his gayness

occasions even more provocative forms of contradictory self-assertion. His patented twofold de-gaying strategy—of seeking refuge from gayness in a master dialect of naïf-tricksterism and of spotlighting behavior that is even more outrageously gay than his own—becomes further consolidated in his self-revisionist writings. The antics of Warhol in print, particularly in *Philosophy* and *Popism,* provide memorably autobiographical outworkings of his basic approach-avoid, assert-erase tactics. The books present a kind of scrapbook-album reverie on Warhol's greatest moments of the sixties, permitting both a nostalgic return to the heyday of the Silver Factory as well as an opportunity to doctor the record. Finding refuge in both the historical and authorial removes permitted by memoir writing, Warhol presents a subtly altered account that soft-pedals and de-sexualizes his image.

The artist's famous celebration of drag queens as the "living testimony to the way women used to want to be" appears in *THE Philosophy of Andy Warhol,* published in 1975.[38] Warhol says, "I'm fascinated by boys who spend their lives trying to be complete girls, because they have to work so hard" (54). The "because" clause here helps to preclude further discussion of what else about boys might fascinate Warhol. The intrigue of drag queens, Warhol asserts, lies in the fact that they work so hard, not that they are boys trying to be girls; or that they are boys, period. The passage is emphatic about the value of arduous labor: "What I'm saying is, it is very hard work. You can't take that away from them. It's hard work to look like the complete opposite of what nature made you" (54). While ostensibly celebrating drag culture, the passage manages to perform a dual sanitizing operation: it exonerates drag performance by establishing links to a redemptive work ethic; and it exonerates Warhol by countermanding the implication that his interest in drag queens might be prurient or sexual. Warhol positions himself as an ordinary member of the general public, effectively quarantining himself from the drag queens he previously welcomed at the Factory: "Drag queens are reminders that some stars still aren't just like you and me" (55). Casually inserting himself into the company of his readers, Warhol implies that all non–drag queens together form a cozy, homogeneous interpretive community. If there are homosexuals in this community, their presence is unheralded, seemingly uninvited.

The arts of inclusion and of exclusion crisscross each other in *Philosophy,* ensuring that no direct access is granted to the matter of Warhol's sexual orientation. *Philosophy* includes a smattering of Warhol's offhand remarks about gay individuals: "that lesbian" (179); "Fags with dykes" (191); "She married a staple-gun queen" (47).[39] The offhandedness of such remarks precludes discussion of their homosexual content. Here Warhol constructs what D. A. Miller, in his essay on Hitchcock's film *Rope,* has called "a homosexuality of no importance"; the fact of someone being gay is treated as a source of fun or derision, but not allowed to intrude on the narrative in a substantive way.[40] In fact, Warhol's objectifying rhetoric develops the stamp of a full-fledged private lexicon in *Popism.*

Warhol's female phone partner in *Philosophy,* referred to as "B," does, in fact, speak hypothetically about Warhol's attraction to men. B imagines Warhol at the White House as "the first non-married President"; she amends this impression by adding: "if you were President right now, there'd be no more First Lady. Only a First Man" (14). Later, B becomes upset when

Warhol abruptly leaves the phone without explanation; she accuses him of going off "to another part of the house with the delivery boy or the plumber" (225). These marvelous throwaway moments wittily insinuate same-sex attraction as Warhol's native domain, and present sturdy obstacles to any reading of *Philosophy* as a text consistently de-gaying itself. They typify the kind of low-voltage camp humor that is found throughout the book. At the same time, they are, technically, *thrown away* by Warhol; he neither confirms nor disconfirms the insinuations, but lets the remarks pass without comment. B's attribution of Warhol's same-sex desire remains in the realm of hypothesis, awaiting substantiation by the individual reader.

While speaking about himself, Warhol characteristically remains guarded and surreptitious, careful to reserve a de-gayable space in the folds of his authorial persona. After remarking that he finds a man adorable, he asks B for permission to do so: "'Is it okay for guys to be adorable?'" (172). He speaks of having an affair with his TV set and describes his tape recorder as his wife ("my first tape recorder. My wife. My tape recorder and I have been married for ten years now" [26]). The admission is so deadpan that it is impossible to discern whether "wife" is used with hard- or soft-edged irony. One could say it has the thoroughly campy air of the word "girlfriend" as used among gay men today; but this is not consistent with the passage's tone or with Warhol's use of gender-specific language in other contexts, such as the diaries. Even the nonmechanical love interests of his life are heterosexually coded: he uses a feminine pronoun while referring to his "romances" (50); conjectures about going to a female prostitute ("If I went to a lady of the night, I'd probably pay her to tell me jokes" [49]); and mockingly refers to the role of "bringing home the bacon" (46, 92). He reports being "fascinated-but-horrified" when a renowned fashion model shares his bed (36).

Philosophy's author-naïf retains a position for himself that is, to borrow a phrase from Eve Sedgwick's essay "Privilege of Unknowing," coercively incoherent.[41] The reader, who is presented with a series of artful dodges, is left to hash out a kind of multiple double negation: Don't mistake me for someone who is not gay yet don't abandon the idea that I might not be gay. The trail of false clues Warhol leaves behind him conveys the ambivalence of his relation both to dominant heterosexual as well as to emergent homosexual cultures. Warhol's resistance to the post-Stonewall Gay Liberation movement, with its extroverted rallies and publicized outings, may be attributed to a host of inhibiting factors—shyness, envy, incomprehension, voyeurism, apoliticism. It is hard to imagine an artist accustomed to the homosexual codes of the 1950s not feeling a complex sense of disappointment and loss at the constricting labels and slogans, the procrustean options and antibohemian tones of the fledgling seventies gay movement.

In a profounder way, though, it is similarly hard to imagine someone of Warhol's temperament being able to thrive without a constantly maintained and revisited locus of inward retreat. Michael Moon points to the artist's vision of himself in *Philosophy*—a "cartoon idyll of happy solitary play"—as crucial to the adult Warhol's self-rehearsed sense of identity.[42] The passage appears early in the first chapter:

I had had three nervous breakdowns when I was a child, spaced a year apart. One when I was eight, one at nine, and one at ten. The attacks—

St. Vitus Dance—always started on the first day of summer vacation. I don't know what this meant. I would spend all summer listening to the radio and lying in bed with my Charlie McCarthy doll and my un-cut-out cut-out paper dolls all over the spread and under the pillow.

My father was away a lot on business trips to the coals mines, so I never saw him very much. My mother would read to me in her thick Czechoslovakian accent as best she could and I would always say "Thanks, Mom," after she finished with Dick Tracy, even if I hadn't understood a word. She'd give me a Hershey Bar every time I finished a page in my coloring book. (21–22)

Victor Bockris reports that, according to Warhol's brothers, "Andy greatly exaggerated his bouts of St. Vitus' dance: He came down with it seriously only once, and was really too young to have been worried about it" (20). "Yet," as Bockris writes, "the emphasis Andy gave his illness in later life indicates how important the experience was to him" (20). Bockris goes on to make the case even more emphatically: "If Freud is right in saying that - subconsciously we remain the same age throughout our life, then Andy would always remain the two-sided eight-year-old who emerged from the cocoon of his illness" (22). Stephen Koch and Ultra Violet's biographies corroborate Bockris and Moon's conviction that Warhol never wandered far from this secret childhood *imaginaire*.[43] Such places of secrecy, as D. A. Miller has shown, are extraordinarily vital in terms of psychological self-preservation:

> In a world where the explicit exposure of the subject would manifest how thoroughly he has been inscribed within a socially given totality, secrecy would be the spiritual exercise by which the subject is allowed to conceive of himself as a resistance: a friction in the smooth functioning of the social order, a margin to which its far-reaching discourse does not reach. (27)

Warhol's imaginative childhood idyll, circa 1936, may be seen as the primary source of his "resistance," both to a work ethic fueled by 1950s conformism as well as, two decades later, to an ethic of social protest fueled by the human rights movement and Stonewall activism. His *imaginaire* was a realm safeguarded from, and antecedent to, the emergence of the homosexual, in both the psychological and historical senses of the phrase. Revisiting this site, dwelling there, granted Warhol a double immunity: it was a means of protecting the ludic and open-ended region of childhood sexuality over against the heavily partitioned domain of responsible, coherent adult sexual identity; and it was a means of protecting a prepoliticized sense of homosexuality as relating to acts but not persons.

The kinds of about-faces and double reversals Warhol performs, thus, cannot be metabolized to produce a cohesive political stance. Warhol's self-fashionings are, finally, too peculiar to be accounted univocally as either harbingers of, or implied critiques of, post-Stonewall culture. It is not simply that he was, as Andrew Ross has said, "the bane of the intentionalist critic's existence," but that his statements actively refuse certain forms of stabilized meaning, and recurrently do so along the hetero/homosexual divide.[44]

IN *POPISM: THE WARHOL SIXTIES,* published in 1980, Warhol's ability simultaneously to denote and disclaim gay desire develops into a surprisingly consistent lexicon. The book's celebrated anecdote, in which he learned that Rauschenberg and Johns were snubbing him because he was too commercial, too "swish," and too forward about being a collector of art, shows how Warhol uses naïf-trickster methods to de-gay himself even while recounting an episode in which he stands accused of being swish.

> And as for the "swish" thing, I'd always had a lot of fun with that—just watching the expressions on people's faces. You'd have to have seen the way all the Abstract Expressionist painters carried themselves and the kinds of images they cultivated, to understand how shocked people were to see a painter coming on swish. I certainly wasn't a butch kind of guy by nature, but I must admit, I went out of my way to play up the other extreme. (12–13)

What possible sense can be made of Warhol in 1980 pretending that being swish in the sixties had "always" been "a lot of fun"? As the passage unfolds in *Popism,* no sooner does he finish indicating how much it hurt him to be snubbed by Rauschenberg and Johns at the time, than he speaks as if he had no recollection of suffering from their homophobic ostracism and contempt. Further, no sooner does he quote de Antonio as saying that "the post–Abstract Expressionist sensibility is, of course, a homosexual one" (12), than he presents a transpositionally de-gayed version of his own image. The rhetoric he uses—"fun," "just watching the expressions," "play up the other extreme"—is closely reminiscent of his *Painters Painting* rhetoric and casts him firmly in the role of inspired mischief maker rather than of desiring gay subject. The term *swish* itself has a substitutional or euphemistic effect, since it is more closely linked to the sixties vernacular of effeminacy and being a "window-dresser type" than it is to a specifically *sexualized* identity.[45] Being "swish" in Warhol's book is connotatively divorced from being gay, from being (as he says in a later passage) "so gay you can't believe your eyes" (222).

Popism reveals Warhol's carefully objectified way of describing other men as attractive while avoiding the suggestion that he in particular is attracted *to* them. As presented in the book, male pulchritude seems to exist in a realm from which the author is hermetically sealed. Discreetly entranced, Warhol watches and records from a safe remove: "a very intense, handsome guy in his twenties" (55); "handsome, young, smart" (60); "a tall, good-looking Harvard guy with blond hair and green eyes" (112); "unbelievably good-looking" (124); "very cute, very sexy lead singer" (190); "young, good-looking, and beautifully tailored" (214). A number of Andy's given tendencies—his shyness, his acute consciousness of his own appearance, his fraught relation to sexuality, his bafflement about gay politics—collude with the conventions of first-person omniscient narrative voice to make certain self-disclosing locutionary structures unspeakable. He never says anything as sexually incriminating as, "I loved his eyes," "I was intensely drawn to him," "I fell for him on sight," "I couldn't get him out of my mind." Warhol retains a circumspect and passive stance even when presenting more subjective information, describing a party attended by a number of young Hollywood actors as "the most exciting thing that had ever happened to me" (42).

Andy refers to the gay element in his entourage and films with a pre-emptive, unconcerned dryness: "The Factory A-men were mostly fags" (62); "It was the story of an old fag" (125); "a movie about a one-woman all-fag cowboy town" (259). In these passages, "fag" appears as a self-contained, self-explanatory term needing no gloss, as if it were beneath further mention. Recurrently Warhol signals gay behavior ventriloquistically, like a smart-aleck grade-school kid maintaining a straight face while smuggling dirty words into a class oral presentation. He seems to take particular delight in repeating stories that feature homophobic epithets and gay bashing: "This friend got busted for something like 'sodomy in a steam bath' and lost his teaching job" (53); "Ondine came out from the back holding a huge jar of Vaseline and launched into a whole big tirade against drag queens and trans-vestites" (101); "Then she added, 'Good luck with that fairy'" (104); "don't think we're going to forget you're still our queen!" (187); "Then the group of sightseers marched in to 'You fags! You queers!'" (261); "'you're all a bunch of fags!'. . .'Listen, you fag bastard!'" (267–68). In such accounts the phe-nomenon D. A. Miller describes as a "homosexuality of no importance" is promoted into a louche form of storytelling. The casualness with which these anecdotes are conveyed has an edge of cruelty; it is as if Warhol, or Drella, as he was nicknamed at the Factory, had devised a cunning new form of blood sport.

It must be remembered that such accounts circulated long after Warhol had cut himself off from all the "crazy, druggy" people who had sustained his work in the sixties; by this time he had begun professionally courting the likes of Imelda Marcos and the shah of Iran. By the seventies and eighties he had also lost the fervor of his great adversarial relation to the New York School. At the same time, the publications of *Philosophy* in 1975 and *Popism* in 1980 are interspersed with some of the most homoerotically explicit work of his career: the *Athletes* and *Torso* series (1977); drawings such as "Untitled (Boys Kissing)" (1980), which recalled his 1956 "Drawings for a Boy Book"; a poster for the Fassbinder film *Querelle* (1982); and the portrait, "Keith Har-ing and Juan DuBose" (c. 1983).[46]

At no point does Warhol's career present a smooth, coherent front, either politically or otherwise. The methods he uses in his autobiographical writings must be seen in the context of his other output at the time, and placed on a continuum with methods he had employed in the sixties and ear-lier. Warhol discovered novel and contradictory applications for cultivated naivete throughout his life, and as he did so, he crossed and recrossed tradi-tional political demarcations in a spirit of amiable insouciance. In his most productive period, his ruses revealed untruths about an entire Western epis-teme; and yet these ruses retain a symbiotic link with later ploys that revealed untruths primarily about himself. Extrapolating from the epigraph that opens this final section, one could say that, after high school, Warhol found ever more devious methods of wondering out loud—"always," "every day," to "everybody"—what used prophylactics were.

Notes

I am grateful to Howard Singerman, Michael Levenson, and Candice Breitz for their helpful comments and encouragement.

1. Victor Bockris, *The Life and Death of Andy Warhol* (New York: Bantam, 1989), 106.

2. The figures of the naïf (or fool) and the trickster are conceptually as well as historically intertwined. The collection, *The Fool and the Trickster,* ed. Paul V. A. Williams (Totowa, N.J.: Rowman and Littlefield, 1979), addresses the marked resemblances between the two character types; D. J. Gifford's essay, for instance, posits the medieval fool as having evolved from the more sinister figure of the trickster, an archetypal bringer of chaos and confusion. In *The Trickster of Liberty* (Minneapolis: University of Minnesota Press, 1988), Gerald Vizenor cites Robert Pelton's assertion that all "tricksters are foolers and fools, but their foolishness varies; sometimes it is destructive, sometimes creative, sometimes scatological, sometimes satiric, sometimes playful. . . . the pattern itself is a shifting one, with now some, now others of the features presented" (xiv).

Warhol presents a radically urbanized variant of these paired tropes, making a clear break both from the pastoral-nostalgic tradition of the naïf, and the folk-rural tradition of the trickster.

3. "What Abstract Art Means to Me," *Bulletin of the Museum of Modern Art,* 18, no. 3 (Spring 1951); report in ed. Herschel Chipp, *Theories of Modern Art: A Source Book by Artists* (Berkeley: University of California Press, 1968), 562.

4. *Andy Warhol In His Own Words,* Mike Wrenn, ed. (New York: Omnibus Press, 1991), 33.

5. I define "cultivated naïveté" as the strategic withholding, disabling, or refusal of knowledge; an apparent ignorance that nonetheless wields a critical edge.

6. See Amelia Jones, *Postmodernism and the En-Gendering of Marcel Duchamp* (New York: Cambridge University Press, 1994), 20–21.

7. Jonathan Katz, "The Art of Code: Jasper Johns and Robert Rauschenberg," in *Significant Others,* ed. Whitney Chadwick and Isabelle de Courtivron (New York: Thames and Hudson, 1993), 188–207.

8. On the near-impossibility of being a female Abstract-Expressionist, see Michael Leja, in *Reframing Abstract Expressionism: Subjectivity and Painting in the 1940s* (New Haven: Yale University Press, 1993), 253–68; and Anne M. Wagner's essays, "Lee Krasner as L.K.," *Representations,* 25 (Winter 1989): 42–57; and "Fictions: Krasner's Presence, Pollock's Absence," in *Significant Others,* ed. Chadwick and de Courtivron, 222–43.

9. Dore Ashton, *The New York School: A Cultural Reckoning* (New York: Viking Press, 1973), 198.

10. Ibid., 166–68.

11. Karal Ann Marling, *As Seen on TV: The Visual Culture of Everyday Life in the 1950s* (Cambridge, Mass.: Harvard University Press, 1994), 67.

12. Ibid., 62. On the gendering of mass culture as feminine, see Andreas Huyssen, *After the Great Divide: Modernism, Mass Culture, Postmodernism* (Bloomington: Indiana University Press, 1986), 44–62; and Jones, *Postmodernism,* 18–21.

13. On the Abstract-Expressionists, see Marling, *As Seen on TV,* 67.

14. Ann Gibson, *Issues in Abstract Expressionism: The Artist-Run Periodicals* (Ann Arbor, MI: UMI Research Press, 1990), 3; and Ann Gibson, "Abstract Expressionism's Evasion of Language," in *Abstract Expressionism: A Critical Record,* ed. David and Cecile Shapiro (New York: Cambridge University Press, 1990), 198–205.

15. See Ashton, *The New York School,* 189–92.

16. Allan Kaprow, "Pop Art: Past, Present and Future," *Malahat Review,* July 1967; rpt. in Carol Anne Mahsun, *Pop Art: The Critical Dialogue* (Ann Arbor: UMI Research Press, 1989), 63.

17. Gene Swenson, "What Is Pop Art?," *ARTnews,* November 1963 and February 1964; rpt. in Mahsun, *Pop Art,* 112, 124.

18. See Warhol's *THE Philosophy of Andy Warhol* (New York: Harcourt Brace, 1975), 21–22; Bockris, *Life and Death,* 18–22; and Michael Moon, "Screen Memories, or, Pop Comes from the Outside: Warhol and Queer Childhood," in *Pop Out: Queer Warhol,* ed. Jennifer Doyle, Guy Flatley, and José Esteban Muñoz (Durham, N.C.: Duke University Press, 1996), 78–100.

19. Bockris, *Life and Death,* 117.

20. Ibid., 120.

21. Jean Stein, *Edie: An American Biography* (New York: Knopf, 1982), 257. A witness reports that Mr. Sedgwick said this "with a great sense of relief," since he perceived that Warhol no longer posed a threat to his daughter.

Warhol prompted a similar response from Frederick Eberstadt in the early sixties: "Here was this weird coolie little faggot with his impossible wig and his jeans and his sneakers and he was sitting there telling me that he wanted to be as famous as the Queen of England! It was embarrassing" (Bockris, *Life and Death,* 102).

22. John Giorno, one of Warhol's sexual partners in the early sixties, and the model for his film *Sleep,* writes:

> The art world was homophobic. . . . De Kooning, Pollock, Motherwell, and the male power structure were mean straight pricks. No matter their liberal views, they deep down hated fags. Their disdain dismissed a gay person's art. On top of it, those guys really hated Pop Art. . . . I am a witness to their being cruel to Andy Warhol. (*You Got to Burn to Shine* [New York: High Risk Books, 1994], 132–33).

Homophobic epithets were readily available at the Factory as well, as is seen when Brigid Polk exploded at Warhol in 1971: "You're nothing but a fucking faggot! You don't care about anyone but yourself!" Bob Colacello, *Holy Terror: Andy Warhol Close Up* (New York: Harper, 1991), 66.

23. The editors of *Pop Out: Queer Warhol* (Doyle, Flatley, and Esteban Muñoz) write in the Introduction that "with few exceptions, most considerations of Warhol have 'de-gayed' him" (1). I envision the present chapter as a companion to *Pop Out,* a book that promotes Warhol as a "fabulous queen" (1) and only passingly considers the ways in which he de-gayed himself.

24. Emile de Antonio and Mitch Tuchman, *Painters Painting* (New York: Abbeville Press, 1984), 119.

25. Patrick S. Smith, *Warhol: Conversations about the Artist* (Ann Arbor: UMI Research Press, 1988), 144.

26. See Calvin Tomkins, "Raggedy Andy," in *The Scene: Reports on Post-Modern Art* (New York: Viking Press, 1976), 35–54.

27. Wrenn, *Andy Warhol in His Own Words,* 33.

28. On their relationship, see Charles Harrison and Fred Orton, "Jasper Johns: 'Meaning What You See,'" *Art History,* 7, no. 1 (March 1984): 76–101; Jonathan Katz, "The Art of Code: Jasper Johns and Robert Rauschenberg," in *Significant Others,* ed. Whitney Chadwick and Isabelle de Courtivron, 188–207; and Kenneth E. Silver, "Modes of Disclosure: The Construction of Gay Identity and the Rise of Pop Art," in *Hand Painted Pop: American Art in Transition 1955–62,* ed. Russell Ferguson (New York: Rizzoli International, 1992), 178–203.

29. Silver, "Modes of Disclosure."

30. De Antonio produced the documentary for Turin Film Corp., and it aired on the Public Broadcast Service (PBS) in 1972. It later appeared in retrospective book form (see de Antonio and Tuchman, *Painters Painting*). Quoted material from this section refers to the film version, unless noted by a page number from the printed text (the book includes minor inaccuracies of transcription).

31. Frankenthaler's appearance in the documentary is a model of self-composure, elegance, and restraint. Naïf-tricksterism as a progressive role was largely unavailable to women artists until well after the advent of feminism. Lynda Benglis's work in the early seventies is a significant pioneering effort. More recent examples include the work of Laurie Anderson, Sherrie Levine, Jenny Holzer, Barbara Kruger, and Cindy Sherman.

32. The show referred to is "New York Painting and Sculpture: 1940–1970." The exchange appears in de Antonio and Tuchman, *Painters Painting,* 129–30.

33. Bockris, *Life and Death,* 87.

34. See Eve Kosofsky Sedgwick's writings on Wilde, Henry James, and Proust in *Epistemology of the Closet,* and her essay, cowritten with Michael Moon, "Divinity: A Dossier, a Performance Piece, a Little-Understood Emotion": "the rabid frenzies of public deniability are an inextricable part of the same epistemological system as the sophisticated pleasures of public knowingness" in *Tendencies* [Durham, N.C.: Duke University Press, 1993], 223).

35. Sedgwick and Moon, "Divinity," 240.

36. On the strategem, see Warhol's *THE Philosophy of Andy Warhol,* 111.

37. Ibid., 199.

38. Ibid., 54–56.
The "literary assembly line" production of *Philosophy* is discussed in Bob Colacello's biography, *Holy Terror,* 207–8; its public and critical reception is discussed in the Bockris biography, *Life and Death,* 292–93. Colacello describes the manuscript's circuitous editorial journey from himself to Warhol to Brigid Berlin to Pat Hackett, back to Warhol, and finally on to publisher Harcourt Brace Jovanovich.

39. "Staple-gun queen" was Warhol's pejorative term for Johns and Rauschenberg during the seventies (see Colacello, *Holy Terror,* 26). It seems to have served an expiatory function, allowing Warhol to out the two artists as well as to have a good laugh at their more closeted situation.

40. D. A. Miller, "Anal *Rope,*" *Representations,* 32 (Fall 1990): 114–33.

41. Eve Kosofsky Sedgwick, "Privilege of Unknowing: Diderot's *The Nun,*" *Tendencies* (Durham, N.C.: Duke University Press, 1993), 23–51.

42. in *Pop Out,* ed. Doyle, Flatley, and Esteban Muñoz, 81.

43. Stephen Koch, *Stargazer,* 2nd ed. (New York: Marion Boyars, 1985), ix; Ultra Violet, *Famous for 15 Minutes* (New York: Avon, 1988), 94.

44. Andrew Ross, *No Respect: Intellectuals and Popular Culture* (New York: Routledge, 1989), 168.

45. Truman Capote, among others, applied the implicitly derisive term, "window-dresser type," to Warhol (Bockris, *Life and Death,* 90).

46. On the drawings, see David Bourdon, *Warhol* (New York: Harry N. Abrams, 1989), 372.

4

■

THE "SWEET ASSASSIN" AND THE PERFORMATIVE POLITICS OF *SCUM MANIFESTO*

Laura Winkiel

SCUM [SOCIETY FOR CUTTING UP MEN] *MANIFESTO* opens with the following infamous lines: "Life in this society being, at best, an utter bore and no aspect of society being at all relevant to women, there remains to civic-minded, responsible, thrill-seeking females only to overthrow the government, eliminate the money system, institute complete automation and destroy the male sex" (Solanas 3). This declaration of war against capitalism and patriarchy marks the emergence of the radical feminist movement in the United States.[1] Valerie Solanas wrote the manifesto in 1967 and then peddled the mimeographed document in the streets of Greenwich Village in New York City. The price for the fifty-page pamphlet was $2 for men and only $1 for women. The pricetag played within the capitalist market that Solanas despised, inserting gender inequality into a money economy whose instrumental rationality overlooks qualitative differences. Despite its marketing strategy and feminist polemics, the manifesto failed initially to make any significant impact among the nascent radical feminist movement. In fact, Solanas's first and only organizational meeting, advertised in the *Village Voice* simply as "'SCUM' Men $2.50, women $1.00," attracted only forty people. Solanas reported in an interview that those forty people were mostly men who "were creeps. Masochists. Probably would love for me to spit on them. I wouldn't give them the pleasure" (Marmorstein 10).

It was not until June of 1968 that Solanas and her manifesto were propelled to fame and notoriety. If the name Valerie Solanas is known at all today, it is primarily because she attempted to kill Andy Warhol on June 3, 1968.[2] The source of her conflict with Warhol was her play, *Up Your Ass,* which Warhol promised to produce but never did—and, to make matters worse, he lost the script. When Solanas appeared that June day at the Factory, she pulled a .32 pistol out of her trench coat and shot Warhol three times, nearly, but not quite, killing him. Four hours after the shooting, Solanas gave herself up to a rookie cop in Times Square. When asked for a motive for the shooting during an impromptu press conference, she said: "I have a lot of very involved reasons. Read my manifesto and it will tell you what I am" (Smith 54). Solanas thus deferred an explanation for the shooting

to a reading of her manifesto, a document that performs a political identity. The performative aspect of the manifesto brings something into being that did not exist before: it constitutes a new political community through its enunciation of an imaginary group of women, SCUM.[3] It, in effect, creates the political actors by calling them into being, providing a script for action that is not based on a prior, stable identity.

Performance

The fictional identities of SCUM females are not specified, except for their episodic, multiple selves, who engage in resistance in whatever position they find themselves and whatever action comes to mind, insofar as it directly disrupts patriarchy and capitalism. Women who believe themselves to be "thrill-seeking" and "civic-minded" are called by the manifesto to demonstrate these qualities by performing in the public domain. Solanas's implicit suggestion, "I am what you read in my manifesto," evokes a politically performative identity that is multiple, dynamic, and citational. From this perspective, political performativity is constituted dramatically and non-referentially through reading the manifestic text; it does not exist *as such* outside the text. As represented in Solanas's text, SCUM females are "dominant, secure, self-confident, nasty, violent, selfish, independent, proud, thrill-seeking, free-wheeling, arrogant females, who consider themselves fit to rule the universe, who have free-wheeled to the limits of this 'society' and are ready to wheel on to something far beyond what it has to offer" (40–41). The emotive rhetoric of the polemical tract works to create a highly charged atmosphere of complicity between the speaker and her audience. The high-pitched polemic leaves no room for debate or qualified assent. The text demands solidarity: it preaches to the converted by assuming an unconditional acceptance of its exhaustive critical catalogue of male-dominated society even while pedagogically raising the consciousness of those who assent. The seeming spontaneity of the polemical utterance unabashedly asserts the correctness of its political position and assumes the pre-existence of SCUM females. But the paradoxical pose of spontaneity is calculated to do something with the words themselves: the text produces SCUM females.[4]

My reading of Solanas's manifesto counters her image as a "straightforward" feminist revolutionary who was antisex. Historians and commentators on the women's movement such as Alice Echols and B. Ruby Rich have connected the SCUM manifesto's antisex element to celibate radical feminist groups and, later, lesbian separatism and the Mary Daly–Andrea Dworkin sex-dread politics.[5] While the SCUM manifesto's influence on these groups is undeniable, tracing such a lineage emphasizes the cultural feminist outcomes rather than the radical potential of SCUM's performative politics.[6] What is lost in this reduction is the contingency of performative politics that constitutes its actors in a way that is radically different from identity politics in which the experience of oppression serves as the foundation for a political constituency. Solanas neither identified with a particular group nor was she, in practice, antisex. She sometimes claimed to be a lesbian; she had at other times worked as a prostitute, panhandled, and written pornography (Rich 18). SCUM's satiric cool comes in part from knowing the sex "scenes." SCUM females are "always funky, dirty, low-down" (32), but the fictional SCUM females bracket these personal idiosyncrasies so that they can mimic

63
■
The
"Sweet
Assassin"
and the
Performative
Politics
of SCUM
Manifesto

the disembodied, masculine universal, a mimicry that, at first, appears anti-sex. Solanas considered infeasible sexual politics, a politics based on sexual desire; she states, "Sex is the refuge of the mindless" (30), and she substituted relationships reminiscent of erotically charged Platonic friendships: "Love is not dependency or sex, but friendship. . . . Love can exist only between two secure, free-wheeling, independent, groovy female females, since friendship is based on respect, not contempt" (26). To this extent, she uncritically assumed a political position that leaves the body behind. This rhetorical stance serves two purposes. The first addresses the need for women to fight for control of their bodies and reproductive capacity. SCUM females are liberated from their bodies and their material condition as women by imagining themselves freed from biological constraints. By so doing, SCUM females are said to be no longer subjugated by men who mask their dependency on women by dominating them.[7] Second, the rhetoric reverses the roles between males and females and exaggerates them to make a controversial point. Men are imagined to be encumbered by their bodies and sexuality while women move effortlessly through public space. In Melissa Deem's apt phrase, SCUM females become "frictionless" (531). They confidently travel a "nomadic path" while the hyperembodied male encounters resistance: "He is a completely isolated unit, incapable of rapport with anyone" (Solanas 4).

The female body is not out of sight. In order to fight an all-out war with capitalism and patriarchy, the imagined SCUM females abandon, but do not hide, their experimentation in the sexual underworld. In this aspect, *SCUM Manifesto* differs from earlier feminist polemics that advocate chastity.[8] SCUM females enjoy a nomadic existence that includes excursions into the seamier side of the nightworld; they gain knowledge and experience in such places. Further, the sexed difference of SCUM females remains always in sight to underscore the polemical hostility of SCUM females towards the world run by men: they would "sink a shiv into a man's chest or ram an icepick up his asshole as soon as look at him" (31). They refuse even a spectator's passive view of male activities and instead substitute violent action. Sexual desire is transformed into an angry political desire, a desire for SCUM women to seize control of social, political, and economic structures, including sexuality, from men and redefine those structures in their own terms. As a polemical text, the manifesto scripts the SCUM female's rebellion in roles that maintain the sexed polarity of males versus females.

The rhetorical contradictions in *SCUM Manifesto* between "spontaneous" pose and calculated utterance and between the assertion of women's sexually knowledgeable bodies and celibate control of those bodies are symptomatic of the problems of representing collective fantasies of violence. Violence in language is by definition excessive: it cannot be contained within the semantic structure of language.[9] Further, it provokes a powerful antisocial response in its audience. Arthur Redding attests to the ambivalence such an uncontained response might provoke:

> Such a theory [of provoking unchecked antisocial response] underlies both the radical imagination that would insist on direct political action and the censorial imagination moved by the dread of mobs rioting. . . .

Were critique ever to become truly ruthless in its response, and aimed at everything that exists, as Marx wished, it would pass over into wide-scale demolition. Censorship itself confirms the idea that any audience may be mobilized into pandemonium. . . . "Violence" is understood to clarify and illuminate the compelling and manichean forces at work upon consciousness, forcing it to choose between the real urgencies of the moment. For even as violence inspires rebellion and breaks down hypothetical barriers to disorder, its unveiling manifests, too, a desire for rigorous and absolute clarity. (2–3)

65

■

The
"Sweet
Assassin"
and the
Performative
Politics
of SCUM
Manifesto

The desire for rebellious violence tempered by a desire for clarity and control is evident in *SCUM Manifesto*'s disdain for crowds: "SCUM is not a mob, a blob" (47). Instead, it prefers an elite guerrilla group. *SCUM Manifesto* paradoxically imagines an orderly, rational, uncontested, yet violent coup: "SCUM—always selfish, always cool—will always aim to avoid detection and punishment" (47).

Given this contradictory dilemma between violence and control, between seeming spontaneity and calculated theory, it is no wonder that other revolutionaries who proposed anarchist methods of social uprising, most notably Emma Goldman, turned to public performance as a means to stage and contain the very contradictions so impassably present in the violent imagination. Goldman writes: "the social significance of modern drama . . . is the dynamite which undermines superstition, shakes the social pillars, and prepares men and women for the reconstruction."[10] The rhetorical performance of *SCUM Manifesto,* as well as Solanas's theatrically staged, but nevertheless real, shooting of Andy Warhol, enact fantasies of political violence. The symbolic power of these fantasies generates a new form of political realism: what Goldman calls the "dynamite" or what Raymond Williams calls "structures of feeling" provides the semantic and rhetorical power to construct reality in a different way, to break from class norms and received meanings of the social world. Violence is transformed into symbolic power—what Pierre Bourdieu calls a "real transubstantiation of the relations of power" via performance:

> Symbolic power—as a power of constituting the given through utterances, of making people see and believe, of confirming or transforming the vision of the world and thereby, action on the world and thus the world itself, an almost magical power which enables one to obtain the equivalent of what is obtained through force (whether physical or economic), by virtue of the specific effect of mobilization—is a power that can be exercised only if it is *recognized,* that is, misrecognized as arbitrary. This means that symbolic power does not reside in "symbolic systems" in the form of an "illocutionary force" but that it is defined in and through a given relation between those who exercise power and those who submit to it, i.e. in the very structure of the field in which *belief* is produced and reproduced. What creates the power of words and slogans, a power capable of maintaining or subverting the social order, is the belief in the legitimacy of words and of those who utter them. And words alone cannot create this belief. (170; Bourdieu's italics)

This essay shows how both *SCUM Manifesto*'s rhetoric and Solanas's insurgent act of shooting Andy Warhol provide the performative force through which to shake meanings from their accustomed moorings and realign relations of power. Their performative force renders arbitrary and subject to change the institutional power to reproduce social meanings.[11] This emphasis on the performative staging of the assassination attempt by no means advocates murder as a revolutionary strategy. Rather, it suggests that as a feminist intervention into, among other things, the institution of art, Solanas's violent act, scripted by her manifesto, generates new social possibilities even while it exposes the limitations of violent rhetoric and action. But the unchecked violence of their beliefs must be mediated. The libidinous and chaotic range of these performative subjects become caught in the contradictions of fantasies of violence: the contradictory desires for pandemonium, on the one hand, and clarity and control, on the other. *SCUM Manifesto* paradoxically makes sexuality politically visible and insists on celibate control. Its ambivalence toward the deployment and containment of sexuality is a key indication of the power of sexuality in the political realm. Libidinal utopian energies are hesitantly deployed, creating what Redding calls "a tense and dissonant collective 'subject'" (9). This collective subject cannot be theorized adequately, stretched as it is between containment and violence, formation and dissolution, emotive spontaneity and calculated praxis.[12]

The Text

In what follows, I demonstrate how *SCUM Manifesto*'s performative strategies articulate a "tense and dissonant collective 'subject.'" To start, Solanas's performative politics breaks the category of "women" into various roles. SCUM is not dedicated to the betterment of women as a natural class. Solanas suggests, instead, that it will "steamroller" over those women who "surrendered long ago to the enemy" (48–49). Only SCUM females are imagined to rewrite their gender scripts in order to engage in political struggles. Solanas's political actors choose to be SCUM—adventurous, rebellious women who are politically engaged—or they can choose to be "Daddy's Girls"—women who consent to society as it currently operates. SCUM and Daddy's Girls identities are not fixed and permanent but rather offer roles for reimagining civil society based on a theatrical notion of performative political agency: "Why should the active and imaginative consult with the passive and dull on social policy?" (41–42). Political performativity articulates agency as an active and imaginative style, a move which repetitively recreates the self "unseriously" to undermine the everyday nature of hegemonic practices. This "style" is not a privatized "lifestyle politics," rather, it is public performances that are satiric, ironic and iconoclastic.[13] This strategy takes seriously the accumulated weight and materiality of authorizing language and reiterates its scripts—re-cites them—to expose their basis in performance.

This notion of a performative, satiric feminism has been critically repressed by histories of the women's movement which focus instead on identity politics surrounding feminist civil rights struggles.[14] The formation of Cell 16 will serve to demonstrate this repression. Roxanne Dunbar, a Mexico-based revolutionary, canceled her move to Cuba after reading the news report of the Warhol shooting; she returned to the United States con-

vinced that a women's revolution had begun (Rich 18). Shortly after the assassination attempt, Dunbar formed a Boston-based women's group called Cell 16. Other segments of the women's movement considered those in Cell 16 the "movement heavies" (Echols, *Daring* 158). The group read SCUM as their first order of business and, from their interpretation of the manifesto, followed a strict program of celibacy, separatism, and karate. No negotiation was allowed. Women could join only if they agreed in advance with the group's beliefs. Cell 16's antisex policy was based on rejecting the patriarchal institution of sex and keeping all energies and attentions focused on the polit-ical realm. Similarly, Ti-Grace Atkinson, then president of the New York chap-ter of the National Organization of Women (NOW), declared that Solanas would go down in history as the "first outstanding champion of women's rights" (Rich 18). A few months after Cell 16 began, Atkinson formed a sim-ilar antisex political group called The Feminists.

67

■

The
"Sweet
Assassin"
and the
Performative
Politics
of SCUM
Manifesto

The antisex element of SCUM's cool, controlled militant vanguardism is largely responsible for this development. Steven Siedman describes antisex lesbian feminism as "repudiating . . . lesbianism as a type of sexual desire or orientation. [Lesbian feminists] interpreted lesbianism as a personal, social, and political commitment to bond with women" (112). He cites the radicales-bians' classic manifesto "Woman-Identified Woman" as the founding of les-bian feminism and the beginning of cultural feminism. The precursor to that manifesto is *SCUM Manifesto,* which is omitted from Siedman's history. This is a strange omission, given that he urges a shift away from the preoccupation with self and representations characteristic of identity politics to an analysis that embeds the self in institutional and cultural practices (137). *SCUM Mani-festo* is key to rethinking political activism as based on gender but not predi-cated on fixed identities. SCUM females can choose to be SCUM or Daddy's Girls; each are definitions based on political engagement, not sexual object choice. Sexuality must be put aside in order to be rational and objec-tive—controlled and contained—-enough to seize symbolic power to speak and act in the public domain. Solanas repudiates sex as "a gross waste of time" because SCUM females need to be "completely cool and cerebral and free to pursue truly worthy relationships and activities" (30). Prior to this cerebral abstraction, SCUM's sexualized women are imagined in sites of public visibility and urban settings. Their working class language and pres-ence comments on and breaches middle class decorum. As outsiders, SCUM females assume the role of the female picara:

> Unhampered by propriety, niceness, discretion, public opinion, "morals," the "respect" of assholes, always funky, dirty, low-down, SCUM gets around . . . and around and around. . . . they've seen the whole show— every bit of it—the fucking scene, the sucking scene, the dick scene, the dyke scene—they've covered the whole waterfront, been under every dock and pier—the peter pier, the pussy pier . . . you've got to go through a lot of sex to get to anti-sex, and SCUM's been through it all and they're now ready for a new show; they want to crawl out from under the dock, move, take off, sink out. (31–32; Solanas's ellipses)

This is the same manifesto credited with beginning the antipornography movement. Given so many "scenes," Solanas sounds like an advocate of the

gay liberation movement's ideal of polymorphous androgyny (Siedman 129). When groups read the manifesto as advocating celibacy, they map the manifesto onto an identity politics in which people only occupy one position and hold it without contradiction. Performative politics concerns the process and contradictions of role-playing. As such, SCUM females are constituted through the uneven positions of performative political engagement.

That uneven political position has more in common with Queer Nation and current lesbian political theory than it does with straightforward identity-based politics. Lauren Berlant and Elizabeth Freeman describe how Queer Nation "dismantle[s] the standardizing apparatus that organizes all manner of sexual practice into 'facts' about sexual *identity,* as . . . it mobilizes a radically wide range of knowledge—modes of understanding from science to gossip—to reconstitute information about 'queerness'" (196; Berlant and Freeman's italics). Similarly, "funky, dirty, low-down" SCUM females are moving, knowing, becoming bodies. They travel the streets and the scenes gathering information and generating conflict. They demand public presence despite apparent contradictions in their theories and analysis.

SCUM Manifesto articulates an important shift in social style and consciousness centered around a reworking of the status quo. In contrast, the way in which histories of the women's movement reduce *SCUM Manifesto* into codes of behavior and praxis cuts short some of the manifesto's most suggestive possibilities of performative politics. Performance keeps open revolutionary change as a process by repeatedly, but not identically, disrupting everyday life. In the *SCUM Manifesto,* the disruption occurs by parodying positions of power to reveal their performative—contingent—basis. To this end, men in the *SCUM Manifesto* are shown to be far more performative than women; and what is worse, they are really bad actors. If life is theater, Solanas suggests that SCUM females can put on a better show, all they have to do is act up. SCUM females are "civic-minded, responsible and thrill-seeking." While the first two terms "civic-minded" and "responsible" claim an engaged, public political agency for women, the last term, "thrill-seeking," suggests that those political actions should be over-the-top: risky, creative, and controversial in order to counter the disaffection and isolation experienced in an irrelevant, boring society. The manifesto's language is sarcastic, street-smart and relativizing even as the rhetoric polemically urges the complete overthrow of heterosexual capitalism. The terms of analysis—"culture," "society," "experts," "higher" education, "Great Art"—are in quotation marks to suggest that those terms can be resignified and improved if only women could define them. The quotations parody naturalized meanings of the signifiers and signal that what passes for universal ideas of culture, society, and so forth is relative to the particular group (white, propertied men) that defines them. Therefore, the terms are subject to redefinition. Resignification must be repeatedly performed to dislodge sedimented meanings from their naturalized contexts.

The performative tension between utopian possibilities of radical resignification and historical constraints on meaning is evident in *SCUM Manifesto.* Take its name, for example: the term "SCUM" shifts from signifying the rejects of society to naming a vanguard class, but can "SCUM" really come to mean hip revolutionaries who will save the world? The SCUM manifesto parodies the performance of patriarchal social order it refuses. It claims a uni-

versal authority to run the world based on a seamless "we" of SCUM women, but by the appropriation of universalizing discourse, the manifesto reveals how the universal is not universal at all. Solanas's imagined group of vanguard feminist revolutionaries proclaim their takeover of the world. These particular women, who are only a subset of all women, mock the "serious" way in which certain men actually do run the world. Those men naturalize their universal authority through the guise of a purportedly democratic access to such power within the public sphere. In principle, the bourgeois public sphere offers a utopian universality where individuals' embodied specificities (backgrounds, status, gender) are bracketed so that all citizens may participate equally and objectively, but in practice, only white, male, literate and propertied citizens can transcend their bodies and status by representing themselves as abstract, objective and universal. Their power and performance are naturalized and unmarked while women as well as people of color are marked as particular, embodied, and partial subjects which preclude them from full political participation. In contrast, SCUM's use of the universal is strategic. The manifesto plays on the productive dissonance between particular and universal discourse, a strategy similar to how Linda Zerilli interprets Monique Wittig's utopian fiction: [15]

69

■

The
"Sweet
Assassin"
and the
Performative
Politics
of SCUM
Manifesto

> Wittig does not create the possibility of universalism for women by getting rid of men with a stroke of the feminist pen; instead she deconstructs the terms of heterosexual discourse, male and female, men and women, by deploying the universal to reveal the lie that gender speaks in the name of universalism and the lie that the universal speaks in the name of gender. (150)

Solanas universalizes women by imagining a world run by women, but her manifesto is an illicit performance, a mockery of the "serious" speech acts of patriarchy. In effect, the *SCUM Manifesto* exposes the particular and contingent foundations of established sites of authority while never attempting to hide its own imagined replacement as yet another particular and contingent group: a vanguard of revolutionary women. The *SCUM Manifesto* figures the violent technologies by which these women will assume power. The fictional SCUM females are openly selfish; instead of offering the pretense of universal access, they dismissively and violently reveal their contempt for men. Solanas states that men can "go off to the nearest friendly neighborhood suicide center where they will be quietly, quickly and painlessly gassed to death" (51), a rather shocking deployment of genocidal political practices. Further, rational men "want to be squashed, stepped on, crushed and crunched, treated as the curs, the filth that they are, have their repulsiveness confirmed" (51). The particular and universal dissonance resounds as Solanas imagines that women openly declare war on other particular subjects—men—in the name of the universal. The declaration of war parodies masculine politics in order to challenge its authority, but the delegitimation of authority is hard to achieve because authorizing power reinforces itself. Solanas states this fact succinctly:

> We know that "Great Art" is great because male authorities have told us so, and we can't claim otherwise, as only those with exquisite sensitivities

far superior to ours can perceive and appreciate the greatness, the proof of their superior sensitivity being that they appreciate the slop that they appreciate. (28)

The mutually constitutive nature of power means that it is hard to dislodge and often provokes violent measures from groups outside the closed circuit of reinforcing knowledge and power.

Given this real equation of power, Solanas's attempt to resignify "scum" in her manifesto must take into account its previous use by dominant discourses. This necessity is made clear by Judith Butler's similar analysis of the recontextualization of the term "queer." The derogatory and exclusionary force of the term "queer" to punish those who refuse compulsory heterosexuality has been appropriated and revalued by queer activists and writers. Butler cautions against a belief in an easy possibility of resignification: "Neither power nor discourse are rendered anew at every moment; they are not as weightless as the utopics of radical resignification might imply. And yet how are we to understand their convergent force as an accumulated effect of usage that both constrains and enables their reworking?" (224). The accumulated force of meaning are repetitions of previously successful utterances. Speech acts produce effects because they echo the successful conventions of previous authoritative utterances within a similar context. Thus, when a groom says, "I do [take this woman to be my lawfully wedded wife]," that speech act successfully performs the legally binding action of marriage. The force of its authority comes from its repetition of countless other marriage ceremonies, the long tradition of which grants the statement continued power and significance. Matrimony's configuration within authorizing institutions of religion, the legal system, and capitalism also adds to its force. Butler suggests, however, that while the reiterative nature of authorized speech acts reinforce prevailing structures of power, the space for agency occurs within those non-identical repetitions, enabling a change in authorizing practices. Likewise, for Solanas's imaginary SCUM females, it is precisely the force of the accusation "you scum" directed at groups of people deemed to be vile and worthless that enables such outsiders to resignify scum as "SCUM." As Mikhail Bahktin reminds us, in revolutionary situations, common words take on opposite meanings.[16] Two audiences become diametrically opposed over the meaning and legitimacy of the word "scum." Further, unlike "queer" subjects who can be either male or female, SCUM maintains the sexed difference of the female body. SCUM females are doubly outsiders due to their "scum" and female designations; as such, they are well positioned to challenge authorizing patriarchal practices by acting as (parodying) those authorized insiders.

Indeed, as Andrew Parker and Eve Kosofsky Sedgwick show, since J. L. Austin first categorized speech acts in 1961, the "serious" performative utterance has always been in danger of infection by "parasitic" usage: "What, to our knowledge, has been underappreciated . . . is the nature of the perversion which, for Austin, needs to be expelled as it threatens to blur the difference between theater and the world" (4). Sedgwick and Parker call attention to how illegitimate performances are devalued because they are not "serious." Those performances make evident their "parasitic" use of authorizing scripts because they are uttered outside of conventional contexts. The con-

text in which the "scum" and "queer" subjects repeat authorizing scripts is illegitimate. Therefore, the performance becomes perverted, artificial, diseased, and theatrical. The prevalence of reiterations by "scum" and "queers" exposes what Austin calls "ordinary circumstances" of authorized speech acts as equally "hollow" performances (22). For example, the solemnity and seriousness of the marriage ceremony—as the gender-norm script par excellence—has long been a target for mock appropriations through parodic performances. By means of a wide variety of contexts and creative rewritings, the act of marriage has become relatively denaturalized as a locus of transparent authority and intentionality. The new wedding packages offered at amusement parks like Walt Disney World ("Design your own Disney fantasy wedding") are one example in which fantasy and reality are glaringly juxtaposed. The "serious," "real" event begins to look more like "theater." As we shall see, Solanas's serious, and very real, assassination attempt likewise takes on a theatrical appearance.

The Event

The symbolic transformation by which superfluous, illegitimate actors effect a take-over of legitimate activity takes place through the event. The event helps break the boundaries between theater and the world or between art (aesthetic, imaginative representation) and life (pragmatic representation). The artistic "event" has a long history within the avant-garde whose project is to link art with politics in order to alter consciousness and effect historical change.[17] The artist must anticipate that the event's reception will be favorable to the type of social change she seeks. To this end, Solanas's manifesto provided a script—an imaginative representation—with which to interpret the shooting. She tells her audience to "cite" the manifesto as an explanation for the shooting. But, conversely, the event generated a news-worthy stage from which to gain visibility and legitimacy to encourage citing the "script" at all. The event's theatrical framing and the written script work in tandem. The event serves as an instrument or vehicle by which the script might be launched. Once launched through event, however, the script circulates beyond the control of its author. Though the SCUM Manifesto originates in a particular context, it is not confined there. The shifting horizons of reception, both spatial and temporal (texts are read at various times and locations) allow the manifesto to have many unanticipated effects. For instance, Solanas was outraged that her manifesto was appropriated by the women's movement.

Equally unanticipated, the event of the Warhol shooting was interpreted in many contradictory ways: the Warhol celebrity circle read the shooting as an act of lunacy by a deranged, obsessional superstar wanna be. They, along with the media, cited Solanas's man-hating manifesto as evidence of her insanity.[18] For the burgeoning feminist movement, however, the shooting represented the feminist movement's righteous rage against patriarchy. As we have seen, the act served as evidence for women activists such as Roxanne Dunbar and Ti-Grace Atkinson that the SCUM Manifesto had called a revolutionary movement into being. The shooting provided an impetus for women to share the responsibility and publicity of the event. Women organized in support of Solanas. In Greenwich Village, they distributed a broadside announcing "PLASTIC MAN VS. THE SWEET ASSASSIN . . .

NON-MAN SHOT BY THE REALITY OF HIS DREAM . . . A TOUGH CHICK WITH A BOP CAP AND A .38 . . . VALERIE IS OURS" (*Newsweek* June 17, 1968, 86). Solanas's crime can also be read as an artistic "event." Indeed, the Up-Against-the-Wall Motherfuckers Collective declared Solanas's act "the true vengeance of Dada" (Rich 18). The Greenwich Village feminists' slogan, "Non-man shot by the reality of his dream," suggests too that the "thrill-seeking" excess of radical acts injects an avant-garde "elsewhere" into the pragmatic field of political organizing.

Just as dreams represent the avant-garde "elsewhere" of the otherwise unknowable unconscious, the "elsewhere" in *SCUM Manifesto* is heretofore an unrepresented standpoint of women's sexed difference. The creative energy of this "elsewhere" is directed toward rewriting cultural narratives.[19] Solanas's "elsewhere" occurs when women reappropriate the gendered characteristics that men have claimed for themselves. While for Solanas, gendered characteristics are culturally constructed and open to reappropriation, she maintains "the sexed difference of female subjects." Thus, she holds onto "woman" while transforming femininity.[20] According to Solanas, men have stolen from women: "Emotional strength and independence, forcefulness, dynamism, decisiveness, coolness, objectivity, assertiveness, courage, integrity, vitality, intensity, depth of character, grooviness," and, in return, men have given them: "vanity, frivolity, triviality, weakness" (6). The evidence that men have taken what does not belong to them—vitality, intensity, depth of character—comes from Solanas's observation that men do not perform those qualities convincingly:

> Having a crudely constructed nervous system that is easily upset by the least display of emotion or feeling, the male tries to enforce a "social" code that ensures perfect blandness, unsullied by the slightest trace of feeling or upsetting opinion. He uses terms like "copulate," "sexual congress,". . . overlaid with stilted manners; the suit on the chimp. (7–8)

Rather than relying on women's shared experience of oppression, which forms the basis for identity politics, Solanas's "elsewhere" comes from the reappropriation of the roles and attributes men have unrightfully exchanged with women. According to Solanas, when SCUM females imaginatively map "male" characteristics onto their own sexed bodies, they find the "elsewhere" of feminine reciprocity by affirming their intense, emotionally transcendent selves. Women can assert their "grooviness," defined as a coming together in an intensely pleasurable way, providing an "elsewhere" of joyful, collective transformation.

In order to reappropriate their disinherited qualities, Solanas resorts to crime as a violent response to patriarchal violence. She strips the chimp of his suit by attempting to kill him. In that act, she assumes his most visible sign of power, the gun, while simultaneously asserting her sexed difference as a woman. For the shooting, Solanas wore makeup as well as a "secret agent" khaki trench coat on a hot June day. She left on Warhol's desk a mysterious paper bag, which contained another gun, a sanitary pad, and her address book (Warhol and Hackett, 279). She used props to stage the assassination: the phallic gun, the sanitary pad's suggestion of castration, and the self-incriminating address book. The contradictory props break down a coherent

representation of the act, interrogating the "scenography," in Irigaray's terms, that makes representation feasible (75). Solanas refused to disavow the incoherent unsettling of rebellious femininity: a rebellion that asserts itself at the site of masculine aggressiveness. The added signs of femininity helped stage a feminist revolutionary event while the revolution itself was foreclosed: Solanas surrendered four hours later. Her violent act was voluntarily contained but only after performing a revolutionary act that recontextualized masculine symbolic power. The "elsewhere" of women's emergent possibilities is attained by stripping the suit off the "chimp," putting it on herself, and accessorizing with feminine particularities.

73
■

The
"Sweet
Assassin"
and the
Performative
Politics
of SCUM
Manifesto

Just as Solanas contained her violent action by surrendering, the manifesto also contains the violence it envisions through its formal constraints. The manifesto form recontains violence through its paradoxical formula of violent threat/static word.[21] Solanas plays on both the utopian promise of a SCUM takeover and on its own impossibility given its containment by the firmly established sites of power—including the generic form—that it seeks to overthrow. The manifesto form confines violent fantasies into an easily recognized sign of dissent, a form that has been used mostly in political power struggles between men. Janet Lyon remarks, "[SCUM Manifesto] advertises at every moment its negotiations of a traditionally masculinist form" (106). The manifesto has three basic functions. First, it articulates a break from the past and the social status quo, usually achieved through a critique of the present social, political, and aesthetic situation. Second, it announces the emergence of a group who imaginatively gives force to the articulation of dissent. Finally, it channels dissent by formulating a program for change and a vision of the future. SCUM Manifesto, even from the opening sentence, reproduces this formula exactly. The bulk of the fifty-page pamphlet, however, concerns itself with the first element: critiquing the status quo. It itemizes and analyzes what men are responsible for: wars, politeness, marriage, prostitution, money, work, motherhood, mental illness, conformity, the invasion of privacy, the suburbs, authority, the government, religion, prejudice, competition, "Great Art," and "culture," philosophy, censorship, boredom, prevention of conversation, ugliness, hate, violence, disease and death. In the satiric tradition of Jonathan Swift's "A Modest Proposal," Solanas proposes that all these problems will be eliminated if women took over. The heterogeneous, serialized lexography of what men have produced are reduced to "scum," the refuse and grotesque, even scatological, tropes of dominant culture. But if all are scum, how can revolution occur? The dependence on men's world and its forms both precipitates crisis—the rebellion of women who hope to save the world before it is too late—and evacuate "straightforward" revolutionary intent.

If the shooting was Solanas's "straightforward" revolutionary gesture, she parodied its masculine form by means of makeup and a sanitary pad. The crime should have made her an outlaw and forced her to go underground, but that possibility was quickly dissolved when she turned herself in. Unlike serious underground revolutionaries, she attracted media attention which she used to her advantage. Solanas hyperbolically claimed access to the public sphere, appropriating and parodying it at the same time. The manifesto and shooting made her publicly visible, but her demands for publicity quickly escalated. While Solanas was released on bail following the Andy

Warhol shooting, she called Warhol demanding that he should drop all criminal charges, pay her twenty thousand dollars for all the manuscripts she'd ever written, publish her manifesto in the New York *Daily News,* put her in more movies, and book her on the Johnny Carson show.[22] Clearly, Solanas knew how to take up public space. She pushed to theatrical, parodic proportions the publicity mania that dominates American politics and culture. Her demands for publicity transgressed selective media decisions that authorize who and what gets said in public. Before the shooting, producers of the Alan Burke Television Show kicked her off the show within fifteen minutes of taping for "talking dirty," preventing her from explaining to the public how and why SCUM will eliminate the male sex.[23]

The publishing industry also shapes and frames what it allows to enter the public domain. After her manifesto had been published by Olympia Press in 1970, Solanas went to the New York Public Library and checked out its copy of her manifesto. She returned to her text to counter and control its shift in interpretive context: from a mimeographed pamphlet handed out personally in the streets of Greenwich Village to a library volume whose jacket copy makes the sweeping claim: "No one should presume to discuss what is happening to American society today, who has not yet read SCUM MANIFESTO."[24] Solanas defaced the marketable framing of her manifesto by her publisher. She was angry with Maurice Girodias for "cutting up" SCUM by putting periods after each letter in the acronym, S.C.U.M. She scribbled out her name on the cover and wrote in the publisher's name as the author, claiming that "This is not the title." On the inside cover, she promised to write another book called *Valerie Solanas* in which she will tell how she was manipulated and sabotaged by her publishing company: it will be her version of the events.[25] Solanas was most disturbed by the back cover advertisement which reminds browsing readers of the shocking Warhol shooting: "Then we were horrified when she shot Andy Warhol in 1968, just to make a point, to wit, that man's world is corrupt beyond redemption and must be physically defeated, captured and colonized by women if it is to be saved from self-destruction." Solanas vigorously blacked out the phrase "just to make a point" and remarked, "lie." The rest of the paragraph was scribbled over in rebuttal to the literalizing, transparently intentional equation between the imaginative representation of the manifesto and the shooting. She also attacked the marketing promotion for the introduction written by Vivian Gornick. The jacket reads, "A new preface by Vivian Gornick serves as a brilliant commentary and introduction to this new edition—and adds to it the point of view of today's Women's Liberation militants." Solanas attached the appellation "flea" after Gornick's name, crossed out "brilliant" and replaced it with "would-be," and scribbled out "the point of view of today's Women's Liberation militants," substituting it with "a flea." Those fleas were riding all over her back, she claimed. Significantly, her own text was left intact though she accused the copy editor of sabotaging her words with "typos." Solanas made clear that her text was altered by contexts she did not control. In particular, she fought against the reduction of her words and actions to an authentic, foundational "Women's Lib" gesture.

The manifesto's performative utterance seizes symbolic power from the dominant class by rendering its institutional power arbitrary. It subverts dominant meanings by positing an ideal vantage of a world run by women

from which to satirize the world run by men. From this vantage, the manifesto's biting satire, humor, and polysemy reduced to "just to make a point" seems, indeed, to miss the point. Rather, the point is more like grapeshot that explodes after a delayed impact. Monique Wittig writes that the point for a writer attuned to the materiality of language is to create a "war machine":

> To carry out a literary work one must be modest and know that being gay or anything else is not enough. . . . The universalization of each point of view demands a particular attention to the formal elements that can be open to history. . . . It is the attempted universalization of the point of view that turns or does not turn a literary work into a war machine. (75)

Wittig's image of a war machine is the Trojan Horse, a metaphor for how the reformulation of language destroys the naturalness of the contexts that produce meaning. *SCUM Manifesto* universalizes its attention to "formal elements," primarily the gendered structure of meaning that organizes knowledge. It demands change by seizing symbolic power in order to rearrange gendered structures of meaning. The language form (the horse) is a war machine that "will sap and blast out the ground where it was planted" (69), destroying foundational categories of meaning and redeploying symbolic power. Solanas's intervention in the published ground in which her manifesto is buried, covered as it is by a market-oriented book jacket, draws attention to the manifesto's larger project of "blasting" forms of meaning.

Technology

The manifesto as a war machine is an apt metaphor for its technological assault on meaning. Solanas uses technology to overcome the limits of the female body, the materiality of which often provides an essential ground of undisputed meaning.[26] She employs the radical Marxist-feminist tenet that holds that women, as an oppressed class, must seize the means of reproduction.[27] Like Shulamith Firestone, Solanas imagined that technological progress put to socially just and progressive use would allow workers to be liberated from the alienation inherent in capitalist labor. Radical Marxist-feminists held that production and reproduction imperatives prevent women from revealing their unique creative natures. But unlike the careful analysis and dialectic posed by Firestone, in which male and female relations are ultimately merged into an androgynous harmony, Solanas announces that men are superfluous: "We now have sperm banks" (16).[28] For Solanas, the polarity of sexed differences is not overcome; rather, the assertion of their sexed difference produces women's anger and political desire for radical change. Further, technology allows an escape from the constraints of biology; the reproductive female body is no longer a problem because automation will liberate women from their sexed bodies without deconstructing them. While Judith Butler asks "How precisely are we to understand the ritualized repetition by which [gender] norms produce and stabilize not only the effects of gender but the materiality of sex?" (x), Solanas deconstructs gender norms but does not destabilize sexed bodies. Instead, she substitutes technological innovations for the productive and reproductive functions of sexed bodies.

The ground for reconfiguring the meaning of gender is cleared immediately after *SCUM Manifesto*'s opening statement. It takes the categories of "male" and "female" and renders each a mimed, parodic signifier by invoking the liberatory potential of science and technology. In fact, writes Solanas, "the problems of aging and death could be solved within a few years, if an all-out, massive scientific assault were made on the problem" (35). The utopian power of technology can literally create heaven on earth—"it is possible, therefore, never to age and to live forever" (35)—if only technology were not in the hands of men. But even as Solanas imagines technology helping to build utopia, she appropriates and mocks scientific discourse. She begins with biology, a foundational site for solidifying gender differences based on "facts" about sexed bodies:

> It is now technically possible to reproduce without the aid of males (or, for that matter, females) and to produce only females. We must begin immediately to do so. The male is a biological accident: the y (male) gene is an incomplete x (female) gene, that is, has an incomplete set of chromosomes. In other words, the male is an incomplete female, a walking abortion, aborted at the gene stage. To be male is to be deficient, emotionally limited; maleness is a deficiency disease and males are emotional cripples. (3–4)

Solanas employs the language of sexology, the biological science of the study of sexual behavior. She parodies the sober, scientific ground it claims by giving first a mini-scientific lecture about genes, chromosomes and the perfectibility of science. Then, she translates those two sentences—"in other words"—into insults: the male is "a walking abortion," "a deficiency disease," "an emotional cripple." The insults posit males as "incomplete females"; this rhetorical twist inverts sexological theories. In the *Psychology of Sex,* Havelock Ellis begins with the sex-chromosomes XX and XY, but "the female . . . represents the neutral form which the soma assumes in the absence of the male sex hormone" (227). Women are defined by their lack of male sex hormones, and sex hormones exist to ensure reproduction of the species. In contrast, Solanas posits the female sex as the complete sex and the male sex as the incomplete sex; reproduction is automated so it becomes irrelevant to SCUM.

While this interpretation challenges standard sexological views, the renegade insults and urgent calls for immediate change underscore SCUM's illegitimacy. Solanas parodies sexological discourse in order to expose its position within a network of authorizing institutions. Sexology designates normal and abnormal sexual behavior; the weight of its scientific authority enforces those categories. Sexological discourse acts as a performative utterance insofar as it effects other institutional authorizations: psychological treatments, social attitudes, and the legal and civil rights of those who engage in "abnormal" sexual practices. The authoritative power of sexological discourse assumes a receptive audience, that the audience agrees with and consents to the institutional power that authorizes and enforces performative statements. In contrast, Solanas's performative utterance presupposes an audience with an oppositional relation to authority. By challenging sexological definitions of gender and reproduction, Solanas breaks up the notion of

an audience in agreement about what "male" and "female" means. She creates an oppositional audience which expands the possibilities of dissent. Though her rhetoric attempts to invert gendered categories, it also parodies the authorizing language which gives meaning to those categories. The parody of authority invites competing claims for legitimation or censure which, in turn, opens the horizon of reception to a vastly widened scope of semantic possibilities.

SCUM Manifesto breaks up precipitated forms—"male," "female," sexuality as reproduction—and suggests a range of receptions with new semantic possibilities. The breakup of forms occurs as the manifesto's language implodes, setting "male" and "female" loose and available for new social meanings. Take this implosion for example: "The fag, who accepts his maleness, that is, his passivity and total sexuality, his femininity, is also best served by women being truly female, as it would then be easier for him to be male, feminine" (37). "Fag" has a complicated position in Solanas's critique. Fags exemplify those traits most despised by Solanas, "passivity," "sexuality" and "femininity." However, fags are the best types of men because they refrain from masquerading as "men" who, according to Solanas, project their femininity onto women, nor do they bother women. Their "maleness" signifies "femininity" or sometimes "female." While Solanas finds fags, and especially drag queens, admirable in their lack of conformity to masculine codes of behavior, for her, they end up reproducing and reinforcing "man-made feminine stereotypes, ending up as nothing but a bundle of stilted mannerisms" (20). Here, an objectionable homophobia intrudes into her text. Fags enable Solanas to expose men as sexual, passive subjects who want to be women. Solanas conflates biological sex characteristics, "male" and "female," with their cultural meanings, "masculine" and "feminine." Sex and role slip together. These distinctions were not clearly established in 1967, but the confusion is deliberate. Rather than simply defining what she means, male equals femininity, Solanas repeatedly juxtaposes male with femininity, passivity, sexuality. Likewise, women who are "male females" turn out to be the opposite of what one might expect; they signify Daddy's Girls. SCUM women are "female females" a similar semantic formation to what Luce Irigaray calls the "disruptive excess" of femininity (78). Women are not just different based on masculine constructions of difference: those constructions merely reflect back and reinforce patriarchal positions of power. Rather, women have to inject their "elsewhere" of matter and style which present the sort of femininity disavowed and contained by men: aggressive women who take up lots of public space and mock patriarchy. The catachrisis—female females who engage in guerrilla warfare—creates constant double takes and demands a rethinking of what "male" and "female" mean. The semantic dissonance one experiences when reading "maleness, his passivity and total sexuality, his femininity" implodes any naturalized meaning of those terms.

Further, biology and social construction of sex roles are intertwined; predisposition and experience at first seem indissolubly linked. Usually, women's biology provides cultural constraints to limit women's roles in society, but Solanas uses biology as a weapon for attacking men. She claims that male scientists shy away from biological research because they are terrified of the discovery that males are females. This "lie" keeps women from positions of public power: "The male has one glaring area of superiority over the

77
■
The
"Sweet
Assassin"
and the
Performative
Politics
of SCUM
Manifesto

female—public relations. He has done a brilliant job of convincing millions of women that men are women and women are men" (6). Here, Solanas means the unrightful exchange of gender norms between men and women, not their sexed bodies. She uses as much public space as possible to convince women otherwise. Her parody of sexology is just the first step for women to reconfigure social meanings. The second step is to engage publicly in a politics of resistance.

Solanas announces in her manifesto that SCUM females will take over all aspects of society by systematically fucking up the system, selectively destroying property, and murder. SCUM women will get jobs of various kinds and unwork. SCUM salesgirls will not charge for merchandise, bus tokens, or telephone calls. They will destroy "Great Art," storefront windows and cars. They will kill all men not in the Men's Auxiliary of SCUM: those men conduct "Turd Sessions," the inverse of "Consciousness Raising Sessions," at which every male present will give a speech beginning with the sentence: "I am a turd, a lowly, abject turd," and then proceed to list all the ways in which this is so (43–44). Further, Solanas deploys the media to mobilize feminist consciousness and effect historical change: "Eventually SCUM will take over the airwaves—radio and T.V. networks—by forcibly relieving of their jobs all radio and T.V. employees who would impede SCUM's entry into the broadcasting studios" (42). If mass-media is a national theater where "serious" real-life drama occurs, SCUM will invade with campy performances. Heterosexual normativity becomes a crime. For instance, SCUM will "couple-bust—barge into mixed (male-female) couples, wherever they are, and bust them up" (43). Solanas's imagined SCUM females will occupy public spaces and "unwork." They will take over the means of production and un-produce, thereby rendering themselves parodic, parasitic, and artificial. The key aspect of SCUM is engagement: "Dropping out is not the answer; fucking-up is. Most women are already dropped out; they were never in. Dropping out gives control to those few who don't drop out; dropping out is exactly what establishment leaders want; it plays into the hands of the enemy" (46). Given Solanas's demand that SCUM females must be engaged in mainstream society, capitalist enterprises, and daily life, it is curious that *SCUM Manifesto* was also influential in the spread of "womansculture" and lesbian separatism.

SCUM Manifesto makes more contradictory demands than just the messy pandemonium of violent action tempered by the clarity and control of celibacy and separatism. First, it calls for reproductive technologies to produce only females. Later, it asks, "Why produce even females? Why should there be future generations? . . . When aging and death are eliminated, why continue to reproduce? Even if they are not eliminated, why reproduce? Why should we care what happens when we are dead?" (39). The upshot of these speculations is complete attention to the present, in all its contradictions, and a politics of engagement that does not depend on the sanctity of one's identity or brilliant master plan for political action. But, conversely, its political stance eludes coherent conceptualization. The tense, libidinous and dissenting collective subject cannot be represented adequately.

SCUM's political landscape figures engagement as a series of contamination zones, urban sites where "low-down" knowledge and experience are

gained and then reinjected into the mainstream public to unsettle and challenge dominant discourses. Solanas advocates the necessity to be both inside and outside mainstream culture and sexual practices. Her call to "sink out" is an ambiguous construction, one that does not create hierarchies but rather suggests that both the docks and piers, both the dicks and the dykes, are as important to political practice as is donning an antisex, objective, tough, and cerebral stance against the dominant structures of power. Temporalities are synchronous: sex and antisex are equally important. This mobile position allows Solanas both to invoke a revolutionary crisis in the name of women (a minority position) and to ironize and control that crisis from within mainstream society (a universal position) by situating the tools of revolution: science, technology, the manifesto, the media, even the concept of revolution, squarely within masculine forms of oppression. The result is a contradictory deployment of violent revolution and careful containment of agency.

79
■
The
"Sweet
Assassin"
and the
Performative
Politics
of SCUM
Manifesto

Structures of Feeling

Within the controlling confines the manifesto allows, the polemical utterance can "shake[] the social pillars." *SCUM Manifesto* demands that all present aspects of society change immediately. To create such urgency, Solanas uses men to personalize a complex society and provide easy targets for consolidating anger. She gives:

> A few examples of the most obnoxious or harmful types. . . : rapists, politicians; . . . lousy singers and musicians; Chairmen of Boards; Breadwinners; landlords; owners of greasy spoons and restaurants that play Musak; "Great Artists"; cheap pikers; cops; tycoons; . . . liars and phonies; disc jockeys; . . . real estate men; stock brokers; men who speak when they have nothing to say; men who loiter idly in the street and mar the landscape with their presence; etc. (45)

Dissatisfaction with the social status quo is generated through this satire of men. The humor and anger of satire invites women to produce this feminist script by taking on the roles of the politically performative SCUM females. The polemical outrageousness of the manifesto combined with a utopian belief in a better world run by women makes available new social meanings that are not fully formed, what Raymond Williams calls "social experience *in solution*" (133). The affective and generative tension of the manifesto helps stir up and reformat social structures to align more readily with lived, daily consciousness. The tension felt by women in a sex-segregated society allows Solanas to articulate an emergent structure of feeling of which the feminist movement was part. The manifesto participated in a larger social movement which gave rise to a reconfiguration of class, race and gender norms. Solanas cuts up hardened social forms to generate a space riven with contradictions and discontinuities which allows reception to gain its own momentum and to give rise to unanticipated results. The space of reception cannot be said to be predictable, formulaic, or uniform. *SCUM Manifesto* did not simply result in one failed assassination and lesbian separatism. It participated in the political, social, and cultural shift known as the sixties.

Notes

Thanks to my friends and mentors at the University of Notre Dame, especially Gloria-Jean Masciarotte, Joseph Buttigieg, Barbara Green, Glenn Hendler, and Christine Doran, and to those at the Wesleyan University Center for the Humanities—Jennifer Burwell, Margaret McLaren and Elizabeth Traube—for their comments, suggestions, and enthusiasm. Thanks also to the American Academy of University Women for their generous support of this project.

1. Alice Echols makes this claim ("New Feminism" 440) and in wider, more detailed scope (*Daring*, 43–50).

2. Indeed, Solanas's notoriety appears to be on the rise. Mary Harron's new movie, *I Shot Andy Warhol*, won rave reviews at the Sundance Film Festival and enjoyed a good run across the country in the spring and summer of 1996. Two other films about the Warhol circle have been, or are, in production: Julian Schnabel's *Basquiate* and Michael Zoumas's *A Low Life in High Heels*, and possibly two others, an adaptation of George Plimpton and Jean Stein's *Edie* as well as one of Victor Bockris's *The Life and Death of Andy Warhol*.

Further, Solanas's manifesto is attracting interest in academic and other feminist circles: Elizabeth Pincus calls Valerie Solanas "the toast of the angry-girl intelligentsia" (232). B. Ruby Rich speculates that one reason for renewed interest in Solanas is the recent need to counterbalance the careful, strategic feminism with a renewed, vigorous, angry feminism: "The '90s is the decade of the Riot Grrls, the Lesbian Avengers, *Thelma and Louise*, the Aileen Wuornos case, and Lorena Bobbitt (the woman who cut off her rapist husband's penis). There's something intensely contemporary about Solanas, not just in her act, but in her text as well" (19).

3. Performative utterances can be defined in contrast to constative utterances which are statements of self-evident truth or factual knowledge. B. Honig uses Hannah Arendt's example from the Declaration of Independence, "We hold these truths to be self-evident," to clarify this distinction:

> The new regime's power, and ultimately its authority, derive from the performative "we hold" and not from the reference to self-evident truths. Both dramatic and nonreferential, the performative brings a new political community into being; it *constitutes* a "we." This speech act, like all action, gives birth, as it were, to the actor(s), in the moment(s) of its utterance (and repetition). (216–17; Honig's italics).

See also J. L. Austin's classic categorization of performative and constative utterances in *How to Do Things with Words* (1962).

4. The production of SCUM females is a political myth that creates its own reality. Richard Griffiths analyzes how polemics produce political myths. He argues that what characterizes twentieth-century polemics, and the Dreyfus Affair in particular, is "the all-embracing nature of the phenomenon, the single-minded insistence which made what should have been polemical ornament into the central thrust of argument and attack. . . . The net result was an unthinking entrenchment and exacerbation of attitudes, based not on political reality but on the myths created by language" (78–79). The polemicists, "carried away by their own rhetoric, lost hold on reality and created a new 'reality' of their own" (16).

5. B. Ruby Rich writes:

> The *Manifesto* is deeply sex-phobic, making her the progenitor not only of today's best and brightest feminist warriors but equally of the Daly-Dworkin tradition of sex dread. Since she saw sex with women every bit as exploitative as sex with men, her attitude toward lesbians wasn't significantly different from that toward men; a generalized homophobia dims her appeal today for lesbians. (19)

Further, Alice Echols finds that "Cell 16 prefigured cultural feminism not only in its essentialist formulations of gender, but in its antipathy toward sex. . . . Dunbar

echoed Solanas when she declared that '[t]he person who has been through the whole sex-scene, and then becomes by choice and revulsion, a celibate, is the most lucid person'" (*Daring* 164).

6. Ellen Willis defines cultural feminism as:

[seeking to free] women from the imposition of so-called "male values," and creating an alternative culture based on "female values." Cultural feminism is essentially a moral, countercultural movement aimed at redeeming its participants, while radical feminism began as a political movement to end male supremacy in all areas of social and economic life, and rejected the whole idea of opposing male and female natures and values as a sexist idea, a basic part of what [they] were fighting. (91)

7. Solanas's rhetoric uncritically reflects the dichotomy between nature and culture, a problem also found in Shulamith Firestone's *The Dialectic of Sex* (1970). In *The Disorder of Women,* Carole Pateman analyzes Firestone's argument for its Hobbesian reduction of individuals to their natural state. Firestones's argument leads to a theoretical dead end because it fails to take historical forces into account (125–26).

8. For instance, Christabel Pankhurst's *The Great Scourge and How to End It,* a polemical tract written during the height of the women's suffrage campaign in Britain (1913), proclaims the slogan "Votes for Women and Chastity for Men." It condemns male participation in prostitution, claiming that the brothel pollutes men's mind and body which is then passed on to the "cleaner, stronger, higher" bride at home who naively believes that "a man can live as pure and moral a life as a woman can" (1987, 192). Pankhurst claims that if women have a larger share of political participation through the vote, they will reestablish order, control, and stable identities through the eradication of a "conspiracy of silence" (190) that surrounds venereal disease and its secret source in the brothel. Prostitution will be eradicated and monogamous marital relations restored which—playing to Britain's imperial insecurities—will prevent "race suicide" (195).

9. See, for instance, Pierre Bourdieu (37–42) and Elaine Scarry (3–23).

10. The Goldman quote is from *The Social Significance of Modern Drama* (1914) and can be found in Arthur Redding (1995).

11. I use the term "institution" as Pierre Bourdieu uses it—in a wider sense than is usually meant in English: as "any relatively durable set of social relations which *endows* individuals with power, status and resources of various kinds" (8; Bourdieu's italics).

12. Arthur Redding says of the impossibility to narrativize or theorize political fantasies of violence that "The 'subjective' space opened up by the confrontation with one's own violent condition—making one a foreigner to one's own self—is inherently contradictory, even chaotic, and may be why anarchism, unlike scientific socialism, could never evolve into a coherent theory" (9). Further, he asserts that "Narrative shies away from the violence that everywhere threatens its exclusive legitimacy" (1995, 13).

13. The notion of "style" corresponds to that of Raymond Williams in "Structures of Feeling." Style, for Williams, marks a general shift in social life—observable in manners, dress, and buildings—which disrupts and reworks a cultural language of possibility. He writes:

For what we are defining here is a particular quality of social experience and relationship, historically distinct from other particular qualities, which gives the sense of a generation or of a period. The relations between this quality and the other specifying historical marks of changing institutions, formations and beliefs, and beyond these the changing social and economic relations between and within classes, are . . . a set of specific historical questions. (131)

14. Alice Echols shows how radical feminist groups like The Feminists and Cell 16 prefigured cultural feminism, but she also makes clear that politicos (feminists who

saw women's oppression as primarily caused by capitalism and who were closely allied with the leftist movement) were aware of the inherent danger that an absence of class analysis (and, I would add, race analysis) would result in mere tokenism rather than substantive change in economic and cultural structures. She writes:

> Without an explicitly anti-capitalist analysis . . . the women's movement would be unable to resist the system's attempts to co-opt it and would merely advance the interests of white, middle-class women. . . . Radical feminists seemed to suggest that class analysis was expendable and thus unintentionally paved the way for cultural feminists who would later dismiss the struggle against capitalism as altogether irrelevant to women's liberation. (*Daring* 79–80)

15. For more on the productive dissonance between particular and universal discourse, see the special issue on universalism in *differences*, 7, no. 1 (1995), especially essays by Joan W. Scott, "Universalism and the History of Feminism," and Naomi Schor, "French Feminism Is a Universalism." For more on the history of feminist political struggles surrounding this dissonance, see Joan B. Landes, and for "minoritizing" versus "universalizing" discourses as they relate to gay identities, see Eve Kosofsky Sedgwick.

16. Quoted in Bourdieu (40).

17. In 1825, the French utopian socialist, Saint-Simon, described the new destiny of the arts as the vanguard of social progressivism in his essay entitled "Literary, Philosophical, and Industrial Opinions." He anticipates "a magnificent destiny for the arts . . . that of exercising a positive power over society, a true priestly function, and of marching forcefully in the van of all the intellectual faculties" (cited in Foster 4).

18. See Leah Hackleman for a discussion of the containment strategies surrounding the shooting of Andy Warhol.

19. Teresa de Lauretis formulates a feminist "elsewhere" that is grounded in existing relations of cultural production. *SCUM Manifesto* extensively critiques alienating, objectifying social forms in order to posit an elsewhere of women's space based on reciprocity and lack of exploitation. Conversely, this "elsewhere" perspective allows for critique of dominant discourses. De Lauretis explains, "For that 'elsewhere' is not some mythic distant past or some utopian future history: it is the elsewhere of discourse here and now, the blind spots, the space-off, of its representations" (25).

20. This phrase comes from Naomi Schor's "This Essentialism Which Is Not One: Coming to Grips with Irigaray" (50), in which Schor argues that Irigaray defamiliarizes femininity while maintaining the sexed difference of female subjects.

21. I take this useful description of the manifesto's paradox, "violent threat/static word" from Janet Lyon's "Transforming Manifestoes" (106). While Lyon claims that Solanas's manifesto goes beyond this paradox by demanding more literal violence and less orderly rage (106), I would counter this assertion with a qualified assent. While expanding the political imaginary to new heights of violent political possibilities, Solanas tempers her call for violence by controlling the female body, eschewing mass revolts (what Lyon calls the limits of exclusionary rhetoric), and turning herself into the police after she commits the only act of violence to come as a direct result of the manifesto.

22. While Solanas denies such allegations in an interview in *Village Voice* with Howard Smith and Brian Van der Hurst (July 25, 1977), such demands are clearly made in letters from Solanas to Andy Warhol written after the shooting (archives, Andy Warhol Museum). See also accounts in Warhol and Hackett (286) and Ultra Violet (186).

23. SCUM recruiting poster, Andy Warhol Museum archives, Pittsburgh, Pa.

24. Olympia Press edition, 1970, back cover. The markings of this text are found in the Rare Books and Manuscripts Collection at the New York Public Library.

25. Jacques Derrida argues that textual utterances presume the absence of an addressee, an absence that allows for radical shifts in context. Though the manifesto

performs a "we" by producing it imaginatively, the fact that it is a text allows that "we" to be reconstituted and reimagined through time and place. Derrida asserts that the written text performs a destruction "of the authority of the code as a finite system of rules; the radical destruction, by the same token, of every context as a protocol of a code" (316). A written text circulates outside conventional contexts which provide a system of rules for their interpretation. Though a text originates in a particular context, it is not confined there. The shifting horizons of reception, both spatial and temporal (texts are read at various times and locations), allow for texts to have many unanticipated effects that do not extend to an uninhibited "free play" of language. Derrida maintains that language is tied to its history. The first function of written statements, he insists, is to communicate. Written language must be legible as a citation from some other source; the materiality of words function as a constraint to meaning. What Derrida disrupts is the reading practice by which meaning is coded as a final, foundational, and self-evident truth.

83
■
The
"Sweet
Assassin"
and the
Performative
Politics
of SCUM
Manifesto

26. For accounts of feminist essentialism, see Diana Fuss (1989), and ed. Naomi Schor and Elizabeth Weed in *The Essential Difference*. Bloomington, IN: Indiana University Press (1994).

27. In *The Dialectic of Sex,* Shulamith Firestone writes:

> Just as to assure elimination of economic classes requires the revolt of the underclass (the proletariat) and, in a temporary dictatorship, their seizure of the means of *production,* so to assure the elimination of sexual classes requires the revolt of the underclass (women) and the seizure of control of *reproduction:* not only the full restoration of women of ownership of their own bodies, but also their (temporary) seizure of control of fertility—the new population biology as well as all the social institutions of child-bearing and child-rearing. (19; Firestone's italics)

28. Firestone anticipates an androgynous pansexuality:

> The interplay between the two cultural responses, the "male" Technological Mode and the "female" Aesthetic Mode, recreates at yet another level the dialectic of the sexes. . . . And just as the merging of the divided sexual, racial, and economic classes is a precondition for sexual, racial, and economic revolution respectively, so the merging of the aesthetic with the technological culture is the precondition of a cultural revolution. (166)

The end goal of a feminist revolution must be "not just the elimination of male *privilege* but of the sex *distinction* itself: genital differences between human beings would no longer matter culturally" (19; Firestone's italics).

References

Austin, J. L. *How To Do Things with Words.* Cambridge: Harvard University Press, 1962.

Berlant, Lauren, and Elizabeth Freeman. "Queer Nationality." In *Fear of a Queer Planet,* ed. Michael Warner, 193–229. Minneapolis: University of Minnesota Press, 1993.

Bourdieu, Pierre. *Language and Symbolic Power.* Cambridge: Harvard University Press, 1991.

Butler, Judith. *Bodies That Matter: On the Discursive Limits of "Sex."* New York: Routledge, 1993.

Deem, Melissa D. "From Bobbitt to SCUM: Re-Memberment, Scatological Rhetorics, and Feminist Strategies in the Contemporary United States." *Public Culture,* 8 (1996): 511–37.

De Lauretis, Teresa. *Technologies of Gender.* Bloomington: Indiana University Press, 1987.

Derrida, Jacques. "Signature, Event, Context." In *Margins of Philosophy,* 309–30. Chicago: University of Chicago Press, 1982.

Echols, Alice. *Daring to Be Bad: Radical Feminism in America: 1967–1975*. Minneapolis: Minnesota University Press, 1989.

——. "The New Feminism of Yin and Yang." In *Powers of Desire*, ed. Ann Snitow, Christine Stansell, and Sharon Thompson, 439–59. New York Monthly Review, 1983.

Ellis, Havelock. *Psychology of Sex*. New York: Emerson, 1942.

Firestone, Shulamith. *The Dialectic of Sex: The Case for Feminist Revolution*. New York: William Morrow, 1970.

Foster, Stephen. "Event Structures and Art Situations." In *"Event" Arts and Art Events,* ed. Stephen Foster, 3–9. Ann Arbor: University of Michigan Press, 1988.

Fuss, Diana. *Essentially Speaking: Feminism, Nature and Difference*. New York: Routledge, 1989.

Griffiths, Richard. *The Use of Abuse: The Polemics of the Dreyfus Affair and Its Aftermath*. New York: St. Martins, 1991.

Hackleman, Leah. "Plastic Man versus the Sweet Assassin." In *Sexual Artifice: Persons, Images, Politics,* ed. Ann Kibey, Kayann Short, and Abouali Farmanfarmaian, 125–47. New York: New York University Press, 1994.

Honig, B. "Towards an Agonistic Feminism: Hannah Arendt and the Politics of Identity." In *Feminists Theorize the Political,* ed. Judith Butler and Joan W. Scott, 215–38. New York: Routledge, 1992.

Irigaray, Luce. *This Sex Which Is Not One*. Ithaca, N.Y.: Cornell University Press, 1985.

Landes, Joan B. *Women and the Public Sphere in the Age of the French Revolution*. Ithaca, N.Y.: Cornell University Press, 1988.

Lyon, Janet. "Transforming Manifestoes: A Second-Wave Problematic." *Yale Journal of Criticism,* 5, no. 1 (Fall 1991): 101–27.

Marmorstein, Robert. "A Winter Memory of Valerie Solanis [*sic*]." *Village Voice,* 13 June 1968, 9–20.

Pankhurst, Christabel. *The Great Scourge and How to End It*. 19/3. Rpt. in *Suffrage and the Pankhursts,* ed. Jane Marcus, 187–240. New York: Routledge, 1987.

Parker, Andrew, and Eve Kosofsky Sedgwick. "Introduction." In *Performativity and Performance,* ed. Andrew Parker and Eve Kosofsky Sedgwick, 1–18. New York: Routledge, 1995.

Pateman, Carole. *"The Disorder of Women": Democracy, Feminism and Political Theory*. Stanford, Calif.: Stanford University Press, 1989.

Pincus, Elizabeth. "They Shot 'I Shot Andy Warhol.'" *Harper's Bazaar,* no. 3412 (March 1996): 232–36.

Radicalesbians. "Woman-Identified Woman." In *Notes from the Third Year,* ed. Anne Koedt and Shulamith Firestone, 81–84. New York: Radical Feminism, 1971.

Redding, Arthur. "The Dream Life of Political Violence: Georges Sorel, Emma Goldman, and the Modern Imagination." *Modernism/Modernity,* 2, no. 2 (April 1995): 1–16.

Rich, B. Ruby. "Manifesto Destiny: Drawing a Bead on Valerie Solanas." *Voice Literary Supplement,* 119 (October 1993): 17–18.

Scarry, Elaine. *The Body in Pain*. New York: Oxford University Press, 1985.

Schor, Naomi. "French Feminism Is a Universalism." *differences,* 7, no. 1 (1995): 15–47.

——. "This Essentialism Which Is Not One: Coming to Grips with Irigaray." In *The Essential Difference,* ed. Naomi Schor and Elizabeth Weed, 40–62. Bloomington: Indiana University Press, 1994.

Scott, Joan W. "Universalism and the History of Feminism." *differences,* 7, no. 1 (1995): 1–14.

Sedgwick, Eve Kosofsky. *The Epistemology of the Closet*. Berkeley: University of California Press, 1990.

Siedman, Steven. "Identity and Politics in a 'Postmodern' Gay Culture: Some Historical and Conceptual Notes." In *Fear of a Queer Planet,* ed. Michael Warner, 105–42. Minneapolis: University of Minnesota Press, 1993.

Smith, Howard. "The Shot That Shattered The Velvet Underground." *Village Voice,* 13, no. 34 (6–13 June 1968): 1, 54.

Solanas, Valerie. *S.C.U.M. Manifesto.* New York: Olympia, 1971.

Ultra Violet. *Famous for 15 Minutes: My Years with Andy Warhol.* New York: Methuen, 1989.

Warhol, Andy, and Pat Hackett. *POPism: The Warhol '60s.* New York: Harcourt Brace, 1980.

Williams, Raymond. *Marxism and Literature.* New York: Oxford University Press, 1977.

Willis, Ellen. "Radical Feminism and Feminist Radicalism." In *The Sixties, without Apology,* ed. Sohnya Sayres et al., 91–118. Minneapolis: University of Minnesota Press, 1984.

Wittig, Monique. *The Straight Mind and Other Essays.* Boston: Beacon, 1992.

Zerilli, Linda. "The Trojan Horse of Universalism: Language As a 'War Machine' in the Writing of Monique Wittig." In *The Phantom Public Sphere,* ed. Bruce Robbins, 142–72. Minneapolis: University of Minnesota Press, 1993.

"The Shooting of Andy Warhol." *Newsweek,* 71, no. 25 (17 June 1968): 86–87.

A PERFECTLY DEVELOPED PLAYWRIGHT
Joe Orton and Homosexual Reform

Francesca Coppa

JOE ORTON is often described as an apolitical playwright. In a famous assessment, drama critic Kenneth Tynan divided Orton and his contemporaries into two categories: "the hairy men—heated, embattled, socially committed playwrights, like John Osborne, John Arden, and Arnold Wesker" and "the smooth men—cool, apolitical stylists, like Harold Pinter, the late Joe Orton, Christopher Hampton, Alan Ayckbourn, Simon Gray, and [Tom] Stoppard."[1] However, this is a misleading assessment of Orton, who always sets the individual stories of his characters within a larger, symbolic context that is critical of institutions and the institutional culture of Britain. Orton is critical of the nuclear family, of the corporation, of the police and the law, of the church, and of a psychiatric discourse that constructs facile categories such as "healthy" and "sick," "normal" and "abnormal." The fact that he launches this critique through the medium of well-constructed, entertaining plays that are overtly connected to the larger history of British drama—that he makes his critique of the master's house by mastering the dramatic tools of the master—should not, I believe, be held against him. Like all the best British playwrights of the time, both "hairy" and "smooth," Orton advertises his familiarity with the history of his craft: to do so was characteristic of the late fifties and early sixties.

Orton, as a "smooth" man, does differ from the "hairy" men is in his commitment to overt political engagement. Osborne, Arden and Wesker's reputation for "commitment" derives at least as much from their off-stage personae and activities as from the nature of their plays. Orton's distrust of institutional culture seems to preclude any overt political involvement on his part. However, this seems incredible considering that one of the most visible and volatile political debates occurring during his professional life was over the construction and passing of homosexual law reform, an issue in which one might reasonably expect Orton to be interested.

In his diaries, Orton recorded in loving detail the conversation of old women on buses, the postcoital chatter of the men with whom he had sex, the backstage musings of the actors in his plays, and the dry discussion of expert commentators on television, almost completely ignored the great

public debate about and eventual passing of the Sexual Offenses Act (No. 2) of 1967, which decriminalized male homosexuality in England. At only two points in his diary does Orton directly or indirectly refer to this important historical event. The first of these references occurs as he is recounting a conversation with his agent, Peggy Ramsay:

> Saw Peggy. She's quite extraordinary. Being v. sophisticated about my taste "for little boys." Willes [Peter Willes, a television producer and friend of Orton's] has told her this. "Well, you're legal now," she said, showing her ignorance. (The homosexual bill becomes law today.) "It's only legal over twenty-one," I said, "I like boys of fifteen." She looked rather bright. Great attempts at modernity.[2]

It might seem surprising that Orton would be so blasé about the new law; the argument that he preferred boys (which, while true, also seems calculated to shock his agent: Orton did, after all, have sex with men over twenty-one, and he lived with his lover) does not completely explain his attitude. After all, Orton and his lover Kenneth Halliwell were put in prison for six months for defacing library books, and Orton believed that they received such harsh sentences because the authorities suspected they were queer. Orton lived his entire sexual life at a time when homosexuals were being prosecuted in record numbers: surely, he, of all people, suffered under the continual threat of the old law and knew the relief that the new law would bring. Aside from two brief mentions in his diaries, Orton is silent on the matter of homosexual legal reform, which dominated the news over the last months of his life.

In order to understand how Joe Orton, posthumously famous as *the* gay British playwright of the sixties, could have had so little to say about the homosexual legal reform happening at the height of his career, we must first look back at the history of the legislation and understand the atmosphere in which the 1967 reform took place. In the first part of this essay I explain how the 1967 Sexual Offenses (No. 2) Act, which decriminalized private homosexual acts between men over twenty-one, was not simply the first step toward the establishment of gay, or human, rights, but also an effort to relegitimize the authority of the British legal system. Orton's play *Loot,* which was running as the debate raged, contains within it a devastating critique of the police and the legal system: it is therefore not surprising that Orton might have resisted the bolstering of what he was attempting to tear down. Orton's own personal and dramatic strategies of political engagement, which I discuss in the second half of this essay, run contrary to many of the underlying aims of homosexual legal reform. In contrast to the philosophy of commitment practiced by many of his contemporaries, Orton subscribed to what I will call the philosophy of being "perfectly developed," a way of aggressively negotiating with established culture by conquering and occupying specifically masculine positions of privilege. While the government was debating whether or not to legalize the behavior of adult homosexuals, Orton was working to explode the very definition of "homosexual."

"Please, Not in Public"

There has been civil law in England against sodomy since 1533, when the post-Reformation Parliament placed an old canonical law into the statute books. Henry VIII introduced hanging as the penalty for what he called "this detestable and abominable vice."[3] In 1861, the death penalty for sodomy was abolished and replaced with life imprisonment. It is important to remember that this prohibition against sodomy applied equally to heterosexuals and homosexuals. Not until 1885 were homosexuals singled out as a group; in fact, they really could not have been targeted previously as "homosexuals" since the word was only coined in 1869, and actually predates "heterosexual," which was coined in response. Up until that point, laws had prohibited certain types of *acts,* not certain types of *people*.

In 1885, the Criminal Law Amendment Bill was passed in Parliament. Attached to the bill was the Labouchere Amendment, which classified all sexual relations between men short of buggery as "gross indecency," a crime that carried a sentence of up to two years in prison, either with or without hard labor. (Oscar Wilde got the full sentence—two years at hard labor—for his conviction of gross indecency in 1895.) The creation of the category of gross indecency marked an important change in the law in that it legislated specifically against men performing certain acts *together*: the acts themselves might not have been illegal, but two men doing them made them illegal. These are the laws which remained on the books until the 1967 reform: life imprisonment for sodomy; two years with or without hard labor for gross indecency.[4]

Although homosexual reform did not occur until 1967, these laws began to come into disrepute as early as 1954, when Parliament formed the Wolfenden Committee. The committee was charged with the task of "learning" about homosexuality, something about which much was already known—if Parliament had bothered to ask the right people. When the Wolfenden Report was published three years later, it revealed more about the then-current conception of British law than it did about the "nature of homosexuality." As historian Jeffrey Weeks puts it: "The conclusions that the majority of the committee came to stemmed from its definition of the function of criminal law. Its purpose, they argued, was to preserve public order and decency, and to protect the weak from exploitation. It was not to impose a particular pattern of moral behavior."[5]

Ironically, the government suddenly found itself needing to focus on preserving public order precisely because it had previously been so rigorous in its imposition of patterns of moral behavior. The police did not have to restore order because thousands of homosexuals had taken to the streets, noisily demanding their rights. Thousands of homosexuals did suddenly appear, but at their local police stations, sought out and arrested by an over-enthusiastic police force. The number of recorded cases of sodomy rose from 134 in 1938 to 1,043 in 1953, and the number of cases of gross indecency skyrocketed from 316 in 1938 to 2,322 in 1955.[6] The late forties and early fifties were the great years of police entrapment (entailing the use of agents provocateurs, particularly in public lavatories) and chain convictions (in which the police promised immunity to suspects if they reported on other homosexuals, leading to large chains of arrests). The laws were such that so-called "stale offenses"—offenses which took place over twelve months

previously—could still be prosecuted, and so gay men could find themselves arrested for events committed years before.[7]

By casting such a wide net, the police caught a lot of people, and ultimately caused their own problems of legal legitimacy. As the numbers of arrests soared, it became apparent that, despite the numbers, this was just the tip of the iceberg. Those who were caught happened to be in the wrong place at the wrong time, or had confided in the wrong people, but were ultimately arrested fairly arbitrarily for activities that were now clearly seen to be widespread. Additionally, the police nets turned up some rather unexpected fish, resulting in a series of scandals involving government officials, prominent aristocrats, and prestigious artists.[8] All this served to make people aware of the magnitude of the problem, and the random and unfair nature of the current law. As Ian Gilmour, Member for Norfolk, stated during the Commons Sexual Offenses debate:

> It [the current law] is unenforceable because there are too many of these people to enable the law to be enforced. We do not know how many there are but, if there are half a million and we were able to catch them, we would not have any idea of what to do with them.[9]

The solution of the time—prison—suddenly seemed absurd: "Sending these men to prison is, as has been said again and again, as therapeutically useless as incarcerating a sex maniac in a harem."[10] It suddenly seemed that the law either had to be tightened and more evenly applied, or abandoned altogether. The latter was the solution proposed by the *Wolfenden Report*:

> What was proposed was that offences which were difficult to discover and troublesome (and politically embarrassing) to prosecute should be removed from the statute book. . . . The chief recommendations were therefore that consensual homosexual behavior between adults (i.e. of men over twenty-one) should be decriminalized; that those under twenty-one should be prosecuted only with the sanction of the Director of Public Prosecutions or the Attorney-General; that maximum penalties should be revised; that buggery should be reclassified as a misdemeanor; and that, except for indecent assaults, the prosecution of any offence more than twelve months old should be barred.[11]

Even though the Wolfenden Committee made its recommendations in 1957, it took ten years for the British legal position to become so untenable that the government felt it necessary to take action. Between 1957 and 1967 the divorce rate steadily climbed and people lamented the decline of the nuclear family. Homosexuality ceased to be seen as a major threat requiring legal punishment once it was compared to other legal, though perhaps "immoral," activities. This point was made repeatedly during the Parliamentary debates over the Sexual Offenses Bill, though it was perhaps most comprehensively summarized by Richard Wood, the member for Bridlington:

> Provided I am careful, I think I could make my wife's life a misery without a local policeman paying me a call. I might also be able to

reduce my children without overstepping the bounds of the law to cowed and terrified shadows of their present selves. If I could get someone to carry me to bed, and could afford it, I could perhaps consume a bottle or two of whiskey every night until I was quite unconscious and the law would have nothing at all to say.

There is a much wider and larger field than this where the law remains entirely silent. Apart from divorce, which is exactly what some want, there is no legal penalty for adultery. Provided that one of the participators is not under the age of 16, the law does not forbid fornication. Homosexual behaviour between women is not illegal, but when we come to homosexual practices between males the position is very different.[12]

By 1966 these contradictions had become clear enough that they could be recited in Parliament, the restricted and elite place where homosexual law reform was created and debated. The proponents of the Sexual Offenses Bill stressed that the current policy made the law (with a capital L) look ridiculous:

That this law is unenforceable is obvious. Everybody must agree with that, however much people may dislike its repeal. I suggest, however, that the present situation, because the law is unenforceable, is not tolerable for Parliament. Parliament would never pass a new law which it knew to be unenforceable or enforceable only at the whim of a chief constable who may or not want to operate it. . . . If we find an existing law unenforceable, thereby bringing the legislature and criminal justice into disrepute, we must surely want to repeal it.[13]

Everyone did agree that the law was unenforceable, but, more important, everyone in Parliament shared the goals of bringing the legislature and criminal justice systems *out* of disrepute, and of making sure power stayed within proper channels (not given over to police "whims"). The real question of the Sexual Offenses Act was how these goals might best be achieved, and both sides were fairly blatant about their political agendas and concerns. The pro-reform side felt that the current law was illogical and unfair and that it provoked a lack of faith in the government since civil society had recently undergone massive social changes. As Jeffrey Weeks puts it, "If a David Hockney could be a luminary of the 'swinging London' scene, how to explain his (homo) sexual lifestyle? . . . If sexual pleasure was a desirable goal, how could homosexuals be excluded?"[14] These inconsistencies in the British legal position were seen as a threat to the efficacy of the authorities: "We are faced with a crime wave of unparalleled gravity and it is essential that we should have a united public opinion in support of criminal law. We cannot have that while offences such as this remain on the Statute book."[15]

Those members of Parliament who opposed homosexual reform were equally concerned with maintaining the authority of the law; however, they felt that for Parliament to decriminalize behavior which a large portion of the population (including many members of Parliament) found disgusting, immoral, and sinful, would cause people to lose faith in the law's moral authority.

The law is the law and is accepted by the community, rightly or wrongly, as representing the moral standards and the strength of the social fabric. This House cannot right a wrong just by changing a law. It has to consider the psychological implications on society of this House coming forward, as the public will see it[,] . . . as Parliament, as the legislature, and saying, "We are giving our blessing to sexual licence and to practice which you regard as abominable."[16]

This antireform argument illustrates the underlying Judeo-Christian moral assumptions of the lawmakers: you can change the law, but you cannot change what is innately "right" and "wrong." This argument also stressed the power and influence of the law by claiming that citizens relied heavily on statute law in developing their moral positions. In other words, without a law to guide the people, all hell would break loose—or, as one anti-reform member put it, "Let us remember that the veneer of civilization is incredibly thin. . . . Unless we attempt to preserve standards in our society they will very easily deteriorate."[17] Still more frightening was the idea that the granting of private rights could well lead to a desire for public rights:

If it [homosexuality] is to be permitted, the next question is: to what extent? What has been said consistently, not only about homosexuality but every form of public lewdness or obscenity, is, "Please, not in public.". . . Whatever else we do, we cannot have homosexuals parading their homosexuality in public.[18]

In both these cases, the government role as "preserver of public order and decency" would be threatened. Yet another fear was that the law would become obsolete altogether:

This stupid and dangerous argument can be used by every criminal, by everyone who breaks the code right through the calendar. The klepto-maniac says: "I cannot help it. You must not punish me. I cannot help thieving—I was born that way." And so we would destroy our commercial system.[19]

Ultimately, however, the pro-reform side was able to make a case that their means provided the better way to relegitimize the British legal system. In making this case, they appealed to and received the support of most other British authorities: the Church of England, the majority of doctors, the majority of psychiatrists. The pro-reform side was also able to gain legitimacy from other Western European countries. Only the Federal Republic of Germany had laws that were as strict as Britain's, and Denmark, having had homosexuality legalized at twenty-one years of age for some time, had recently moved to lower the age to eighteen.[20] Ultimately, the pro-reform side of the British government was simply able to marshal more authority in support of its position than the anti-reform side.

All of these authorities—the pro-reform and anti-reform sides of Parliament, the Church, the doctors, the psychiatrists—agreed on two things: first, the importance of relegitimizing the law, and second, that homosexuality was not a good thing. Whether members wished to legalize homosexuality or

not, all claimed that they had no desire to sanction it, and they did not want the public to get the impression that anyone in the Government actually approved of it. All members spoke as heterosexuals, many beginning their speeches with long prologues about how unfamiliar they were with the subject matter of homosexuality, and mentioning the great number of children they had. One hopes this was the only time when proclaimed ignorance was a credential in Parliament.

Homosexuality was described during the debates as a terrible fate, a failure, an abnormality, a dire handicap, a great sin—and these words came from the bill's supporters. The words of the anti-reform contingent were accordingly harsher: homosexuality is unnatural, wholly disgusting, physically dangerous, an abomination, repulsive, a depravity; homosexuals are pansies and queers, child molesters and disloyal citizens. The positions in the debates were such that a pro-reform member could make the argument that: "A relatively small section of the community is in the position of deserving our sympathy rather than our condemnation, since, for example, the members of that small section of the community can never have their hearts lifted by the sight of a mini skirt."[21] Likewise, an anti-reform member could say: "When one finds a flaunting of homosexuality, one feels—if the House will forgive the colloquialism—the desire 'to land him one in the chops.' I say that the House should do the same to the Bill."[22] It is frightening that the slang is potentially offensive here, not the desire to punch a queer. Perhaps the scariest statements came from the very sponsors of the bill. In the House of Commons, Leo Abse, in introducing the measure, noted that:

> The paramount reason for the introduction of this Bill is that it may at last move our community away from being riveted to the question of punishment of homosexuals which has hitherto prompted us to avoid the real challenge of preventing little boys from growing up to be adult homosexuals. Surely, what we should be preoccupied with is the question of how we can, if it is possible, reduce the number of faulty males in the community.[23]

In the House of Lords, moments before the bill was to pass, its sponsor, the Earl of Arran, made the following speech:

> I ask those who have, as it were, been in bondage and for whom the prison doors are now open, to show their thanks by comporting themselves quietly and with dignity. This is no occasion for jubilation and certainly not for celebration.
>
> Any form of ostentatious behaviour now or in the future, or any form of public flaunting, would be utterly distasteful and would, I believe, make the sponsors of the Bill regret that they had done what they had done.
>
> Homosexuals must continue to remember that while there may be nothing bad in being a homosexual, there is certainly nothing good.[24]

When You're A Boy . . .

The Earl of Arran's speech was published in the London *Times* on July 22, 1967, under the headline: "The Lords: 'Do Not Flaunt' Appeal to

Homosexuals." On the following day, Joe Orton recorded in his diary a second, oblique reference to the new law:

> Kenneth Williams [a popular comedian and actor who was the original Truscott in Orton's play *Loot* and remained a good friend of Orton's] rang today. He's feeling low and depressed. I invited him round for a cup of tea. He accepted with a touching gratitude. . . . Later I walked him to King's Cross where he caught a bus home. On the way we talked about sex. "You must do whatever you like," I said, "as long as you enjoy it and don't hurt anyone else, that's all that matters." "I'm basically guilty about being a homosexual you see," he said. "Then you shouldn't be," I said. "Get yourself fucked if you want to. Get yourself anything you like. Reject all the values of society. And enjoy sex. When you're dead you'll regret not having fun with your genital organs." He told me how he'd visited an East End pub. "And all these young fellows were crowding around. One of them said to me, 'Kaw! Ken, it's legal now, you know.' And he started to pull his trousers down. And the landlady said, 'Ernie! Now then! We'll have none of that.' 'But he's a celebrity, we've got to put on a show,' Ernie said. 'Not that kind of a show,' the landlady said. She was the disapproving type," Kenneth said. "And what happened," I said. "Oh, nothing. We went back about a week later and the pub was empty." "You should have seized your chance," I said. "I know," Kenneth said, "I just feel so guilty about it all." "Fucking Judeo-Christian civilization!" I said, in a furious voice, startling a passing pedestrian. We parted and I hope I'd done him a bit of good. At least I'd told him not to feel guilty. It isn't as simple as that, but at least I've tried to help him.[25]

This diary entry serves as an illustrative counterpoint to the Earl of Arran's speech the day before. The "young fellows" in the East End pub wanted to "put on a show," to publicly celebrate the passing of the bill ("it's legal now you know,"), but they are squelched by the disapproval of the landlady ("do not flaunt") and Kenneth Williams' own guilt ("while there may be nothing bad in being a homosexual, there is certainly nothing good"). A week later the pub is empty: the celebrating lads have dispersed. Orton's response to this is unequivocal and angry: "Fucking Judeo-Christian civilization."

Orton sees Kenneth Williams's guilt, correctly, as socially constructed, as resulting from the Judeo-Christian values of the lawmakers and the society they represented. Orton is alienated from these values; he does not share Parliament's religious, class, or sexual assumptions. Orton's response to the potentially crippling rhetoric of the lawmakers is to advocate guilt-free enjoyment of the body. Orton's particular genius was not simply that he took pleasure from the physical body (which is now, ironically, what he is most famous for), but in his ability to see that the taking of a certain kind of physical position was aligned to taking a certain kind of societal position: that the physical body was related to the social body, that one's relationship to one's own body had larger cultural ramifications. Orton saw that fully inhabiting one's own body was *masculine,* and that masculinity was a means of accessing a certain kind of power. Orton's attempt to forge a connection between queers,

Photographer Lewis Morely posed many subjects in this famous chair, most notoriously Christine Keeler (inset), the woman at the center of the Profumo affair—the sexual scandal that brought down the MacMillan government. This famous photograph of Orton, on display at the National Portrait Gallery, marks the perfectly developed playwright as a sexually provocative figure and reminds the viewer that sexuality can have subversive political repercussions. The naked body is vulnerable; the photo is almost threatening. *Photographs courtesy of the Akehurst Trust.*

masculinity and power is what I am calling his philosophy of being "perfectly developed."

In a 1966 letter to his agent, written from Tangier, Orton opens by claiming, "This reply will be more unintelligible than ever because I'm writing it after performing a lot of violent gymnastic exercise—I shall be the most perfectly developed of modern playwrights if nothing else."[26] Orton's joke about being "perfectly developed" straddles two definitions: a perfectly developed playwright would commonly be one who had used his dramatic gifts to their fullest potential; Orton uses it to define himself as a playwright with a fully developed, muscular *body*. Orton's understanding of the relationship between the physical and social body informs his entire dramatic

project, and informs his strategy of social resistance: to reshape the place of the homosexual in the social body by reshaping the potential physical body: to empower gay men by reshaping the relationship between queers and masculinity.

The early 1960s was an ideal time for such a reshaping: it was the era of the young man. In an appendix to his book, *The Neophiliacs: A Study of the Revolution in English Life in the Fifties and Sixties*, Christopher Booker gives a list of "two hundred or so" figures who "played a chief part in creating and representing the English social revolution in the period 1955–66."[27] Of the seventy-nine listings under the heading of the "Rising, urban 'lower classes,'" an astounding twenty-three are associated directly with the theater: only pop stars rack up similar numbers. The theater of "Angry Young Men," which exploded onto the scene in 1956, gave young, working-class men a public voice that they had not previously had and provided them with an easily recognizable mythology. Orton fell so clearly into a popular "type" of the time that one drama critic expressed doubt as to whether any such person as "Joe Orton" actually existed:

> As for Mr. Orton, I confess to some dubiety as to his identity. The dossier provided in the programme [of Orton's first stage play, *Entertaining Mr. Sloane*] may well be part of the jape: born in Leicester (Nottingham or Salford would, perhaps, have been more suitable), working-class, long periods of idleness, a prison record. It is all just a little too "with it" to be true. I suspect the hand of some distinguished, old-world critic, an admirer of the theatre that concerns itself with recognizable human situations, aspirations, and dilemmas, out of patience with the praise heaped indiscriminately upon so much aimless latter-day trivia. If I am right, he must shortly reveal himself, now that he has seen how well he has hoaxed his peers.[28]

The growing interest in Orton's life, the construction of his biography as a homosexual (or, even more specifically, as a murdered homosexual), and the attention paid to sensationalistic accounts of his promiscuity and "rebelliousness" have actually served to obscure the real importance of Orton's role in gay history. As David Van Leer notes in his essay "St. Joe," the fact that Orton's own promiscuity is often characterized as rebellious does not address the specific cultural situation of Orton's pre-liberation sixties.[29] A furtive kind of promiscuity is almost culturally determined in a world where homosexual relationships must be conducted invisibly. However, both gay and straight critics fail to apprehend that Orton's rebelliousness is not located in his originality, but in his ability to fully inhabit the then-already-cliched "with it" position of rebellious young man, while using the power gained from that position to make theatrical inroads for a new kind of gay viewpoint. Orton the young, male, working-class, ex-convict, rebel playwright fell into an acceptable niche by the early sixties; but those adjectives had yet to be paired with *queer* in the popular imagination. In fact, they were almost the antithesis of queer.

In the popular imagination, to be queer was to be effeminate, leisured, aristocratic, decadent. The euphemisms tell the story: "sensitive," "delicate," "artistic." In his book, *Literature, Politics, and Culture in Postwar Britain*, Alan Sin-

field explains that literary culture was constructed according to the paradigm shown in Table 5.1, with homosexuality as the unspoken, destabilizing element.

Table 5.1

dominant	the state	the working class	"masculinity"	
literary	the personal	the leisure class	"femininity"	*homosexuality*

Homosexuality subverts the model because of the class divide in the paradigm, and, as Sinfield notes: "homosexuals often chose their partners across it (as Oscar Wilde had done), producing connections where the model enviages oppositions. The 'effeminate,' leisured literary intellectual sought relationships—either personal or (equally provocatively) impersonal—with masculinity and the working class."[30] As a working-class, masculine, literary homosexual, Orton completely wrecks the paradigm. His class, profession, and sexuality were at odds in the traditional structure. Orton attempted to construct a new paradigm for himself, as shown in Table 5.2.

Table 5.2

literary	the personal	the working class	masculinity	homosexuality

In order to do this, Orton had to define himself against the old model; in particular, Orton defined himself against Oscar Wilde. When Orton became successful, he was referred to by the sobriquet, "The Oscar Wilde of Welfare State Gentility." While Orton admired Wilde's talent as a writer and admitted Wilde's influence on his work, he was careful to draw distinctions between himself and Wilde as people:

> I didn't suffer or anything the way Oscar Wilde suffered from being in prison—but then Wilde was flabby and self-indulgent. There is this complete myth about writers being sensitive plants. They're not. It's a silly nineteenth-century idea, but I'm sure that Aristophanes was not sensitive. I mean there's absolutely no reason why a writer shouldn't be as tough as a bricklayer.[31]

Underneath Orton's overt comparison of himself and Wilde as writers lies a comparison of himself and Wilde as homosexuals: neither writers nor homosexuals need be "sensitive"; both writers and homosexuals can be tough. In making his argument, Orton reaches back to the Greeks as models of virile writers and homosexuals, overtly engaging the paradigm by which literary equals homosexual equals feminine equals weak.

ORTON REFUSED TO BE RELEGATED to the sidelines, to be invisible, to not flaunt—to assume the role of a traditional "artistic" queer. He preferred to strut with the other young men whom he thought of as his peers: the group that Booker refers to as the "rising, urban lower class." Those who are disappointed in Orton's failure to strut more publicly as an out gay man are, I think, being unrealistic vis-à-vis the times: they are people who sound as if they have not recently been deprived of the luxury of being part of a

sympathetic avant-garde. If mainstream culture is all you have, it becomes the only culture that matters, the only culture worth impressing, or impressing yourself upon. The true threat of Orton does not lie in his overt gay *difference* from the other mainstream masculine power brokers of the time, but in his *similarity,* for what Orton demonstrates again and again in his life and work is that the masculine positions of power in place in Britain at the time were *already queered.*

Both Orton's development of his body and that of his playwrighting skills were part of the same project: he was preparing himself for public consumption. He was doing so because he knew that the times were right: the cult of masculinity developing in the late 1950s and early 1960s in popular culture was moving society ahead faster than could the law. How could the government tell homosexual men "not to flaunt" when the Beatles, at that stage in their careers still defined largely by their status as attractive, young, working-class men, were being consumed by record numbers of people? (And weren't they constantly being filmed *running away* from screaming hordes of young women—confirming their status as sex objects but also, to the homosexual viewer, possibly signifying a sympathetic rejection of women?) Obviously, homosexuals were something other than men, since men had just been given a license to flaunt themselves as much as they pleased.

Flaunting was the modus operandi for men in the sixties: it was the time when men really took center stage as objects of display. That may seem to fly in the face of what we know about sexism in Western history, but, for example, most of the big Hollywood stars of earlier periods were women— Greta Garbo, Joan Crawford, Bette Davis, Barbara Stanwyck, Judy Garland, Ingrid Bergman, Betty Grable, Marilyn Monroe, and so on. Today, a list of the biggest Hollywood stars would mostly consist of men: Harrison Ford, Jack Nicholson, Clint Eastwood, Tom Cruise, Sylvester Stallone, Arnold Swartzenegger, and so forth. Moreover, the 1960s is really the time when this switch occurred: stars like Elvis Presley and James Dean, Marlon Brando and the Beatles put male sexuality center stage, and suddenly it seemed as if everyone had gained permission to look at men as aesthetic objects. Masculinity became cool, and looking at other men became a sign of hipness rather than effeminacy or faggotry.

However, if you *did* happen to be a gay man during the sixties, the sudden mass popularity of male icons and pinups was a particular gift. As Orton used the then-current popularity of young, male, working-class writers to steal into the literary spotlight, artfully flaunting his lower-class masculinity by wearing leather jackets and jeans in the fashionable ways, he also creates characters who seem to fit (but never *quite* do) within already existing cultural patterns. The presence of charismatic, attractive, working-class male characters in plays was common by 1964, but Orton's young men are very carefully designed—carefully made fashionable, made bisexual, and crafted as objects of desire for a variety of audiences.

Consider the eponymous Mr. Sloane from Orton's first major stage play. When Mr. Sloane first makes his entrance as a prospective lodger, we might be viewing a Pinter play. Sloane is carefully decked out as the familiar young hooligan of 1964, and we are prepared for him to threaten the household, to be the familiar menace. By the end of the play we know that we are in the realm of the Ortonesque: the lodger is not the threat—he is the fly

Courtesy of the Orton family private collection.

who has entered the parlor of the spider. Kath and Ed, the brother and sister
who run that household are far more ruthless than he. On *Entertaining Mr.
Sloane*'s road from the Pinteresque to the Ortonesque, the assumed hetero-
sexuality of the sexy young hooligan is threatened; Sloane uses his masculine
strut and beauty to charm both men and women, and Sloane, like Orton,
works out:

SLOANE: We had a nice little gym at the orphanage. Put me in all the teams they did. Relays . . .

ED looks interested.

. . . soccer . . .

ED nods.

. . . pole vault, . . . long distance . . .

ED opens his mouth.

. . . 100 yards, discus, putting the shot.

ED rubs his hands together.

Yes, yes. I'm an all rounder. A great all rounder. In anything you care to mention. Even in life.

ED lifts up a warning finger.

. . . yes I like a good work out now and then.[32]

Admittedly, bisexuality, as Alan Sinfield points out in his article "Who's Afraid of Joe Orton?" can be seen as a cop-out. Orton's tack also helps cast doubt on all the other hip young men out there—he is training his audience to see them, too, as sexually suspect. (A mark of how well Orton has helped change the stereotypical image of the queer is that, in more recent productions, Sloane's 1960s hip young hooligan outfit marks him as gay from the get-go, which it would not have done in the sixties.) This sexually ambiguous position was to be further developed and exploited by the next generation of hip boys; as David Bowie put it in his 1979 song, "Boys Keep Swinging" (from his album entitled, ironically, *Lodger*):

> When you're a boy
> You can wear a uniform
> When you're a boy
> Other boys check you out
> You get a girl
> These are your favorite things
> When you're a boy.[33]

(The refrain of the song—"Boys keep swinging, boys always work it out"—contains within it the Ortonesque straddling of definitions you can work things out when you work out.)

 Entertaining Mr. Sloane and Orton's other plays do more than queer the position of the fashionable young, working-class hero; they also queer the more traditional position of the older, masculine power broker. As each of Orton's plays feature at least one of these hip young men (Sloane in *Entertaining Mr. Sloane,* Hal and Dennis in *Loot,* Nick in *What the Butler Saw*), they all also feature a more traditional representative of the British male power structure (the businessman, Ed, in *Sloane;* Inspector Truscott in *Loot,* and Drs. Prentice and Rance in *Butler*). Each of these characters, to one degree or another, reveals homosexual or, at the very least, homosocial sympathies.

 The situation is clearest with Ed in *Entertaining Mr. Sloane,* who has been referred to as Orton's only clear homosexual character. While Ed has a clear preference for boys, he does not seem to regard himself as "homosexual" either—rather, his behavior is typical in the powerful circles within which he travels:

KATH: Are your friends nice?
ED: Mature men.
KATH: No ladies?

Pause.

ED: What are you talking about? I live in a world of top decisions. We've no time for ladies.
KATH: Ladies are nice at a gathering.
ED: We don't want a lot of half-witted tarts.
KATH: They add colour and gaiety.
ED: Frightening everyone with their clothes.[34]

Ed never admits that his clear personal and sexual preference for men might make him a homosexual. While he is clearly attempting to seduce Sloane, he tightens up whenever Sloane seems on the verge of making the real intent of his actions explicit. In the scene with Sloane quoted above, Ed raises a warning finger to Sloane when the latter suggests that he is an "all-rounder" even in life, which is to say, sexually; in another scene, Ed balks at Sloane's sympathetic characterization of him as "sensitive"—a famous euphemism:

SLOANE: You're sensitive. You can't be bothered.
ED: You got it wrong when you say that. I seen birds all shapes and sizes and I'm most certainly not . . . um . . . ah . . . sensitive.
SLOANE: No?
ED: I just don't give a monkey's fart.
SLOANE: It's a legitimate position.
ED: But I can deal with them same as you.[35]

In fact, in his dealings with the beautiful, young Mr. Sloane, Ed hides behind the rhetoric of a hearty, moral, masculinity:

ED: Why am I interested in your welfare? Why did I give you a job? Why do thinking men everywhere show young boys the strait and narrow? Flash cheque-books when delinquency is mentioned? Support the Scout movement? Principles, boy, bleeding principles. And don't you dare say otherwise or you'll land in serious trouble.[36]

This passage is rarely mentioned when critics discuss Orton's subversiveness, but Orton's attempt to make overt the homosocial undertones of the British power structure represents a radical gesture of staggering implications. Similar discomforting moments for the British ruling class occurred during the debates over homosexual reform four years after the success of *Entertaining Mr. Sloane*. For example, when it became clear that homosexual reform was about to pass, conservative backbenchers tried to change the age of consent from twenty-one to twenty-five at the last minute. One of their arguments was that twenty-one came right in the middle of a university career—a remark that brought laughter to the House. At that point, the known homosociality/homosexuality of public school and university education was on the verge of being openly admitted. Things were moving quickly—a year after the passing of the Sexual Offenses Act and Orton's death, playwright Peter Barnes was able to explain the erratic behavior of a young aristocrat with an explosive joke in his play, *The Ruling Class*:

DR. HERDER: Of course, he never forgot being brutally rejected by his mother and father at the age of eleven. They sent him away, alone, into a primitive community of licensed bullies and pederasts.
SIR CHARLES: You mean, he went to Public School.[37]

The atmosphere was quite different in 1963, when Orton began his career as a playwright. Throughout all seven of Orton's major plays, he works to broaden the conception of who could be homosexual—of what kind of man wants to have sex with other men. Strictly speaking, there are no "homosexuals" in Orton's plays—not any that would have been easily recognizable in terms of the then-current stereotypes.[38] Using his status as a hip, working-class playwright—which gave him a license to flaunt and shock—Orton repeatedly queered the two most powerful forms of masculinity of his time: the hip young man and the established older man.

Orton himself publicly moved between these two positions of masculine privilege. He acts as both the perfectly developed playwright, aspiring to cultural, social and financial power (dining with elites, negotiating deals for his plays, traveling abroad), and as the perfectly developed body, working, in his words, to see and charm everyone, particularly the rest of the homosocial power structure, by flaunting his youth, fashion sense, and physique.[39] Neither role involved Orton's assuming the position of the stereotypical queer; both roles involved massive amounts of public flaunting (the former, intellectual and financial; the latter, physical.)

I am not claiming that there are no problems with Orton's "perfectly developed" approach. As Simon Shepherd points out throughout his book on Orton, *Because We're Queers,* Orton's appropriation of masculinity led him to adopt uncritically a lot of traditionally masculine baggage, most notably sexism. Orton also runs the risk of being appropriated by the very forces he was trying to queer. For example, Shepherd argues that the straight and closeted worlds taught Orton to despise his lover Kenneth Halliwell, who appears as a more conventional literary queer (what Shepherd calls the "dated older homo")[40] in the Orton narrative. If that is true, it is possible to argue, as Shepherd does, that Orton's appropriation of masculinity might be partly responsible for the breakup of his relationship and for his death.

I think that this view of Orton is dependent on a necessarily biased construction of his personality. Biographers and critics have almost no access to Orton's personal life, the life he spent in his one-room flat with Kenneth Halliwell. The popular construction of Joe Orton, the man, is based on his plays and on the memories of people who knew him—all except, of course, Kenneth Halliwell, who died with him. In other words, the construction of "Joe Orton" is based entirely on Orton's own *public* projections (even his diary, written for publication, is a public projection).

Orton was not simply an "uber-Sloane," or the sum of all the sexy young men who appear in his plays. Orton the writer was consciously strategizing about how to present queer sexuality onstage. Orton the man, while consciously adopting certain masculine postures in public, self-identified as a homosexual and was schooled in the canonical queer works. He was described by the publisher Charles Monteith in 1956 as Kenneth Halliwell's "young, pretty, and rather vivacious boyfriend," and Monteith's snapshot view of John Orton before he had developed the public persona of "Joe

Orton" is revealing: "On this occasion, John produced, I think, a very funny and penetrating piece of literary criticism. . . . I asked if they'd read Gibbon. To which John replied, 'What an old queen she is! Send up, send up, send up the whole time.'"[41] There is plentiful evidence to suggest that Orton enjoyed camp and "homosexual" culture and humor—but these were already making their way into public culture while Orton was writing and he did not see their presentation as particularly radical. For example, Orton said that he thought that the very camp gay character in Peter Shaffer's play *Black Comedy* (1965) was "very funny," but thought it "an awfully conventional portrait."[42]

Orton's chosen role was not to reclaim and validate the stereotyped homosexual figure; indeed, no recognizable homosexual figures appear in Orton's work at all. Rather, Orton gives us a world seen through queer eyes—a queered worldview—in which hip young men are erotic and powerful older men *know* it; a world in which the police are out to get you and psychiatrists will drive you crazy if you let them; a world in which Winston Churchill is symbolically figured as a gigantic penis, which commands admiration in a world of bruised and defeated souls. Orton's vision is exuberantly, jubilantly, infectiously queer—and as a result, despite his refusal of practical politics, he easily earns his status as *the* gay playwright of the 1960s.

■

A Perfectly Developed Playwright

Notes

1. Kenneth Tynan, *Profiles* (New York: HarperPerennial, 1989), 296.
2. Joe Orton, *The Orton Diaries,* ed. John Lahr (New York: Harper and Row, 1986), 233.
3. Quoted in Paul Goodman, "Focus Homosexual Law Reform: Gays: The Age Old Question," (*London*) *Sunday Telegraph,* 2 January 1994, 12.
4. It is important to note that the age of female consent is 16, and that homosexuality between women has never been legislated upon since Queen Victoria, rather notoriously, refused to believe that it existed.
5. Jeffrey Weeks, *Coming Out: Homosexual Politics in Great Britain from the Nineteenth Century to the Present* (London and New York: Quartet Books, 1977), 165.
6. Weeks, *Coming Out,* 158.
7. Great Britain, Parliamentary Debates, House of Commons 5s, 11 February 1966, 787.
8. Weeks cites the Burgess and Maclean spy affair, the Montagu-Wildeblood prosecution (Lord Montagu being "the heir to a long aristocratic tradition"), and the conviction of Sir John Gielgud on a trivial charge in 1953 as examples (*Coming Out,* 159–60).
9. Parliamentary Debates, House of Commons, 5s, 19 December 1966, 1091.
10. Mr. Leo Abse, Member for Pontypool, Parliamentary Debates, House of Commons, 5s, 19 December 1966, 1072.
11. Weeks, *Coming Out,* 166.
12. Mr. Richard Wood, Member for Bridlington, Parliamentary Debates, House of Commons, 5s, 11 February 1966, 838.
13. Mr. Strauss, Member for Vauxhall, Parliamentary Debates, House of Commons, 5s, 19 December 1966, 1098.
14. Weeks, *Coming Out,* 158.
15. Mr. St. John-Stevas, Conservative Member for Chelmsford, Parliamentary Debates, 5s, House of Commons, 19 December 1966, 1122.
16. Mr. Iremonger, Member for Ilford, North, Parliamentary Debates, House of Commons, 5s, 19 December 1966, 1103.
17. Mr. William Shepherd, Member for Cheadle, Parliamentary Debates, House of Commons, 5s, 11 February 1966, 822.

103

18. Mr. Rees-Davies, Member for the Isle of Thanet, Parliamentary Debates, House of Commons, 5s, 3 July 1967, 1439.

19. Sir Cyril Osborne, Member for Louth, Parliamentary Debates, House of Commons, 5s, 11 February 1966, 835.

20. On Britain and Germany, see Parliamentary Debates, 5s, House of Commons, 11 February 1966, 849.

21. Mr. Hugh Jenkins, Member for Putney, Parliamentary Debates, House of Commons, 5s, 3 July 1967, 1515.

22. Mr. Mahon, Member for Preston, South, Parliamentary Debates, House of Commons, 5s, 3 July 1967, 1508.

23. Leo Abse, Member for Pontypool, Parliamentary Debates, House of Commons, 5s, 19 December 1966, 1078.

24. "The Lords: 'Do Not Flaunt' Appeal to Homosexuals," London *Times*, 22 July 1967, 13.

25. Orton, *The Orton Diaries*, 251.

26. Orton to Peggy Ramsay, 10 June 1966.

27. Christopher Booker, *The Neophiliacs: A Study of the Revolution in English Life in the Fifties and Sixties* (London: Collins, 1969), Appendix.

28. Kenneth A. Hurren, "Theatre," in *What's On*. Undated clipping from Joe Orton's *Entertaining Mr. Sloane* scrapbook.

29. David Van Leer, "St. Joe," in *The Queering of America* (New York: Routledge, 1995), 84.

30. Alan Sinfield, "Queers, Treachery, and the Literary Establishment," in *Literature, Politics and Culture in Postwar Britain* (Berkeley: University of California Press, 1989), 66.

31. John Lahr, *Prick Up Your Ears,* (New York: Vintage, 1987), 152.

32. Joe Orton, *Entertaining Mr. Sloane,* in *The Complete Plays* (New York: Grove Weidenfeld, 1976), 86.

33. David Bowie, "Boys Keep Swinging," on *Lodger* (Ryko, 1979).

34. Orton, *Entertaining Mr. Sloane,* 90.

35. Ibid., 113.

36. Ibid., 134.

37. Peter Barnes, *The Ruling Class,* in *Collected Plays* (London: Heinemann, 1981), 24.

38. Charles Dyer's play, *Staircase* (1966), and Peter Shaffer's *Black Comedy* (1965) provide contemporary contrasting gay portraits.

39. Orton to Ramsay.

40. Simon Shepherd, *Because We're Queers: The Life and Crimes of Kenneth Halliwell and Joe Orton* (London: Gay Men's Press, 1989), 165.

41. John Lahr, *Prick Up Your Ears,* (New York: Vintage, 1987), 131.

42. Ibid., 187.

6

■

"YOU DON'T HAVE TO SAY YOU LOVE ME"
The Camp Masquerades of Dusty Springfield

Patricia Juliana Smith

We live, I regret to say, in an age of surfaces.

—OSCAR WILDE
*THE IMPORTANCE OF
BEING EARNEST*

You always wanted me to be something I wasn't,
You always wanted too much.
Now I can do what I want to, forever,
How am I gonna get through?

—PET SHOP BOYS AND DUSTY SPRINGFIELD
"WHAT HAVE I DONE TO DESERVE THIS?"

DURING THE PEAK YEARS of her career, Dusty Springfield presented herself in an admixture of oxymoronic and seemingly incongruous roles, those of the "Great White Lady" of pop and soul, the "Queen of the Mods," and the prototypical female drag queen. When one considers these larger-than-life roles, her subsequent fall from fame into a cycle of personal and public disaster that would befit any tragedy queen worthy of the name, and her ultimate apotheosis as a veritable pop icon, one might well ask, "What becomes a [semi-]legend most?" Yet, when one considers Mary Isobel Catherine Bernadette O'Brien, the bespectacled, tomboyish, convent schoolgirl and closeted lesbian underlying this fantastic and even fictional persona, one must ask instead, "What's a girl to do?"

While today it seems a truth universally acknowledged that the "Swinging Sixties" was an era of great sexual license that liberated everyone's libido from the restraints of bourgeois morality, the sexual freedom the decade brought forth was primarily for the benefit of heterosexual males. Although this now mythologized neo-romantic revolution also granted heterosexual women and, to some lesser extent, gay men more sexual emancipation than they had previously known, in the years before Women's and Gay Liberation, those who were neither male nor straight remained at best nonentities and at worst monsters, particularly in the masculinist and generally homophobia world of rock music. One of the great pop culture icons of

the British Mod music and fashion scene was, nevertheless, a lesbian, though few of her fans—many of them sexual outlaws themselves—were completely aware of Dusty Springfield's "bent" sexuality.[1]

Through a metamorphosis stranger than most fiction, Mary O'Brien—a proper, middle-class, British Catholic girl of Irish descent, who was somewhat unsocialized and seemingly destined for a career as a librarian—became the flamboyant Dusty Springfield, the idol of a cultural movement that, ironically, had little to do with her own existence. In the fantastic Mod ethos of swinging London, however, one generally could be almost anything, no matter how extreme or incongruous, except oneself—particularly if one's own, true self were queer. As a result, Dusty Springfield paradoxically expressed and disguised her own unspeakable queerness through an elaborate camp masquerade that metaphorically and artistically transformed a nice white girl into a black woman and a femme gay man, often simultaneously. In doing so, this individual, who had placed herself outside mainstream British society, subverted fixed ideas of identity by assuming the personae of two oppressed and excluded groups. Thus, consciously or otherwise, Dusty Springfield blurred the distinctions of race, gender, and sexuality just as she did those between life and art and those between reality and artifice.

Such camp masquerades are hardly new to or uncommon in lesbian culture; critics have noted similar semiotic modes in other areas of queer art, particularly literature.[2] Dusty Springfield's gender- and race-bending antics in the already-extreme world of rock music and pop culture were as elaborate as, and far more vivid than, any we are likely to uncover in the more conventional (i.e., respectable) arts; they were, moreover, capable of affecting and influencing a wider and more varied audience by means of the mass media. Unlike the lesbian disguises one encounters in the "higher" sister arts, however, Dusty Springfield's palimpsest was not a premeditated strategy set in motion from the outset of her career; rather, her amalgam of fictive identities and façades grew in complexity and extremity over time and in direct proportion with rumor, innuendo, and consequent public pressure regarding her sexual "inclinations." Thus, her camp masquerades and metamorphoses in many ways comprise a quintessential story of the queer sixties.

In January 1964, a seemingly new and unknown voice became a frequent presence on American airwaves. "I Only Want to Be with You" was among the flood of recordings released in the United States in the first wave of the so-called British Invasion spearheaded by the Beatles; it was, in fact, the first recording of this period by a British artist *other* than the Beatles to reach the American Top Twenty. This was not, however, Dusty's first American musical success. Two years earlier, as a member of the Springfields, her brother's traditional folk/country combo, she enjoyed a Top Twenty hit with "Silver Threads and Golden Needles," which showcases her distinctive voice in a brief solo passage. Despite the Springfields' high visibility and popularity in Great Britain, they remained, after this isolated success, nameless and faceless to American audiences and were therefore virtually forgotten by 1964. Consequently, the greater part of the audience who acclaimed "I Only Want to Be with You" quite understandably failed to make the connection.

Unfamiliar, then, with the identity and appearance of the androgynously named singer, American listeners formed various misconceptions about her nationality, her race, and even her sex. The initial impression of

Martha Reeves, lead singer of the 1960s Motown girl group Martha and the Vandellas, is typical: "When I heard her on the radio, I just assumed she was American and black. Motown signed up nearly all the best talent at that time, and I remember being a little surprised to find she was with a different label—and I was absolutely astounded when I finally saw her on TV."[3] Springfield's name and husky timbre, however, led some less astute listeners to imagine that the tenorish female voice that made her first hit so compelling was that of a young—and probably black—man. Lloyd Thaxton, host of a popular Los Angeles television teen music program in the early 1960s, awkwardly confessed to her on the air that he had expected his guest, whom he had not seen before the show, to be male. As gauche as this statement may now seem, his error was not completely unreasonable. Recordings by black male rhythm-and-blues singers who had adapted the high tenor voice of gospel music to a secular format—and who frequently bore non–gender specific names (e.g., Smokey Robinson, Frankie Lymon, Garnett Mimms, Jewel Akens)—were relatively common during the late fifties and early sixties.[4]

Springfield's fascination with American soul music and identification with black female singers provided the foundation not only for her vocal disguise but also for the visual masquerade that eventually made her a role model for British drag queens. Publicity photos of the Springfields taken before her metamorphosis show a red-haired Dusty in high-collared, full-skirted gingham dresses embellished with starchy cravats and voluminous petticoats, a countrified version of the quintessential *nice* (i.e., repressed, artificial, and asexual) white "lady" of the Cold War era. While visiting the United States with the Springfields in 1962, she discovered the various black girl groups then popular and eventually adopted not only their vocal styles but also their fashion sensibilities. The high beehive hairstyles, heavy mascara, and false eyelashes favored by the Ronettes, the Crystals, and the Marvelettes soon became Dusty's own trademark—and a sign of her complete break, in late 1963, with the Springfields and what she later called "that happy, breezy music" with which she "[wasn't] at all comfortable."[5]

Three decades after its release, her first British solo album, *A Girl Called Dusty,* provides a veritable catalog of subversive lesbian camp.[6] The cover photograph shows the "new" Dusty smiling boldly into the camera and outfitted casually in denim jeans and a man's blue chambray work shirt. If Springfield appeared thoroughly butch from the shoulders down, she is virtually a parodic femme from the neck up, displaying exaggeratedly back-brushed and suggestively mussed-up, peroxided hair; heavy, black kohl mascara; false eyelashes; and bright, frosted-pink lipstick. This vampy over-kill completely shatters any naturalistic illusion of femininity and creates a highly ironic lesbian resignification of the gay man in drag—in effect, that of the *female* female impersonator. In like manner, her musical repertory undergoes an equally dramatic evolution. The disc consists primarily of her interpretations of hits originally performed by American black women vocalists, including the Supremes, Dionne Warwick, and, particularly, the Shirelles.[7] Conversely, the hyperbolically melodramatic "My Colouring Book" portends her future tragedy queen "arias," while her impassioned cover version of Lesley Gore's "You Don't Own Me" provides yet another recording of this proto-feminist anthem, which has been a lesbian favorite over the decades.[8] The most impressive and complex lesbian resignification of soul music in

this collection, however, is her cover of Inez and Charlie Foxx's "Mocking-bird." The original, sung by the brother-and-sister duo, is a playful call-and-response based on a traditional nursery rhyme and parodically laments the difficulties and disappointments of heterosexual romance. In her version, though, Springfield herself becomes a mocking "bird" (to use the contemporary British idiom), who takes the parody a degree further. She demonstrates, lest anyone assume otherwise, that she, unlike Inez Foxx, can do without her brother, and, through recording overdubs and a startling display of a female baritone voice, she sings the male part to her own female lead.

Although her record company was no doubt pleased with the commercial success of this *new* Dusty Springfield, a certain nervousness about the playful incongruity of her style and deviance from the conventions of the female vocalist creeps into the liner notes of her record albums, in both their British and their American configurations. Lucy O'Brien observes that the "tradition[al] British female singer with the reassuring 'girl-next-door' image . . . was the kind of girl who'd listen to your problems and make you a cup of tea" (45). Springfield's best-known contemporaries (e.g., Cilla Black, Sandie Shaw, and Petula Clark) "went for the bright, clean, fun-loving look," and "were commonly viewed as dolly birds who simply sang what was put in front of them" (44, 47). Moreover, the *white* female vocalist, whether British or American, was inevitably caught in a web of contraries. Singing the joys and sorrows of heterosexual love, she needed to present an image of sexual availability to her male audience while maintaining the decorous asexuality required of middle-class white women. Simultaneously, for her female audience (who, after all, formed a considerable portion of the record-buying public), she was called upon to replicate the friend in whom a girl could confide rather than the sexual rival who would steal one's boyfriend.

The black woman and her music, conversely, symbolized a displaced sexual freedom and power to middle-class white audiences—and thereby provided a means of subversively articulating unspeakable sexuality for a queer girl. This mode of identification with fellow female outsiders could also give the lesbian a sense of connection nonexistent in her own very limited cultural context. Val Wilmer, a noted photographer of the 1960s British pop scene, a jazz and blues critic for the British music journal *Melody Maker,* and, later, an outspoken lesbian feminist writer, explains from her own perspective the appeal that African-American culture held for many British lesbians in the 1960s: "However 'progressive' the individual might be, she . . . would have to be rooted. And it's that rooting, so vital to life's continuity, that is missing, being deliberately destroyed with little to replace it . . . in contemporary white British society and culture. Small wonder I've often felt more at home elsewhere."[9] Springfield's publicists, themselves facets of this "contemporary white British society and culture," had a vested interest in promoting her as part of their own "unrooted" cultural context. They were hard pressed, then, to reconcile a blues-singing and covertly lesbian white woman with conventional public expectations. Accordingly, blended into the banal and irrelevant information typical of 1960s publicity notices and fan magazine journalism, several basic "facts" are repeatedly emphasized on the covers of virtually every album Dusty Springfield released before her 1968 masterwork *Dusty in Memphis*. The public is reminded, for example, that Dusty was a member of the wholesome Springfields, is the product of a middle-class family and a

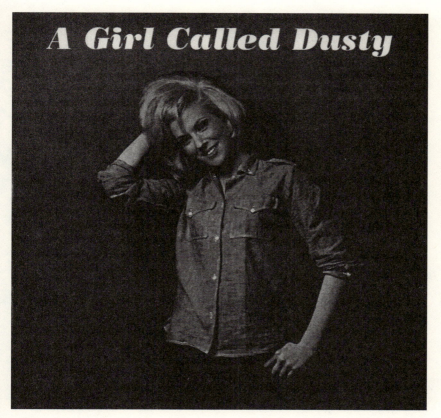

A Girl Called Dusty

A Girl Called Dusty (1964): Femme from the neck up, butch from the shoulders down.

Catholic education, and that her *real* name is Mary—which calls to mind, not only the Blessed Virgin, but also all that is safe and pure. At the same time, her publicists go to great lengths to extol her "eccentricity"—a term often employed in explaining away what might otherwise be identified as *queerness,* Dusty, we are told, is a lovable goon who keeps a pet monkey, slides down banisters, plays practical jokes, and vents her pent-up anxieties by smashing cheap dishes. In light of such odd yet thoroughly trivial peculiarities, her penchant for rhythm-and-blues—as well as the much-noticed absence of a "boyfriend"—could be dismissed as more of the same. This would, presumably, reassure the public that Dusty, despite her newly acquired soulful vocal style and her radically artificial "feminine" appearance, was still a "nice" if adorably eccentric white girl—and therefore a harmless one.

The truth will nevertheless come out, if only obliquely. Amidst the collected trivia that constitute the liner notes for A *Girl Called Dusty,* a rather startling bit of information appears. A smarmy narrative of her schoolgirl days and her early attempts as an amateur performer ends with the revelation that her convent school jazz vocal combo "was brought to a sudden and unhappy end by the geography mistress who banned them from the school concert as she felt that their use of deep purple lighting during a hip version of 'St. Louis

Blues' had an erotic effect."[10] Considering that her record company certainly had no desire to "out" Dusty Springfield in 1964, this anecdote becomes a puerile and not terribly original indulgence in ridiculing the sexual repression of nuns, thus distancing her from their presumed prudery and giving her the illusion of sexual availability while paradoxically reemphasizing the propriety and sexual distance of the convent—and its product. The male writer of this piece either conveniently overlooks the intrinsically homoerotic ethos of the convent (upon whom, after all, would her performance have "an erotic effect") or appropriates it for a peculiarly heterosexual male variety of voyeuristic titillation.

Whatever the purpose, this anecdote becomes a double-edged discourse that many lesbians readily recognize. Convent school homosociality and its subsequent ramifications in the lives of those who have experienced it have been a commonplace in Western culture and discourse since Diderot's *La Religuese.* That Dusty Springfield manifested such homosocial sensibilities in her early solo performances is undeniable. Videotapes of her on the mid-sixties weekly British television program *Ready Steady Go* clearly demonstrate that she directs her performance to and interacts closely with the female portion of her audience—while admiring males keep a respectful distance. According to Charlotte Grieg, Dusty represented to her adoring schoolgirl audience "the height of decadence" and "suggested all sorts of unknown indulgences and pleasures," making her the subject—and, very likely, the *object*—of many adolescent female fantasies.[11]

In gathering her "court," initially composed of teenaged girls but later predominantly young gay men, Dusty approximated the Queen Bee (or Queen B[ulldagger]) figure common in and peculiar to African-American lesbian fiction and culture. SDiane A. Bogus describes this prototype as "a female blues singer who bonds with other women," and who, through "her role as a musical artist, [becomes] a central figure in the community at large," moving and leading her audiences to a collective and even cathartic emotional response.[12] Equally significant as the Queen Bee's sway over her followers is her unorthodox sexual behavior, "her bisexuality, her multiple relations, her liaisons, her lesbianism, and questionable heterosexuality—whatever we call her romantic involvements" (287). Moreover, although generally not a particularly or conventionally feminine woman, she frequently dresses as a femme, or in some paradoxical combination of butch and femme attire—as Springfield does on her early album covers. Yet if the qualities and conditions of the Queen Bee's reign are, as Bogus suggests, inextricable from those of African-American culture and community, the social, economic, and even psychological pressures informing the life of Mary O'Brien and the career of Dusty Springfield were, unquestionably, those of white, middle-class British society. These pressures—and the inevitable limits on any artist attempting to create an art form rooted outside of her or his own culture—eventually redirected Dusty Springfield from the role of Queen Bee to that of another sort of pop culture monarch: the drag queen.

The release of her second album, *Ev'rything's Coming Up Dusty,* in September 1965, marked the first significant change in her solo career. To signal that Dusty Springfield had become a major international star, her recording company presented *Ev'rything's Coming Up Dusty* as an extravaganza in every sense, from its lavish packaging, replete with a gatefold sleeve and photo-

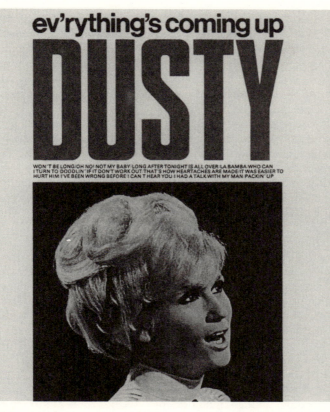

WON'T BE LONG/OH NO! NOT MY BABY/LONG AFTER TONIGHT IS ALL OVER/LA BAMBA/WHO CAN I TURN TO/DOODLIN'/IF IT DON'T WORK OUT/THAT'S HOW HEARTACHES ARE MADE/IT WAS EASIER TO HURT HIM/I'VE BEEN WRONG BEFORE/I CAN'T HEAR YOU/I HAD A TALK WITH MY MAN/PACKIN' UP

Ev'rything's Coming Up Dusty (1965): Becoming all things to all audiences.

filled booklet insert, to its often excessively orchestrated musical arrangements. Over the eighteen months between her album releases, Springfield's
public persona and position as an artist had gradually evolved from that of
the youthful, insouciant, and safely rebellious "girl called Dusty" to that of a
more "serious" performer who attracted a wider (i.e., an older and more
affluent) audience. This modification in style, manifested in both her music
and her sense of fashion, not only simultaneously promoted and contradicted her youth-movement image as the "Queen of the Mods" virtually
omnipresent on British teen-oriented television programs throughout 1964
and 1965, but also represented a stunningly covert, albeit campy, expression
of lesbian sensibility by means of inversion and antithesis.

After the success of the soulfully upbeat "I Only Want to Be with You"
and its sound-alike follow-up, "Stay Awhile," the conventional wisdom of the
recording industry dictated that Springfield, like all female vocalists of the
time, demonstrate another—and possibly safer—side of her artistry by releasing a series of so-called ballads, the typically slow and generally melodramatic
fare commonly associated with heterosexual romantic love.[13] Moreover, in a
period in which recording artists' royalties were relatively low and performers' publicity and travel expenses were deducted from their earnings, Springfield's handlers increasingly pushed her into the cabaret and supper-club

circuit as well as family-oriented "light entertainment" television variety series. These were, at the time, the only truly lucrative venues in Great Britain for women performers who, unlike their group-based male counterparts, had the added expenses of wardrobe, cosmeticians, and hired musicians. Not surprisingly, their clientele required a more socially conforming style of performance and fashion than that presented by an eccentric, blues-singing white girl.

Accordingly, that she might be all things to all audiences, Dusty's subsequent single releases and the repertoire of her second album included a greater number of dramatic lost-love laments and more sanitized family fare, balanced with a proportionate offering of rhythm-and-blues material and songs that amazingly combined elements of both these seemingly opposite modes. *Ev'rything's Coming Up Dusty,* for example, juxtaposes cover versions of Aretha Franklin's "Won't Be Long," Baby Washington's "That's How Heartaches Are Made," and Mitty Collier's "I Had a Talk with My Man" with Anthony Newley's "Who Can I Turn To?" and an embarrassingly exotic rendition of "La Bamba," the latter a souvenir, no doubt, of her Springfield days. Simultaneously, her ballad releases increasingly manifested bathetic emotionality and overblown musical arrangements, suggesting that if a lesbian were required to embody and give voice to the heartbreak of heterosexuality, she would subvert the process by exaggerating it to the point of absurdity through high camp.

Her ironic approach to this excessive sentimentality can be readily discerned in a videotaped *Ready Steady Go* performance of "Losing You," a Tom Springfield composition that served as her British follow-up to "Stay Awhile." After participating with American singer Gene Pitney in a frenetic, high-speed, gender-bending, mimed rendition of "Twenty-Four Hours from Tulsa," Springfield, assuming an attitude best described as amused embarrassment, allows Pitney to escort her, gallantly if awkwardly, to center stage in a seeming satire of conventional heterosexual decorum. Responding to this travesty, she misses the first line of her lip-synched performance ("How many tears do you cry if love should break your heart in two?").[14] Then, after glancing at an audience who regard both her and her song with great mock-seriousness, she giggles through the song's equally "heartrending" second line ("How many tears will I cry now that I know I'm losing you?"). The rest of the song is delivered with camp grandiosity as Springfield makes elaborate gestures of mock melodrama, bemused divalike aloofness, and little connection between the lyrics sung—or, rather, mimed—and her stage actions. Consequently, she inverts the bitter, self-pitying irony of the song's concluding line, "I won't mind losing you," turning it into a comic statement of fact.

This deployment of camp parody eventually extended to her performing attire as well. During the early stages of her solo career, Springfield earned the appellation "Queen of the Mods" from admirers and detractors alike by setting fashion standards for her adolescent female fans. Often purchasing her own clothing from the same relatively inexpensive retailers as her audience, not only did her fans dress as she did, but she as they did. Indeed, during one television performance she discovered a fan in the audience wearing a dress identical to hers—they had both purchased them "off the rack" from Marks and Spencer, a British department store comparable to J. C. Penney. As she was propelled into the world of cabaret and its older, more

sophisticated audiences, however, she found it necessary to assume the evening-gown wardrobe characteristic of the chanteuse.

Within two years of her liberation from the restrictive pseudofemininity to which she was subject as the lady singer of the Springfields, she was, ironically, compelled to assume the role of an "unnatural woman" once again, only now in a more elaborate and glitzy mode. In doing so, she took as her role models the most unnatural "women" of all. By 1966, Dusty Springfield impersonations had become standard fare for British drag queens—while Dusty, in turn, impersonated them: O'Brien notes that "her own image was becoming more outrageous and difficult to control. She took tips from male drag queens, learning what kind of mascara lasted longest, and how to apply the heavy eye shadow. 'Basically, I'm a drag queen myself!' she said later" (83). Springfield learned far more from drag queens than mere cosmetology. To succeed in gaining a wider audience while retaining her earlier following, and to blur the distinctions between reality and projected fantasy, she assumed the drag queens' epistemology of camp, a philosophy best articulated by none less than Oscar Wilde: "We should treat all the trivial things of life very seriously, and all the serious things of life with sincere and studied triviality."[15] In this manner, the marginality of the lesbian became a joke the outsider herself controlled.

Camp masquerade allowed the closeted aspect of Springfield's persona not only an outlet but an identity as well, albeit that of a cross-dressed gay man. While the status of lesbians in pre-1970s Britain might seem privileged when compared with the legal persecution to which gay men were subjected, the very criminality of male homosexuality gave it definition and even an aura of outlaw glamour, unlike the relative invisibility and nonidentity of lesbians during the same period.[16] Moreover, the dichotomy between drag queens' public and private lives often paralleled the disjunctions in Springfield's own experience. Val Wilmer describes the double existence of her drag queen friends—among the few "safe" friends for a lesbian in the British entertainment industry—during the mid-1960s:

> On stage, these men could be sad or hilarious by turns, but they seemed to revel in the insults and coarse badinage. . . . Backstage, though, it was a different story. . . . [They] drank heavily, were nervous and self-deprecatory. One covered his nervousness with bluster but they really were stereotypical queens for whom life was probably a lonely existence. (161)

The lonely, nervous, and self-deprecatory Mary O'Brien, who was ever present in Dusty Springfield most likely found kindred spirits in these outcasts from respectable society. At the same time, paradoxically, her own adoption of drag allowed her a mode of purely lesbian expression in a context in which virtually no lesbian "femme" aesthetic existed. At a time when mini-skirts and revealing bodices were the standard attire for fashionable women, particularly those constantly in the public eye, Springfield effectively deflected the heterosexual male gaze through her elaborate and concealing guise of gowns, wigs, false eyelashes, and cosmetics.

This masquerade could not, however, completely reconcile Dusty Springfield to the alien atmospheres of the cabaret and family entertainment.

She therefore sought a trump card that would allow her to exert control over her own career. Her means to this end was the recording of a relatively arcane Italian popular song refitted with English lyrics by Simon Napier-Bell, the grand con-man of sixties pop, and *Ready Steady Go* producer Vicki Wickham.[17] "You Don't Have to Say You Love Me" was a phenomenal international success, topping sales charts throughout the English-speaking world and continental Europe. In creating this triumph, Springfield quite consciously embellished her drag queen persona with yet another facet of gay male camp—sheer tragedy and queen melodrama: "I chose 'You Don't Have to Say You Love Me' because it's commercial," she frankly admitted, adding "it's good old schmaltz" (O'Brien 83). The success of this recording resulted not from her appeal to the lowest common denominator of public taste, but rather from the artistic balance she maintained in its performance. What set it apart from pure kitsch is that she, like any grand diva, treated this work of somewhat dubious artistic merit with the integrity and creative energy one would bestow upon an aria. For better or worse, "You Don't Have to Say You Love Me" firmly established Dusty Springfield as *La Prima Donna Assoluta* of Pop.

Throughout this period, Dusty continued to push her drag queen image to even greater extremes, donning ever more extravagant gowns and appearing in complex combinations of wigs, chignons, falls, and other hairpieces. However outrageous and attention-getting this masquerade may have been, it had, like all divided lives, very definite limits. Although she had established a considerable and supportive gay male following with whom she enjoyed a level of mutual sympathy and identification, Springfield nonetheless faced tremendous professional and personal frustration. While obviously relishing her new and greater success, she continued to seek the woman-centered ethos and identification with fellow female outsiders available to her only through the music of American rhythm-and-blues girl groups.

As she became increasingly unable to bridge the gap between disparate musical modalities, her artistic output became radically inconsistent both in kind and in quality, as evinced by her disappointing third album. The ironically, if aptly, titled *Where Am I Going?* is a chaotic jumble of divergent and conflicting musical and visual styles. Packaged to evoke a Carnaby Street Mod trendiness that was, by 1967, giving way to hippy sensibilities, the cover displays a thoroughly campy photo of the artist, standing knock-kneed in a minidress and wearing a flower-bedecked straw hat. The title, issuing forth from her mouth in a cartoon-style balloon, is rendered in orange and magenta psychedelic lettering—despite the absence of anything in the repertoire even remotely resembling the then-nouveau acid rock. The pretentious sleeve notes, which pointedly demean the irrelevant "information" dispensed on her earlier album covers, merely reiterate it—only less coherently. The product inside the package is equally confused. While soul selections predominated on previous album releases, here they are not only bogged down by over-orchestration but also outnumbered by Broadway musical songs and syrupy, lugubrious ballads, including the Jacques Brel-Rod McKuen tearjerker, "If You Go Away," replete with an interpolated passage spoken in carefully articulated French. The album's release was met with critical indifference and poor sales, marking the first of many low points in Dusty Springfield's career.

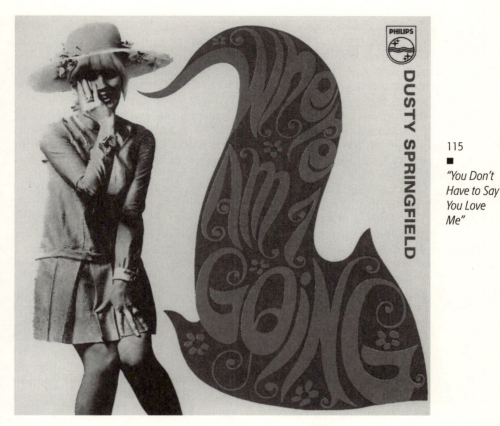

PHILIPS

DUSTY SPRINGFIELD

115
■
"You Don't
Have to Say
You Love
Me"

Where Am I Going? (1967): The title—and the cover—tell it all.

Within months of this dismal commercial and artistic failure, Dusty launched the project that would secure her lasting critical acclaim and assure her place in rock posterity, even through her long period of relative obscurity. Early in 1968 she entered into a long-sought contract with Atlantic Records, a major American purveyor of rhythm-and-blues music since the 1940s. She traveled to Memphis to cut an album at American Studios, where Aretha Franklin habitually recorded. Not only was this done at Aretha's studio; it was recorded with Aretha's musicians and with Aretha's backing vocalists, the Sweet Inspirations, and produced by Aretha's producer, Jerry Wexler. Although overdetermined even beforehand by the Queen of Soul's presence in absentia, the sessions resulted in what is beyond question her finest record-ing, *Dusty in Memphis*. Lauded by American pop music critics, who had heretofore considered Springfield a somewhat more interesting member of the same league as her compatriots Petula Clark and Cilla Black, the album brought her a new American following among white and black audiences alike and established her as a "credible" artist at a time when authenticity and sociopolitical relevance were becoming the criteria for both critical and popu-lar success.

Paradoxically, her greatest musical triumph was also the beginning of her downfall. During the recording sessions she was self-conscious in a

"foreign" environment, and her dealings with Wexler, who maintained authoritarian control in the studio, became increasingly strained. If Wexler did not create Springfield's reputation as a neurotic, demanding, and "difficult" woman, he has certainly perpetuated it through numerous public statements over the years. The sessions were also charged by rumors of her sexual "perversity." Pianist Bobby Woods, in an incredible admixture of absolute candor, "good old boy" gaucherie, and unreflecting homophobia, describes the atmosphere in the studio: "It was a kinda icky situation. I didn't want to get too close to it. At that time people didn't dare come out of the closet. In the country where I came from, if someone found out someone was homosexual you either got hung [*sic*] or ran out of town. It was that strong. I was a naive Southern Baptist boy. I'm not judging her, that's between her and the Almighty" (O'Brien 156).[18]

Dusty in Memphis also carved a complete dichotomy in her recording career and in her modes of masquerade and style. As Atlantic issued the album in the United States, Philips, which remained her British label, regarded her new grittier soul style with disapprobation and, perhaps, unarticulated racism. British audiences, accordingly, were treated to *Dusty . . . Definitely,* a collection of easy-listening ballads packaged with a photo of the artist smiling demurely and semi-reclining in a lavish, canary yellow, sequined gown. In place of the soulful "Son of a Preacher Man," the initial hit single from her American album, Philips released "I Close My Eyes and Count to Ten," a piece of ersatz grand opera accompanied by Liberace-style piano and full orchestra. Divided between two recording companies in two countries, Dusty Springfield's masquerade became irrevocably bifurcated. She was now a "blue-eyed soul singer" for her American audiences; in Britain she remained a female drag queen. Never again would she—or could she—negotiate both identities simultaneously.

Although under contractual obligation to record three albums for Atlantic, she did not return to Memphis for a projected second set of sessions with Wexler and his associates. Instead, she recorded the optimistically titled *A Brand New Me* under the auspices of Leon Huff and Kenneth Gamble, pioneers of the 1970s "Sounds of Philadelphia." A recording of considerable merit in its own right, *A Brand New Me* proved an only moderate commercial success after its American release in 1970. In Britain, however, where it was released as *From Dusty . . . with Love,* the album fared poorly, plagued not only by Philips's underpromotion but also by the self-competition resulting from the almost simultaneous rerelease of *A Girl Called Dusty.*

Springfield had heretofore been a major British star with a modest American following; now, as her British popularity began to wane, she was at the peak of her success in America. But rather than utilizing her newfound American acclaim to its utmost potential, her ever-conservative management chose to construct the next phase off her career according to the model deployed in Great Britain several years before. Although Springfield's favor with American critics and audiences was based, by this time, on her unique soulish stylings, she was booked for engagements in Las Vegas, America's ultragrandiose version of the cabaret and supper-club circuit. Finding herself in a venue that historically has provided a congenial atmosphere for any number of performers who have presented variations of the drag queen figure (e.g., Liberace and, in his final stages, Elvis Presley), Springfield, conceiv-

ably weary of the masquerade she had virtually embodied, felt repulsed by the ethos of the gambling capital of the universe and returned to England in a fit of high dudgeon.

Soon after this homecoming, Dusty startled the public by answering the unspeakable question that had dogged her since the beginning. In an interview in the London *Evening Standard,* she utterly demolished the image of asexuality her publicists—and perhaps even she herself—had long and carefully cultivated:

> A lot of people say I'm bent, and I've heard it so many times that I've almost learned to accept it. . . . I couldn't stand to be thought of as a big butch lady. But I know that I'm as perfectly capable of being swayed by a girl as by a boy. More and more people feel that way and I don't see why I shouldn't." (O'Brien 106)

Although rock stars could, as a rule, openly conduct unorthodox heterosexual lives with near impunity by 1970, virtually no highly visible popular performer had—or would—make a public admission of his or her still-taboo homosexuality.[19] Val Wilmer posits that "although there is just as much lesbian and gay activity among musicians as in any other sector of society," the music industry has in practice tended to be "a rather conservative world, particularly in its expectations of how women should behave" (168). When considered in this historical context, the sheer courage—if not the downright recklessness—behind Dusty Springfield's coming out is little short of amazing. At the same time, her own fear of being perceived as a "big butch lady," as well as her statement that "I could never get mixed up in a gay scene because it would . . . undermine my sense of being a woman" (O'Brien 107), are indicative of the baleful self-image from which many, if not most, lesbians then suffered. In 1970, Women's Liberation and Gay Liberation were still in their infancies and had yet to make significant inroads into the social consciousness of most individuals, much less that of the general public in Britain and America.

Whether intentionally or not, this gesture of candor allowed Springfield to unburden herself of both a masquerade and a career that had become untenable. Trends in popular music had shifted in the early 1970s; the primary emphasis was on the "socially conscious" singer-songwriter, while "simplicity" and "naturalness"—albeit essentially artificial in and of themselves—informed rock sensibilities. Having based her career on being much that she was not and little that she in fact was, Springfield found no place for herself in this new rock order and was left feeling that "I had run out of things to do. . . . I could feel the rot setting in" (O'Brien 107). When the storm of controversy over her sexual revelation subsided, Dusty Springfield simply and quietly disappeared from the music scene.

LATE IN 1972, relocated in Los Angeles and freed from further contractual obligation to Atlantic Records, she returned to the recording studio, hoping to begin a new phase of her career. Instead she experienced a fifteen-year cycle of even more ineffectual management, abortive comeback attempts, and record company bankruptcies, along with recurring bouts of drug and alcohol abuse, hospitalizations, abusive relationships, and suicide attempts.

Her tragedy queen persona of the 1960s had become a self-fulfilling prophecy in the 1970s.

While Dusty drifted in the demimonde of West Hollywood, seemingly forgotten by the public, she nonetheless maintained the loyalty of a large gay following. Her 1978 album *Living without Your Love* was no more success-ful commercially—and certainly less successful artistically—than any of her other recordings between 1970 and 1987, yet it is noteworthy for "Closet Man," a surprisingly open song through which she publicly acknowledges her long-faithful gay supporters. Recorded at a time when Florida orange juice spokeswoman Anita Bryant was leading her fundamentalist Chris-tian cohorts in a crusade of legislative gay bashing, the song declares that homosexuality (discreetly referred to as "it") is "older than religion, and quite honestly more fun"; and while Springfield and her chorus repeatedly assure her listener that "your secret's safe with me," she nonetheless encour-ages him to "come out into the light."[20] Despite suffering from the same musi-cal blandness that afflicts the entire album, this song is remarkable for the singer's courage in recording it, a courage few other artists then demon-strated.

While her recordings throughout this long period of relative obscurity were, without exception, commercial failures, Dusty Springfield was not without her artistic triumphs in those years. The most notable of these is the 1982 album *White Heat,* which she coproduced. The album is a compelling work in the technopop genre then being pioneered by such gender-benders as the Eurythmics, Prince, and Culture Club. The sexually forthright songs that constitute its repertoire are a far cry from the pathos and melodrama of "You Don't Have to Say You Love Me" and demonstrate, perhaps for the first time, Dusty Springfield's musical persona as subject rather than object. Although it demonstrated considerable artistic merit, *White Heat* remains the most obscure of her recordings. Lost in a maze of record company financial failures, it was unreleased in England, unpromoted in the United States, and, consequently unsold and unknown virtually everywhere.

Despite the severity of the ensuing disappointment, Springfield made one more comeback attempt in 1985, this time at the urging of gay British supporters. When this, too, failed, with even more acrimony and embarrass-ment than her many previous forays, she quietly retired from the music busi-ness. She returned to California to live and work on a ranch devoted to the preservation and rehabilitation of wild animals defanged, declawed, and sub-sequently abandoned by owners who had attempted to domesticate them. Seeing, perhaps, a metaphor for herself in these maimed creatures, she used her past celebrity to publicize her newfound cause. It was, then, with consid-erable reluctance—and allegedly a year of delays—that she accepted the offer of the Pet Shop Boys, a newly popular queer British technopop duo, to record "What Have I Done to Deserve This?" Their collaborative effort eventually returned her to fame and the top of the popular music charts.

ALL THIS RETURNS US to the two rhetorical questions posed at the begin-ning. The answer to the second question, "What's a girl to do?"—especially when the last thing she can do is be herself—should, by now, *be obvious.* Even while Dusty Springfield was missing from the public eye, she remained a cult figure, not only to her 1960s devotees, but to a new generation of gay and les-

bian fans as well. And this leads us back to the first question: "What becomes a [semi-]legend most?"

From the 1970s to the present, an unofficial Dusty Springfield fan club, many of whose members are gay men, has persisted in England.[21] Lucy O'Brien suggests that these men find a reflection of themselves in their cult diva, and respond particularly to "her warmth, vulnerability, and a stage show that is . . . camp in its melodrama" (127). For her smaller, but equally loyal, lesbian following, identification with Springfield and her music, while just as personal, has had, as Val Wilmer suggests, sociopolitical undertones as well: "I was sure of a welcome, confirmation as well [from her music], years before any of us became aware just how much such self-expression is necessary for spiritual survival. With *Dusty in Memphis* on the [tape] deck I felt safe. She was something of a lesbian icon, a singer we thought of as one of our own" (314).

That Dusty Springfield is indeed "something of a lesbian icon," may well account for her popular resurrection. Although the heterosexual women who have traditionally served as the popular tragedy queen icons of gay male culture (e.g., Judy Garland, Edith Piaf, Marilyn Monroe) have often died prematurely and unnecessarily, the figure of the lesbian heroine is that of a survivor—and Dusty Springfield, perhaps in spite of herself, proved to be that after all. Having regained her fame through the success of "What Have I Done to Deserve This?" she returned to England to enjoy her *new* status as a living legend for a *new* era of rock musicians and fans.

During the years of her absence important aspects of the social dynamics and gender politics of rock changed. Although the rock world remains a predominantly heterosexual and male field, openly lesbian performers such as k. d. lang and Melissa Etheridge, among others, have made their mark. At the same time, a sufficient number of gay men—whether such technopop pioneers as the Pet Shop Boys and Erasure, who transformed the seventies disco sound into a witty and intelligent synthesizer-based art form; such latter-day tragedy queens as Marc Almond and Morrissey; or such dance bands turned gay militants as Jimmy Sommerville's band the Communards and Frankie Goes to Hollywood—have exerted significant influence on the shape and direction of contemporary popular music.

Dusty Springfield, for own her part, continued her famous ironic camp, making television commercials for the British orange juice industry—and thus playing Anita Bryant with a decided twist. She also resumed her recording career. Her 1990 album, *Reputation,* although not released in the United States, proved moderately successful in England and enormously popular on the Continent, particularly in Germany. Many of the songs on this album explore the problematic nature of secrecy and the dichotomy between public and private life, themes all too familiar in gay and lesbian life. "Reputation," for example, while not specifically autobiographical, addresses the absurd burdens imposed by the need to maintain a false public persona. "In Private" and "Nothing Has Been Proved" (the theme song of the film *Scandal*) both directly address the psychological and social perils of keeping sexual secrets, and, along with "Born This Way," contain suggestive and indirect allusions to homosexuality for the *cognoscenti*. There are remarkably few instances of gender specificity on the album; those that do occur, curiously, are in songs written by Neil Tennant and Chris Lowe of the Pet Shop Boys. In articulating

their lyrics, Dusty, ever the lesbian *en travesti,* can be seen in the subject position of a gay man addressing a male lover and thus retains, even now, this aspect of her 1960s masquerade.

For Dusty Springfield, then, all has come full circle. In a 1988 interview, she assessed the signs of her newly regained fame:

> I'm terribly proud. You know, I've always been ripe material for the drag queens. In England, they love to do me. I went out of fashion for a while, because I wasn't very visible. But I know things must be going well, because they are starting to do me again![22]

Although a middle-aged lesbian diva in drag is something of an anachronism in a music scene that includes such bands as Gaye Bykers on Acid and God and the Lesbians from Hell, Dusty's contribution to popular culture is still obvious. Most of the queer boy bands of contemporary rock music, as well as such androgynous or sexually ambiguous women performers as Annie Lennox, Allison Moyet, Chrissie Hynde, and even Madonna, demonstrate the musical, visual, or aesthetic influence of Dusty Springfield, one of the very first women in rock who dared to "strike a pose."

Afterword: All You Have to Say is "Thank You"

This essay's first incarnation was as a conference paper at the Fifth Annual Gay and Lesbian Studies Conference at Rutgers University in November 1991. This occurred at the height of that phenomenon that some have derisively—and unfortunately—deemed "Madonna Studies." I was amazed at the size of the audience and the outpouring of enthusiasm that greeted the paper. To me, this was not so much applause for my own work, but rather a demonstration of the ongoing appreciation and affection that the gay and lesbian audience—even when comprised primarily of academics—have held for Dusty Springfield. An expanded version was first published in 1993.[23] In the beginning, the "agenda" inspiring this work was an altruistic if, in retrospect, a somewhat naïve one: to preserve a facet of lesbian history—one that for me held great personal significance—lest Dusty Springfield and her contribution to queer culture be forgotten.

My fears were quite misplaced. Upon rereading this essay after the passing of several years, I am struck by the ironies and ephermeralities of popular culture. Bands that seemed so outré and au courant in the early 1990s have vanished with little or no trace; Gaye Bykers on Acid and God and the Lesbians from Hell, the two to whom I referred in my conclusion, came and went without making much of a mark. Even the technopop luminaries whom Springfield influenced seem considerably dimmer these days. When I attempted to explain Dusty Springfield to undergraduates in the early 1990s, it was necessary to do so in terms of the Pet Shop Boys; today, the very mention of the latter generally evokes nervous giggles at the allusion to anyone so apparently passé. To my surprise, a tremendous number of twenty-year-olds know who Dusty Springfield is; some even own copies of recordings she made more than a decade before they were born. It does not matter that she has had no recent hits on the charts, nor has she been visible as a performer in the past seven years. It does not matter because Dusty Springfield is no longer merely a "[semi-]legend"; Dusty Springfield is, quite

simply, an icon. And, I might add, not merely a "queer" or "lesbian" icon—for, in a sense, she has always been that—but rather an icon of postmodern popular culture in general.

Several divergent factors have contributed to this apotheosis. As early as 1992, Rhino Records reissued her two Atlantic albums, *Dusty in Memphis* and *A Brand New Me,* both long unavailable in the United States. The inclusion of "Son of a Preacher Man" (to which Uma Thurman makes her entrance) in Quentin Tarantino's 1994 film *Pulp Fiction* created a new, cultish interest in both the singer and her song. Later in the same year, Springfield made herself visible, if only briefly, by means of *Full Circle: The Life and Music of Dusty Springfield,* a British television retrospective hosted by the comedy team of Dawn French and Jennifer Saunders and since broadcast on various American cable channels. This program served as the harbinger of yet another comeback attempt, the 1995 album *A Very Fine Love,* a curious and ultimately disappointing country-western tinged confection aimed at an easy-listening audience. In and of itself, the album did little to reestablish its artist or gain her a new public, but the reappearance of the now Garbo-like diva and the resultant articles and interviews in both the mainstream and queer-oriented press provided any number of new insights into this unceasingly enigmatic figure. Moreover, the revelation that Springfield had recently been treated for breast cancer—a disease that, coincidentally, is believed to take a disproportionately large toll among lesbians—would seem to have excited that less-than-admirable trait of the general public, that of not truly appreciating the artists who have enhanced our lives until we realize the danger of losing them. The bitter irony was not lost on Springfield: "I know if I die, I'll sell a lot of records. . . . I could be the female Roy Orbison. Of course, then I wouldn't get the royalties."[24]

In her newfound status as living legend, Springfield has nonetheless managed to "sell a lot of records." In a series of moves that uncannily echoes those of the Beatles—albeit on a smaller scale—Dusty Springfield has managed a mid-1990s revival of her past glory through which she has achieved an acclaim far surpassing any she attained in her 1960s heyday. The commercial issue of the videotape of the French and Saunders interview, the British serial rerelease of her 1960s albums in a digitally remastered compact disc format, and Phonogram's 1997 edition of *The Dusty Springfield Anthology,* a splendidly extravagant, three-disc, seventy-seven-song box set with a lavishly illustrated booklet (followed by a one-disc "mini-version" for the more economically minded) have drawn widespread critical attention that has, in many cases, proclaimed her as nothing less that one of the greatest popular artists of the postwar era. Her long-overdue induction into the Rock and Roll Hall of Fame will take place in early 1999, and, as of July 1998, no fewer than three "unofficial websites" dedicated solely to the admiration of Dusty Springfield exist on the Internet, as does "DustyMail," an Australian-based e-mail service that offers her followers around the world a sort of virtual communion of fan worship. Also in 1998, Springfield became, in a manner of speaking, an exchange commodity, selling shares in her future royalties via Prudential Investments, a move that, one may assume, only a true icon—like David Bowie before her—would dare to make. Most recently, Springfield has been awarded the Order of the British Empire on the Queen's 1999 New Year Honours List for services to music.

Springfield has, moreover, become a literary allusion. Patrick McCabe's *Breakfast on Pluto,* a novel short-listed for the 1998 Booker Prize, chronicles the adventures of an Irish drag queen who performs Dusty Springfield as part of "her" show in a local hotel:

> As out I wriggled—truly over the top, I swear!—and launched into the most fabulous version of "The Windmills of Your Mind," completely losing myself in it when I got to the bit about the world being just an apple whirling silence in space. I don't think I was in the hotel at all for three whole minutes, Dusty waltzing through the vast and shining firmament with a microphone in her hand. After that, for mischief, I belted out: "Son of a Preacher Man" and have to say I brought the house down![25]

If, as Springfield suggested in 1988, being "done" by drag queens is an indicator of one's success in life, then truly she has achieved the pop culture equivalent of the Paterian ideal of burning with a hard, gem-like flame.

For Springfield's queer constituency, it is no doubt exhilarating to see the world discover what we knew long ago. Still, as queer culture has evolved, so has Springfield become, ironically, a somewhat more problematic figure. Granted, the liner notes that grace the 1996 British edition of *A Girl Called Dusty* use the "l-word," if only in acknowledging her *following:* "She has survived the vicissitudes of fortune and remains an icon for others (not least among them, a legion of gay men and lesbians around the world)."[26] Indeed, as the scriptural demons said, we are legion; but why we admire her remains unexplained—or inexplicable—in this context. The icon herself, however, remains aloof. Lucy O'Brien, Springfield's erstwhile biographer, has more recently suggested that constant harassment and prying by the homophobic music industry and press have, more than any other factor, accounted for both Springfield's personal problems and the many years of critical and commercial neglect she endured.[27] Those years have taken a severe toll; she is, even now, reluctant to discuss matters of sexuality and unwilling to offer more than a vague self-definition. As Rob Hoerburger notes:

> She won't use the words "gay," "lesbian" or "bisexual" when speaking to the press: "Who's to say what you are? Right now I'm not in any relationship by choice, not because I'm afraid I'd be that or that. Yet I don't feel celibate, either. So what am I? It's other people who want you to be something or other—this or that. I'm none of the above. I've never used my relationships or illnesses to be fashionable, and I don't intend to start now."[28]

The overly idealistic lesbian graduate student who wrote the 1991 version of this essay would have taken umbrage at such reluctance to take a stand, to *come out;* it does fly in the face of the identity politics and political correctness we have learned to regard as sacred. But I, too, have changed since 1991; even if I disagree with her over the meaning of that simple if culturally overdetermined word that labels us alike, I am nonetheless willing to consider with great compassion the guardedness of one who has paid cruel and overwhelming dues for unsanctioned desires.[29]

Dusty Springfield is now, quite deservedly, an icon, a legend. Legends are immortal, but human beings, sadly, are not. As this essay goes to press, she is once more battling the cancer that she had apparently defeated in 1995. In light of all that has transpired in the past seven years, I no longer think we need ask what becomes a [semi-]legend—or even a genuine icon—most, for Dusty Springfield is well beyond that. Rather, I think, we should ask ourselves, the legion of gay and lesbian admirers, what, at this point in time, becomes *us* most. To put a new spin on the title of her greatest hit, I would suggest that *all we have to say is "thank you."*[30]

<div align="right">July 1998–January 1999</div>

POSTSCRIPT

"A lot of people thought that Dusty's life would end in some kind of tragedy, but in the end she proved everyone wrong. She was fab and, because of her music, she always will be."

<div align="right">—Neil Tennant, funeral oration
12 March 1999</div>

<div align="center">

IN MEMORIAM
16 April 1939–2 March 1999

</div>

Notes

1. Although Dusty Springfield personally shuns the word "lesbian," I use it in this essay—indeed, for lack of any other or better word—in the manner delineated by Terry Castle in *The Apparitional Lesbian: Female Homosexuality and Modern Culture* (New York: Columbia University Press, 1993):

> I [use] the term in the "ordinary" or "dictionary" or "vernacular" sense. (A lesbian, according to *Webster's Ninth,* is a woman "characterized by a tendency to direct sexual desire toward another of the same sex.") And indeed, I still maintain, if in ordinary speech I say, "I am a lesbian," the meaning is instantly (even dangerously) clear: I am a woman whose primary emotional and erotic allegiance is to my own sex. (15)

There are sufficient documented statements regarding Springfield, I feel, to justify this "ordinary" and "vernacular" use of the term.

Castle offers a provocative *homage à Dusty* elsewhere in her study of lesbian culture, sardonically defining "lesbian eroticism as we know it today" as being "the kind presumably involving soft lighting, old Dusty Springfield records, multiple orgasms, and so on" (92).

2. The intersections of racial and sexual "passing" in texts by lesbian authors are discussed in Adrienne Rich, "The Eye of the Outsider," in *Blood, Bread, and Poetry: Selected Prose, 1979–1985* (New York: W. W. Norton, 1986); Lillian Faderman, *Surpassing the Love of Men* (New York: William Morrow, 1981); and Lillian Faderman, *Odd Girls and Twilight Lovers* (New York: Columbia University Press, 1991). Discussions of various historical aspects and applications of camp and masquerade as gender subversions may be found in Marjorie Garber, *Vested Interests: Cross Dressing and Cultural Anxiety* (New York: Routledge, 1992); Terry Castle, *Masquerade and Civilization: The Carnivalesque in Eighteenth-Century English Culture and Fiction* (Stanford, Calif.: Stanford University Press, 1986); Terry Castle, *The Apparitional Lesbian: Female Homosexuality and Modern Culture* (New York: Columbia University Press, 1993); Kristina Straub, *Sexual Suspects*

(Princeton, N.J.: Princeton University Press, 1992); and Julia Epstein and Kristina Straub, eds., *Body Guards: The Cultural Politics of Gender Ambiguity* (New York: Routledge, 1991).

3. Lucy O'Brien, *Dusty* (London: Sidgwick and Jackson, 1989), 63–64. Further references are to this edition and are noted within the text.

4. Similarly—and ironically—through Dusty's indirect influence this mode was once again transferred, some two decades later, across lines of gender and race and embodied in Boy George, the great drag queen of punk-rock soul. Boy George and his alter ego, George O'Dowd, manifest uncanny parallels with Dusty Springfield/Mary O'Brien. A gay British Catholic of Irish descent, he grew up trapped in a world in which his sexual orientation and his affinity with black, white, and Asian women could only be expressed through masquerade. Ultimately he created what was certainly the most elaborate and campy identity ruse in popular music, one that easily surpassed Dusty's own. His performance persona, which might best be described as Elizabeth Taylor in the guise of a Rastafarian/Hasidic Jewish geisha girl qua soul diva, along with his widely publicized series of personal disasters and subsequent fall from public grace, firmly established him as the Dusty Springfield of the 1980s.

5. The numerous photographs of Dusty Springfield that appear in the British music weekly *Melody Maker* between 1962 and 1964, indicate that these most visible signs of her characteristic public persona developed during this period, rather than occurring as part of an overnight transformation in 1955, as Lucy O'Brien asserts in her information-filled, if cautiously superficial, biography, *Dusty*.

6. *A Girl Called Dusty* (Philips, 1964) is substantially different in content from her first American album, which bears the cumbersome title *Stay Awhile—I Only Want to Be with You* (Philips, 1964). In the fashion of the day, the American release included material previously released as singles while the British issue did not. As a result, the songs that make up *A Girl Called Dusty* are divided between her first American album and its follow-up, released a year later and simply entitled *Dusty* (Philips PHM 200-156, 1965), and are augmented with material released separately in the United Kingdom. The observations I make here regarding the British album are nevertheless applicable to these two American releases. The covers of *A Girl Called Dusty* and *Dusty* are identical, while the photograph gracing the cover of *Stay Awhile—I Only Want to Be with You* is obviously a product of the same session, as the singer appears in the same clothing in both photos.

7. A similar observation could be made of *Please Please Me,* the Beatles' first album, recorded earlier in 1963. On it John Lennon sings "Baby It's You" and Ringo Starr sings "Boys"; one might speculate if, like Springfield, the Beatles also entertained a secret desire to be the Shirelles.

8. For a discussion of the significance of "You Don't Own Me" and insights into the lives and careers of two other singers who have enjoyed iconic status with lesbian audiences, see "Lesley Gore on k. d. lang . . . and Vice Versa," in *Ms. Magazine,* July/August 1990, 30–33.

9. Val Wilmer, *Mama Said There'd Be Days Like This: My Life in the Jazz World* (London: Women's Press, 1989), 307. Further references are to this edition and appear within the text. It is noteworthy that Wilmer's 1964 photograph of Dusty Springfield performing on "Ready Steady Go" serves as the backdrop for the publicity shot of the Pet Shop Boys used in promoting "What Have I Done To Deserve This?"

10. John Frantz, liner notes to *A Girl Called Dusty*. It is worth noting that while the original cover artwork is reproduced in the 1997 Phonogram (formerly Philips) compact disc (CD) reissue of this recording, these liner notes do not appear. Instead, they have been replaced by Peter Burton's retrospective critique, in which Springfield's gay and lesbian following is, for the first time, given recognition from an "official" source. Noteworthy, too, I believe, the extent to which the new liner notes'

analysis of Springfield's visual semiotics echoes this essay, which was first published in 1993.

11. Charlotte Grieg, *Will You Still Love Me Tomorrow: Girl Groups from the '60s On* (London: Virago, 1989), 97. Correlatively, the hazards of purely heterosexual adolescent female fantasies about Dusty Springfield—or those that fail to see the camp irony inherent in her performances—are well illustrated in Kate Jennings's "Dusty Springfield Grows Up," in *Save Me, Joe Louis* (Harmondsworth: Penguin Books, 1988). I thank Liz Wood for bringing this text to my attention.

12. SDiane A. Bogus, "The 'Queen B' Figure in Black Literature," in *Lesbian Texts and Contexts: Radical Revisions,* ed. Karla Jay and Joanne Glasgow (New York: New York University Press, 1990), 278, 282, 287. As Bogus implies here, the Queen Bee's "homosexuality" is rarely defined precisely An examination of Dusty's few and guarded statements about her own sexuality indicates that she has generally tended to define her involvements vaguely and virtually has never "named names." (See also note 1 above.)

13. I would suggest that this strategy on the part of record companies is inextricably linked with the repressed sexuality of the early 1960s. Dances—for which records, more often than not, provided musical accompaniment—were among the few safe and acceptable public expressions of sexual desire and activity. Hence the commercial demand for recordings suitable for slow dancing, regardless of artistic considerations, was doubtlessly high.

14. Tom Springfield and Clive Westlake, "Losing You" (Springfield Music, 1964).

15. "Robert Ross in Dialogue with Wilde, 1895," in *Wilde: Comedies,* ed. William Tydeman (London: Macmillan, 1982), 41.

16. Although male homosexual activity was outlawed and punishable by imprisonment from the 1880s until the early 1970s, lesbianism has never been a criminal offense in Great Britain. For a most astute discussion of homosexuality and the law in Britain during this period, see Jeffrey Weeks, *Sex, Politics, and Society: The Regulation of Sexuality since 1800* (London: Longmans, 1989).

17. Wickham, who has been Springfield's manager since her 1987 comeback, also masterminded the 1970s transformation of the rather undistinguished girl group Patti LaBelle and the Bluebelles into the campy and flamboyant disco–drag queen combo, Labelle. For an insightful analysis of the creation of Labelle, which is in many ways analogous to the evolution of Dusty Springfield's public persona, see Grieg, *Will You Still Love Me Tomorrow,* 175–79.

18. Aside from this particular matter, however, Woods actually admired her. (See O'Brien, *Dusty,* 99.)

19. It is worth noting in this context that Elton John and David Bowie, who eventually made public statements of their bisexuality, were still only moderately successful performers in 1970. Both came out to the public in the mid-1970s, when, at the height of their respective careers and at a time when the disco craze provided greater visibility for gay men in the popular music industry, their established popularity deflected much of the resulting "fallout" and allowed both to survive relatively unscathed.

20. D. Foster, E. Mercury, and D. Gerrard, "Closet Man" (Cotaba Music/Midnight Wizard), on Dusty Springfield, *Living without Your Love* (United Artist Records, 1978).

21. Dusty Springfield's legendary status among gay men, even those who were not yet born at the height of her fame, as well as her ability to bridge both gender and racial dichotomies, is illustrated in Philip Saville's 1988 film, *Wonderland.* In it, a biracial gay British teenager on the run from the authorities informs a middle-aged gay opera singer—with great seriousness—that although he had never met a star, he had smelled one: his aunt had caught a perfumed handbag that Dusty Springfield tossed

into the audience during one of her 1960s performances. Similarly, the gay bar performance of "I Only Want to Be with You" by a sexually ambiguous singer in Neil Jordan's 1992 film, *The Crying Game,* demonstrates the continuing influence of Springfield and her work in the British gay subculture.

22. Brant Mewborn, "Wishin' and Copin' with Dusty Springfield," *Us Magazine,* 2 May 1988, 59.

23. The original publication may be found in David Bergman, ed., *Camp Grounds: Style and Homosexuality* (Amherst: University of Massachusetts Press, 1993), 185–205.

24. Quoted in Rob Hoerburger, "Dusty Rides Again," *New York Times Magazine,* 29 October 1995, 37.

25. Patrick McCabe, *Breakfast on Pluto* (New York: HarperFlamingo, 1998), 89.

26. Peter Burton, line notes to *A Girl Called Dusty* (Phonogram/Mercury [UK] 534 520-2), 1996. (See also note 10 above.)

27. Lucy O'Brien, *She Bop: The Definitive History of Women in Rock, Pop and Soul* (Harmondsworth, U.K.: Penguin, 1995), 246–48. I had earlier taken issue with *Dusty,* O'Brien's biography of the singer (see note 5 above). While I stand by that criticism, in fairness I would like to applaud *She Bop* as a comprehensive, well-researched, and intelligent overview of women in popular music, perhaps the best work of its sort to date.

28. Hoerburger, "Dusty Rides Again," 36.

29. I have elsewhere articulated my own grievances about the use and abuse of the word "lesbian." (See Patricia Juliana Smith, *Lesbian Panic: Homoeroticism in Modern British Women's Fictions* [New York: Columbia University Press, 1997], xi–xii.)

30. I have taken the phrase, as it is used in the title to the Afterword, from a photograph caption—where it is given a rather different context—in Stacey D'Erasmo's provocative article on Springfield, one of the best journalistic applications of queer theory I have encountered. (See D'Erasmo, "Beginning with Dusty," *Village Voice,* 29 August 1995, 67.)

"GIVE US A KISS"
Queer Codes, Male Partnering,
and the Beatles

Ann Shillinglaw

THE ARTISTIC ACHIEVEMENT of the Beatles has enriched postwar popular culture in innumerable ways, contributing among the finest melodies and most creative musical products of the popular music idiom as well as playing a major role in our figuring of male celebrity. The Beatles are indelibly burned onto the retina of Western postwar popular culture. Their two major films, *A Hard Day's Night* (1964) and *Help!* (1965), display deeply queer sensibilities that have been largely overlooked, both critically and in public opinion; perhaps thanks to this blindness regarding content, the Beatles' global popularity ensured that these queer touches were broadcast to untold millions of viewers. In the general discourse, the queerness residing in these two films, which plays a major role in the films' subversive charm and surrealistic style, has hidden behind the cover of a "zany story" about "boys having a lark." An examination of the overt queer moments and less obvious queer aspects of these films shows that queer has a strong place in the Beatles' cinematic oeuvre. Embedded in their films and in their essential identity as four tightly knit men are signals and codes—some overt, some implied—introducing queerness into the cultural icon that is the Beatles, and perhaps reflecting back to the culture at large its own queer concerns.

A Hard Day's Night:
Queer Rides in Unannounced on Surreal's Coattails
A Hard Day's Night is, in the words of one writer, "the one film guaranteed to ensure [director] Richard Lester his place in cinema history" (O'Brien 511). The film was written by a young Liverpool playwright, Alun Owen, who spent time with the Beatles (Yule 6) and produced a film script based loosely on their frenetic lifestyle. It is a highly influential film, inspiring dreams of rock stardom in legions. For example, the *New Yorker* had this to say about one of rock's deities, Jerry Garcia: "Garcia and his friends went to see *A Hard Day's Night* and metamorphosed from a jug band into a rock band" (Espen 12).

Filmed in only eight weeks (Hertsgaard 80), the film depicts two days in the lives of the Beatles, during which they must perform on a live television

show and care for Paul's grandfather. The film contains a variety of scenes that mirror the surreal quality of their superstar lives and express the Beatles' fresh, freaky essence. The film contains overt references to queerness that show the Beatles as knowing insiders, or utilizers of queer codes to establish that they are a new generation and are comfortable on the unspoken tip of the cutting edge where their parents' generation would not go and to establish a queer sensibility, knowingly or not, of stylish men as icons and objects of pursuit. The Beatles are seen as a strongly homosocial unit, four men for whom women are dangerous outsiders, even threats, and who need each other and belong to each other in a way that excludes the outside world, including women.[1] Both films were made while Brian Epstein, the Beatles' manager, determined the group's clothing and overall style. Paul McCartney notes about Epstein that "his real thing was the *flair*" (Giuliano 304). Epstein's homosexuality was accepted by the Beatles and has subsequently become widely known; what is not so widely acknowledged, however, is how deeply queer moments—perhaps the result of the Beatles' association with a gay manager and friend, perhaps not—are rooted in their films.[2]

The Overtly Queer in *A Hard Day's Night*

Early in the film, the boys encounter in their train compartment a snobbish older gentleman and in a moment of verbal conflict that engages issues of class, Lennon leans in close to the man and says, "Give us a kiss." The man is equal to Lennon's queer threat and does not respond, revealing an aristocratic composure in the face of Lennon's working class, gender-bending boldness. The Beatles then leave with a witty riposte. "Give us a kiss" is an in-your-face queer moment. It establishes Lennon as the challenging personality of the group, the fearless breaker of barriers, and it occurs in the same scene as the film's first breakout into surrealism; they magically appear outside the man's train window, running, riding a bike, and shouting, to the man's stunned amazement. Queer thereby becomes quickly linked to the surreal.

Later, calling a man a queen becomes the basis of verbal wordplay in a dressing room scene. Ringo Starr sits under a hairdryer wearing a grenadier's hat and reading the women's magazine *Queen* as if this were perfectly normal—thus creating a surreal scene in which queerness slips in. Lennon observes, "Hey, he's reading the Queen!" Lennon makes his meaning even more clear by adding, "That's an 'in' joke, you know." In another scene, Lennon plays the royal herself. In a queenly falsetto he takes scissors to a measuring tape held by their tailor and announces, "I now declare this bridge [snip] open." He overtly takes on the mantle of the queen to play with the image, to project his role as a barrier-breaker and humorist and to rebel against his manager Norm's straight(laced) authority.

Shortly after Lennon's in-joke gay reference, Paul's grandfather declares, "It's my considered opinion that you're all a bunch of sissies!" Lennon answers playfully, "You're just jealous"—a perfect queer comeback if ever there was one—but Lennon is reprimanded by Norm who threatens, "Leave him alone, Lennon, or I'll tell them all the truth about you." This implies Lennon has a shameful secret and in the context of being called a sissy, the secret is not hard to assume. Lennon says in a soft voice, "You wouldn't." "I would, though," Norm replies. Lennon gives in. The threat of

exposure is too much, and audiences are left to wonder what the "real" Lennon might be concealing if the fictional representation of himself has secrets.

These queer moments, performed in the name of surreal humor, cannot be misread. They add up, one after another, as the film unfolds. To bring Starr out of a sulk, for example, Lennon serenades him with the lyric, "If I fell in love with you, would you promise to be true?" In another, even more remarkable scene, the Beatles are crowding through a backstage hallway when Lennon stops to take in an actor in historical costume. John admires him and says approvingly, "Gear costume." The actor sizes him up and with noticeable gay inflection, propositions him with the single word, "Swap?" John replies "Cheeky!" and laughingly continues on his way, showing homosexuality to be something that could be engaged in fun. The actor's implication that John's mod suit is just another costume is apt. Beatle suits are a costume; the film self is a costume.

The Beatles' knowledge of gay codes positions them as knowing cultural insiders. For example, when they observe the effeminate TV director, played by Victor Spinetti, walking away with a girl assistant and one Beatle wonders aloud if the man's wife knows about the girl, Lennon quips, "[I] bet he hasn't even got a wife. Look at his sweater." This knowing reading of a fuzzy, angora, V-neck sweater as a sign adds to the audience's sense that the Beatles exist deep inside codes and disguises. The comfortable knowledge of gay codes as a sign of coolness becomes a part of the Beatle's cultural contribution.

Camp abounds in the film. The TV director is shown coming close to a campy, hyper-calm breakdown when the four lads nearly fail to meet their live TV air time, and he is seen singing along to an opera performance. The opera is disrupted, appropriately, by Paul's raging hetero grandfather, who pops up center stage through a mechanical goof.

In her essay written in the same year as *A Hard Day's Night*—1964—Susan Sontag makes observations about camp, which she links strongly to homosexuals and that resonate significantly in relation to the film. Sontag notes, "Clothes, furniture, all the elements of visual decor, for instance, make up a large part of Camp" (278)—and these items have a large role in Beatle films. She implies the Beatles' music is camp in comparisons of camp with non-camp when she writes: "There is a sense in which it is correct to say: 'It's too good to be Camp.'. . . Thus the . . . works of Jean Cocteau are Camp, but not those of Andre Gide; . . . concoctions of Tin Pan Alley and Liverpool, but not jazz" (278). Sontag also considers British television's "The Goon Show" to be camp (282), and it is interesting to note that the American Richard Lester was associated with the Goons, especially Spike Mulligan and Peter Sellers, with whom Lester had produced surreal TV work prior to working with the Beatles (Murphy 114).

Perhaps the highest camp moment in the film occurs when the Beatles wander onto the sound stage and find a TV choreographer tripping through dance steps with showgirls. The dancer defines the term "light in his loafers" as he tiptoes through his paces, and Lennon cannot resist participating in camp; he erupts in an energetic dance. The stage set bespeaks over-serious excess; it is adorned by large-sized graphics of insects (beatles?). Sontag notes, "Camp is art that proposes itself too seriously, but cannot be taken

altogether seriously because it is 'too much'" (284). Lennon quickly recognizes the camp of the dancers and delights in it, joining in for a moment.

In addition to their employment of gay codes and camp, the Beatles enjoy the privilege of a highly stylized, exclusionary language meant for, and shared by, cultural insiders. For example, Harrison must define his term "grotty" for a marketing executive, who does not know it means "grotesque." McCartney says "straight up" to mean "I'm telling it to you straight," and words like "gear" and in-jokes like Lennon's sneer, "You're a swine," bespeak insider privileged communications that destabilize outsiders. Obfuscatory dialogue fills the film. In fact, in one scene, George Harrison's language is even too surreal for his partners to comprehend; when he says, "But don't rush none of your five bar gate jumps and over sorts of stuff," McCartney asks, "What's that supposed to mean?" "I don't know," Harrison says, "I thought it just sounded distinguished-like." The Beatles occasionally appear to be speaking in code, and their Liverpudlian accents render some comments nearly indistinguishable. As a collaboration between four men, the entity of the Beatles is rife with "double talk." In a discussion of male literary collaborations of the past, Wayne Koestenbaum states, "Collaborators express homoeroticism and they strive to conceal it" (Double Talk 3). He notices that something interesting goes on when men collaborate on creative projects. Koestenbaum writes:

> When two men write together, they indulge in double talk; they rapidly patter to obscure their erotic burden, but the ambiguities of their discourse give the taboo subject some liberty to roam. Looking at a variety of specimens of "double talk," I apply to each the same paradigm, which is, bluntly stated, that men who collaborate engage in a metaphorical sexual intercourse, and that the text they balance between them is alternately the child of their sexual union, and a shared woman. (Double Talk 3)[3]

The Beatles' union is a collaboration on many levels, from creating shared lyrics and melodies to films, performances, interviews, and deep personal bonds. It can be argued that a homosocial tendency runs throughout each element of their remarkable collaborative shared experience.

Less Overt Queer Elements:
The Threat of the Female in *A Hard Day's Night*

In this film, females constitute a clear threat. In the opening credits, the four men flee a crowd made up almost exclusively of women, who chase them like hounds after the kill. George tumbles onto the sidewalk in what looks like a genuinely painful fall, and the race to get away from their female pursuers is shown as both comic and serious. Screaming hordes of women can do real damage and the Beatles are aware of this as they duck through the train station.

In the train car, the male fear of female rejection is implied when Paul introduces his grandfather as "nursing a broken heart." We first see John and Paul's attempt to charm schoolgirls in uniform in the dining car fail. The girls reject them when Paul's grandfather implies they are criminals. Ringo and George, the other Beatle couple, wander down a train carriage and, peering

into a compartment, discover an attractive woman sitting with a little dog. The woman beckons to Ringo. George encourages him to take up her silent invitation. But Ringo responds with fear, saying, "No, she'll only reject me in the end and I'll be frustrated." "You never know; you may be lucky this time," George says dourly. "No, I know the psychological pattern," Ringo replies, "it plays havoc with me drumskins," a strange comment that no doubt makes a double entendre about the male organ and actual drumskins. He would rather retreat to the male partnership of his male Beatle comrades than venture into that railway carriage to suffer at the hands of the appealing woman.

Homosocial Quality of the Beatles' Male Partnership

This film's central energy comes from homosocial activity, as defined by Eve Kosofsky Sedgwick:

> Homosocial is a word occasionally used in history and the social sciences, where it describes social bonds between persons of the same sex; it is a neologism, obviously formed by analogy with "homosexual," and just as obviously meant to be distinguished from "homosexual." In fact, it is applied to such activities as "male bonding."... To draw the "homosocial" back into the orbit of "desire," of the potentially erotic, then, is to hypothesize the potential unbrokenness of a continuum between homosocial and homosexual—a continuum whose visibility, for men, in our society, is radically disrupted. (1)

John, Paul, and George are shown standing in private with pretty showgirls in sexy, bejeweled costumes, but instead of responding to them with hetero intent, the Beatles treat the women as if they were hard, plastic mannequins, fingering their clothing as if the flesh wearing it were not real. When George announces that Ringo is missing, John and Paul turn from the sexually available women as if they no longer existed.

Paul's grandfather convinces Ringo that the other Beatles do not give him enough respect, and Ringo, feeling hurt, deserts them. His little journey of separateness, accompanied by a sentimental instrumental rendition of "This Boy," teaches him how badly he needs his boys; he will not only be rejected by women but by society in general. Starr dons a disguise and to test its effectiveness approaches a girl outside a shop. Her disgusted reaction tells him the disguise is working while at the same time sending the message that the "real" Ringo, unprotected by his Beatle identity, meets with harsh treatment from women. Later Starr tries to act the gentleman when he lays down his coat over puddles for a woman. She thankfully traverses the mud until Ringo unknowingly covers a manhole and she falls deep into the mud—at which point the policeman observing him decides that he is a danger to society. Starr is harmed by his attempt to perform a traditional boy-girl convention. He is also shown up by a "real" man, a worker who emerges from the manhole accompanied by the woman. During his solo time, Ringo encounters a boy alone who mirrors himself, and the boy leaves Starr to join his three mates—reminding us that a boy belongs with his mates and heightening Starr's sense of being alone.

The outside world is an unfriendly place to the other Beatles as well. The solo episodes highlight the protection their male partnership provides.

Their need for each other and the sanctuary of their male partnership is a shared experience. This echoes the life of the closet, a world of inner and outer selves, where the outer self is a mask or protective shell, such as the recognizable Beatle identity that makes women swoon, while the vulnerable "real" self learns to stay hidden to avoid pain and rejection, as enacted here by females.

In each of their solo scenes, the Beatles go unrecognized and we see how they would be treated without the protection of their Beatle identity—an identity created by, and dependent on, their male partnership. Lennon's scene in a theater hallway is a surrealistic bit of dialogue with a woman who mistakes him for "him," then realizes John cannot possibly be "him," a turn that rejects Lennon. "She looks more like 'im than I do," he mutters as he retreats, again playing with gender rules. George tells a snooty marketing executive what he really thinks of the man's attempt to be "fab" and gets thrown out of his office as a troublemaker, echoing Ringo's fate. (Paul's scene with a costumed actress was cut by Lester.) These encounters remind the Beatles how much they need their Beatle selves and their Beatle partners. In a 1995 *Newsweek* cover story, George Harrison comments on the obviously split self with which the Beatles had to contend: "I am not really 'Beatle George.' 'Beatle George' is like a suit or shirt that I once wore on occasion and until the end of my life people may see that shirt and mistake it for me" (Giles 64).

The Beatle's bond with each other is exclusive of women and, the film argues, must remain so. This bifurcated self resonates in much of marginalized gay identity. The film is a conceit purporting to show the Beatles' "real" lives. Some viewers still mistake it for a documentary, and the conceit of the four *playing* themselves in a fictional film echoes the gay life experience in a hetero-dominated world. As Wayne Koestenbaum notes in *The Queen's Throat,* in a discussion of Maria Callas, "Her operative performances seemed real; her real life seemed operatic. Since Oscar Wilde, this confusion between mask and truth has been a cornerstone of gay culture" (140).

Such a queer reading of the male partnership and its implicit rejection of the female might surprise film viewers who have not examined the basic film conceit of playing acting as themselves. Other film goers might not want to problematize the Beatle bond or pry too deeply into their cover story that, "no, actually we're just good friends" (a phrase that resonates throughout the film after it is uttered as a repeated non sequitur by McCartney to a reporter during the press conference scene). As Alexander Doty states, queer readings are not necessarily a reading *of* the margins, even though queer readings have historically been forced to exist *on* the margins. Doty writes: "I've got news for straight culture: your readings of texts are usually 'alternative' ones for me, and they often seem like desperate attempts to deny the queerness that is so clearly a part of mass culture" (xii).

It is possible to see the Beatles' entire performances in *A Hard Day's Night* and *Help!* as one tremendous act of camp. The Beatles' conceit in both films of acting as themselves expresses a camp sensibility. Sontag notes, "To perceive Camp in objects and persons is to understand Being-as-Playing-a-Role. It is the farthest extension, in sensibility, of the metaphor of life as theater" (280).

Perhaps the most important moment of joy in the film comes when the four break free from the confinement of their career imperatives and run down a fire escape onto an empty playing field. The four run, jump, dance, play and exude such perfect joy in their friendship that the "Can't Buy Me Love" scene is a centerpiece of the film. The images of John, Paul, and George falling from the sky in slow motion present the male body as an object of high style for its own aesthetic sake as the male form cuts through space in artful fashion. Given the film's many images of woman as a pursuing, dangerous threat, the absence of women is felt in the Beatles' relief and contributes to the homoerotic or homosocial subtext of this famous scene. Hetero union with the female is not the apex of joy; freedom with one's male partners is the apex. Doty notes, "Queer readings aren't 'alternative' readings, wishful or willful misreadings, or 'reading too much into things' readings. They result from the recognition and articulation of the complex range of queerness that has been in popular culture texts and their audiences all along" (16).

It is perhaps useful to note that queerness plays at the margins of real-life Beatle encounters with the press. When one interviewer asked, "What are your feelings on the 'hints of queerness' American males found in the Beatles during the early days of your climb to popularity?" Paul replied, "There's more terror of that hint of queerness—of homosexuality—here than in England, where long hair is more accepted" (Giuliano and Giuliano 67). When an interviewer asked in 1966, "May I ask about the song 'Eleanor Rigby'? What was the inspiration for that?" Lennon answered, "Two queers" (Giuliano and Giuliano 87).

There is also a notable homoerotic quality to shots of McCartney and Harrison sharing a microphone. They move fluidly toward each other with mouths open; they sing together, then move back from the microphone when their shared chorus is sung; and all is performed with smooth, rhythmic motions.

The tightness of the Beatles' union is shown explicitly in one brief but telling moment. When the three run outside to the sidewalk to find Starr, McCartney says, "Split up and look for him." He heads in one direction, but Harrison and Lennon tag behind. When McCartney turns to find them at his side, Lennon says lamely "We've become a limited company," as a way of explaining his inability to leave his partners. Paul has to point in the opposite direction to force them to separate from him.

The Feminized Manhood
of the Beatles in *A Hard Day's Night*

From the vantage point of the 1990s, after decades of rock musicians sporting highly feminized clothing, hair and makeup, it is hard to remember that in their time, the Beatles were perceived by some audiences as feminine. *A Hard Day's Night* presents a feminized kind of manhood in the Beatles. We see them combing their hair, tossing their hair in a girl-like fashion while performing their music, standing before mirrors, and showing great concern for their appearance. The Beatles are linked to questions of fashion and hairstyle in a way that in the sixties was considered unmanly by some. In the film's press conference scene, journalists ask the name of their hairstyle and type of

jacket collar. But when Ringo is asked how he likes his girlfriends to dress, he can only respond with an awkward laugh. When George Harrison sits in the marketing executive's office, he is asked his taste in shirts. It is also interesting to note that all Ringo needs to disguise himself is a hat and overcoat, a superficial ensemble that only hides his clothes and hair, the two external features the Beatles are most associated with—as are women, usually, as well. In a 1980 interview, Yoko Ono told a journalist, "The feminine side of society was represented by them [the Beatles] in a way" (Lennon, Ono, and Peebles 29); later, in real life, Lennon would famously serve as house-husband while Ono tended to their financial affairs.[4]

The Beatles are also feminized in this film by their position as caretakers of Paul's grandfather. Paul must serve as a mother figure, constantly asking his grandfather's whereabouts and worrying about his well-being. As Ringo complains when charged with watching the elderly man, "I'm a drummer, not a wetnurse." The gender cross-signals extend to their managers, Norm and Shake; Norm worries about Lennon's attempts to drive him crazy with a helpless passivity, and Shake tells the doorman at an exclusive club who attempts to halt his entry, "I'm with them. I'm Ringo's sister."

The Beatles play with gender in this film by presenting what at the time was conceived as an effeminate kind of manhood—the result, perhaps, of the stylistic sensibilities of the gay man who managed their style choices and careers. This play with gender is not inconsistent with theories today (largely feminist critical theory) that claim gender to be a thing to be played with—not a natural given, but a construct. As Judith Butler notes in *Gender Trouble*:

> If the inner truth of gender is a fabrication and if a true gender is a fantasy instituted and inscribed on the surface of our bodies, then it seems that genders can be neither true nor false, but are only produced as the truth effects of a discourse of primary and stable identity. (136)

While gender becomes unstable with the four men, and their adherence to codes of manliness fades and shifts, the film provides a raging heterosexual counterpart to their sexless interaction with women. Paul's grandfather exhibits a rampant heterosexual desire to engage with women, a drive that is perceived as a danger that works hand-in-hand with his troublesome tendency to create misunderstandings between usually friendly people, such as Norm and Shake. His "dirty old man" tendencies are referenced in the film's repeated non-sequitur descriptions of him as "a clean old man." The threat he poses to the Beatles' male partnership is also referenced in McCartney's warning to his comperes about his grandfather: "He's a king mixer. He hates group unity, so he gets everyone at it [arguing]."

Within the Beatles' male partnership is a hint of the kind of dominant/submissive pattern evident in patriarchal heterosexual relations, with Ringo Starr in the role of the submissive or most feminized member of the partnership. (His position can also be understood within the occupational hierarchy in which singer/songwriters are deemed superior to drummers.) In scenes on the train, Starr discusses with Harrison his feelings of inferiority. When Harrison bluntly informs Starr he has an inferiority complex because he is small (double entendre perhaps intended), Ringo answers, "I know,

that's why I play the drums. It's me active compensatory factor." Perhaps this dynamic results from real-life feelings of inadequacy due to Starr's late arrival into the partnership, replacing Peter Best as drummer well after the other Beatles had settled into their union.[5] Starr is the butt of jokes (about his large nose and lack of fan mail) at the hands of the other Beatles, who seem to enjoy putting Ringo in his place. In the "Can't Buy Me Love" scene, when the others are filmed in slow motion falling from the sky, Starr can only give a pathetic, if funny, hop. He deserts the others, feeling unappreciated—a "womanly" reason to leave—and he ultimately needs to be rescued from jail by the others. This dynamic continues in *Help!* as Starr badly needs his "more manly" partners' help to save him from becoming a human sacrifice. Yet Starr's "littleness" has a bold streak; for instance, on the train, when the stuffy gentleman reminds the lads, "I fought the war for your sort!" Ringo replies, "I bet you're sorry you won," implying that English manhood has gone to the dogs.

By breaking the general patriarchal pattern of equating men with the public sphere (jobs, politics, etc.), and women with the private (home, family, etc.), these two films can be seen as feminizing the public image of the Beatles by drawing viewers into their private and domestic life, no matter how surreally it is presented. In *A Hard Day's Night,* we see Lennon in the bathtub, while in *Help!* we see them in the men's room and in their private, shared living space.

HELP!: Still Surreal, Still Running from the Threat

In *Help!* (1965), the Beatles are still running, but this time instead of escaping hordes of female fans, they run from the threat of Ringo's murder as a human sacrifice to a female god. The threat is embodied in a team of bumbling Indian pursuers (played by obviously Anglo actors), whose most prominent member is the female Ahme. Along the way, an effeminate mad scientist named Foot (played by Victor Spinetti, who portrayed the effeminate TV director in *A Hard Day's Night*) also pursues Ringo for the ring. The ring was sent by a female fan in a letter and Ringo wears it, not knowing it marks its wearer as the next human sacrifice. Therefore, a female is responsible for Ringo's endangerment. As in the Beatles' first film, this movie is basically a chase, in which female threat is primary in the pursuers.

The foursome's sense of isolation and surrealism is more pronounced in their second film. *A Hard Day's Night* included Paul's grandfather and managers Norm and Shake, three men who were admitted into the Beatles' private lives and interacted substantially with them as quasi-parents and friends. In *Help!* the four exist in a vacuum. Even during exterior scenes such as walking down a London street or eating in a restaurant, they seem invisible to the world. There are neither family, friends, nor fans, only several characters who help protect them in their escape from their pursuers. Their disconnection or invisibility from the outer world resonates in the life experience of any marginalized population who, far from the locus of power in society, feel they are making their way in a vacuum. The Beatles' problem—Ringo is in danger as long as he cannot get the ring off his finger—is a private dilemma they attempt to solve in isolation from the larger world of friends, relatives, or business associates. This unrealistically isolated position adds to the surrealism of the film.

135

■

"Give Us a Kiss"

Help! and the Overtly Queer

Help! was directed by Richard Lester and written by Marc Behm and Charles Wood. (Behm also wrote the story to the film *The Party's Over,* a film about beatniks and starring Oliver Reed.) Following the film's opening credits, a swami named Clang, played by Leo McKern, strategizes how to regain the ring, and a male minion says to him "You ask of me, master?" "Obedience and love," Clang answers, to which the feminized male minion replies with a loving expression, "This is so." The queer is immediately referenced in this manner as well as in the Beatles' odd living arrangement; once again, the queer slides in on the surreal's coattails. When the Beatles enter their shared apartment, it appears from the street as if they had separate abodes. As they each walk through their own doorway, to the outside world they are four separate identities. But appearances are deceiving. Within their supposedly separate homes, we see that they really inhabit one large, loft-like space. Living together is their shared secret from the outside world. Once inside, Lennon heads for his bookshelf, spins a secret shelf around, pulls out a large book, pulls from within that the hidden book he really wants to read, and, with a giddy smile, falls into bed eagerly clutching it. The symbolism of the book within a book on a hidden shelf contributes to the sense of secret pleasures, secret lives.

An overt queer moment occurs when John and Ringo stand alone in an elevator. Close together, Ringo looks over his shoulder at John and asks in an intimate voice, "What was it that first attracted you to me?" Lennon ponders and replies, "Well, you're very polite, aren't you?" in a matter-of-fact tone. It is a moment of brief pathos, a vision of two unequal lovers where one asks an intimate question with emotional content and the lover replies with matter-of-fact emotional detachment. At the film's closing fight scene on a beach, it is Lennon who performs a tango pass with the Scotland Yard detective.

Less Overt Queer in *Help!*

A scene shot in a bathroom provides an interesting queer resonance when Ringo and Paul stand washing their hands. As Paul combs his hair, Ringo turns on the hand dryer and its vacuuming action, altered by the villains, nearly sucks the ring from his finger. The dryer's force pulls Ringo's hand in, comically pulls a sleeve off Paul's jacket, and causes the two men to slip and slide. Lennon and Harrison walk in together and unknowingly join the mayhem; George completely loses his shirt (except for the collar and tie, like today's male striptease dancer); the Beatles look ridiculous, all shocked surprise; and a broken sink spurts water onto Starr.

Their shared surreal lives and worldview make them, as in *A Hard Day's Night,* a tightly knit unit existing quite separately from the rest of the world. They again understand each other's dialogue when no one else could be expected to do so. For example, at the jeweler's, Ringo remarks, "The fire brigade once got my head out of some railings." "Did you want them to?" Lennon asks. "No," Starr responds. "I used to leave it there when I wasn't using it for school. You can see a lot of the world from railings." Their dialogue again often seems intended for only each other; *Variety*'s film reviewer noted, "many of their throwaway gags are choice non sequiturs. But others are lost to the audience by the lads' mumbling accent" (4 August 1965).

Late in the film, McCartney and Lennon, in an effort to catch the villains, sacrifice of themselves and wear a mask of Ringo's face to lure the villains out of hiding. In each instance, their disguise is pulled off to show their real faces. This makes literal the masking of the hidden and the conjoining of their Beatle selves into one.

When the mad scientist tries to make the ring fall off of Ringo's hand, his equipment brings down Ringo's other rings as well as his pants zipper but fails to affect the ring. In a scene that firmly positions the Beatles as objects of sexual interest (as if their snug-fitting clothes were not enough), Ringo loses his trousers. Ringo is imprisoned in the scientist's machine, which harnesses his hands, helmets his head, and forces him to stand spread-eagled. The shot includes Ringo's hands, stomach, groin, and legs. His zipper unzips itself as a result of the scientist's force field, and his pants fall to his knees, revealing boxer shorts and shirttails. After Paul's humorous wave and Ringo's glance to the heavens in disappointed disgust, we see the mad scientist's face aglow, supposedly from the knowledge that this ring is very special but perhaps also inspired by the sight of Ringo unclothed. Spinetti, recall, is a character clearly assumed to be gay in *A Hard Day's Night,* and his scientist is clearly feminized. He says: "Fantastic. With a ring like that I could, dare I say it, rule the world."

The Beatles, who serve as massive pop icons, are shown as sissies. They engage in fighting, but they are best at running away. During a fight scene in their apartment, an Indian tosses red paint onto Starr to prepare him as a human sacrifice. Looking down at his ruined suit, Starr freezes, speechless, and then weeps quietly. Harrison faints when he sees a hypodermic needle wielded by the Indian woman, Ahme. The Beatles in *Help!* are alternately running from threats and fighting in goofy, surreal scenes. At one point, as they cavort in the Alps to their song, "She's Got a Ticket to Ride," (an interlude that recalls the physical exuberance of the "Can't Buy Me Love" scene), Starr slides backwards, rear in the air. Rapidly succeeding shots then show the Beatles falling down in clumsy attempts to ski. By making their lack of macho comical, the Beatles leave room for an acceptance of another kind of maleness that departs from heterosexual Western conventions of manliness.

A thought-provoking moment occurs when they cruise down the slopes on a large toboggan, bodies piled atop each other like a stack of pancakes. As they pass by, the soundtrack provides a mechanical laughter sound, like that of a carnival fortune-teller; it is an eerie man's laugh that can only serve to complicate the scene of four men piled on top of each other. The idea of stacking male bodies was improbably referred to by Paul McCartney over thirty years later on a 1997 Oprah Winfrey show in which he said about the Beatles:

We knew each other *very* intimately. I mean, there would be the kind of evening where we would be in the van, and it would be, like, very cold and so we'd actually lie on top of each other. You get to know people quite well when you do that [laughs].

The Female Threat in *Help!*
When the Beatles meet with the fearsome hand dryer in the bathroom, Ahme is seen flipping the power switch and thus causing the mayhem. When

she breaks film convention and says directly to the camera, "I am not what I seem," female threat is boldly articulated. Clearly, the greatest threat in *Help!* is that Ringo will lose his life as a human sacrifice to the fearsome female, the goddess Kali. In addition to this large female threat is the character of Ahme, the heavily made-up vamp. Her first actual threat takes place when Ringo puts his hand into their in-house vending machine; she tries to bite the ring off his finger.[6]

However, Ahme switches allegiance to the Beatles and saves them from the scientist by holding him at gunpoint. Clearly, the fickleness of woman does not diminish her threat. After showing herself to be on their side, Ahme is next seen listening to the Beatles sing while relaxing at home. They sing as much for each other as for Ahme, but from then on, her threat has been tamed (like the savage beast, she is tamed by music). However, when she brings a hypodermic needle out of her bag to shrink Ringo's finger and thus dislodge the ring, she frightens Harrison and drops the needle into McCartney's thigh. This creates a visual pun on an erect penis with a close-up shot of Paul's trousered thigh, from which the needle stands straight up, wobbling slightly. Ahme's needle reduces Paul. Recalling fantasy narratives such as *Alice in Wonderland,* he is shrunk to several inches high and, for a brief spell, races around nearly naked and in mortal danger of being stepped on—again, female threat is potentially deadly.

When Ahme is finally contained by the Indians and tied down, female threat in *Help!* changes locus to the Goddess Kali, which in the scene looms nearby in the ocean waters, a gigantic symbol of dangerous female power that makes men seem child-like in a comparison. As when Paul is reduced by Ahme's hypodermic needle to the size of a gum wrapper, so does Kali's statue reduce all men in the movie, from the Beatles to a Scotland Yard official, to puny nothings. While female threat appears disarmed at the end because Ahme is on the Beatles' side, she is a fearful force once again in the closing scenes which dissolve into madcap fighting on the beach. She holds a dagger to Clang, who now wears the sacrificial ring, and threatens to kill him.

The film's presentation of girls as motionless props in the performance of the song "Another Girl" on a beach echoes the distance between the male partnership of the Beatles and the female. McCartney "plays" a girl held rigidly as if she were a guitar and, later, holds her as if she were an unwieldy side of beef, in what seems a clearly forced bit of wackiness. This awkward encounter with girls in bathing suits heightens the sense of the Beatles' disinterest in, and distrust of, women and recalls their abrupt disinterest in the scantily clad showgirls in *A Hard Day's Night.* "Lack of chemistry" does not begin to describe the uncomfortable tone of this musical interlude.

Help! presents a feminized manhood by making its central concern a ring that Ringo wears; with its large red stone, it is a Liberace-style piece of costume jewelry that a macho man would never slide onto his finger. The ring's campiness suggests that perhaps if Ringo were more "manly," the Beatles would not have gotten into trouble to begin with. Camp also plays a role in *Help!* where it brings the marginalized experience to mass popular culture. After all, camp's function, in the words of Moe Meyer, is "the production of queer social visibility" (5).

Through these two films, the Beatles become a sign—the rock star as the feminized male, the sex object for audiences of both genders, and the icon

of the hidden self. Today's rock star Prince, who wears high heels, spangled and luxurious feminine clothes, and dramatic make-up, has even taken the "rock star as sign" truth one step further by demanding to be referred to as a symbol, rather than by the name Prince.

Homosexuality, Epstein, and Lennon

A ripe subject for discussion is whether the role of their gay manager drove this feminization of the Beatles or whether Epstein was merely responding to the potential he saw in the four men. Brian Epstein became the Beatles' manager in December 1961, and in July 1962, they were signed by George Martin to EMI. Epstein not only helped them obtain a recording contract but helped transform their "look" from that of the tough, leather-jacketed rocker to the black-turtlenecked, sharp-suited style they made famous (or that helped make them famous). Under Epstein's management, the Beatles brought a new kind of male image, a feminized yet sexual manhood, to the masses. As Jon Wiener notes, "they helped loosen the straitjacket of conventional sex roles. . . . the Beatles challenged the way rock constructed male and female sexuality" (47). Wiener notes that "the Beatles were denounced for being 'feminine'" but adds that "the construction of this new ideal male figure was not John's project. The idea seems to have come from Epstein, who was gay, and whose only conscious purpose was to make the Beatles more popular" (48).

In the words of the Beatles' official biographer, when Brian Epstein saw them play at the Cavern Club, "he couldn't keep his eyes off John" (Davies 127). While Albert Goldman's lurid account of Lennon's life is often discounted by serious Beatle fans, even Hertsgaard, in his definitive, in-depth look at the Beatles' musical production, agrees with the general consensus that something happened between Lennon and Epstein and that a sexual interest could have fueled Epstein's support of the band. Hertsgaard writes: "After all, it was only natural that a group of rock 'n' rollers who were exciting near-orgasmic adulation from young women should prove attractive to a gay man as well. For his part, Lennon confirmed years later that Epstein 'was in love with me' and it seems clear he and Epstein did have one sexual encounter" (64). Hertsgaard cites Lennon's best friend Pete Shotton's report that Lennon told him he had allowed Epstein to bring him to orgasm manually during their vacation in Spain (64).[7]

The question of homosexuality has long been a part of the stories surrounding John Lennon. In June 1963, Lennon got into a major fight with a local disc jockey who called him "a queer" (Davies 181). In 1980, Lennon had this to say about the incident in hindsight: "the Beatles' first national coverage was me beating up Bob Wooller, at Paul's twenty-first birthday party because he intimated I was homosexual. I must have had a fear that maybe I was homosexual to attack him like that and it's very complicated reasoning" (Lennon, Ono, and Peebles 107). Furthermore, in 1973, Lennon reportedly contributed a poem and drawing to something called *The Gay Liberation Book,* which according to Wiener featured almost all gay contributors, including Gore Vidal and Allen Ginsberg (52).

Gender Identity and the Real Beatles

When Lennon and McCartney found women who served as substantial life partners, the women upset the group's intense homosocial bond by taking the places previously held by the other Beatles as best friend/partner. As Jim O'Donnell's book title, *The Day John Met Paul,* suggests, there is an elemental, Adam and Eve quality to the union of Lennon and McCartney within the world of rock and roll. Before the band's breakup, which was largely understood to have partly resulted from Lennon finding a new "marriage" partner in Ono, Harrison's wife told biographer Hunter Davies, "They all belong to each other . . . George has a lot with the others that I can never know about. Nobody, not even the wives, can break through it or even comprehend it" (33). It is interesting to note that the breakup of the Beatles was largely at the time attributed to the "intrusion" of a woman into the Beatles' recording sessions; when Yoko Ono joined Lennon, the homosocial union of the Beatles was disrupted. That Ono's presence threatened Lennon's male partners to the extent claimed in popular myth speaks of the intense bond or marriage that had predated Ono's arrival.

It is interesting to note that by the time the Beatles' union dissolved, they were visually quite separate. Gone were the uniform-wearing days of *A Hard Day's Night* and *Help!* in which the male partners reflected their own image back to themselves, sharing one visual identity as four elements of the same image.

The recognition of queerness's important role in these films leads to some intriguing questions. Does a hidden or hinted queer touch help popularize those who would become youth culture megastars? What affect did their barrier-breaking fun with gay codes ultimately mean for present-day culture or reveal about the culture of the sixties? Under the guidance of a gay manager, did the Beatles put queerness to the masses to demand that the masses address it? In a history of British filmmaking of the 1960s, Robert Murphy writes: "The Wolfenden Report of 1957 had recommended the decriminalisation of homosexuality; but it was another ten years before legislation was passed, and during this interim period a number of films dealt with homosexuality in a mildly sympathetic way" (40). Murphy mentions *The Trials of Oscar Wilde* (1960) and *Victim* (1961) as examples of sympathetic film treatments of homosexuality. Both preceded the Beatle films.

A Hard Day's Night finishes with the live TV performance in which the Beatles stand isolated on stage, running through their musical numbers accompanied by birdlike screams from their audience. Lester's spinning, dizzy filming heightens the sense that the girls are a shrieking dangerous force, and they are kept quite separate from the Beatles, facing them head on at what is both a physical and psychological distance. We have seen the Beatles rehearse together in the film, when they displayed relaxed enjoyment of their music and their collaboration, joking before and after the songs. Onstage before the hordes of girls and women, however, the four men are going through the motions with little but forced facial expressions—like a well-oiled machine fulfilling a commitment. When they leave the stage, they make no reference at all to the human beings they have just played for or even to their performance itself—it is as if the performance did not include them.

The erasure of the auditorium of females is remarkable. The film audience has just seen girls screaming out, crying, and exhibiting differing stages of emotional distress. They are frenzied and fearsome; indeed, they are not acting girlish. Their outwardly neat and conformist dress and clean-cut faces are at odds with their out-of-control, messy behavior. This dichotomy disturbs the norm and speaks to seething, raging, hurting forces at play in response to the Beatles. This discrepancy between the pretty and clean female exterior and the erupting creatures the women become at the sight of the Beatles is noteworthy and strange, and the four men walk away quickly without giving it a second thought. The nameless girls have sobbed the names, "George," "John," "Paul," and "Ringo" in hysterical fits of frightening intensity; but the men know that what the women seek, their Beatle self, is an illusion. The Beatles are whisked out the door to a waiting helicopter. They rise into the sky, and behind them, somewhere, viewers imagine, the girls find themselves emotionally spent from the empty experience of witnessing their dreamed, unreal men before them.

The Beatles inspired decades of adulation, deeply emotional reactions that continue today to be of an enduring intensity. The queer elements of their work, notably in their two major feature films, deserve our attention and raise interesting questions about the cultural milieu of the sixties and how feminized men came to, briefly, rule the world.

Notes

1. An interesting subject of inquiry might be the relationship between such a homosocial unit and the perception of growing female power as early as 1964 due to the entry of women into the workforce and the nascent women's movement. The young women and girls pursuing the Beatles show none of the shy reserve that women of previous generations were taught to display. The retreat into a male enclave so cutting edge that queer codes are more fun and friendly than females could well be perceived as a response to heterosexual female threat.

2. Although Epstein's influence is not the subject of this paper and instead belongs in a study of its own, it is helpful to keep in mind his role in creating the image of the early Beatles. According to New York attorney and Epstein's close friend, Nat Weiss, Brian Epstein was "the most influential man in pop music in the 1960s. He almost singlehandedly generated the power to revolutionize an age. He was a pioneer who was paving the way. Nobody played stadiums before the Beatles. There was no frame of reference for him" (McCabe and Schonfeld 36).

3. While his subject is neither pop music nor film, Koestenbaum recognizes the relevance of his points to the study of cinema. He states, "my theory of male collaboration might fit Hollywood," and "any studio film could be mined for coded references to the male bonds, economic and erotic, that underlay its production" (*Double Talk* 10).

4. Lennon and Ono were quite open about this cross–gender norm activity, and Lennon was proud to play a role usually reserved for women. Lennon describes his house-husband period in an interview in 1980 in which he notes he made bread the old-fashioned way:

> From scratch with the flour and the hand, doing by hand. And then the time between breakfast and lunch goes very quickly, you hardly had time to read the paper, that's presuming it ain't raining and the babysitter can take the child out, so you get a break from the constant Daddy, look at this; Daddy, look at that, you know, look at me, look at me, . . . feed the cat. (Ono, Lennon, and Peebles, 140)

5. This same "hazing" style treatment of the newest member of a musical partnership can be seen in the popular American rock group Metallica. When they added a new bassist following the death of their original bass player, the new musician, previously a fan of the group, was treated differently, and he has spoken publicly of his perceived inferior position within the group.

6. There seems to be an obvious symbolic link here to the finger as the male organ and the biting female mouth as standing in for female genitalia, whose threat to man, in myth, is its secret nature, which might even hide teeth, which would sever the male genitals.

7. As cited by Hertsgaard, Lennon's comment that Epstein was in love with him appears on page 76 of the *Playboy* interviews (Sheff and Barry, *The Playboy Interviews with John Lennon and Yoko Ono*).

Pete Shotton's quote is taken from his book *John Lennon In My Life,* 73.

References

Butler, Judith. *Gender Trouble: Feminism and the Subversion of Identity*. New York: Routledge, 1990.

Davies, Hunter. *The Beatles: The Authorized Biography*. New York: McGraw-Hill, 1968.

Doty, Alexander. *Making Things Perfectly Queer: Interpreting Mass Culture*. Minneapolis: University of Minnesota Press, 1993.

Espen, Hal. "American Beauty." *New Yorker,* 21 and 28 August 1995, 11–12.

Giles, Jeff. "Come Together." *Newsweek,* no. 17 (23 October 1995): 61–67.

Giuliano, Geoffrey, and Giuliano, Brenda. *The Lost Beatles Interviews*. New York: Penguin Books, 1994.

A Hard Day's Night. Dir. Richard Lester, With The Beatles, Leo McKern, and Eleanor Bron. Produced by Walter Shenson. 1964.

Help! Dir. Richard Lester. With the Beatles and Wilfred Brambell. Produced by Walter Shenson. 1965.

"Help!" In *Variety's Film Reviews*. Vol. 11, *1964–1967.* August 4, 1965. New York: R.R. Bowker/Reed Publishing, 1983.

Hertsgaard, Mark. *A Day in the Life: The Music and Artistry of the Beatles*. New York: Delacorte, 1995.

"Interview with Paul McCartney." *The Oprah Winfrey Show*. ABC. WLS, Chicago. 19 December 1997.

Koestenbaum, Wayne. *Double Talk: The Erotics of Male Literary Collaboration*. New York: Routledge, 1989.

———. *The Queen's Throat: Opera, Homosexuality and the Mystery of Desire*. New York: Random House, 1994.

Lennon, John, Yoko Ono, and Andy Peebles. *The Last Lennon Tapes: John Lennon and Yoko Ono Talk to Andy Peebles*. New York: Dell Publishing, 1981.

McCabe, Peter, and Robert D. Schonfeld. *Apple to the Core*. New York: Pocket Books, 1972.

Meyer, Moe. "Introduction: Reclaiming the Discourse of Camp." In *The Politics and Poetics of Camp,* ed. Moe Meyer, 1–22. New York: Routledge, 1994.

Murphy, Robert. *Sixties British Cinema*. London: British Film Institute, 1992.

O'Brien, Daniel. "Richard Lester." *International Dictionary of Films and Filmmakers—2*. 2nd ed. Ed. Nicholas Thomas, 510–11. Chicago: St. James Press, 1991.

O'Donnell, Jim. *The Day John Met Paul: An Hour-by-Hour Account of How the Beatles Began*. New York: Penguin, 1996.

Sedgwick, Eve Kosofsky. *Between Men: English Literature and Male Homosocial Desire*. New York: Columbia University Press, 1985.

Sheff, David, and G. Barry Golson. *The Playboy Interviews with John Lennon and Yoko Ono*. Chicago: Playboy Press, 1981.

Shotton, Pete, and Nicholas Schaffner. *John Lennon in My Life*. New York: Stein and Day, 1983.

Sontag, Susan. *Against Interpretation*. New York: Dell, 1966.

Wiener, Jon. *Come Together: John Lennon in His Time*. Chicago: University of Illinois Press, 1991.

Yule, Andrew. *The Man Who "Framed" The Beatles: A Biography of Richard Lester*. New York: Donald I. Fine, 1994.

143
■
*"Give Us
a Kiss"*

"I AM WITH YOU, LITTLE MINORITY SISTER"
Isherwood's Queer Sixties

Joseph Bristow

IN A 1972 INTERVIEW, Christopher Isherwood (1904–1986) was invited to select from his extensive canon the book that pleased him most. Without any hesitation, he replied, "*A Single Man.*" Yet when asked to explain why this—his penultimate novel published in 1964—classed as his highest accomplishment, Isherwood failed to be precise: "Because everything fits. It sort of keeps going, and it's varied. . . . And it's all very much out of my experience, very close to my experience. . . . I don't know. . . . It's hard to say."[1] Certainly, it is tempting to dismiss such a vague, if not puzzled, answer. But over the years Isherwood's most attentive readers would elaborate upon this response to prove why *A Single Man* is a finely honed work that comes closest to his truest—indeed, queerest—self. In his 1979 biography, for example, Brian Finney claims that "in technical terms, the book is almost flawless." He demonstrates how ably the narrative reveals its main character George seeking but failing to hold together a conflicting "set of personalities" in the rapid course of twenty-four hours. Especially significant in this context, argues Finney, is George's homosexuality. George—a fifty-eight-year-old professor of English whose lifestyle, to some extent, resembles the writer's own—enables Isherwood "to introduce the whole question of the loneliness and alienation experienced by members of any minority group."[2] Like many gay people to this day, George disguises his sexual identity from much of the world.

Equally impressed by this sympathetic portrayal of homosexual oppression is pioneering gay critic Claude J. Summers. In his view, *A Single Man* stands as "the masterpiece of Isherwood's maturity," a work that touches on universal themes. "[T]he book," writes Summers, "concretely explores the minority sensibility, presenting the homosexual predicament as a faithful mirror on the human condition."[3] More recently, Katherine Bucknell has described *A Single Man* as "a small but undoubted masterpiece" that shows how Isherwood finally "matured as an artist" in a long career spanning the 1920s to 1980s. Bucknell contends that with each successive volume, Isherwood's "narrative persona" becomes "more vivid, more complicated, more dynamic, and in most respects truer to Isherwood's actual personality." She

believes that this "truer" persona eventually "emerged in a character in its own right":[4] the protagonist George who suspects that one of his straight neighbors wishes to "nail him down with a word"—"*Queer*."[5] Taken together, all three opinions suggest that in this novel Isherwood found his metier—as a skillful writer who at last discovered a liberating means of coming out in his fiction as a gay man depicting sexual injustice.

I must confess that this account of Isherwood's oeuvre in general and *A Single Man* in particular seems a little odd. It is not that I would deny that the novel in some respects stands as a "comic masterpiece," as Carolyn G. Heilbrun maintains.[6] Nor would I suggest that this memorable narrative provided Isherwood with significant opportunities to explore the pleasures and pains—the desires and denials—of being "*Queer*." Yet it is difficult to interpret this writer's long career, which spans the 1920s to the 1980s, as a developmental chronicle of homosexual emancipation that ultimately found its truest voice in 1964. The shortcomings of this viewpoint are plain to see. As Elizabeth Hardwick observed in a 1964 review of *A Single Man*: "Isherwood's books have all been homosexual in spirit; even campy."[7] Likewise, Summers provides plenty of evidence that reveals how homosexuality "makes its presence felt in the novels," even "when it is suppressed or disguised for legal or artistic reasons." But it is rather misleading to claim—as Summers does—that "Isherwood's work anticipates the gay-liberation perspective that would flower in the aftermath of the 1969 Stonewall riots."[8] This perspective can distort how we understand Isherwood's historical significance as a writer, since it erroneously implies that his novels fixated their gaze upon an emancipating future, one filled with the spirit of queer revolution. Moreover, the very idea that Isherwood's fiction was somehow ahead of its time—long before the growth of the civil rights movement—mistakenly positions his work within post-Stonewall debates about the need to come out and declare one's gayness in the public sphere. In any case, Isherwood's homosexuality was not exactly located either inside or outside the doors of the closet: the emblem that would become one of the most powerful means of thinking about gay oppression and gay liberation in the 1960s and beyond. His fictions, which date from the late 1920s, make same-sex desire legible in a rather different set of terms.

Isherwood's earliest readers were hardly unaware of his interest in homosexuality. In 1976 he reflected on how the presence of same-sex desire in his fiction resulted in the rather poor reception of his second novel, *The Memorial* (1932). He recalled how "one reviewer remarked that he had at first thought the novel contained a disproportionately large number of homosexual characters but had decided . . . that there *were* a lot more homosexuals about, nowadays."[9] But it is not just this kind of thirties statement that makes one think twice about upholding Isherwood as an icon of sixties gay liberation. Even though *A Single Man* is unapologetic about male homosexual living and loving, its vision of the sixties appears more jaded than celebratory, for *A Single Man,* despite its unforgettable moments of comedy, remains largely an elegiac novel of loss. It records not just the bereavement of a gay man who cannot share his grief with either neighbors or coworkers. Set one month after the Cuba missile crisis of 1962, the narrative also—partly because of George's anguish—mourns the past, specifically, the mid-1940s in Santa Monica, California—the heyday of the queer life that he and his deceased

lover Jim had once shared in this vibrant part of southern California, before the bohemian ocean town became straighter than ever before. These moments of retrospection in *A Single Man* largely conform to a well-established narrative trajectory that shapes almost all Isherwood's work.

In this chapter, I consider in some detail why we need to exercise caution when claiming that Isherwood's approach to homosexuality was avantgarde, for his "*Queer*" sixties depends not so much on political prophecy as obsessive memory: an unerring backward look that characterizes the larger part of his oeuvre. That is not to say that his novel of 1964 appears outdated. Nor would I say that the book feels anachronistic. It is simply to observe that *A Single Man*—like its predecessors, *Prater Violet* (1945), *The World in the Evening* (1954), and *Down There on a Visit* (1962)—works out from a present moment to resuscitate a mesmerizing, if ever-receding, past. Isherwood's persistent return to the past, not just in his fiction but also in his autobiographies, frequently explores the first three decades of his adult life—the 1920s to the 1940s—whose personal significance continued to absorb him both in mid-career and in old age. Isherwood devoted much of his energy as an elderly man to revisiting the fictional ways in which he represented this era in his earlier writings. Particularly notable here is *Christopher and His Kind*. This 1976 autobiography—dedicated to the decade 1929–1939—frequently accounts for why his Berlin stories (*The Last of Mr Norris* [1935] and *Goodbye to Berlin* [1939]) were unable to be explicit about his narrators' homosexuality. He says that his project in 1935 was to find a narrative persona that would "make the reader experience Arthur Norris just as he had experienced" Norris's original, Gerald Hamilton. "But," Isherwood adds, "the narration problem wasn't to be so easily solved."[10] Certain sensitivities—his fear of creating scandal; his reluctance to embarrass his mother; and his unwillingness to offend the uncle who gave him an allowance—prevented the disclosure of his narrator's same-sex desires. For all this tactful silencing of gayness, it would take a remarkably imperceptive reader not to see how and why William Bradshaw—the narrator whose first and last names come from Isherwood's own middle names—remains central to a sexually perverse culture. One incident will disclose why. Aware that he has wrapped his "arm round a girl" at a party, William looks with "almost microscopic distinctness" at Baron von Pregnitz, who is "reclined upon the farther end of the sofa in the embrace of a powerful youth in a boxer's sweater." Slightly later William finds himself "seized round the waist, round the neck, kissed, hugged, tickled, half undressed. . . . I danced with girls, with boys," he adds, "with two or three people at the same time."[11] Even if William is not openly identified as queer (one reviewer called him a "sexless nitwit"), his experience of Berlin assuredly is.[12]

One could advance the view that this striking depiction of Germany's sexual dives is perhaps more radical for its epoch than culture of the Californian sixties, which often disgruntles George in *A Single Man*. Before making any such claim, it is advisable to hesitate about ranking Isherwood's works in terms of their respective challenges to some notion of the status quo, since this task can be as unhelpful as the view that his "mature" voice resides in the "truer," homosexual George. At any rate, his autobiographies and fictions are not political tracts—which is one reason why they do not necessarily anticipate a Gay Liberation Front (GLF) perspective—even if politics (like

Nazi anti-Semitism) suffuses their highly polished prose. In what follows, then, I attempt to recast how we think about the seemingly progressive—indeed, determinedly "out"—narrative of *A Single Man* by looking closely at how it extends Isherwood's sustained interest in representing homosexuality in some of his earlier novels. Two topics, in particular, warrant attention: first, the connection between autobiography, fiction, and historical process; and second, the mutable—even chimerical—form of his narrators' identities. These topics will remind us that Isherwood's continuing fascination with using personal experience to make sense of historical change repeatedly comes up against certain limitations. In devising personae to show how history operates at the level of individual perception, Isherwood simultaneously acknowledges that it is difficult—if not impossible—to find a "truer" self that will authenticate the moment in question. In other words, his personae—including his different autobiographical selves—more often than not keep their eyes fixed on a past that can never be fully recuperated. My overall intention, therefore, is to show that by the time he composed *A Single Man* in 1962, Isherwood was partly rewriting a backward-looking story that—for quite intricate reasons—he had already told on previous occasions. But this accomplished novel, I would add, is not any the worse for that.

DURING THE FIRST DECADE of his writing career, Isherwood's fiction experimented with different narrative personae to make homosexuality legible. William Bradshaw is one, and Christopher, another. Both figures stand, if only in name, in such close proximity to their author that the boundaries between writer and character tend to blur. Christopher first appears in *Goodbye to Berlin*. This is arguably the best known of Isherwood's earlier works, not least because one of its vignettes ("Sally Bowles") formed the basis of John van Druten's play, *I Am a Camera* (1951), which was later transformed into the musical and then film *Cabaret* (1972), starring Liza Minnelli. All of the events depicted in this discontinuous sequence of stories originate in Isherwood's life in Berlin during the years before the Nazis seized power in 1933. The memorable statement, "I am a camera," sets the tone of this novel by characterizing Christopher's unusual narrative position. At first glance, the statement defines the seemingly dispassionate viewpoint of a man uninvolved in the world around him. "I am a camera," says Christopher, "with its shutter open quite passive, recording, not thinking."[13] It is almost as if a coolly technological eye maintained control over any interference from Christopher's own subjective "I." The fact that Christopher shares his author's name suggests that there may well be a personal investment in bringing this "passive, recording, not thinking" narrator to quasi-autobiographical life. Both the eye and the I, therefore, look at Berlin from a complex dual perspective: distanced and passive, on the one hand, while intimate and active, on the other.

This doubled consciousness—whereby the narrator remains detached from his world yet central to its every activity—provides an ingenious device for concealing and revealing Christopher's and (by extension) Isherwood's sexual inclinations. Let me give just one example where Christopher emerges as both the disinterested spectator of queer desire and the embodiment of it. In "A Berlin Diary (1932–33)" (the final section of *Goodbye to Berlin*) Christopher follows his friend Fritz Wendel to a "tour of 'the dives.'" They end up in

a cabaret club called the Salomé that features a "few stage lesbians and some young men with plucked eyebrows," together with some drag artists. In the main, though, the audience comprises "middle-aged tradesmen and their families" who express "good-humoured amazement" at the female impersonators. As they enter the club, Christopher and Fritz encounter some young American people. One of them, a man, asks Fritz "what's on here?" When told that the performers are "men dressed as women," the American guy cannot believe it. "Men dressed as *women?*" he exclaims. "As *women* hey? Do you mean they're *queer?*" To this tiresome inquiry Fritz wryly responds: "Eventually we're all queer." Aghast, the man turns on Christopher and asks: "You *queer*, too, hey?" "Yes," Christopher affirms, "very queer indeed."[14]

Is this, then, a moment when Christopher comes out, or is it just an instance of sophisticated closeting? In many ways, this intricate narrative structure of this episode throws doubt on the commonplace vocabulary used since Stonewall for talking about the liberation or oppression of homosexual identity. In this witty exchange, the disclosure or hiding of gayness is somewhat beside the point. To be sure, Isherwood felt obliged not to identify either himself or his character—through his half-veiled self-portrayal—as definitively queer. What matters here lies in how the American man's prurient fascination with the club looks just as queer as what he imagines its performers and audience to be. Once he discovers that Christopher too is queer, the homophobe eagerly lets out a "wild college battle-cry" and rushes "headlong into the building" with his friends, joining the tradesmen and their families, who are fascinated by the drag acts.[15] So, Fritz's remark—"we're all queer"—makes perfect sense. It produces a delightfully perverse piece of logic. Fritz insists that people who are drawn to gay culture but identify as straight are nonetheless part of its all-embracing queerness.

Undoubtedly, some readers might claim that this amusing exchange evades the problem of affirming a positive homosexual identity in fiction. It is easy to follow Isherwood's elderly retrospective on his 1930s queerness when making such a point. Toward the end of *Christopher and His Kind,* Isherwood asserts that he was slow to "express himself freely as an individual," especially as a homosexual. Only in 1939, he says, when he immigrated to the United States, did he free himself from the "left-wing friends he admired and loved," whose political thought demanded "solidarity" with groups fighting fascism. Writing of his younger self in the third person, Isherwood recalls: "His obligations wouldn't be the same in the States." No longer a member of a group, he could now move toward a position where the personal commitment to homosexual love became a political matter:

> As a homosexual he had been wavering between embarrassment and defiance. He became embarrassed when he felt that he was making a selfish demand for his individual rights at a time when only group action mattered. He became defiant when he made the treatment of the homosexual a test by which every political party and government must be judged. His challenge to each one of them was: "All right, we've heard your liberty speech. Does that include us or doesn't it?"[16]

In the ensuing paragraphs, he expresses despair at how in 1934 the Soviet Union, having decriminalized homosexuality after the 1917 revolution, went

149

■

"I am with You, Little Minority Sister"

back on its word and made same-sex desire punishable with heavy prison sentences. What the Nazis denounced as "sexual Bolshevism," the Communists under Joseph Stalin labeled "Fascist perversion." To make matters worse, Isherwood experienced the loss of his German lover, Heinz Neddermeyer, to the Nazi regime. In 1937, unable to secure residence in England for his boyfriend, Isherwood soon learned that the Gestapo had charged his lover with homosexual offenses. After serving a six-month prison sentence and a year of labor service, Neddermeyer was rehabilitated in German society as a soldier fighting for the fascists.

Unquestionably, *Christopher and His Kind* fills in many of the details about Isherwood's homosexual consciousness that his Berlin stories repress rather than express. Yet one should bear in mind that Isherwood's compulsive return to this period of his life involves more than a desire to delineate his homosexual experiences in fuller, richer, and more accurate detail. For as the extract just quoted reveals, Isherwood retains a certain distance between himself as the writing subject and himself as the subject of his narration. Isherwood, after all, calls his 1930s self "Christopher"; it is a self that approximates, yet remains distinct from, the authorial voice. By 1976 he had been referring to this earlier incarnation for almost forty years, remodeling him in works of fiction—such as *Prater Violet* and *Down There on a Visit* (1962)—that have their sources once again in Isherwood's life during the 1930s and 1940s. Further, this engaging volume of autobiography sets in motion a narrative of political maturation from a mid-1970s viewpoint informed by Gay Liberation: a political movement to which Isherwood gave his support. (Jonathan Fryer reminds us that Isherwood "loathed the word 'gay,' usually employing the term 'queer'": the older idiom that—for all its homophobic uses—he believed most accurately defined his generation's self-understanding of homosexuality.)[17] My contention is that Isherwood's mid-1970s rewriting of his Berlin experiences might wrongly suggest that it provides a better version of the past because it brings his same-sex desire much more into the open. Similarly, his decision to refer to himself as Christopher when recalling his younger self might imply that this is the same persona as the Christopher who first emerged when "Sally Bowles" appeared in 1937. In other words, Isherwood's own leads can entice us to believe that his later work draws to completion the inchoate political consciousness evident in writings such as "A Berlin Diary (1932–33)." But *Christopher and His Kind*—no matter how much it seeks to be "truly autobiographical"—arguably generates as much fiction as it does fact, offering yet another version of Christopher, which probably tells us more about the aging Isherwood's queer politics than the ingenuous homosexual he once was.

At any rate, Isherwood himself was the first to note the difficulties involved in giving a clearer and "truer" picture of the past self that he named Christopher. Early in the *Down There on a Visit* (which Isherwood called a novel, even though it reads like autobiography),[18] the narrator muses on his mixed feelings of intimacy with, and withdrawal from, a figure whom he once knew well but whom he now believes is a "stranger":

> For, of course, he *is* almost a stranger to me. I have revised his opinions, changed his accent and his mannerisms, unlearned or exaggerated his prejudices and his habits. We still share the same skeleton, but its outer

covering has altered so much that I doubt if he would recognize me on the street. We have in common the label of our name, and a continuity of consciousness; there has been no break in the sequence of daily statements that I am I. But *what* I am has refashioned itself throughout the days and years, until now almost all that remains constant is the mere awareness of being conscious. And that awareness belongs to everybody; it isn't a particular person.[19]

This thoughtful passage certainly casts doubt on how, if ever, Isherwood felt that any of his narrative personae might render a "truer" version of his former self. There are additional points to be made about his persistent fascination with reinterpreting his earlier incarnation, in the full knowledge that his every claim upon his past existence—whether in autobiography or fiction— militates against retrieving and preserving an authentic identity. Here Isherwood emerges as an acutely self-critical writer whose commitment to autobiographical reflection readily admits that the "I" central to its genre remains a fictional invention. As a consequence, his trenchant comments on the apparent benefits of hindsight admit that his autobiographical project depends on structures of alienation from the very history that informs the position from which such an idea has emerged. That is to say, Christopher embodies a compelling paradox. He is both what Isherwood invents and the life history that provides the conditions that make Christopher's narrative persona possible in the first place.

There is a further reason why we should focus for a moment on Isherwood's preoccupation with his contradictory distance from, and proximity to, Christopher, whose queerness extends beyond the limiting question of whether Isherwood feels obliged, at different points of his career, to place him in or out of the closet. Slightly later in *Down There on a Visit,* Isherwood makes a number of thought-provoking remarks on what might be called his filial relations with the narrative persona that simulates his younger self. "I will never sneer at him," he writes. "I will never apologize for him. I am proud to be his father and his son."[20] Typically for Isherwood, such plain declarations contain an initially obscure but ultimately meaningful knowledge that complicates his approach to representing homosexuality. These words disclose that in creating Christopher, he has produced his own queer genealogy, in which he perversely fathers the figure from whom he descends. Taken to its logical extreme, this intriguing statement suggests that Christopher has emerged from a certain kind of male parthenogenesis. Such speculations result from a style of queer thinking that redefines heterosexual ideals of the family. This model of queer filial descent does not reproduce itself with an eye to what might be thought of as a heteronormative future comprising his children and his children's children. Instead, Isherwood traces his creation's unusual ancestry while remaining aware that his persona cannot glimpse the future, in which Christopher, embodying both "father" and "son," is the man from whom Isherwood descends and to whom the author gives life. "I keep forgetting," observes Isherwood, that Christopher "is as blind to his own future as the fullest of animals. As blind as I am to mine." Yet, he continues, that is not to claim that Christopher's ignorance has terrible consequences: "His is an extraordinary future in many ways—far happier, luckier, more interesting than most." Indeed, that "extraordinary future" turns out to be

happy, lucky, and interesting because it becomes the time when Isherwood—who rarely looks forward—once again enjoys scrutinizing his own personal history.[21]

Even when Isherwood's fiction dispenses with Christopher and employs instead a more conventional type of protagonist—one that appears distinguishable from the author himself—the question of queerness similarly adopts a retrospective stance. This is especially the case in *The World in the Evening,* which probably counts as Isherwood's least appreciated novel. This underrated narrative features the thirty-four-year-old Stephen Monk looking back on his two marriages—together with his sexual involvement with a man—while recovering from a serious injury. Published in 1954, the novel largely covers his convalescence in a Pennsylvania village during summer 1941. Intermittently, Stephen recalls various episodes in his life from 1935 onward. Each retrospect in turn helps to account for his troubled state of mind, not least the loss of his first and much-loved wife, Elizabeth, whom he sexually betrayed on several occasions. In this peaceful Quaker (ostensibly liberal) environment, Stephen develops friendships with his doctor, Charles Kennedy, and with Charles's male lover, Bob Wood. Both men are candid with him about their relationship. Bob, in particular, becomes strident when he fears any antagonism that Stephen may hold against queerness; he has a firm analysis of queer oppression:

> "There's a few people right here in the village who really know what the score is between Charles and me, but they won't admit it, not even to themselves. We're such *nice* boys, they say. So wholesome. They just refuse to imagine how nice boys like us could be arrested and locked up as crooks. They're afraid to think about it, for fear it'd trouble their tender consciences. Next thing you know, they might get a *concern*"—Bob's mouth was twitching ferociously—"and they'd have to *do* something. Jesus, I'd like to take them and rub their noses in it."[22]

It would, I think, be difficult to locate a more politicized queer voice in fiction of the mid-1950s.

No sooner has Bob's wrath turned to frenzy than we find that the narrative expresses caution at his justifiably angry viewpoint. Just at the moment when Bob has vented his spleen, Stephen tells him: "There was a guy *I* liked once. In that way, I mean—." "Sure, I know," Bob answers. "Some kid in school," he presumes. "And afterward you hated yourselves. And now he's married and got ten children." Faced with such mockery, Stephen protests: "No. This wasn't in school—." To which Bob replies: "Well, then, it was in some low bar in Port Said, and you were drunk, and you got picked up, and it was horrible—." All Stephen can do is deny such imputations. In many respects, Bob—who by his own admission grows volatile because liberal hypocrisy makes him "sick to the stomach"—can be heard as the militant voice of Gay Liberation a generation before the advent of Stonewall.[23] Yet the novel situates this politicized antipathy to heterosexual stereotypes of queerness well over ten years before this narrative was published, and it does so in a manner that shows some skepticism toward Bob's aggressive militancy, which eagerly seeks to predict and control any signs of straight bigotry.

Later, Stephen and Charles privately discuss the sources of Bob's considerable anger. "He'd like us," says Charles, "to march down the street with a banner, singing 'we're queer because we're queer because we're queer because we're queer.'" Bob's desperation to take his queerness onto the streets through an organized political movement—one that, according to Charles, would offer Bob a "heroic setting"—remains a source of conflict in their relationship. Even though Charles in principle supports Bob's sentiments, he adopts a more pragmatic and reformist position on his day-to-day queer existence. "I'm sick," declares Charles, "of belonging to these whining militant minorities. Everybody hates them, and pretends not to. And they hate themselves like poison." In fact, he feels some discomfort at the extent to which he disguises not just his sexual but also his ethnic identity. Having criticized Bob's combative standpoint, Charles comments on how his father changed the family name from Klatnik to Kennedy. "I used to tell myself," he remarks, "that I'd change it back when I grew up. But I never did. . . . I didn't have the guts."[24]

Throughout these closely related exchanges, the narrative shows rather than tells us about the moral complications surrounding minority consciousness, allowing us to glimpse a range of arguments about the survival of homosexual identity in an intolerant culture. On the one hand, we see that Bob's forthright desire for visibility throughout the public sphere rests on an almost paranoid rage. On the other, we realize that Charles's reticence about his sexuality and ethnicity originates in a measure of self-hatred. The novel neither upholds nor condemns either viewpoint but instead offers insights into why these homosexual lovers have reached such different conclusions about how best to maintain their queer relationship in straight society during the early 1940s. There is little doubt that this debate has more than a ring of familiarity even today. But rather than assume that these crucial moments in Isherwood's fiction anticipate our post-GLF perspective on such topics as gay pride and gay self-oppression, we might reflect on the ways in which the debate in question has a much older history. In all probability, Isherwood encountered discussions of this kind in Berlin as early as 1929 when he lived next door to the Institute of Sexual Science (led by homophile campaigner Magnus Hirschfeld). No doubt this kind of conversation also continued much later, in the mid-1950s, when Isherwood became a close friend of courageous psychologist Evelyn Hooker, who worked at the University of California at Los Angeles. Hooker's research, which confirmed the normality of homosexuality, brought her into contact with one of the earliest gay organizations, the Mattachine Society, whose members, she discovered—according to Isherwood—were so "cagey with each other that they didn't even know each other's professions."[25] Though set in the early sixties, *A Single Man* reiterates many aspects of these earlier debates.

THE BEGINNINGS OF *A Single Man* date from the 1950s, a time when Isherwood was trying to regenerate his career as a novelist. In his voluminous diaries covering 1939 to 1960, he often expresses discontent with the ups and downs of his writing life. Early in 1958, he muses:

Look at it like this—the effective part of one's life, barring sickness, falls into three-thirds—twenty-five to forty, forty to fifty-five, fifty-five to

seventy. My impression is that I packed a terrific amount into the first third, and that I've wasted a great deal in the second. (In the first third, I produced twelve works—including two translations and three collaborations: the plays. In the second third, I have so far produced four works—including two translations. Maybe I can in the novel and the Ramakrishna book before the August 1959 deadline—but I doubt it.)[26]

In this—his fifty-fourth—year, Isherwood clearly understood how and why his literary reputation had slumped from its high point in the late 1930s. By this time, he was not uncommonly regarded as the castoff from the renowned interwar coterie comprising W. H. Auden, Stephen Spender, and C. Day Lewis, all of whom sustained fairly high profiles in later life. Even though some London critics had long been antipathetic to his homosexuality and his socialism, his desertion with Auden of England for the United States before World War II deepened his compatriots' displeasure. That is why Cyril Connolly, in the February 1940 issue of *Horizon,* said that their departure was "the most important literary event since the outbreak of the Spanish Civil War."[27] Though seen by some as traitors to their homeland, Auden and Isherwood had no interest in participating in armed combat. Once he had settled on the West Coast, Isherwood's religious beliefs would, in due time, come under similar attack. Dating from 1939, his commitment to Vedanta—led by Swami Prabhavananda and subsequently chronicled in *My Guru and His Disciple* (1980)—on occasion made Isherwood appear, as he put it in 1954, as "a preacher of sloppy uplift."[28] It is not surprising to see him filled with dismay when, in 1958, he tries to imagine how he might make the second "third" of his life as productive as the first.

Finding it tough to write a new novel, Isherwood missed the self-imposed deadline marked by his fifty-fifth birthday. When he eventually managed to pull together his first two novels of the 1960s—*Down There on a Visit* and *A Single Man*—both works drew on the expansive diaries in which he was the main protagonist. In many ways, *A Single Man* employs personal materials and applies narrative techniques that distinguish his most successful writings, like the Berlin stories.[29] Even if George is not as implicitly autobiographical as either William Bradshaw or Christopher, he is very much a product of Isherwood's self-representation. George's age, location, national origin, and profession—not to say his homosexuality—bear more than a slight similarity to his creator. Yet at the same time George could not be further from the fifty-eight-year-old Isherwood. In 1962 George has recently lost a lover of many years. At that time Isherwood had, for almost a decade, enjoyed a rewarding partnership. Indeed, this novel of emotional despair could not have been written during a personally happier period in Isherwood's life. In early 1953, Isherwood became intimate with Dan Bachardy. By all accounts, their relationship was the most important that Isherwood experienced; the bond between the two men lasted until his death at the age of eighty-one. Why, then, did Isherwood use so much of his own life to create a character unquestionably distinct from himself? Like all inquiries intended to reach deep into a writer's psychology, this one remains in some respects unanswerable. It is worth posing the question anyway since it keeps in mind what might have been at stake in making George—as with Christopher and

William before him—both like and unlike his author, in a manner that gave great satisfaction to Isherwood.

From what we can tell, *A Single Man* emerged from two aborted projects, and it is useful to consider how Isherwood remodeled these earlier materials. The first was a novel titled *An Englishwoman,* which traced the main character's life in California as the English spouse of a GI. "I was meaning to write it," Isherwood stated in 1972, "in a sort of Willa Cather manner—very, very simple and describing this woman in the third person."[30] As he sketched out the narrative, he grew more interested in the English professor who befriends her student son. That professor, who became George, originated in Isherwood's experience teaching at the State College, Los Angeles, from 1959 until 1961. The second source for *A Single Man* was a projected film titled, *A Day's Journey,* which his diaries first mention in late 1952. Isherwood had a long association with the film industry, and in fact, *Prater Violet* reshapes in fictional form his time working on Austrian director Berthold Viertel's *Little Friend* (1933). In California Isherwood drew much of his income from writing Hollywood screenplays. *A Day's Journey* based its time frame—just one day—on Virginia Woolf's *Mrs. Dalloway* (1925). Bearing these points in mind, Bucknell asserts that *A Single Man* "synthesizes the style of English literary Modernism with the most important genre of contemporary American culture—the film script."[31] When an interviewer suggested that *A Single Man* would make an "excellent film," Isherwood gave an animated response: "There's a sequence toward the end where George is masturbating and has these sex fantasies and keeps changing the actors in the fantasies because they don't function properly. This could be an extraordinary scene of comedy which I have never seen on the screen."[32] All of this information might suggest that *A Single Man* brilliantly combines Modernist influences with a cinematic eye in the name of depicting the one subject of decidedly sixties interest—sex. But Isherwood had long been a Modernist, his narrative eye had for years been a camera, and one of his more prominent subjects had always been homosexuality.

One must turn toward more reserved accounts of Isherwood's work to gain a firmer critical perspective on his queer sixties. Like many of the reviews that appeared in 1964, Stanley Kauffmann's article (wittily titled "Death in Venice, Cal.") observes how the novel portrays George's broad repertoire of emotions "from nobility and desolate grief to viciousness and lecherousness. . . . The only obvious omission," Kauffmann quickly adds, "is a sexual act."[33] That is why he closes with some misgivings about the "vagueness of contact and embrace" evident throughout the novel. By comparison, John Gross in the British *New Statesman* states that Isherwood should be congratulated for sparing his readers such graphic details: "The treatment of homosexuality in *A Single Man* is honest but mercifully not 'frank'. Yet the final section"—featuring George's masturbation—"does provoke a few squirms—not on account of the realism, but because of the anti-climax."[34] (It is not entirely clear if Gross detests the poor quality of George's fantasy of two men having intercourse because it pitifully substitutes for the unmentionable act itself.) In one of his last published interviews, Isherwood agreed that, although he wrote extensively about homosexuality, he was not "interested in . . . revelations about either physical acts or about specific lovers." Instead, he focused his attention on "studying the psychology" of his "whole

outlook on life," an outlook "far more influenced by [his] homosexuality than [he had] ever supposed."[35] On this view, his homosexuality cultivated the mind more than the body. Undeniably, his fictions rarely represent desire in a highly physical form. He had to be careful in testing his publisher's liberal tolerance. (Bucknell observes that when writing *The World in the Evening* he "deliberately drafted" two "sex scenes rather strongly in order to be able to agree to alterations and still retain the minimum of detail that he felt was essential for his artistic purposes.")[36] In an oeuvre pervaded by gay male sexuality, George's masturbation stands as the most intense—if disappointing— moment of orgasm. Once George comes in his handkerchief, it appears that this "little death" (so to speak) leads to his demise.

Even Kauffmann's and Gross's reservations appear tame by comparison with D. S. Savage's exceptional—if magnificently disgraceful—essay "Christopher Isherwood: The Novelist as Homosexualist," which the journal *Literature and Psychology* had the indignity to publish in 1979. Homophobic criticism rarely comes in such a compelling form. Where Isherwood's reviewers sometimes muted their hostility to his sexual interests, Savage draws on various pieces of mangled psychoanalysis to legitimate his outright animosity. In Savage's eyes, Isherwood looks anything but "mature." Everywhere Savage discovers "the homosexual regression which affected Isherwood's entire career."[37] Such "regression" comprises a "recessive orientation towards the past and his preoccupation with the immature."[38] Providing ample textual evidence, Savage claims that Isherwood's fictions depict the "homosexualist" in a state of arrested development that directly reveals how the author "remained, in the J.M. Barrie–Peter Pan tradition, the little boy who refused to grow up."[39] These regressive tendencies, we learn, enable characters like William Bradshaw to "have the advantages of adult sophistication while sidestepping the onerous demands of authentic maturity."[40] Since queerness supposedly protects Isherwood, like his protagonists, from the moral demands of adult heterosexuality, it comes as no surprise to Savage that this writer's work celebrates infantile behaviors. Particularly significant in this regard are telltale epithets. Savage finds this regressive vocabulary in *A Single Man* where George is chatting to his student Kenny Potter in a Santa Monica bar. Kenny quizzes George about what people mean by "experience" (160). This is George's reply:

> Let me tell you some thing, Kenny. For other people, I can't speak—but personally, I haven't gotten wise on anything. Certainly I've been through this and that; and when it happens again, I say to myself, Here it is again. But that doesn't seem to help me. In my opinion, I personally, have gotten steadily sillier and sillier—and that's a fact. (160)

George, of course, engages in light banter, a mild form of camp. Yet it is only because Savage remains ignorant of such tones that he finds "the odd use of 'silly'"—like the words "naughty" and "innocent" scattered elsewhere in the novels—as an obvious sign of Isherwood's "own unreadiness . . . to grasp, evaluate and comprehend experience so as to grow inwardly to maturity."[41] Even if Savage reaches these ludicrous conclusions from outrageous premises, there is more than an element of truth in his determination to show

how Isherwood's "emotional bent is always to the past."[42] In *A Single Man,* George certainly resists the idea that he might have grown to maturity. In his eyes, there could not be a "sillier" notion than the complacent belief that wisdom necessarily comes from adult "experience," since George resents the everyday pressure to pass as an acceptable—implicitly heterosexual—grown-up man.

Right from the outset, the novel makes it perfectly clear that George hardly assumes a fully developed subjectivity, for all his fifty-eight years. As the narrative proceeds, however, such lack of conventional maturity produces a queer existence that dissents from dominant models of straight middle-aged behavior. Every morning—just like the morning that opens the novel—he must once again confront who he is and what he is supposed to be, and it takes him a while to come into full consciousness of his actual identity: an "I" that gradually coalesces out of various linguistic fragments. That is why the impersonal narrator withholds George's name for several pages. "Waking up," we learn at the start, "begins with saying *am* and *now*" (9). Once the predicate and its adverbial modifier stand in place, then it becomes possible for him to attach the subject "*I*" to a complete sentence: "*I am now*" (9). Soon he contextualizes exactly where "*I*," "*am*," and "*now*" reside: namely "*at home*" (9). And as he "shambles naked into the bathroom" (10)—sensing that he still weighs (as did Isherwood) "a bit over 150 pounds" (10)—he looks into the mirror.[43] And what does he see? "[M]any faces within its face—the face of the child, the boy, the young man, the not-so-young man—all present still like fossils on superimposed layers, and, like fossils, dead" (10). Both present and absent to himself at once—rather like Isherwood's relation to Christopher—the still unnamed "I" views itself paradoxically as a "live dying" creature (10-11). Only when this "I" covers its nakedness and walks outside into "the world of other people" does it obtain a proper name. "[O]thers," we are told, "must be able to identify it. Its behavior must be acceptable to them" (11). That is why it is in public that "[i]t knows its name. It is called George" (11).

There is no doubt that George's queerness—which he feels constantly obliged to hide—lies at the source of his discomfort with the public role that he dutifully inhabits. Surrounded by heterosexual families, like his neighbors the Strunks, George fears that they suspect his lifestyle. He reckons that Mr. Strunk stigmatizes him as "*Queer*" because his neighbor harbors homosexual feelings of his own. It is hard for George to gauge whether such downright ill will proves worse than Mrs. Strunk's liberal pretensions. He conjectures that she has probably a "psychology book" (27) that attributes homosexuality to "possessive mothers," "sex-segregated British schools," and "arrested development" (28). "How dearly," he muses, "Mrs. Strunk would enjoy being sad about Jim!" (28). But she can spare George her pity, since none of his neighbors knows that Jim died. George has only told them that Jim has returned to his folks back East, which in a sense is "gospel truth" (28). Unwelcome at Jim's family funeral, unable to acknowledge his grief, George speculates on how the would-be liberal Mrs. Strunk might construe his relationship with Jim, if only she knew for sure about their intimacy. Her "psychology book," he guesses, probably informs her that Jim was a "substitute . . . for a real son, a real kid brother, a real husband, a real wife" (29). To his mind, though, "Jim

wasn't a substitute for anything" (29) because the heterosexual family provides the wrong frame of reference for comprehending their queer love.

Just when the novel encourages us to sympathize with George, it also becomes bleakly violent, quickly suggesting that the nuclear threat of 1962 offers an apt context for imagining the end of straight society. As soon as George steps into his car and starts driving to college, he embarks upon a series of disturbing fantasies that involve taking vengeance upon persons and things that offend him. In an apocalyptic spirit, he imagines spreading a virus that would destroy the fabric of a "huge, insolent building" blocking "the view along the coast from the park on the cliffs above" (36). Next he envisages kidnapping a "local newspaper editor" who "has started a campaign against sex deviates" (36). Once in George's possession, the editor and his staff-writers would be threatened with "red-hot pokers" unless they performed, for his enjoyment, "every possible sex act" (38) to be filmed for imminent release at every local theater. Last of all, he considers tormenting the senator who was "prepared to sacrifice three-quarters of our population" (37) because of the Soviet threat to the United States. Such atrocities, thinks George, necessitate a "campaign of systematic terror" (38), one that he would only be too happy to lead. Above all, he would take pleasure in devastating the "principal criminal" in each case (39):

> His wife may be kidnapped, garroted, embalmed and seated in the living room to await his return from the office. His children's heads may arrive in cartons by mail, or tapes of the screams his relatives utter as they are tortured to death. His friend's home may be blown up in the night. (39)

To be sure, this is imaginary, not real, violence. There is sardonic humor in the very thought that an ugly apartment building angers him as much as an impending nuclear war. (One can hardly take George's fantasies in earnest.) These fierce fantasmatics, no matter how much the novel pokes fun at them, contribute to a more general fear and loathing where heterosexuals, parents, and children continually repulse George. What is more, his misogyny can be virulent.

Two short episodes accentuate George's hatred of women. Both incidents help to account for why the novel turns its back on the crisis-ridden present and why it locates homosexual desire in a consoling past. Having finished teaching, George visits a hospital to see Doris, the woman who survived the car crash that killed Jim. By inference it seems that Jim might have enjoyed a sexual relationship with her. The idea fills George with ferocious resentment. Faced with "this yellow shriveled mannequin" on the bed (95), he wallows in how Doris's once-attractive body has undergone a Gothic transmogrification:

> Gross insucking vulva, sly ruthless greedy flesh, in all the bloom and gloss and arrogant resilience of youth, demanding that George shall step aside, bow down and yield to the female prerogative, hide his unnatural head in shame. I am Doris. I am Woman. I am Bitch-Mother Nature. The Church and the Law and the State exist to support me. I claim my biological rights. I demand Jim. (96–97)

Certainly, once these repellent thoughts have passed through his mind, George recoils from such bile. "Would I ever," he asks himself, "wish this on her?" (96). Yet his vivid disgust at Doris belongs to an entrenched revulsion with the sixties: a period when reproductive heterosexuality feels almost as totalitarian as the "Monroe Doctrine" (37) guiding the foreign policy of the United States. Obviously, George resents how modern society glorifies femininity and sanctifies motherhood. So when a woman later encroaches on George's own body—sticking "her tongue right in" to his mouth (145)—it is unsurprising that his anger flares once again. In the evening, George enjoys dinner at the home of an English woman friend, Charley. Having gotten extremely drunk with her, he decides to return home, and during their farewell embrace, she indulges in deep kissing. "She has done this before, often," he remarks. "Do women ever stop trying?" (145). Such repetitive behavior, he thinks, makes women "good losers" (145).

Once women disappear, then George's fantasy life becomes almost ecstatic as he takes pleasure in men: presumably the sexual winners. Particularly agreeable is the "physical democracy" of his gym (109). As he casts around his eyes upon the various male bodies—including a "godlike young baseball player" and a "plump banker"—he draws one satisfying conclusion: "Nobody is too hideous or too handsome to be accepted as an equal" (109). Little wonder he finds himself "more than unusually unwilling" to desert this vaguely Whitmanian paradise (109). Warm feelings of *Blutbrudershaft* emerge quite literally when George subsequently returns home and "changes out of his suit into an army-surplus store khaki shorts, faded blue denims, moccasins, a sweater" (115). Contemplating whether this semimilitary gear means he likes to "dress young" (115), George recalls how Jim used to say it "made him look like Rommel in civilian clothes." "George loved that," we are told (115). Like most campy jokes, this one is hardly innocent. Even though George detests dictatorship, his fantasies brim over with images of masculine authority, images that find a mocking yet erotic charm in the fascist past.

Equally arousing is George's accidental meeting with Kenny, the student with whom he chats and drinks before sharing a midnight swim. They discover each other in the bar called the Starboard Side, where George and Jim spent time together toward the end of World War II. "The blackout," George reminisces, was "no more than excuse for keeping the lights out at a gangbang" (147). Especially memorable were the months immediately after peace broke out when a "vast naked barbarian tribe" formed a "tribal encampment" along the beach (148). Now, in Kenny's youthful company, George recaptures some of that energy, and he "tries to describe to himself what this kind of drunkenness is like" (154). "Well," he thinks, "it's like Plato; it's like a dialogue" (154). As this reverie develops—rather like Socrates reveling in Alcibiades' devotion—George "can't imagine having a dialogue of this kind with a woman, because women only talk in terms of the personal" (154). And what emerges from this erotic-cum-pedagogic encounter? It is the speech where George announces what he thinks of "experience." Perhaps it is because of his active fantasy life that George believes he has with time grown "sillier and sillier." This lighthearted comment makes us wonder how seriously the novel wants us to take his sexual and political outlook. George, after all, has little time left in which to grow any "sillier." After Kenny leaves his apartment, George masturbates, only to die—or so we are led to believe—

of heart failure. In its final section, the novel prompts us to "suppose" (185) that in his sleep, George might as well be dead, since when he loses consciousness he returns once more to the condition of a "nonentity" (186). By going back to the nothingness from which he assembles his identity at the beginning of the book, the novel therefore achieves a circular—nonprogressive—structure.

Such existential—or perhaps, more properly, Vedantic—musings certainly encourage further reflection on the attention Isherwood pays to facile concepts of maturity, but arguably the most serious part of *A Single Man* derives from the episode that Heilbrun calls "the best American college classroom scene ever portrayed."[44] Surrounded by a diverse student body (characterizing the multicultural ethos of Los Angeles), George attempts to teach Aldous Huxley's *After Many a Summer* (1939). This is the little-known Huxley novel set in California of the 1930s that Isherwood found "*so* dry and prissy" when preparing it for his own students in 1959.[45] Much could be said about the significance that Huxley held for Isherwood, since this older writer was in some respects a role model. Huxley was in part responsible for introducing Isherwood to Vedanta, a religion that certainly informs the view that George is a "live dying" creature. Then again, Huxley represented a tiresome "English academic tradition" that Isherwood had come to "violently hate" in the 1930s.[46] Further, as Isherwood remarked in 1980, Huxley "for all his liberalism, found homosexuality and the homosexual temperament distasteful."[47] The reactions to Huxley's novel here may appear conflicted.

The same might be thought of its subject matter. The idea guiding *After Many a Summer* has some bearing on Isherwood's larger preoccupations in *A Single Man*. Huxley's narrative takes its title from Alfred Tennyson's poem "Tithonus" (1864): the dramatic monologue featuring the classical figure George calls "a repulsively immortal old man" who yearns for death (65). Perhaps we are to think that George is somewhat like Tithonus. Huxley's novel, after all, considers the futility of seeking the key to eternal life. But that topic, as George discovers, counts as one among many themes. Assuredly, his class works hard to fathom what Huxley's narrative is "*about*" ("nearly all of them," he reckons, "deep down regard this *about* business a tiresomely sophisticated game" [66]). One of his male students enthusiastically provides an excellent plot summary, but George finds himself more enchanted by this student's "beautiful head" than what the young man says (61). Unsure what to make of this pupil—a Chinese American man named Alexander Mong— George sees him as one of the "enigmatic Asians" (61), like Kenny's girlfriend Lois Yamaguchi. This racial stereotype endorses how hard it is for George to interpret his contemporary surroundings. Try as he might, George must face up to the fact that these bright and lively students simply cannot share his knowledge of the past: the 1930s when Huxley was famous for his pacifism. That is why he despairs when a Jewish member of the class, Myron Hirsch ("that indefatigable heckler of the *goyim*"), asks: "Is Huxley antisemitic?" (69). George politely responds "No" (69), but rather than dismiss the student's inquiry, he then takes it as a cue to extemporize—often in a hilarious unthinking manner—on the continuing persecution of minorities.

I will conclude with George's speech because it represents a minority consciousness that in some ways approximates the scene of coming out that we might imagine voices the political ambitions of the novel. It would, how-

ever, be misleading to think that what he says amounts to a coherent argument, not least because—after all the turbulent fantasies we have witnessed—it suggests that George is letting off steam. Loath to engage with Jewish oppression ("it's impossible to discuss Jews objectively nowadays" [70]), George opens up a diffuse discussion of how and why a "minority is only thought of as a minority when it constitutes some kind of threat to the majority, real or imaginary" (70). Just before making these remarks, he offers a "deep shining look that says, I am with you, little minority-sister" (70) to his gay student Wally Bryant. Yet he recoils from this campy moment of solidarity when he realizes that the "plump and sallow-faced" Wally has polished nails and "discreetly plucked" eyebrows, effeminate features that make the young man "much less appetizing" (70). Hereafter, his rambling discourse asserts, among other things, that a "minority has its own kind of aggression" and that "all minorities are in competition" (72). Such points implicitly critique George's own floundering performance.

Is George, though, simply babbling nonsense? In my view, it does not really matter whether we think George's speech contains wisdom of some kind, since he hardly figures as either a political mouthpiece or a role model. Nor is he an object of pity. He is purely—as the title says—a single man: a representative individual left with his own personal hell, one that Isherwood felt came "very close" to his own homosexual experience. It appears that Isherwood could not bear for George to outlive him. Without much to hope for, George is quietly put to sleep. His demise—if that is how we choose to read his end—may move us or disappoint us. But one thing is sure. The conclusion serves as more than a device that brings the story neatly to a halt. As it draws to a close, *A Single Man* makes us confront one blunt but inevitable fact. In Isherwood's queer sixties, there is not much of a future to be had. At the same time, that does not mean that in producing this troubled alter ago Isherwood was putting his own career to rest. Instead, George features as yet another inscrutable persona in a queer genealogy of self-invented fathers and sons on whose passions and problems Isherwood never ceased to reflect. As a consequence, George's confused minority consciousness belongs to an intensely personal past that reaches back through several decades: a time that Isherwood felt it was his prerogative to go on reimagining for many years to come.

Notes

My thanks must go to Laura Franey for invaluable research assistance, to Nigel Maxted for a peaceful context in which to write, and to Patricia Juliana Smith for something more than patience.

1. David J. Geherin, "An Interview with Christopher Isherwood," *Journal of Narrative Technique,* 2, no. 3 (1972): 157.

2. Brian Finney, *Christopher Isherwood: A Critical Biography* (New York: Oxford University Press, 1979), 255, 252, 249.

3. Claude J. Summers, *Christopher Isherwood* (New York: Frederick Ungar, 1980), 107.

4. Katherine Bucknell, "Introduction," in Christopher Isherwood, *Diaries,* vol. 1, *1939–1960,* ed. Bucknell (London: Methuen, 1996), xxx.

5. Christopher Isherwood, *A Single Man* (1964; reprint, New York: North Point Press, Farrar Straus and Giroux, 1996), 27. All further references to this edition (1996) appear in the main text.

6. Carolyn G. Heilbrun, *Christopher Isherwood* (New York: Columbia University Press, 1970), 13.

7. Elizabeth Hardwick, "Sex and the Single Man," *New York Review of Books,* 20 August 1964, 4.

8. Claude J. Summers, "Christopher Isherwood (1904–1986)," in *Contemporary Gay American Novelists: A Bio-Bibliographical Critical Sourcebook,* ed. Emmanuel S. Nelson (Westport, Conn.: Greenwood Press, 1993), 214.

9. Christopher Isherwood, *Christopher and His Kind 1929–1939* (1976; reprint, New York: North Point Press, Farrar, Straus and Giroux, 1996), 89.

10. Isherwood, *Christopher and His Kind,* 184–85.

11. Christopher Isherwood, *The Last of Mr. Norris* (1935; published in England as *Mr Norris Changes Trains*), in Isherwood, *The Berlin Stories* (New York: New Directions, 1963), 29.

12. Isherwood, *Christopher and His Kind,* 186.

13. Christopher Isherwood, *Goodbye to Berlin* (1939), in Isherwood, *The Berlin Stories,* 1.

14. Isherwood, *The Berlin Stories,* 192–93.

15. Ibid., 193.

16. Isherwood, *Christopher and His Kind,* 333–34.

17. Jonathan Fryer, *Eye of the Camera: A Life of Christopher Isherwood* (London: Allison and Busby, 1993), 216.

18. See, for example, his diary entry for 15 August 1960, where he considers calling his work-in-progress "The Enemy": Isherwood, *Diaries,* 895. The *Diaries* contain several other instances where he calls this work a novel.

19. Christopher Isherwood, *Down There on a Visit* (1962; reprint, London: Minerva, 1997), 7.

20. Ibid., 9.

21. Ibid.

22. Christopher Isherwood, *The World in the Evening* (1954; reprint, Harmondsworth, U.K.: Penguin, 1966), 110.

23. Ibid., 110–11.

24. Ibid., 116–17.

25. Isherwood, *Diaries,* 730. Hooker's findings from her experimental research appear in her paper, "Male Homosexuality in the Rorschach," *Journal of Projective Techniques,* 22, no. 1 (1958): 33–54.

26. Isherwood, *Diaries,* 740–41.

27. Cited in Fryer, *Eye of the Camera,* 131.

28. Isherwood, *Diaries,* 467. In a footnote to this diary entry, Bucknell states that his remark relates to Ronald Searle's captioned cartoons, "The Rake's Progress: The Poet" (*Punch,* 24 March 1954, 386), which "made fun of the artistic, political and spiritual idealism of Isherwood's perceived coterie"; this included Auden and Aldous Huxley, among others.

29. Bucknell helpfully identifies where Isherwood himself notes those parts of his diaries that he used when composing *A Single Man.* See Isherwood, *Diaries,* 621, 623, 629. These entries date from 1956.

30. Geherin, "An Interview with Christopher Isherwood," 150.

31. Bucknell, "Introduction," xl.

32. Geherin, "An Interview with Christopher Isherwood," 157.

33. Stanley Kauffmann, "Death in Venice, Cal.," *New Republic,* 5 September 1964, 23.

34. John Gross, "Civil Monsters," *New Statesman,* 11 September 1964, 361.

35. Sarah Smith and Marcus Smith, "To Help along the Line: An Interview with Christopher Isherwood," *New Orleans Review,* 4 (1979): 310.

36. Bucknell, "Introduction," xxxi.

37. D. S. Savage, "Christopher Isherwood: The Novelist as Homosexualist," *Literature and Psychology,* n.s., nos. 29, 1 and 2 (1979): 77.

38. Ibid., 72.

39. Ibid., 77.

40. Ibid., 78.

41. Ibid., 72.

42. Ibid., 85.

43. Isherwood tried to keep his weight below 150 pounds. In March 1959, for example, Isherwood wrote "I weigh 154 lbs. I mean to do something about this, at once" (*Diaries,* 802).

44. Heilbrun, *Christopher Isherwood,* 42.

45. Isherwood, *Diaries,* 835.

46. Ibid., 62.

47. Christopher Isherwood, *My Guru and His Disciple* (1980; reprint, New York: North Point Press, Farrar, Straus and Giroux, 1996), 50.

L.A. WOMEN
Jim Morrison with John Rechy

Ricardo L. Ortíz

The secrecy, the mysteriousness of human life is of course what we are speaking of in reference to Jim Morrison[:] . . . not only the secrecy of his life but the practice of concealment. He may have been unaware of his own secrets, unwilling to fathom the drives of his nature and the motives of his actions.
—WALLACE FOWLIE (104)

I've led a double life, in so many ways. I've worked so much on my form—my own, as well as my books—it's hard to insist that people look past that. A drag queen once said to me, "Ya know, hon, your muscles are as gay as my drag." She's right, of course, I do view life as a wonderful performance.
—JOHN RECHY, (*LOS ANGELES TIMES*,
15 SEPTEMBER 1996, E1–2)

[H]omosexuality is never homosexuality . . . it is always something else. . . . the only American literature of homosexuality exists in the underground of fantasy and pornography. —STANTON HOFFMAN
("CITIES OF NIGHT," 1964)[1]

Prologue: Beat, Noir

These three epigraphs perform a number of complex moves, across both spaces and times. In one way they move backward, from Jim Morrison, to John Rechy, to Hoffman's general statement about a history of "homosexual" literature in the United States predating even *City of Night*. It is an odd—a queer—genealogy, which links the putatively straight, but androgynous and exhibitionistic, lead singer of the Doors, as he is understood by a much older admiring male scholar and connoisseur of poetic and other beauties, to the once too withholding, now perhaps too forthcoming, but always narcissistic *ur*-poseur of queer fiction, John Rechy, and then to a critic whose detached statement nevertheless links itself through its betrayal of its intimate knowledge of "fantasy" and "pornography," not only to Rechy's fiction, but to much of the body of "Beat" writing, which set the stage for Rechy's early dubious performances of queerness-for-pay. What Fowlie needs to keep

secret, not only about Jim Morrison, but also about his own fascination with the image of Jim Morrison translates backward into what Rechy only recently has addressed most directly as the doubleness of the life he always led, both literally and fictively, which in turn translates back to the failure of translation imbedded in Hoffman's observation, that "homosexuality is never homosexuality. . . . it is always something else."

"Something else" has always, in fact, been what both Morrison and Rechy have been understood to "give" sexually. In concert they give us that "something else" most explicitly in a citation, one immediately observable but indeterminately meaningful, by the more coy Morrison, in the song "L.A. Woman": it goes, "Are you a lucky little lady in the City of Light?/Or just another lost angel, City of Night, City of Night, City of Night, City of Night." Biographers, hagiographers, and commentators of Morrison like Jerry Hopkins, Danny Sugerman, and Wallace Fowlie briefly acknowledge Morrison's reference, at least to the title of Rechy's late beat novel of existential drift and male hustling, *City of Night,* but none pursue further the varied implications of this citation, especially the suggestion imbedded in the "lost angel" phrase that Morrison had read more than Rechy's title.[2] What follows here will be an attempt to pursue these implications further; John Rechy will function in this essay as both a prism and a fulcrum, a critical and crisis-inducing, disruptive turn in what has traditionally passed for Morrison and the Doors' simultaneously geographical, genealogical, and gendered contextualizations. Reading Morrison "with" his fellow "lost" angeleno Rechy offers us an opportunity, not only to broaden and to "queer" our current understanding of the erotic quality of life in 1960s Los Angeles (LA) countercultures, but also to reroute the often quite literary citational, iterative, and performative tracks leading into and out of some of the Doors's better-known lyrical and choreographic expressions, and finally to reencounter gender as a more ambivalent construct than conventionally understood in both what Morrison has embodied, especially since his death, and specifically what "women" (there) actually *are* in either his or Rechy's cities of night.[3]

Reading Hustlers: Jim and His Johns

More people credit Jack Kerouac for Jim Morrison than they credit Jack Kerouac for John Rechy—but perhaps there are other "Beat" fathers, elusive Old Dean Moriartys, to name here as sources of anxious influence on our paired poet-posers.[4] One is William S. Burroughs—his echoes in Doors song titles, especially in the slide from one "soft machine" to an entire "soft parade," deserves further attention—and the other is Jean Genet—who, though himself not categorically "Beat," may stand as beat's absently enabling condition. Nothing necessarily "begins" with Beat, but Beat has a beginning, a "coining" really, by another player-for-pay, Herbert Huncke, who, if we believe the Burroughs and Allen Ginsberg that Ann Charters makes speak to us, issued the newly devalued semantic piece to subvert whole economies of exchange, transaction, and investment: "As Ginsberg remembered first hearing the word 'beat,'" Charters recounts, "the 'original street usage' in Huncke's speech meant 'exhausted, at the bottom of the world, looking up or out, sleepless, wide-eyed, perceptive, rejected by society, on your own, streetwise.'"[5] Roger Austin, in the 1977 study *Playing the*

Game, sees in this coining the immediate operation of the counterfeit: Beat is not so much Beat, but not-queer, and as such it is the viable stand-in, the truer, falser coinage for queer. All this comes from a hustler who understands how the counterfeit of Beat, the subterfuge that names and misnames queer, leads to coinage: "the gay members of this milieu, " Austin argues, "preferred the label 'beat' to that of 'queer.' A beatnik was considered weird and maladjusted enough. . . . a queer beatnik would have caused unbearable consternation."[6] Thus, the terms "Beat" and "queer" perform their perverse alchemy; add to the recipe a kind of "noirish" apocalypticism supplied by the peculiarly unangelic Angeleno spin on Beat supplied by Rechy and Morrison, and a potent concoction results, precipitated, not only through a hypostatized triangulation of the three, but through the complex inversions into each other and equally complex semiotic exchanges among them.[7]

Morrison's debt to a romantic/symbolist literary movement, arguably culminating in the Beats, is both common knowledge, and commonly cited in biographical material. James Riordan and Jerry Prochnicky include the following genealogy in their *Break on Through* (1991):

> Morrison . . . idolized poets and writers, having been helped by an English class where he was introduced to the classics. . . . His heroes were Blake, Baudelaire, Rimbaud and Kerouac and he devoured their works.
> *On the Road,* Jack Kerouac's beat novel, especially impressed Morrison. It is a saga of youth adrift in America, traveling the highways, exploring drugs, liquor, sex, and the philosophy of experience. Kerouac preached the poetry of being—freedom from rules that he felt didn't make sense, from emotional repression, elitism, hypocrisy, and the worship of comfort and material goods. He entices the readers to discover the world, experience life, and find out who they are on their own terms. . . . When Morrison grew up, he would live out the exploits of these writers [Jack Kerouac, Arthur Rimbaud, . . . but also presumably Neal Cassady and Allen Ginsberg] in his own life, the vagabond lifestyle—wild liquor, wild women and wild nights and a legendary career that streaked across the universe like a shooting star to end in tragic death, just like so many of his heroes.[8]

The astonishing closeting of, especially, Rimbaud and Ginsberg in this passage, in a text as recent as 1991, best measures the truth of Roger Austin's earlier remark about the persistence of queer anxiety and absenting in the cultural legacy of both Rimbaud and the Beat movement.

If Morrison, the poet of the inchoate, glances back solicitously at the older, "previous" Beat/queer generation of writers in his lyrical citations of the Burroughs/Kerouac coupling, his even more explicit, at times even visual and choreographic citing of Rechy (who always stands alone), corrects the ongoing mainstream attempt to keep Morrison's potential for sexual subversion within hetero-normative bounds. Indeed, Morrison's solicitous appeal to a queer genealogy shows him to be quite a willing participant in an act of textual hustling; he unapologetically cruises their texts for what pleasure they can afford him, never compensating them for their services to him except to the extent that his explicit and promiscuous quotations of them acknowledges a debt. Their texts father or sire his only to the extent that he enlists

them in such a service; otherwise, these earlier texts stand in sublime indifference to his, "precedent" but "younger," more innovative and more new.[9]

While Rechy and Morrison may have come to Kerouac, Burroughs, and the others independently, Morrison needs Rechy, finally, specifically, to reach beyond, say, the easy mythography of "The End," with its oedipally archetypal sexual apocalypse, to, say, the specific, corrosive nihilism of "L.A. Woman's" world of "motel, money, murder, madness." This is recognizably Rechy's urban nightworld, one offering Morrison models of male sexual exhibitionism, for starters, wildly alternative to the studied, precious Lizard King prance that he had exhausted of novelty and subversive potential by 1969. That Morrison took that opportunity for exhibitionism as far as he did, both in his notorious moment of self-exposure during a concert in Miami in the spring of that year and in his gleefully masturbatory play on an anagram of his own name in the chorus of "L.A. Woman," remains rather striking even to this jaded audience. On the subject of the anagram, Wallace Fowlie insists on reading a kind of hope in his hopelessly literalized reading of "Mr. Mojo Risin'."[10] Fowlie confesses that anagrams are encrypted signs, then insists on the least decoding of readings; "Mr. Mojo" may be sexual slang, but it is "Jim" who is "rising" to new prominence as resuscitated artist in "L.A. Woman"—this Morrison is Fowlie's Ganymede, however; not the Morrison who learned to hustle from Rechy—and not merely to hustle, but to perform the most potent kind of public masturbation, a signatory masturbation of his own perverted signature, making "Mr. Mojo" rise, and swell, musically, to a full and satisfying crescendo for a very appreciative, willing, and paying audience.

Touch Me: Morrison's Cocks

On the least problematic level, Morrison is infinitely more comfortable an exhibitionist than a voyeur. What he exhibits is chosen, not for the writers from whom he takes his cues, but for an audience comprised of an anonymous mass of admiring fans (presumably not all of them female), a less indeterminate audience of journalists and music critics (presumably most, but not all of them, male and straight), and a camera, any camera—perhaps even "the" camera as the paradigmatic instrument of simultaneous reproduction, multiplication, and projection. These all figure as the "subjects," of varying degrees of collectivity, anonymity, and determinate identity, that Morrison most aggressively solicits and have precipitated themselves for the purposes of this essay in the (soft/hard) "parade" (cortège) of writers, both hagiographers and cynics (all but for one significant exception, male), who have come not to mourn but to resuscitate and resurrect Morrison, post mortem, in the odd assortment of texts constellated here. This primal horde of Morrison mourners is comprised in part of those who, like the other members of the Doors and their primary producer, Paul Rothchild, have frequently been called on and at times have called on themselves to testify to Jim's many fascinating qualities. Joining the feast, however, are those who, like Danny Sugerman, James Riordan, Oliver Stone, and Wallace Fowlie, had little or no direct contact with Morrison yet feel the need to recreate something of him in the images of their own various desires.

These might be said to be Morrison's true "daddies," all men who outlived, not only Morrison, but Morrison as the visual embodiment of youth

(his and theirs), a Morrison who, in the persistence of his youthful image—of his reproducible image as a promise of an impossibly everlasting youth—incites in each of these commentators an impulse to bear their own anxious sexual proclivities in their probings of his remembered, recorded, projected, and disseminated body image. While none of these "writers" and artists comes close to avowing for themselves a specifically homoerotic fascination for Morrison, all their attempts to handle the Morrison mystique, to determine Morrison's complex negotiation of both the sincere "shaman" and disingenuous "showman" qualities, and to judge even Morrison's status as a "poet" fail in the end to veil their intense interest in the two aspects of Morrison's body one might expect any daddy to want to probe once he lands his delectable trick—the boy's cock, and the various "ends" (in)to which he might have put it.[11]

In a 1969 *Advocate* article, Leonard Riefensthal described the transformation of hustler body types through the course of the 1960s in LA; uncannily, Riefensthal sounds almost conscious that he is specifically observing how Rechy's tough-boy hustler narrators morph (for better or worse) into Morrisonian waifs:

> He slouches against a window of the Gold Cup on Hollywood Boulevard . . . hair down to his shoulders, his lanky calves cased in buckskin . . . you're looking at a hustler, Model 1970.
>
> You have a different image of the hustler? You've read *City of Night*, so you know that one can always spot a member of the trade by the pout, the T-shirt, the thumb in the belt loop?
>
> The youthquake has shaken the knights of the street no less than the other segments of Young America. The shake-up affects not only the hustler's dress and grooming, but his whole self-image . . . and consequently his performance in the sheets. Those addicted to the company of hustlers know that the overall picture has changed markedly in the last half-decade—not with the disappearance of those hustlers rooted in the working classes, but with the entry into the trade of the new breed of middle class dropout.
>
> Note the changes resulting from this new arrival. First and most obvious is the change in looks. Costumes aside, the new breed tends to be tall, willowy, endomorphic, somewhat slight of chest. One remembers the eyes.
>
> By contrast, his counterpart in the old school was short to medium in height, chunky in build, with pectorals and biceps that he liked to show off. One remembered the cock.[12]

Rechy's work clearly establishes the lurking queerness of the environment Riefensthal observes on L.A.'s main thoroughfares, an environment through which Morrison ran in the course of his own artistic development.

City of Night thus not only connects the Beat and rock worlds but also provides textual material for fleshing out the milieu of queer L.A., from downtown to Hollywood to Venice Beach, and a milieu of visible queer male bodies—the stud hustlers and prettyboys Morrison's own self-presentations so clearly mimic. "In Pershing Square," Rechy begins, in a passage that seems to have partly grafted into "L.A. Woman":

while the preachers dash out their damning messages, the winos storm Heaven on cheap wine; hungry-eyed scores with money . . . gather about the head hunting malehustlers . . . [who] like flitting birds move restlessly about the park—fugitive hustlers looking for lonely fruits to score from . . . the scattered junkies, the smalltime pushers, the tea-heads, the sad panhandlers, the occasional lonely exiled nymphos haunting the entrance to the men's head; the tough teenage girls making it with the lost hustlers. . . . And . . . later at night . . . the queens in colorful shirtblouses—dressed as much like women as The Law allows that particular moment—will dish each other like jealous bitchy women, commenting on the desireability or otherwise of the stray youngmen they may offer a place for the night.

The world of Lonely-Outcast America squeezed into Pershing Square, of the Cities of Terrible Night, downtown now trapped in the City of Lost Angels. . . . *And the trees hang over it all like some apathetic fate.*[13]

The self-conscious, feminized preening of the male hustlers also marks a renewed fascination generally in culture with the eroticized male image, one that had gone underground in the decades since the 1920s but had been revived by James Dean, Marlon Brando, Montgomery Clift, and Rock Hudson in the 1950s. The viewer most fascinated with this image is, of course, the one the image is designed to shape: the causelessly rebellious, young, straight boy who, because he cannot be queer, can only queer himself to the extent that his sexual energy directs itself more perversely than conventionally expected; oftentimes, then, not at women but rather back at his own image.

There is a raging straightboy narcissism figured perhaps best in Morrison that certainly predates and survives him; one that, since Morrison's death at least, has generalized itself into the fascination his audience brings to Morrison's image as a necessary step in the formation of its various, individual manifestations of that very narcissism. In *Break on Through,* Riordan and Prochnicky make fairly explicit their sense of the narcissism driving Morrison's artistic life. Indeed, they fashion Morrison's moment of artistic birth as precisely a passage through a "mirror" stage:

> The shard of glass was jagged. It jutted toward the sky as if trying to pierce it, to cut away the boundary between heaven and earth. Or maybe slice off a piece of hell. So thought the lanky figure who stared into the broken mirror. He was handsome; the distorted reflection of the shattered glass could not hide his good looks. His hair was long and curled over the collar of his white t-shirt. His skin was pale and he looked even younger than his twenty-two years. There was a softness to him, a gentleness, an almost seductive quality. His face was more than handsome, it was pretty; and the way he cocked his head slightly, exposing his alabaster white neck, displayed a vulnerability that most men would be afraid to reveal. But he was not feminine. In his eyes something definitely masculine burned. More than masculine even. Something dangerous.
>
> Jim Morrison peered closely at his image in the mirror. . . . His eyes were . . . penetrating, his cheeks hollow and slightly sunken, like a fashion model's.[14]

It would be difficult to overestimate the extent and the importance of Morrison's phallic function, inscribed here best in the metonymic slide from the "cock"ing of Morrison's head to the almost-feminine "alabaster neck" he should not expose, for a vast, public heterosexual male imaginary whose anxieties Riordan and Prochnicky's text so haplessly performs. His image as phallicized (always through a conflation of "eyes" and "cock" in the image of his look) and fetishized by a massive audience of straight men who need to see in Morrison something "dangerously more-than-masculine," an audience remarkably adept at reproducing itself at least once every decade via some resurrection of that image, marks emphatically a site of profound sexual anxiety on the part of that audience and on the part of the larger culture to which it stands in some synecdochal relationship.[15]

It may be impossible to identify the moment when Morrison's image was first initiated into this register, but the moment of its institutionalization, the moment of his alleged self-exposure during a concert in Miami in March 1969, is quite clearly marked. Rock historians have played as perverse a game of fort/da with the did he, didn't he questions raised by an incident so curiously uncaptured photographically, as Morrison himself reportedly played with the cock itself during the incident.[16] In one respect at least, Ray Manzarek's own report of the scene merely elaborates on his larger attempts to explain Morrison's signifying function as a performer. Manzarek plies the conventional proto-romantic reading of Morrison's ability to access something like essence performatively ("Jim was *real,* man, . . . more real on stage than off"). Indeed, he was most real in the most improvised spontaneous moments of performance, when he was least a "showman" and most a "shaman," the embodiment not merely of a Beat poetics so much as the sublime transubstantiation of "Beat" and "body." For Manzarek and the fandom organized by and around such testimonies by Morrison's chief apostolate, Morrison works precisely the magic expressed as the central aesthetic wish of a Western poetic tradition extending at least as far back as William Blake, and through the French symbolists, especially Arthur Rimbaud, to the Beats themselves when their aesthetic was most idealistically construed. This is also the even more ancient wishful, wished-for promise of specifically phallic transcendental signifier, that "impossible" signifier repudiated by post-structural theory, marked in the exemplary moment when, in any offering of, say, bread, the offerer claims "this is my body," at once enacting and erasing, as act, the performance of signification.[17]

By all accounts, Morrison seems to have sensed that, as a performer, he had already exhausted all the potential sources of signification available to him within a cultural and legal regime which, even by the late 1960s, severely limited what was semiotically possible in public musical and theatrical performance.[18] He seemed to recognize, though grudgingly, that all that messy but potent "reality" he was able to perform and peddle onstage left him with no other recourse than to get *really* "real"—to expose, literally, *as* literality, that which he had so successfully merely "performed" previously. Implicit in what might on the surface appear to be a lazily idealized romantic aesthetic is the influence on Morrison of both Antonin Artaud's "theatre of cruelty" and Julian Beck and Judith Malina's Living Theatre. Wallace Fowlie, for example, tells us that:

In Antonin Artaud's book *The Theatre and Its Double,* Jim had read that each performance should be a risk. The audience should be shaken out of its complacency. . . . Thanks to Artaud, Jim had become interested in The Living Theatre of Julian Beck and his wife Judith Malina. The actors often appeared naked onstage where they performed their improvised plays . . . [so in Miami in March 1969] Jim was thrown into the audience, where he formed a snake dance. A large crowd followed him. Back on stage, Jim pulled his shirt off and threw it into the audience. He began to open his pants, and later said he thought he had exposed himself [and] he was charged with lewd behavior, indecent exposure, and with simulating oral copulation.[19]

Fowlie's is one of a number of inconsistent accounts of how exactly the signifying surface bulge of Morrison's leather pants, the object of such intense fascination on the part of the mass of Doors fans, ultimately compelled the divulging of what it signified.[20]

By all accounts, "everything changed" after Morrison's self-exposure in Miami in 1969: Morrison's capitulation to the literal seemed to accompany his capitulation to alcoholism, that central relationship to the real that rendered Morrison-as-subject most beholden to an object. This also marks the point of Morrison's capitulation to his body and its decrepitude. Now Morrison the boy becomes Morrison the bear. No longer the object of beauty as the promise of an impossibly indefinite youth, no longer the performative embodiment of the romantic wish for transcendent sublation and synthesis, Morrison's body, after spring 1969, increasingly bears the marks of its own impending nihilistic end; it distends, widens, balloons, grows hairy.[21] Morrison is now no longer a boy Ginsberg might cruise among the "peaches and penumbras" of an all-night supermarket of libidinal transactions and exchanges; no longer a body to be posed romantically, even as the overgrown, slightly dangerous, Rechean young man hustler in anyone's city of night. No longer, perhaps, Rechean object, Morrison does manage, however, to inhabit more fully after this transformation the noirish nihilism of a Rechean subject. This is the Morrison who, by late 1970, can pen "L.A. Woman" and who can, in turn, abandon the romantically sentimental noir of early songs like "Moonlight Drive" for the apocalypticism appropriate to a world whose "hills are filled with fire."

Light My Fire: Burning Genders, Electric Weddings

Gender unambiguously burns in "L.A. Woman," a song that marks Morrison's abandonment of the wishful physical androgyny he exploited so resourcefully before, for a more fully evolved, internalized, and subjective androgyny.[22] The young Morrison could explicitly declare his oedipal wish in a song like "The End," suggesting that he was both more and less beholden to its demands than most, but the Morrison who posthumously sings to an "L.A. Woman" in a song that cites a novel in which all the L.A. "women" are men takes on a profoundly alternative relation to gender and to sexuality precisely as these constructs figure in the registers of signification. This section will devote its attention to the consolidating semiotics of gender, sexuality and even geography, as they are signaled for both Rechy and

Morrison in the symbolic embodiment of "L.A." (as) "Woman." Given that all of Rechy's memorable women characters, especially in the L.A. sections of *City of Night,* are drag queens, there can be nothing simple about Morrison's settling on the superficially conventional symbol of a strung-out groupie for his. Clearly "L.A. Woman" is more, and better, than a "Ruby Tuesday" retread, if only because there is more of a transvestite/transgender spin to the unsettling gender-apocalypticism of this song.

Rechy's novel features one memorable "L.A. Woman," the camp-tragic "Miss Destiny," whose two interlinked wishes are, one, to be taken so literally for a woman that, two, she will be asked to marry and participate in a wedding. "Miss Destiny" is a remarkable, and remarkably sustained, performance on Rechy's part, a rare point of distancing from the butch hustler who usually serves as the novel's narrative eye:[23]

> She—he (Miss Destiny is a man)—went on about her—his—restlessness, her husbands, asking me questions in between, figuring out how Bad I was . . . looking alternately coyly and coldly at Chuck then me seductively: all of which you will recognize as the queen's technique to make you feel like such an irresistible so masculine so sexual so swinging stud, and queens can do it better than most real girls, queens being Uninhibited.[24]

Counter this with the youngman's account of "real" girls who also gravitate to the brooding boy hustlers in Pershing Square:

> Among the bands of malehustlers that hang out in downtown Los Angeles, there are often a few stray girls: They are quite young, usually prematurely hardened, toughlooking even when theyre pretty. They know all about the youngmen they make it with: that these youngmen hustle and clip other males. And knowing this, they don't seem to care.[25]

These girls, "hardened" and "tough"-ened out of their own conventional femininity, resemble streetwise groupies of the sort one might also expect "straight" rockers like Morrison to sing about; but these girls merely stray through Rechy's text, barely perceptible in the flash and glare of the alternative "females" in their world. These are not the heroic victims of some new apocalypse, but its detritus. They do not figure into the narrative so much as mark its contingent limits; they stray on the borders of what is possible in Rechy's sexual and textual worlds.

Indeed, if anyone functions as the figure for narrative (and its failures) in the Los Angeles section of *City of Night,* it is Miss Destiny. In a passage recounting Miss Destiny's arrest by the vice squad, Rechy tests the efficacy (and exposes the inadequacy) of several conventional modes of storytelling, specifically fairytale and allegory:

> (Oh shes dancing like Cinderella at the magic ball in this Other World shes longingly invading, and her prince-charming turns out to be: the vice squad. And oh Miss Destiny gathers her skirts and tries to run like in the fairytale, but the vice grabs her roughly and off she goes in a very real coach to the glasshouse, the feathers trembling now ner-

vously. Miss Destiny insists she is a real woman leave her alone. (But oh, oh! how can she hide That Thing between his legs which should belong there only when it is somebody else's?) . . . All lonesome tears and Humiliation, Miss Destiny ends up in the sextank: a wayward Cinderella . . .)

"Now, honey," she says with real indignation, "I can see them bustin' me for Impersonating a man—but a woman!—really!"[26]

Gregory Bredbeck has observed that Rechy's narrative practice in his early hustler novels deviates from conventional storytelling by stringing barely contingently related encounters along in order to reproduce the quality of a hustler's life of arbitrarily sequenced tricks.[27] Fully realized episodes like Miss Destiny's elaborate monologue of her arrest and her still-insistent desire for a truly meaningful ritualization of her womanhood operate directly in the service of the larger narrative's radical contingency. Miss Destiny therefore embodies missed destinies and a kind of refusal or failure of the teleological thrust of conventional narrative; this makes her wish for a symbolic ceremony just that much more insistent, however, as well as just that much more impossible. The gendered inversions imbedded in a rhetoric that both exposes "That [stubborn] Thing" that refuses to obey the logic of Miss Destiny's imaginary self-construction and confirms her own sophisticated sense of the greater falsehood of her "impersonating a man" regardless of the "Thing between his legs which should belong there only if it is somebody else's" suggests that Rechy's text struggles, in its own way, to develop a signifying practice that can accommodate such complicated inversions.

Rechy's struggles parallel Morrison's, and these parallels are observable in "L.A. Woman" and also in other Doors songs. "L.A. Woman" is perhaps Morrison's own attempt to imagine a "Miss Destiny" longing for the right ritual to "join her fragments." According to Barney Hoskyns, as early as the 1967 release *Strange Days,* the Doors' music "suggested the lurking malevolence which had begun to encroach on LA's good vibrations." Hoskyns goes on, if LA was, as Morrison told *Time* magazine, "'looking for a ritual to join its fragments,'" then "The Doors [were] looking for such a ritual, too—a sort of electric wedding."[28] Miss Destiny's rant in *City of Night* as she imagines her own "electric" wedding is more than telling here:

> Miss Thing said to me (Miss Thing is a fairy perched on my back like some people have a monkey or a conscience). . . ."Miss Destiny dear, dont be a fool, fix your lovey rair and find you a new husband—make it permanent this time by really getting Married— . . . and Miss Destiny dear, have a real wedding this time.". . . A real wedding, Miss Destiny sighed wistfully. "Like every young girl should have at least once. . . . And when it happens oh it will be the most simpuhlee Fabulous wedding the Westcoast has evuh seen! with the oh most beautiful queens as bridesmaids! and the handsomest studs as ushers! . . . —and *Me*! . . . Me . . . in virgin-white . . . coming down a winding staircase.[29]

This almost perfect inversion of the conventional heterosexual dream of a wedding, of ritual as the instituting ground of heterosexuality and heteronormativity, merely winds down, drained of energy the minute the wish is

spoken. The "Thing" that in the previous scene had been the stubborn "real" reminder of Miss Destiny's delusion becomes in this scene itself a "Miss[ed] Thing," the abstracted and absented voice of both Miss Destiny's fantasy and her perverse conscience. "Thing" here also marks fairly explicitly the execution of at least one successful ritual: castration. The wedding ritual, tested here as the promising ground of Miss Destiny's self-adequation, is, even in its invocation, always already evacuated and exhausted. Miss Destiny's destiny, her accession to a viable "Meness," cannot be guaranteed by the failed ritual effectiveness of the wedding; it fails as both narrative and symbol, and her projected "Me" can only "wind" down, descend into the abyssal hole of its own compulsive self-perpetuation as fantasy.

The End: Missed Destinies
and the Always Already Dead

This hole is perhaps also where Morrison stares in those moments in the Doors' music where he confronts his own missed destinies. A song as distended and deferring as "The End," for example, seems to perform the same evacuation of effectiveness from ritual; it could, and at times reportedly did, in performance, go on forever, and what is conventionally taken to be Morrison's daring confrontation of his oedipal wish in that song seems instead to be the gesture that guarantees the failure of the performance as ritual. As with his self-exposure, the literalization of the oedipal wish can only effectively dismiss any reconstitution of it in ritual, whether as narrative or as symbol—no oedipus, no ritual; no ritual, no story; no story, no "End." While for Morrison, and perhaps for Rechy, this newfound willingness to stare into the abyss typified the darker side of the more general sense of artistic freedom and daring revived in the sixties, there were certainly others, writers just as plugged into the sixties LA zeitgeist, who were less willing to play in the mire of narrative's end. Of these the most curious is Joan Didion, who, in *The White Album,* her fragmented memoir of the late sixties in the United States, and particularly in LA, sounds perhaps the most articulate response to the challenge posed by both Rechy and Morrison in their work. She does so by not only writing specifically about Morrison, but in the manner in which she herself strikes a writerly pose, which might have come right out of Morrison's observation in "L.A. Woman" that he "never saw a woman so alone."

One might argue that Didion and Morrison especially seem to have their fingers on an identical cultural pulse, but from radically different positions relative to the cultural body and "the body" in general. Didion, for example, also combines her observations about the fate of narrative in her time with a gesture of self-exposure:

> We tell ourselves stories in order to live. The princess caged in the consulate. The man with the candy will lead the children into the sea. The naked woman on the ledge outside the window on the sixteenth floor is a victim of accidie, or the naked woman is an exhibitionist, and it would be "interesting" to know which. . . . We live entirely, especially if we are writers, by the imposition of a narrative line upon disparate images, by the "ideas" with which we learn to freeze the shifting phantasmagoria which is our actual experience. . . . I am talking here about a time when I began to doubt the premises of all the stories I had ever

told myself. . . . my entire education, everything I had ever been told or had told myself, insisted that the production was never meant to be improvised: I was supposed to have a script, and I had mislaid it. I was supposed to hear cues, and no longer did. I was meant to know the plot, but all I knew was what I saw: flash pictures in variable sequence, images with no "meaning" beyond their temporary arrangement, not a movie but a cutting-room experience. In what would probably be the middle of my life, I wanted still to believe in the narrative and the narrative's intelligibility, but to know that one could change the sense with every cut was to begin to perceive the experience as rather more electrical than ethical.[30]

There is little question that the "naked woman on the ledge" is Didion herself, both bleakly despairing and exhibitionistic, as she divulges later in the essay when she presents verbatim a psychological diagnosis of herself from 1968.[31] While Didion may openly mourn the demise of "the narrative" without admitting that what were passing were *some* narratives rather than *all* of them—especially narratives from which she and others like her (white, straight, privileged, educated) profited—there is certainly something to her observation that in general, "narrative" could no longer convincingly promise outcomes as it conventionally had.

To this extent, while Morrison might have stood in rather appropriately for the sinister "man with the candy [who] leads the children into the sea," he only functions for Didion as precisely the worst practitioner of the improvisation that has given the lie to all remaining narratives. He stands, pathetically, as the poet who, for all the sexual and symbolic promise of his public reputation, makes nothing happen. She attempts to narrate her encounter with the Doors by establishing her expectations of their "difference" from other rock bands: "The Doors interested me," she tells us, because "The Doors seemed unconvinced that love was brotherhood and Kama Sutra. The Doors' music insisted that love was sex and sex was death and therein lay salvation." Of course, the leader of this band of "missionaries of apocalyptic sex" provided Didion with a momentary flash of fascination organized rather shamelessly around his private parts:

> Jim Morrison . . . wore black vinyl pants and no underwear and tended to suggest some range of possibility just beyond a suicide pact. It was Morrison who had described the Doors as "erotic politicians." It was Morrison who had defined the group's interests as "anything about revolt, disorder, chaos, about activity that appears to have no meaning." It was Morrison who got arrested in Miami in December of 1967 [*sic*] for giving an "indecent" performance.[32]

It was also Morrison who, in the course of the hours Didion spent watching the Doors record an album, went largely "missing." Even after an arrival that none of the other band members acknowledged, Morrison does nothing that leads to anything else; Didion's only comment is that he spoke to Manzarek "in a whisper, as if he wrested the words from behind some disabling aphasia," and her only memorable observation is that he "sat down . . . on [a] leather couch, . . . lit a match[,] . . . studied the flame awhile . . . and then

very slowly, deliberately, lowered it to the fly of his black vinyl pants."[33] Didion lacked the patience and the interest to see the recording session through to its end; instead she leaves her readers with perhaps the paradigmatic image of Morrison's convoluted, flaming narcissism before she goes on exploring her own.

Despite her confused dating of the Miami incident, Didion probably visited with the Doors in spring 1968, when they were recording *Waiting for the Sun*. The single of "L.A. Woman" and album of the same name would not appear for almost three years, but Didion's image certainly figures the masturbatory endgame at play in that song. Didion's sexually curious gazing regard for Morrison plays in its own way with the gender inversion Morrison realizes in the later song; no one writes more "like a man" than Didion, and here she directs her assertive, acerbic style in the service of capturing Morrison's own odd mix of virility and androgyny. And by the time Morrison composed his "L.A. Woman," there may be no reason to assume that the term "woman" functioned any less ambiguously for him than it did for Rechy. Indeed, there may be no "L.A. Woman" in Morrison's city of night who can compete with the various manifestations of his own androgyny.

Gender burning in "L.A. Woman" immediately effects an even deeper gender implosion. There may be no more theoretically honest way to account for the song's radically textualized finality in the turn to the erotic, anagrammatic signing of Morrison's own name except to call it "uncanny"; Morrison's staging with "Mr. Mojo Risin'" of his own jack-off show—of the improbably sexual graphic scrambling of his own mirror-in-writing—bears no other paradigm of accountability. It is perhaps with this gesture that Morrison most clearly marks himself as the poet who, in "showing himself," makes nothing happen—but why "nothing" in the face of all the excesses to which the narratives of his life, artistic career, and their aftermaths have tended? It may be precisely because all these excesses do little but mask, and mask badly, Morrison's chief function (one he willingly took on) as phallic wish, as virtual cock masking actual lack, as simultaneously transcendent symbol and symbol of the possibility of transcendence on which the conventional heterosexual order relies in order to repress its own reliance on the apparatus of homoerotic desire.[34]

Back Doors and Backsides

To the extent that one might probe more deeply an explicit "queerness" in Morrison, interesting possibilities lurk in all the weird sexual innuendo in *Break On Through*. There Riordan and Prochnicky report some of Morrison's more interesting sexual proclivities through usually unreliable sources:

> [According to Mirandi Babitz,] One time . . . [Pam Courson] was pissed off at [Morrison] because she thought he was running around with someone else. So she took his favorite vest that he liked to wear onstage and wrote "FAGGOT" across the back of it with a bunch of colored markers. . . . [This story raises the bisexual question, but Babitz doubts there is any substance to it.] Pam would never tell me exactly what she had meant by that, but I'm pretty sure Jim never had anything like a gay affair because she would've found out and that would've really upset her. . . . I think he probably had a gay experience because of his

experimental nature, but nothing like regular experiences. I know their sex life was weird. He tied her up all the time and sometimes he was really really brutal with her. It was okay with her to a point, but then he would always go over the line. I think the fag stuff came from the fact that he really preferred women from the backside.[35]

Morrison was thus being a "Back Door Man" in more ways than one (in Stone's film he "enters" Pam Courson's life through an unconventional opening—in fact, he refuses to use the front door), which certainly sufficiently "queers" him.[36] According to Hopkins and Sugerman, the song "Back Door Man," originally composed by bluesman Willie Dixon, early on became a Doors standard, as much a calling-card as their cover of "Gloria" and one they did not hesitate to sing when they first arrived in that lair of sixties queerness, Andy Warhol's New York, where they performed "in a chic new disco called Ondine[,] . . . one of those proper clubs designed for the Uptown Bohemian, a Brechtian cabaret where apocalyptic celebration was as thick as the marijuana smoke"; there the Doors opened with "Back Door Man," [Morrison singing,] "Oh ahm a back door man/The men don't know, but the little girls unnerstan."[37] But this anal-yzing semiotic also queers the Doors on at least two interesting levels: the "Door" symbol itself takes on a provocative new dimension by suggesting that all bodily orifices (rather than just the eyes as the conventional romantic/Blakean symbol of perception) are important openings to experience (and to pleasure)—indeed, that experience is both perception *and* sensation, and that any site on the body open, like the anus, to intense experience deepens both. We could probably hyperbolize this to the extreme, questioning what exact "void" it is that Morrison has us "stare into " with him in "The End."

Indeed, Morrison stared into the gloryhole abyss of "The End" and in the same moment retreated to the comforting oedipal mythography of his imputed subjective genesis; but by the time he wrote "L.A. Woman," he seemed to recognize the failed efficacy of such a retreat to the comforting enclosure of any such metaphorical synthesis. Rather, he begins to confront such arbitrary metonymic contingencies as those alliterated across the chain of signifiers marked as "motel, money, murder, madness" and lands, as squarely as he can, in the radical contingency of gender itself, in a textual space discursively and citationally defined as a "city of night," where none of the "women" (and by extension none of the "men") *are*. Perhaps, then, the apocalypticism of "The End" is both at once more general and more specific than conventionally thought: on the one hand we might follow Jeff Pike in pushing further the metaphysical dimension of the song, at the same time that we can resist reducing the effect of its erotic endgame to a subversion of the oedipally authorized construction of gender. According to Pike:

> Why ["The End"] works is a mystery. Certainly it's related to Morrison's ability to convey the erotic attractions of death and murder. When Morrison intones . . ."This is the end, beautiful friend," it's hard to know if the beautiful friend is someone he is about to murder, or if it is death itself. But even by then it doesn't really, you know, matter— either way you're looking squarely into the void. And it's kind of sexy.[38]

Sexy, indeed, primarily because the void is as much the voiding of sex (and gender) as it is the affirmation of the sexiness of death.

Combining thus an analysis of verbal and visual text, from Doors songs to accounts of "live" performances and then to their recreations in both biographies and biographical films certainly opens new possibilities for rereading Morrison's lyrical and choreographic contributions to Doors material, and it also opens up new possibilities for understanding his own pathological exhibitionism in the presence of any and all audiences, including himself. The Doors and Morrison himself deserve more aggressive "queering" than they receive in the rather sexually lame work surveyed here, but performing such a transformation in reading should not be equated with anything like a biographical investigation of just how "homosexual" Morrison ever was or just how "queer" "L.A. Woman" becomes when read more carefully for its Rechean echoes. Those, indeed, may be corollary byproducts of a more semiotically oriented reading of the "intertext" comprised by the assortment of readings at play in this essay.

Ends

In his essay "Cockteaser" Tom Waugh declares the stud/queen dualism a defining paradigm of the 1960s construction of queer (and unqueer) masculinity, a construction this essay studies alongside the anxious negotiations conducted by a presumptively hetero-male-critical community with the subversive "masculine" poses of say, the (presumptively hetero-male) Beat writers (Kerouac especially) who influenced both Rechy and Morrison and the (presumptively hetero-male) rock stars who embodied most visibly the transformation of masculine iconography and its attendant eroticism in the course of the decade (less so Elvis Presley, more so Mick Jagger, David Bowie, and Morrison himself).[39] Rechy's own obsessive relationship with his image—the manner in which he solicits a specific gaze from both his reading audience and anyone who sees one of his author-snapshot poses in full hustler mode—may indeed model, in turn, Morrison's similar relationship with his image. Beyond our interest in how Morrison either sees or presents himself subjectively is the perhaps more interesting question of who his body and its projected image have been looking at since their first appearance in the fields of public fantasy and vision; Morrison may have craved an audience, but his body created one, organizing a mass spectatorship around its own uncannily strong givenness to be seen. That audience clearly includes the likes of Riordan, Prochnicky, Sugerman and Hopkins, and even Oliver Stone and Wallace Fowlie; it is an audience primarily composed of presumptively heterosexual male admirers who seem unaware of the homoerotic spectacle of that very admiration.

Finally, a reading that, like this one, declares itself "queer" should not be seen as incompatible with a demystifying, materialist reading of all the Morrison-as-boy-hustler innuendo that it also, at least implicitly, raises. Beginning with Didion's deep cynicism about him in *The White Album* and continuing with Barney Hoskyns's equally stinging assessment of Morrison in *Waiting for the Sun,* a congruent extension of the analysis I present here must turn to questions of class and race (and the unique pathologies attached to them) in the larger white boy invasion and colonization of rock music (and its own corollary eroticization of the presumptively straight white "young-

man").[40] This is, in one respect, the "back door" into "dangerous" rock that Willie Dixon's blues standard afforded Morrison early on. In *Waiting for the Sun,* Barney Hoskyns flirts briefly with such a critique: some people, Hoskyns argues:

> suspected the whole [Jim-as-shaman] thing was . . . a sham . . . exposing the adolescent exhibitionism at the heart of the Doors' "theatre". . . [symptomatic] of the dysfunctional bourgeois psychopathology . . . [that produced] middle-class hippie kids from the same background as Morrison himself, initially liberated by sex and drugs and rock 'n roll but now simply disoriented, frightened and potentially dangerous.[41]

In an uncharacteristically sober moment, even Riordan and Prochnicky acknowledge the depth of Morrison's own self-doubt about the image he had already overcultivated: "Despite his sense of humor, no one took Morrison as seriously as Morrison took himself. Now [summer 1969], as the tongue-in-cheek Lizard King, he was forced to realize that he would never be so much Baudelaire and Rimbaud as he was Bozo Dionysus."[42] Morrison's turn away from the romantics and symbolists in "L.A. Woman," a move signaled by his citation of Rechy, suggests that he, too, had begun to see the dead end of overdetermining one's relationship to any transcendent, redemptive promise. That materialist analysis will remain underdone here; it must suffice for now to acknowledge queer theory's efficacy for redrawing lines of affiliation and affinity among texts, authors, their sexual positionings, and sexual effects that have previously gone ignored and silenced.

Notes

This essay is for Kelly Dennis.

1. Quoted in Roger Austin, *Playing the Game: The Homosexual Novel in America* (Indianapolis and New York: Bobbs-Merrill, 1977), 201.

2. See, for example, Jerry Hopkins and Danny Sugerman's now-classic *No One Here Gets Out Alive* (New York: Warner Books, 1980):

> "L.A. Woman" was Jim's despairing salute to Los Angeles, a city he now saw as diseased and alienated. "Are you a lucky little lady in the City of Light?/Or just another lost angel—City of Night." Los Angeles *was* a "city of night" for Jim (he took the phrase from a novel by John Rechy) and in another verse he described it: "Drivin' down your freeways/Midnight alleys roam/Cops in cars, the topless bars/Never saw a woman—/So alone, so alone . . ." To this he added a grimmer thought: "Motel money murder madness/Let's change the mood from glad to sadness." (320)

Wallace Fowlie adds to this his observation, "In its lyrical quality and musically, ["L.A. Woman"] is one of the Doors' strongest songs[;] . . . a picture of a decadent Los Angeles," and that "'City of Night' may be a reference to a book by John Rechy." (See Fowlie, *Rimbaud and Morrison: The Rebel as Poet* [Durham, N.C., and London: Duke University Press, 1994], 91.)

3. Rechy himself bends over backward to claim a combined Beat/rock genealogy:

> "Mardi Gras" [from which *City of Night* evolved] appeared in Issue No. 6 [of *Evergreen Review,* which] was publishing Beckett, Sartre, Kerouac, Camus, Robbe-Grillet, Ionesco, Artaud[;] . . . other short pieces appeared in *Evergreen Review;* a lyrical evocation of El Paso and a Technicolor portrait of Los Angeles . . . [and later] I had been asked by one of its editors to contribute to an

adventurous short-lived quarterly, *Big Table,* which had broken away from *The Chicago Review* in a dispute over censorship. Soon, Miss Destiny debuted there, among Creeley, Mailer, Burroughs. . . . Before writing, I listened to music: Presley, Chuck Berry, Fats Domino . . . to absorb the dark, moody sexuality of rock." (See Rechy's Introduction to *City of Night* [New York: Grove Press, 1963], xi–xiv.)

4. The unavoidably oedipal resonances of the critical terminology I deploy here should not be taken merely to reactivate uncritically anything like the traditional (psychological *or* economic) patriarchal functions of Oedipus as such. If anything, the subversive deployment of the "daddy" function in the terminology of male hustling should be enough to dislodge these terms from their former conventional ideological uses; and while the anxieties of influence I trace here primarily along queer filial-genealogical lines also unavoidably bear in them the weight of some considerable literary debt, this most queer of economies of exchange cannot possibly support a reading which would force these transactions back into some conventional market space, libidinal, literary, or otherwise.

5. Ann Charters. "Introduction: Variations on a Generation" in *The Beat Reader* (New York: Penguin Books, 1992), xvii–xviii; see also 145: In 1944 the word "beat," as used by a Times Square hustler named Herbert Huncke, came to the attention of William Burroughs, a Harvard graduate living in New York whom Huncke had introduced to heroin. Through Burroughs, the word passed on to a young Columbia College freshman named Allen Ginsberg and a friend who shared his interest in writing named Jack Kerouac, a Columbia dropout serving during the war as a merchant marine seaman based in New York. Burroughs took Huncke, according to biographer Ted Morgan, as a "sort of Virgilian guide to the lower depths. . . . [H]e was the first real hipster[;] . . . an anti hero pointing the way to an embryonic counterculture, which would arise from this Times Square world of hustlers."

6. See Austin, *Playing the Game,* 184–87.

7. See in relation to this Barney Hoskyns's treatment of the Doors in *Waiting for the Sun: Strange Days, Weird Scenes, and the Sound of Los Angeles* (New York: St. Martin's Press, 1996). "The early Doors," Hoskyns argues, "were essentially a collision between garage punk and Beat poetics. . . . 'Moonlight Drive'. . . was like a *noir* inversion of the California surfing dream, a dark ode to the Pacific which turned Los Angeles back into a city of night and encapsulated the menace which would become the group's stock-in-trade" (154–55).

8. James Riordan and Jerry Prochnicky, *Break on Through: The Life and Death of Jim Morrison* (New York: William Morrow, 1991), 35–36. Riordan and Prochnicky's text is a rich mine of material for a queer-critical reading of the lengths to which heteronormative culture will go to make itself seem interesting to itself while still adhering to the conventions that preserve its privilege. Witness, for example, their elaborate (and elaborately closety) identification of Morrison with Alexander the Great:

> the Morrison look was carefully designed and planned. . . . A student of Roman and Greek drama, [Morrison] loved to read Plutarch, the Greek historian, and he especially loved the sections that described Alexander the Great. In one passage Plutarch mentions that Alexander had a habit of tilting his head on his left shoulder as if he were asleep and letting his eyes open and stare off as if they were melting into space. Morrison practiced this stance until he had it down perfect, until he could strike a pose with the best of them. It wasn't just Alexander's looks that attracted Morrison—it was also the parallels in their lives. . . . Alexander met his intimidation by becoming everything his father wasn't: artistic, a thinker, a pupil of Aristotle. . . . Morrison used to say that "the big mistake Alexander made was that he *hesitated* at the Danube. . . . He should have gone west." (54–55)

Indeed, we can argue that Morrison perhaps went a little further "west" than even Riordan and Prochnicky suspect.

9. This last comment is not meant to impose a judgment on the quality of Morrison's poetry, but merely to describe the weakness of his legacy as a poet vis-à-vis his progenitors. Anyone interested in sampling Morrison's poetic work should look for example at the scribbles collected in *Wilderness, Vol. 1: The Lost Writings of Jim Morrison* (New York: Vintage, 1988), and, for relevance to this chapter, especially at "Ode to LA while Thinking of Brian Jones, Deceased," 128–32.

10. Fowlie, with a slightly different erotic perspective than Hopkins and Sugerman, to his credit picks up especially on the masturbatory energy of the anagram: "'L.A. Woman,'" he explains, "has personal and literary allusions . . . [and] ends with a mysterious line: 'Mr. Mojo Risin'. 'Mojo' is a black slang word for sexual potency. 'Mr. Mojo Risin' is an exact anagram of 'Jim Morrison.' An anagram traditionally conceals a message. Here it might be: Jim rising again" (Fowlie, *Rimbaud and Morrison*, 91).

11. The shaman/showman formulation is Ray Manzarek's. See, for example, his voice-over and on-camera interviews in *The Soft Parade* (Elektra Records, 1969) and *The Doors: A Tribute to Jim Morrison* (Universal Home Video, 1997). Listen also to his very recent, and very suggestive *The Doors, Myth and Reality: The Spoken-Word History* (MonsterSounds Entertainment, 1996). Manzarek's fascination with Morrison's sexuality finds curious expression in a couple of anecdotes there, one having to do with Morrison's predilection for homoerotic wall art, the other with the Rock 'n' Roll Hall of Fame's refusal to take Morrison's dictionary when Manzarek offered it to them: they would, of course, have preferred Morrison's "dick" to his dictionary, says Manzarek.

12. Leonard Riefensthal. "Hustlers: Dirge for a Dying Breed," in *Long Road to Freedom: The Advocate History of the Gay and Lesbian Movement,* ed. Mark Thompson (New York: St. Martin's Press, 1994), 44.

13. Rechy, *City of Night*, 91–93.

14. Riordan and Prochnicky, *Break on Through*, 15–16. Compare this passage with the following in *City of Night* describing Skipper, a Morrisonian prettyboy hustler, and his own narcissism:

> There is a consuming franticness about Skipper which seizes you the moment he begins to talk—the words coming often in gasps—his eyes burning—at times as if to explode with intensity, at times on the brink of closing, giving up. Constantly, he flexes his body, looking down at it, studying it, as if to make sure it is still intact . . . when he is sitting down, he constantly drums his fingers to the frenzied music—and even when the music is slow, the frantic drumming persists, as though the sounds he hears are coming from within . . . stifled by the knowledge of the sad, sad loss of Youth, of the terrible hints that life, perversely, may make one a caricature of oneself, a wandering persistent ghost of the young man that was, once—the attitudes of youth lingering after youth itself was played out. With Skipper, this loss was concentrated, emphasized because life had given him nothing but physical beauty, an ephemeral beauty relying on Youth . . . Behind the sullen look with which he nailed the people who bought him was the unmistakable awareness that he was on the brink of facing his doom: of facing Death . . . and Death for Skipper was the loss of Youth. (155–56)

One might even declare that at this moment Rechy "imagined" Morrison before Morrison imagined himself, down even to the particular quality of his doom.

15. Certainly the spaces within which male heteroerotic- and homoerotic-desiring economies operate enjoy permeable borders, across which certain values travel. Alongside Riordan and Prochnicky, *Break on Through,* one might read Wallace

Fowlie's as a haplessly closeted attempt to read Morrison's erotic power without divulging too much of his own pleasured investment in that power. Indeed, Fowlie covers over so much of Morrison's direct physical sexiness with layers of symbolic reference to classical-mythological iconography of the erotic that he performs an even more elaborate striptease than that alleged of Morrison himself. See, for example, the following passages from Fowlie's *Rimbaud and Jim Morrison*:

> [The song "Hyacinth House" on *L.A. Woman* gets the following treatment:] The lyric of "Hyacinth House" was written by Jim. This is almost an hermetic poem about the poet's need for a "brand new friend." The Greek myth of the boy hyacinthus is in the poem, and it merges with the poet's need for a new life. In the myth, Hyacinthus was loved by Apollo, who slew the boy. To memorialize his love, Apollo causes a flower (the hyacinth) to grow from the blood-stained grass. It is a resurrection piece, the capture of a new life. (91)

> Jim's persona had everything to do with the principle of Dionysus, the dark self-defeating eroticism. In speaking once of his typical audience and trying to explain his movements on the stage and his singing, Jim said: "I can take the trip for them." (97)

> Jim Morrison was a menacing son-figure. . . . But more than the Oedipus figure, he illustrated and embodied the typical narcissism of the male. He watched his image in the fountain (the watery faces of his audience) over which Narcissus leans, eternally anxious, eternally enraptured . . . [this is] art as mystification. Narcissus sees himself in the water of the pool and is drawn to himself, but he has no understanding of that mystery. Why is he in love with himself? The myth is alive, and the mysteriousness is still intact. (103)

> In Greek mythology, Eros excites sexual desires in gods and men with his arrows and torches. Jim used the word "erotic" when he called the members of his band "erotic politicians." By his movements and actions on the stage and by his style of singing, he was a modern-day Eros. . . . [There is also] a general term designating in Greek a young man, an adolescent: *kouros*. . . . the word is applied to a youth attractive to men and women. At times it is in praise of beauty . . . [and suggests] the nonhypocritical innocence of Jim when he was not aware of the power of his appearance and his personality. (105)

16. See Ray Manzarek's videotaped recounting of the incident in *The Doors: A Tribute to Jim Morrison* (1981). There Manzarek describes the incident, of which there is no photographic record, in fascinating detail, especially because of the now you see it, now you don't game that Morrison apparently played with his audience. Like an experienced gay stripper, Morrison, according to Manzarek, kept a shirt in front of his cock, waving it just enough to create the titillating effect.

17. The language of this analysis owes a serious debt to Lee Edelman's work in the introductory essay to his collection, *Homographesis: Essays in Gay Literary and Cultural Theory* (New York: Routledge, 1994). Generally speaking this chapter attempts to answer Edelman's call for "rhetorical analyses of the figurations of homosexual legibility" which are nevertheless politically and in other ways pragmatically engaged; more specifically, Morrison's body, though perhaps not precisely a "gay body," may still function as a homograph that troubles the governing structures of gendered and sexual identity (see esp. 7–14, 20–23).

18. From most indications, Morrison would have been directly aware of the legal limitations of especially public nudity after his encounters with Julian Beck and Judith Malina's Living Theatre in L.A. and San Francisco in the weeks just before the incident in Miami. Pierre Biner recounts in his chronicle *The Living Theatre* that especially in performances of the troupe's epic *Paradise Now,* the actor denouncing social prohibitions against public nudity "angrily undresses in the midst of the audience,

taking off as much clothing as the law allows" (Biner, *The Living Theatre* [New York: Horizon Press, 1972], 183). In his later, and more comprehensive, *The Living Theatre: Art, Exile and Outrage* (New York: Grove, 1995), John Tytell explicitly mentions Morrison's infatuation with Beck and Malina's company and their radical theatrical vision. Morrison, Tytell recounts, accompanied "poet Michael McClure [and] both actively participated in performances of *Paradise Now* at the Nourse auditorium" in San Francisco (256); due to his reading of "Artaud and Ginsberg in college," Tytell adds, Morrison "saw himself as a revolutionary figure and had seen every [Living Theatre] performance in Los Angeles" in February 1969 as well (257). Compare this, too, to the anecdote offered by Riordan and Prochnicky of Morrison's dealings with Tom Baker, one of Andy Warhol's cine-studs. By the summer of 1968:

183

■

L.A. Women

> Booze was becoming a daily escape [for Morrison]. He and Tom Baker were regularly getting drunk at Barney's Beanery in Hollywood. Morrison liked Baker even though Baker needled him constantly. Known for his starring role in Andy Warhol's *I, A Man* in which he did a nude scene, Baker used to chide Jim for being afraid to "let it all hang out." When Morrison argued that blatant nudity wasn't art, Baker called him a "prick tease." Morrison laughed it off, but never took a dare lightly. (254)

19. Fowlie, *Rimbaud and Morrison,* 86–87. Both Biner and Tytell confirm in their analyses of the Living Theatre aesthetic that it was precisely Beck and Malina's intention to break (on) through the conventional distinction between representation and reality. Especially their pieces "*Mysteries* and *Paradise Now*," Biner tells us, were "structured so much like real events that they actually assume a lifelike complexity, impossible to penetrate by means of rational description or formulas for emotions" (*The Living Theatre,* 169; see also Tytell, *The Living Theatre*).

20. According to Tom Waugh, the increasing flirtation in the sixties with more explicit modes of homoerotic art and representation very often took on the quality of "teasing" half-exposure. See his "Cockteaser" in *Pop Out: Queer Warhol,* ed. Jennifer Doyle, Guy Flatley, and José Esteban Muñoz (Durham, N.C., and London: Duke University Press, 1996). Waugh's essay deals primarily with Andy Warhol's role in expanding the possibilities for homoerotic representation specifically through the development of the queen/hustler paradigm. According to Waugh, "the queen-hustler paradigm" that Warhol helped to develop allowed "these two strange bedfellows [to] emerge . . . as primary icons of Euro-American gay male culture in the 1960's," and to "dominate both the fiction and the underground cinema of that transitional decade, from John Rechy to Jack Smith." This "parallel emergence of queen and trade" Waugh goes on, inscribed a "dialogue, interaction and confrontation that [came to] constitute the key dynamic of the 1960's." Waugh observes, however, that everywhere, from Warhol's films to street-level porn, "Queen and trade remain separate, never coming together; the cocksucker stays perpetually offscreen in *Blow Job* and everywhere else, and the duality of object and subject is entrenched" characterizing the

> 1960's continuum of gay imagery that had at its base a structure of familiar dualities, not only queen and trade, but also mind and body, voice and image. This last duality of voice and image, the separation of soundtrack from picture, is especially symptomatic . . . [in that] Image-sound separation . . . cements the irreconcilability of object and subject, exacerbates the tension of the teasing relationship of look-but-don't-touch, touch-but-don't-possess, appear-but-don't-speak, speak-but-don't-appear, and so forth.

Finally, this "teasing" subversion of subject/object duality in Warhol extends to a similarly "teasing" subversion of gender polarities: "On the whole," Waugh argues, "Warhol women are conceived and operate with a specific gay male orality, competing with biological men, both transpeople and swishes, for the hustler, the butch/trade

objects of their desire": as such, Warhol women might be said to inhabit the same ambiguous space of gender as Rechy and Morrison's "L.A. Women" ("Cockteaser," 53–56).

21. I want to push the romantic basis of the former image as far as I can, if only to enlist this analysis in part to counter the still-overweening "romantic" disposition in discussions of topics such as Morrison, the Doors, and the sixties. The genealogical line from the English Romantics to the French symbolists and surrealists, the Beats, and then the Doors is unquestionable, but not exhaustive, and certainly not always analytically useful. The following pronouncement by Julian Beck in Biner's book almost perfectly adequates the persistence of an unambiguously "romantic ideology" into what often passed for avant-garde cultural practice in the West through the middle of the twentieth century: "We believe in the theatre as a place of intense experience," Beck declared, "half dream, half ritual, in which the spectator approaches something of a vision of self-understanding, going past the conscious to the unconscious, to an understanding of the nature of all things . . . [and] only poetry or a language laden with symbols and far removed from our daily speech can take us beyond the ignorant present toward these realms" (27). Professed Marxists, Beck and Malina seem closer to the utopian than to the scientific or critical end of the dialectic; indeed, so utopian, especially in their invocation of the transcendent power of symbolic language, as to appear from certain angles as conventionally romantic. Their views embody much of what fueled the optimistic cultural and political activism of the sixties, but also embody, in Jerome McGann's terms, "an uncritical absorption in Romanticism's own self-representations" (McGann, *The Romantic Ideology: A Critical Investigation* [Chicago and London: University of Chicago Press, 1983], 1). Even the most generous reading of an effectively critical and subversive potential in the aesthetic embraced through this genealogy will suffer, McGann argues, from romanticism's own deep paradoxicality. Romanticism's "greatest moments," according to McGann,

> usually occur when it pursues its last and final illusion; that it can expose or even that it has uncovered its illusions and false consciousness, that it has finally arrived at the Truth. The need to believe in such an achievement is deeply Romantic . . . because it locates the goal of human pursuits, needs and desires in Ideal space. (134)

22. See Judith Butler, *Bodies That Matter: On the Discursive Limits of "Sex"* (New York: Routledge, 1993), 121–140. The felicitous echo of Judith Butler should ring clearly here. Morrison's androgyny, for all that it types a kind of liberation from one particular set of restrictive gender performances, does not guarantee an unambiguously salutary result in the larger theatre of the gender wars we still wage. In the chapter of *Bodies That Matter* entitled "Gender is Burning," Butler initiates her reading of Jennie Livingston's *Paris Is Burning* by cautioning against what has become the prevailing utopian reading of Butler's previous book, *Gender Trouble*. According to Butler, *Paris Is Burning* "calls into question whether parodying the dominant norms is enough to displace them; indeed, whether the denaturalization of gender cannot be the very vehicle for a reconsolidation of hegemonic norms" (125). If Morrison's androgyny borders on a kind of drag, its effect on Morrison's primary audience is anything but subversive of that audience's presumptive privilege in the heteronormative order of things. If anything, Morrison's performed androgyny makes androgyny safe for an audience that might otherwise find its implications threatening; as long as its heterosexual ground remains largely unquestioned, this kind of androgyny does little more than cut the boredom that comes with being always on top. In other words, it seems to do little else than make male heterosexuality more interesting to male heterosexuals.

23. Rechy leaves no doubt of his direct involvement in the hustling scene in downtown L.A. around the time he was composing *City of Night,* and that he, too, was acutely aware of the challenge which his material presented directly to conventional

presumptions about representation, about the relationship of a specifically socialized experience to the distancing afforded it by symbolism, ritual and artistic form:

> The writing was yanking me from the streetworld, the "streets" pulled me as powerfully. To connect both—and with sudden urgency—I wrote a story about Miss Destiny—a rebellious drag queen who longed for "a fabulous wedding"—and about others in "our" world of bars, Pershing Square, streets. The story was very "literal"; I felt that to deliberately alter a "real" detail would violate the lives in that world. . . . [When *Evergreen* turned the story down,] I saw the people I had written about, Chuck the Cowboy, Skipper, Darling Dolly Dane, Miss Destiny [and] it seemed that not only my story but their lives and mine among them had been rejected: exiled exiles. (*City of Night*, xii)

24. Ibid., 95–97.
25. Ibid., 144.
26. Ibid., 96–97.
27. See Gregory Bredbeck's entry on John Rechy in Claude Sommers, ed., *The Gay and Lesbian Literary Heritage* (New York: Henry Holt, 1995), 584–85.
28. Hoskyns, *Waiting for the Sun,* 158.
29. Rechy, *City of Night,* 98.
30. Joan Didion, *The White Album* (New York: Noonday Press, 1979), 11–13.
31. See ibid., 14–15.
32. See ibid., 22–23.
33. See ibid., 24–25.
34. Here I borrow some ideas from Kelly Dennis, whose art historical work implicitly informs much of what I can humbly say here from my more literary perspective. See, for example, Dennis's "Playing with Herself," in *Solitary Pleasures: The Historical, Literary and Artistic Discourses of Autoeroticism* ed. Paula Bennett and Vernon A. Rosario II (New York: Routledge, 1995), 49–74. In part I follow Dennis's conclusion in that essay, that the "continued omission of sexual difference as the precondition of ontological questioning veils the real obscenity of ontology and permits the simultaneous seeing and not seeing that evidences both pornography and the art historical gaze" (66). In this chapter, I translate the "omission of sexual difference" into the "omission of sexual-orientational difference" in the construction and reception of Morrison's image, processes that raise their own ontological and epistemological questions about the aggressive closeting imbedded in their very operations.
35. Riordan and Prochnicky, *Break on Through,* 173–74. This strain of innuendo goes a bit further in *Break on Through;* see the speculation they venture about Morrison's sexual exploits while in film school:

> In an article he wrote for *Crawdaddy,* Richard Blackburn remembers that Morrison never seemed to have any desperate need to "Make it Big" the way others did: "In that way he was oddly pure. He communicated in sexy little inarticulate mumblings. He'd stand off from the action in tight white jeans and tight white t-shirt, round head lolling to one side, exposing the soft white neck that was his seductive come-on to members of both sexes."
>
> Was Morrison bisexual at UCLA? Most likely not, although one former student who wishes to remain nameless mused that "he would've liked to have been." Morrison told anyone who would listen that he wanted to "Have every experience," but those that knew him doubt if he was ready to cross that particular border at age twenty. (54–55)

See also their even more attenuated report of the following reference by John Densmore to "a male-groupie-leech named Freddie" who allegedly " 'got Jim loaded and . . .' [Densmore thus] leaving the reader to fill in the blank" (224–25).
36. Hopkins and Sugerman report that "Back Door Man" was, though a cover, one of the earliest songs included in the Doors's permanent repertoire, and

therefore one of its "signature" songs in performance: "By February [1966] the band had no less than forty songs in its repertoire, about twenty-five of them originals, including 'The End'. . . . the songs the band played were old blues classics or recognized rock hits such as 'Money,' 'Back Door Man,' 'Gloria,' and 'Louie, Louie'" (*No One Here Gets Out Alive,* 81–82).

37. Ibid., 102–3.

38. Jeff Pike. "Jim Morrison's Beautiful Friend," in *The Death of Rock 'n' Roll: Untimely Demises, Morbid Preoccupations, and Premature Forecasts of Doom in Pop Music* (Boston and London: Faber and Faber, 1993), 215.

39. See Waugh, "Cockteaser."

40. Laurence Rickels's brief comment on rock and race in "The Grateful Dead" chapter of *The Case of California* (Baltimore and London: Johns Hopkins University Press, 1991), 60–63 synthesizes several of the strains of this argument. Citing Jacques Attali's *Noise: The Political Economy of Music* (trans. Brian Massumi; Minneapolis: University of Minnesota Press, 1985), Rickels analyzes the nuclear-era morbidity of postwar U.S. popular culture as rock choreographs it: "Rock and roll," Rickels argues, is "the melancholic's" music; it was "first rehearsed as the beams that guided Nazi bombers and missiles to precise spots of detonation" and it thus "recalls when the *Blitzkrieg* raged" as the external context of its own internal "recollection—inside total war," within which in turn it "counts among its stars spectacular casualties of suicide missions."

> The genealogy of rock shows . . . the way mass culture advertises not only one "new" age and one gender, but also one race . . . [a] teen-age race (to the finish line), which already left the body behind among the phantom effects of identification and audition, turns on the other race. Rock represents the careful filtering or vampirization of "black despair" which fuels the commodification of (white) childhood. From jazz to rock, the white race pretends to be the black race, which must go (or pretend to be the white race, as in disco). (60–63)

One could do worse in the interests of such a race-and-class-based analysis than to return as well to Norman Mailer's admittedly problematic early "White Negro" essay for a near-contemporary critique of this appropriation. Ann Charters includes Mailer's essay in *The Beat Reader,* 581–605.

41. Hoskyns, *Waiting for the Sun,* 157.

42. Riordan and Prochnicky, *Break on Through,* 252.

10

"(W)RIGHT IN THE FAULTLINES"
The Problematic of Identity
in William Wyler's *The Children's Hour*

Jennifer A. Rich

REVIEWING A NEW FILM, *The Children's Hour* (1961), that had just opened at two Manhattan cinemas, a *New York Times* (*NYT*) reviewer had this to say:

> It is hard to believe that Lillian Hellman's famous stage play, "The Children's Hour" [*sic*] could have aged into such a cultural antique in the course of three decades as it looks in the new film version of it that came to the Astor and the Trans-Lux fifty-second street yesterday. But here it is, fidgeting and fuming, like some dotty old doll in bombazine with her mouth sagging open in shocked amazement at the whispered hint that a couple of female schoolteachers could be attached to each other by an "unnatural" love. (*NYT,* 28 March 1962)

The charge of atavism may strike contemporary readers as strange, especially those readers familiar with *The Children's Hour*'s status as the first film to evade the censorship of homosexual representation mandated by the Hays code in 1935.[1] For many lesbian and gay critics, however, the film's radical interest stops here. Like the *NYT* reviewer, gay and lesbian critics today find the film to be disturbingly old fashioned—in a slightly different manner, however, from the *Times* assessment. While the *Times* objects to the sense of amazement and shock with which the film greets the "hint of unnatural attachment between the two schoolteachers," and to the social malice and ruination that accompanies this revelation, lesbian and gay filmographers deplore the film for its pathetic rendition of the Martha Dobie character.[2] Specifically, these critics object to the unmitigated despair Martha experiences after realizing her "terrible" secret, a despair that leads her to commit suicide.[3] In fact, *The Children's Hour* has the dubious distinction of being a first cinematic propagator of the lesbian woman as hysterical, mentally unstable, and always doomed to suicide or another form of demise. The hysterization of lesbian women became a standard facet of their characterization in 1960s filmic iconography.[4]

Given these disparate yet (uniformly) contemptuous popular and critical reactions, it is interesting to consider why *The Children's Hour* exerts such

fascination for lesbian and gay critics apart from its historical significance to lesbian and gay film history. I would argue that what compels current lesbian and gay analyses of the film is what goes unquestioned by the *New York Times* reviewer—the question of Karen Wright's sexual identity. While the reviewer implicitly rejects any hint of lesbian sexuality in the character of Karen Wright or in the relation between the two women, for gay and lesbian critics, the question of Karen Wright's sexuality is a fruitful locus for exploring the problematic of sexual identity.[5]

It is this concern that motivates the present critical project. The problematic of identity has, of course, been a seductive category for both political and academic writing about lesbianism and gayness.[6] In recent years, with the advent of queer theory and its theoretical dependence on the work of Jacques Derrida, D. A. Miller, and Gayatri Spivak (among others), the problematic of identificatory indeterminacy has been added to the critical mix. In "Imitation and Gender Insubordination," for example, Judith Butler records the following about the "sexiness" of identificatory indeterminacy:

> I'm permanently troubled by identity categories, consider them to be invariable stumbling-blocks, and understand them, even promote them, as sites of necessary trouble. In fact, if the category were to offer no trouble, it would cease to be interesting to me: it is precisely the *pleasure* produced by the instability of those categories which sustains the various erotic practices that make me a candidate for the category to begin with. (14)[7]

I would argue that recent queer interest in Karen Wright comes from a similarly "pleasurable" theoretical place. What is interesting is not so much whether or not Karen slept with Martha, but the way in which she inhabits what I will call the *seam of* identificatory certitude in *The Children's Hour,* and how by so doing, the film (through Karen) questions the stability of contemporary sexual categorizing. Before exploring the way in which the film "queries" sexual determinacy, it's important to provide some historical background about both the film and the play. As will become clear, the sources of the film and the play are of utmost importance to any queer reading of this film.

The Children's Hour and Gay and Lesbian History

We may point to McCarthyism and the censorship of homosexual representation in the cinema as both contexts and catalysts for William Wyler's 1961 adaptation of Lillian Hellman's *The Children's Hour. The Children's Hour* was the first film to present an unambiguous homosexual character on the screen after the instigation of the infamous Hays code in 1934–1935, which banned all cinematic representations of homosexuality or homosexual characters. *The Children's Hour*'s depiction of Martha Dobie was a direct challenge to the Hays code and resulted in the revision of the code to permit "tasteful treatments of homosexual themes" in 1961 (Weiss 69). To give a sense of the distorting effects of the Hays code, one might note that Lillian Hellman's play was cinematically heterosexualized, as *These Three,* in the late 1930s (when the Hays code was in full censoring force). Predictably, the alleged scandal in this version was adultery and premarital peccadilloes rather than lesbianism.

While the film challenged the censorship of homosexuality on the screen, the history of the play's production is also necessary to recapitulate because of its significance to censorship in the theater. The play opened on November 30, 1934, with no advance publicity. Eight years earlier a play about lesbianism, *The Captive,* had opened on Broadway to rave reviews from the *New York Times*. Despite these reviews, and because of its open depiction of lesbianism, *The Captive* was closed down by the police and the leading ladies were arrested. Because of *The Captive*'s fate, it was very difficult to find actors willing to participate in a Broadway run of *The Children's Hour*. As it turned out, the play was banned in Chicago, Boston, and London, but it was allowed in France and was very successful there. The title was changed to *The Innocents* and, in characteristic French fashion, critics applauded it saying, "we don't care about such things in France." Unfortunately, this theatrical laissez-faire did not survive the Atlantic crossing, and the Pulitzer prize committee refused to consider *The Children's Hour* for its award.

The play's allusive history is also significant for lesbian film history and for McCarthyism. *The Children's Hour* was inspired by the Great Drumsheugh case, which was recounted in a 1930s book of noteworthy British court cases, William Roughead's *Bad Companions*. For Hellman, this case was fascinating because of its detailed recapitulation of the effects of social bigotry. A brief synopsis of the case as it appeared in Roughead's *Bad Companions* is in order.[8] In 1810, Marriane Woods and Jane Pirie, two schoolteachers who had founded and ran a girls' school in Edinburgh, were accused of lesbian activity ("inordinate affection") by a "mulatto" [sic] student, Jane Cumming. Cumming first voiced this accusation to her adoptive grandmother, Dame Helen Cumming Gordon, who succeeded in having all the students promptly removed from the school (in forty-eight hours), much in the same manner as Mrs. Tilford of the play and the film. In this version, Jane Cumming presented as evidence the personal testimony of a maid who claimed she saw Marriane Woods and Jane Pirie embracing through a nonexistent keyhole. The teachers sued for libel, and they only won on appeal. Their school, despite the later favorable verdict, remained closed.[9]

Again, rather than the shock value of lesbian activity, what Hellman found resonant and dramatically provoking was the social genealogy of malice that Roughead's version of the case provided. As William Wright recounts in his study, *Lillian Hellman: The Image, The Woman,* "She [Hellman] was frantic to get working and this [Roughead's Drumsheugh case] seemed ideal for her; the subject matter, with its calumny and monstrous injustice, could harness the anger and the contempt for self-righteousness that was so strong in Hellman's make-up" (86). It is this powerful theme of malice and persecution that, perhaps more than the lesbian content, has made the play and the film a must-see for students of lesbian and gay history. Certainly, these themes are what led to the play's revival in 1952 during McCarthyism and after Hellman's much publicized appearance in front of the House Un-American Activities Committee (HUAC).[10]

The play's origins in a court case involving alleged lesbian activity and the persecution of lesbian activity is significant for a connection between *The Children's Hour* and the early history of the lesbian and gay rights movements. It is now commonplace to observe that McCarthyism and its ruthless hunting-out of homosexuals was a primary catalyst to the creation of the first

homophile organizations for men and women, the Mattachine Society and Daughters of Bilitis (DOB), respectively. The political goals of both these early gay and lesbian organizations were to constitute gay people as an "oppressed minority" and to fight against such gross inequities as job discrimination, police harassment, and social and juridical censure. These organizations' struggles against job discrimination and social ostracism is of particular resonance to any historical understanding of the play and film versions of *The Children's Hour*. In the decade before and after Wyler's film version, Mattachine and DOB focused on combating the notion that homosexuals were a political and moral "security risk" to be routed out from government, educational and/or any other jobs. This involved extricating the idea of the homosexual from McCarthy's communist/homosexual "demonology." As John D'Emilio notes, "According to extreme anticommunist ideologues, left-wing teachers poisoned the minds of their students, lesbians and homosexuals [*sic*] corrupted their bodies" (48).[11]

Following on D'Emilio's comments, the film (and play) version of the *Children's Hour* stage what may be conceptualized as a reverse demonology; what is destructive and ruinsome is not any actual lesbian activity, but the imagination of such activity on the part of a little girl and her conservative grandmother. The film's greatest critical potential then comes not from the inclusion and introduction of a lesbian character, but from its consideration of the effects of social categorizations of sexual behavior and identity, and the inevitable social exclusions that result from such categorizations. It is the character of Karen Wright that both problematizes such identificatory imperatives and, in so doing, reveals the inherent instability of sexual identity. In considering this character, I will make use of Roland Barthes' writings on categorization, particularly his notion of the "seam" in linguistic thought.

Roland and Karen: Identity and Contingency

Writing about reading (appropriately enough, the Marquis de Sade) Roland Barthes situates the erotic in the site of discoherence, in the place of interruption where those things buried beneath a text or an identity reappear and disrupt: "Is not the most erotic portion of a body *where the garment gapes?*" (9)

> Two edges are created: an obedient, conformist, plagiarizing edge (the language is to be copied in its canonical state, as it has been established by schooling, good usage, literature, culture), and *another* edge, mobile, blank (ready to assume any contours), which is never anything but the site of its effect: the place where the death of language is glimpsed. These two edges, *the compromise they bring about,* are necessary. Neither culture not its destruction is erotic; it is the seam between them, the fault, the flaw, which becomes so. (7)[12]

Barthes's notion of the categorical "seam" is important to my consideration of Karen Wright in William Wyler's film version of *The Children's Hour*.[13] Although Karen Wright *does* not linguistically or performatively "come out" as a lesbian at any point in the film, she is one who is most ontologically "contingent" in her identity. Wright's (presumed) heterosexuality is always defined from without, from her everpresent fiancé and from this

relationship's unstated sexual exclusion of Martha Dobie. Karen's heterosexual definition thus always has what Diana Fuss, in *Essentially Speaking,* claims that each identity has: "the specter of nonidentity within it." She is heterosexual by negation because she is "not" not heterosexual: as Fuss continues, "[T]he subject is always divided and identity is always purchased at the price of exclusion of the Other, the repression and repudiation of nonidentity" (Fuss 103).

This identificatory incertitude, the specter of nonidentity to which Fuss refers, manifests most forcefully in those scenes which serve as the empirical basis for the child Mary's later accusations against the two women. By providing the viewer with two possible interpretations of a kiss-scene between Martha and Karen, for example, Wyler's direction italicizes the always unstable referentiality of categorization. This point is better understood by examining the dynamics of the scene in question. Having returned from a drive with her fiance, Karen comes to Martha's room to announce that she and Joe have settled on a marriage date. Martha reacts first with congratulations and then, in a fit of pique, drops the iron that she has been using and berates Karen for potentially abandoning the school for her marriage. Startled, Karen regains her composure and says, "Martha, we've talked about this, my marriage isn't going to make any difference to the school." Martha then apologizes and Karen goes over and kisses her goodnight on the cheek. The camera pans are simple here. It is as if the camera becomes the direct eye of the audience, and reveals to us no more than what we would see if we were watching a conventionally staged play. With the entrance of Mary, however, the camera adjusts to her vantage point, and we are watching, so to speak, from behind the "stage curtain." Mary spies on Martha and Karen through the half-open door of Martha's room (behind our proverbial curtain) because she has been awakened and startled by the sound of the iron dropping. She is far enough away so that she cannot hear what they are saying, but she does see the kiss. By her shocked facial expression, we know that she has not interpreted the kiss as we, the movie's audience, have a moment before.

By being privy to these two different interpretations, the audience is forced to become self-conscious of the dynamics of categorization—we know that we are right in desexualizing the kiss, but we can understand how the kiss might be sexualized if viewed from a different visual and informational vantage point. Although we know that this particular kiss is not a sexual one, we also realize that we are incorrect if we definitively categorize it as such. As Mary has evidently intuited, there is a sexual dynamic that is as yet unspoken between Martha and Karen. Martha is in love with Karen, a fact that is explicitly revealed later in the movie, but which is consistently hinted at by Martha's tense behavior around Joe. As her annoying but prescient aunt Lily puts it a scene or two later in the movie, "Any day that he [Joe] is in the house is a bad day." Therefore, the kiss is at once sexual on one level, perhaps psychodynamically, and nonsexual in its actual expression. By being at the same time *both* one and the other, in a psychologically-based epistemology, and *only* one and *not* the other, in an empirically based epistemology, the kiss lies in a Barthesian fissure—subverting itself by, in a sense, functioning as a (subversive) similacrum of an "innocent kiss" between friends.

In a similar way as the "kiss," the school building becomes associated with lesbian sexuality after Mary's slander. In the beginning of the movie,

Wyler's direction exaggerates the ideal innocence represented by the Dobie-Wright School for Girls. The opening credits show happy girls biking to and entering the inviting gates of the school in tandem, and the movie itself opens with a parent's day where mothers and fathers listen complacently to the musical accomplishments of their girls. The music by which the film audience is guided into the house is a very mechanical but technically impressive Mozart sonata that two of the girls are playing for the gathered parents. We are almost reminded of a Richardsonian drawing room where so many Clarrisas are gathered to exult in their collective innocence, an innocence carefully cultivated and nurtured by Martha Dobie and Karen Wright.

After the accusation, however, the house's unstated function as the brick and mortar caretaker of as-of-yet uncultivated girlhood collapses. The girls are literally run out of the house by frantic parents (mostly fathers!) and nervous chauffeurs anxious to whisk their charges away to the safety of home and another school. Just a few scenes before, Mrs. Tilford also hysterically "escapes" from the house after having come to confront Karen and Martha with Mary's accusation. Once the accusation has been confirmed in Mrs. Tilford's mind by Aunt Lily's unthinking comments about Martha' s attachment to Karen, Mrs. Tilford dispenses with seeing Karen and Martha in her haste to take herself and her granddaughter away from the shudder-producing school.

In the midst of this frenzied exodus, Martha and Karen desperately try to find out the reason for the downfall of their school. Finally, after all the fathers and chauffeurs but one have left, Karen approaches this father, Mr. Burton, and demands an explanation. He first directs her to his wife, implying that she would be a more appropriate person to talk to about this situation. Karen persists and must follow Mr. Burton *outside* the house to get an explanation. Martha remains inside watching the two from a window. It is as if the actual naming of lesbian sexuality cannot be uttered by a heterosexual male within the confines of a now "lesbianed" house. Karen thus is forced to straddle both worlds, becoming most explicitly lesbian to her spectators within the film and not-lesbian to the actual film audience. She is, at this moment, caught in the fissure that has been created between house, now a borderlands of "deviant" sexuality by virtue of its association with Karen and Martha, and the nondeviant, "outside" world. Again this mutually defining duality reminds us of Fuss's conception of identity: that all identities have "the specter of nonidentity" within them. The outside of the house thus becomes metaphorically heterosexualized, because it *is* outside and not-house. It is, however, on another level, only "outside" in purely spatial terms, having become "inside" in the dominant social paradigm, representing as it does "straight (right)" sexuality. Karen Wright, then, must cross the divide in order to hear the accusation, because the naming of lesbian sexuality can only safely occur in a space where it is implicitly rejected. We should also note that after Karen and Martha have lost their libel suit against Mrs. Tilford they are virtually imprisoned within the house by a host of curious men who drive past to try to get a look at the "lesbians."

The film audience does not hear what Mr. Burton tells Karen. We stay with Martha, watching Karen and Mr. Burton from the dispossessed house. It is in the next scene that we finally hear Karen voicing the accusation, and

the way in which she does so also italicizes her positioning as an (at least for the moment) lesbianed nonlesbian. Karen and Martha come to Mrs. Tilford's house to learn the basis for what they see as her slander of them and destruction of their school. Karen's fiancé, Joe, is already in the house having been called by Mrs. Tilford in order that she might warn him as to the true nature of his fiancee. She is prevented, however, from doing so by the forced entrance of Karen and Martha. Mrs. Tilford attempts to prevent their entrance lest their presumed illicit sexuality taint Mrs. Tilford's house as it did the school house. Knowing nothing of the scandal, Joe is shocked by her aunt's treatment of Karen and Martha and demands to know what has happened. It is at this point that Karen turns to Joe and the camera closes in on the two of them as if preparing the audience for another romantic scene. Instead of the embrace that we half expect, Karen utters the accusation, holding his arms: "Mrs. Tilford has said that Martha and I have been lovers." Lesbianed because of Mrs. Tilford's accusation, Karen significantly grasps onto and tells the only person that can allow her to subvert this categorical colonization and remain within a heterosexual matrix. Wyler's directorial telescoping of the two at this moment again underscores Karen's no-man-land's positioning, caught between the social world of Mrs. Tilford who has definitely categorized her and her own self-fashioning as a heterosexual woman in love with a man.

It is at this point in the movie, however, when even Karen's own self-fashioning becomes complicated and fissured. By consistently standing between Martha (the real lesbian) and Joe (her defining appendage) in this stand-off with Mrs. Tilford, she appears as what she is now sociodynamically—one who cannot be categorized. At this point, she is caught in two identificatory double negatives: "not-not lesbian," because of her fashioning by Mrs. Tilford and her allies, and "not-not heterosexual" because of her relation with Joe. These double negatives prevent her from being definitively anything, and thus question the social discourse that demands reliable and firm categorizations. For the rest of the film, until the end, she remains contingent, perhaps inhabiting De Lauretis's space of excess and contradiction.[14]

Later in the movie, after the libel suit has been fought and lost by Martha and Karen, we learn that Karen's sexual identity has become too indefinable even for Joe, who has heretofore functioned to stabilize it for the film audience. Coming to visit Karen and Martha in their now empty school, Joe embraces Karen but avoids kissing her, moving instead to extinguish a cigarette in the fire-grate. Karen quickly picks up on the meaning of this seemingly innocent move, and asks "why did you do that?" Cardin: "Do what?" Karen: "Draw away from me." At first Joe protests her oversensitivity, but in the course of conversation he reveals his own doubts as to whether or not she and Martha have ever been lovers:

> CARDIN: I have nothing to ask. Nothing. All right. It is ___? Was it ever ___?
> KAREN: No. Martha and I have never touched each other.

After having asked, Joe wants to put the whole question aside, and continue their relationship. But Karen realizes that their relationship cannot continue

because for Joe, she will always be a fissured self: instead of being hetero-sexual, she will be not-not heterosexual. As for her, Joe will not-not desire her, but will never, in her mind, desire her. As she explains:

> [I]t doesn't even matter any more whether you do believe me. All that I know is that I'd be frightened you didn't. . . . We'd be hounded by it. . . . I don't believe you could touch my arm without my wondering why you didn't kiss me, and I don't think you could kiss me without my wondering if you really wanted to.

At this moment, the "seam" becomes a de-eroticized site for Joe and Karen. It is de-eroticized because Karen can no longer function as a stable sexual referent for Joe. His sexuality becomes ontologically unstable (and epistemologically unknowable) because Karen's sexuality has become uncat-egorizable. His desire for Karen thus becomes complicated and possibly self-subverting, for if Karen is not heterosexual, why was she desirable to Joe? Is this a reflection of his own, contradictory sexual desire? Does he desire Karen because this desire may be contained in a subject that will not ulti-mately demand its actual expression? Thus, Joe turns away from Karen at this moment because the contradictions palimpsestically encoded within Joe's desire have been significantly decoded by the ontological precarious-ness of Karen's sexuality. In other words, the complications within Joe's sex-ual self-understanding, once comfortably contained in an overtly simple heterosexual relation, have been revealed, and the resultant confusion of Joe's sexuality is psychically unbearable for him.

In this conversation with Joe, Karen reveals her own newly formed view of identity and signification. Speaking almost as a preemptive decon-structionist, she realizes that all words and their attached meanings have a subversive other side that continually threatens to sunder the connection between signifier and signified: "Yes, every word has a new meaning. Child, love, lawyer, judge, friend, room, woman—There are not many safe words any more." In this observation about language, Karen here seems to pinpoint the site of Barthes's second edge, which is "mobile, blank, ready to assume any contours," and the effect of which leads to the death of language. Words are no longer safe because, as Karen realizes, they can easily turn into some-thing else by virtue of this uncontrollable edge. The proliferation of meanings and the contradictions that arise because of this significatory excess destroy the possibility of unvexed communication.

Even with the departure of Joe, for the film audience Karen Wright is still, at this moment, heterosexual. In a later scene when Martha reveals her love for Karen, however, Karen's sexual identity becomes confused for us also. Although in her initial response she seems to explicitly reject the notion of romantic love between her and Martha saying, "It's not the truth. Not a word of it. We never thought of each other in that way," just before Martha's revelation, she positions herself as a lesbian at least to those who censure such behavior:

> KAREN: But it isn't a new sin they tell us we've done. Other people aren't destroyed by it.

MARTHA: They are people who believe in it, who want it, who've chosen it for themselves. That must be very different. We aren't like that. We don't love each other.

We should note that it is also at this moment that the lie becomes caught, like the kiss, in two possible categorizations. On the level of actual lived experience, again in an epistemology of observation, it is a lie—Karen and Martha have never been lovers. But, with our new information as to Martha's true feelings about Karen it is also not a lie. In their psychodynamic relationship, Karen and Martha have been "lovers" because this is the way that Martha has unconsciously positioned Karen in relation to herself. We get hints of Martha's romantic positioning of Karen very early in the movie when Martha describes her first impressions of Karen. She remembers seeing her running from across the campus and thinking "What a pretty girl!" As Bernard F. Dick describes in his article on the Wyler film: "Martha idolizes Karen, thinking of her in terms of a fashion model who must always be kept up in the latest fashions" (45).

What so disturbs Martha about the lie is its definitional instability. For it is the medium through which Martha finds out the truth about herself:

MARTHA: It's funny. It's all mixed up. There's something in you and you don't do anything about it because you don't know it's there. Suddenly a little girl gets bored and tells a lie—and there, that night, you see it for the first time and you say to yourself, did she see it, did she sense it—?
KAREN: What are you saying? You know it could have been any lie. She was looking for anything—
MARTHA: Yes, but why this one? She found the lie with the ounce of truth.

Like the kiss, then, the lie is also a similacrum.

In the play, Martha shoots herself after her confession to Karen. In the movie, however, something quite different happens. Directly after the admission, Mrs. Tilford comes to tell Martha and Karen that Rosalie has confessed to the lie. Upset about the overwhelming irony of the situation, Martha breaks out into hysterical laughter and is ushered up to her room by Karen. Mrs. Tilford then apologizes for her error and begs to make reparations. Karen, however, rejects her: "There's nothing we want from you, Mrs. Tilford." She then turns her back to Mrs. Tilford and demands that she leave: "Please go, Mrs. Tilford, we don't want you here." Karen's reaction to Mrs. Tilford in Wyler's film is very different from what happens in the play. In the play, Karen sees Mrs. Tilford after Martha's suicide. At first, she is reluctant to let Amelia in the house but then she agrees to listen to her apology. Instead of rejecting her, she allows Mrs. Tilford, albeit ambivalently, to reenter her life.

KAREN: Yes. Good-bye now, I don't want to see you again.
MRS. TILFORD: But you'll let me help you? You'll let me try?
KAREN: If it will make you feel better.

MRS. TILFORD: Yes, yes, yes. Will you write to me sometime?
KAREN: If I ever have anything to say.
MRS. TILFORD: You will have something to say. Good-bye, my dear child.
KAREN: Good-bye.

By not rejecting Mrs. Tilford, Karen reenters the heterosexual community. She is no longer relegated to a borderland, but instead becomes a desired, if oblique, presence in Mrs. Tilford's social world. Both for the play's internal characters and for its audience, then, Karen ceases to exist within the seams of the cultural sexual discourse, and allows herself to be restored to a heterosexual matrix. Mrs. Tilford's last words to Karen—"you will have something to say"—suggest that Karen will be in some sort of contact with her, whether with this Mrs. Tilford or the Mrs. Tilfords of her future.

In the movie, however, Karen rejects any attempts by Mrs. Tilford to rescue her from a fissured sexual definition. Instead, after Mrs. Tilford leaves, she goes to Martha's room and asks her to come away with her. Critics of this film have interpreted Karen's invitation to Martha as a coded coming out. As Andrea Weiss writes in her book, *Vampires and Violets: Lesbians in Film,* "Karen's encouraging response to Martha's admission is one of a number of visual and spoken indications that Karen desires Martha as well" (67). It may indeed be this, but it is also more. For Karen not only refuses to abandon the borderlands of sexual indefinitiveness, but also of social censure. The movie resists narrative closure, not only because Karen's sexuality is unresolved, but also because she remains within a space of sexual and social possibility, embracing difference (from the social norm) for its own sake and as an act of resistance. This latter point is important to consider because of the context of the play's production in the fascist-dominated 1930s and the film's production only a few years after the end of McCarthyism. Thus, Karen embraces her lesbian positioning because it allows her to remain uncooptable by a social system that she now despises.

The funeral scene that follows further complicates both Karen's sexual and social identity. After saying an intimate goodbye to Martha at her graveside ("Goodbye, Martha. I'll love you until I die"), Karen walks past the collected mourners, including Joe, and out the gates, alone and determined. Significantly enough, there has been much misreading of this scene. As Vito Russo has discussed in *The Celluloid Closet,* contemporary critics were literally (and figuratively) blind to the fact that Karen walks past Joe, ignoring him, and instead saw the two as reconciling at the funeral Even Wyler, despite his suggestive direction, claimed that Karen could not be seen as anything other than a heterosexual maligned by cruel gossip: "We're not out to make a dirty or sensational picture. . . . As I see it, it is a story that shows the effect of malicious gossip on innocent [hence, not lesbian] people" (Weiss 69).

Later critics were only able to accept Karen's possible lesbianism by phantasmogorically masculinizing her:

Oblivious to Joe and Mrs. Mortar, who stand at the graveside, she proceeds down the road, her walk becoming a stride. Karen is no longer the stylish creature who has to be "kept up" in the latest fashions. She is wearing flats, an ill-fitting cloth coat, and a beret. The camera tracks in

for a close-up of a face that has grown mannish, or more charitably, androgynous—but clearly no longer elfin. (Dick 48)

I would suggest that Dick's characterization of Karen as masculine reenacts, for a very different purpose, the collapse of lesbian identity and social resistance discussed above. While for queer critics of this film, the connotations of the lesbian signified are expanded to embrace social resistance as well as sexual difference, for Dick, masculinizing Karen codes her as socially as well as sexually deviant.[15] Dick's critique is also not limited to an aesthetic reevaluation of Karen's face, "grown mannish, or more charitably androgynous," but concomitantly, and perhaps unconsciously, it is also a censuring of her new-found social defiance. For not only is Karen a creature who does not have to be "kept up in the latest fashions," but she is also one who will not, like Hellman, "cut her conscience to fit the fashion of the times." Thus, her rejection of the collected mourners, is at once perhaps a sexual statement, an erotic aligning with Martha, and an act of social insurrection. By acting in concert, these two moves unsex Karen for critics like Dick, as they frustrate assimilation within expected gender, sexual, and social roles.

Whether or not Karen actually sexually desired Martha can be argued ad infinitum and to no avail, for such arguments inevitably take us outside of the confines of the film's actual narrative. What concerns us is the fact that whether lesbian or not, whether in love with Martha or not, Karen clearly positions herself as a "lesbian," with all the connotations that we have delineated at the funeral. She does so by expressing her love for Martha and by rejecting inclusion in the community that now sees her as heterosexual and wants to take her in. We sense the community's desire to make social reparations by the camera shots that were utilized at this moment. Our view is focused first on Joe, and then on the rest of the mourners as they all watch her walking past. For a moment we, too, are positioned as the mourners are—she walks past us until the camera for a last long shot closes in upon her face—not mannish but determined. This last long close-up of Karen's face works to make the audience self-conscious of the impossibility of ever knowing what she really is, for the lesbian signified itself has lost its meaning as an independent entity. Lesbianism is, by the end of the film, not a provable identity but rather either an ostracizing label, or a signifier of social resistance.

To her spectators within the film, Karen is heterosexual again in the most basic epistemology. Relatively, however, she is still lesbian because of her self-ostracism from this community. Her action of walking away from the collected mourners becomes metaphorically a departure from an insular and internally defined normativity. While the community's understanding of itself and what it considers normal may be, at first glance, clear, it is nevertheless peculiar in its ontology. It is peculiar for two reasons: its existence as a coherent entity is dependent upon a particular and negative relational definition: the rejection of Karen Wright as lesbian. This rejection and the resultant identificatory unification is constituted from a child's moment of incomprehension and, later, premeditated slander. In other words, the community's cohesiveness is based upon the willful lies of a child. Thus, in a sense the community's presumed normativity is itself fissured because its definitional foundation is, ontologically, its definitional opposite: *abnormality,* as it is expressed in Mary's behavior. Thus, the community itself, although visually

presented as a cohesive entity, is also subject to Fuss's definition of identity: "all identities have the spectre of non-identity within them" (103).

Mary also exemplifies Fuss's perception of identity as always and already fissured, for Mary is a child who behaves so cleverly and deviously that she may be understood to exist within a different faultline: the seam that is created between our expectations of childhood innocence and her actual experience and behavior. This is perhaps best seen in her relationship with her grandmother, and especially in the scene when, desperate to escape from a forced return to her school, she accuses Karen and Martha of lesbianism. In this scene, the relation between innocence and experience is inverted as Mary serves as the agent of corruption of her grandmother. The physical dynamics of this scene remind us of traditional imagery of moral corruption: the poisoning of the ear.[16] Like the frog (really Satan) who attempts to corrupt Eve by whispering in her ear in *Paradise Lost,* the camera closes in on Mary whispering into her grandmother's ear. In a terrifying moment, Mrs. Tilford's face is enveloped within a close-up and we see her expression move from incredulousness to a horrified comprehension. Metaphorically and psychodynamically, Mrs. Tilford now becomes "the child" and Mary becomes "the adult," embodying the connotations of this word that suggest a corrupting experience.

For the film audience, as for Karen, all categories are made to be unknowable because they are always-already deconstructed. Despire Wyler's possible posthumous objections, this film may be placed within a postmodern epistemology. For not only does it deconstruct the definitional stability of Karen's sexual identity, it also, in much the same way, deconstructs several conceptual foundations of traditional American "family values": community, childhood, gender and sexuality. Although the last scene of the film shows a determined Karen Wright walking away from the community that has killed Martha (her friend or her lover, we will never know), we can only wonder to what she is moving, especially since, as she so perceptively observed, "every word has a new meaning. There are no safe words anymore."

Notes

1. For an interesting treatment of Hollywood censorship, see Gerald Gardner, *The Censorship Papers* (New York: Dodd and Mead, 1987).

2. As the *New York Times* critic writes in this regard, "It is incredible that educated people living in an urban American community today would react as violently and cruelly to a questionable innuendo as they are made to do in this film" (*New York Times,* 28 March 1962).

3. Boze Hadleigh, for example, writes the following about the film: "Today the cop-out suicide is indefensible: at least Karen calls off her engagement to Joe, mourns her friends, and refuses the townspeople's 'sympathy.'" In quite a different vein from the *New York Times* critic, she continues: "[T]he ease with which Karen and Martha's private girl's school and teaching careers are destroyed is less dated. In the late seventies, State Senator John Briggs initiated California's notorious Proposition 6, which, had it passed, would have barred gay or pro-gay teachers from teaching" (35).

4. Some other films of the 1960s that carried on this grand tradition were *The Fox* (1968) and *The Killing of Sister George* (1968).

5. As Andrea Weiss notes in commenting about Karen's "deep concern about Martha" once the latter has locked herself in her room, "[This concern] suggests that the line between 'normal' and 'abnormal' desire is no longer so clear" (67).

6. Examples of the critical fascination with identity abound in gay and lesbian writing. One such notable example is the now-famous "Identity" issue of the queer theory journal, *differences*.

7. It is important to note that Butler's understanding of identity contains an implicit critique of traditional ego psychology. While Butler understands identity as always and already fragmentary, containing an other that can never be fully integrated into the self, ego psychology posits the other as strictly outside of the self. In this paradigm, the self is gendered by the "imaginary incorporation of various gendered Others who have been loved and lost." Traditional ego psychology hypothesizes that this incorporation is a mode of coping with a loss by preserving the other in the mourner's psyche. Butler reframes this paradigm by positing the construction of the self briefly mentioned above. She writes: "In my view, the self becomes a self on the condition that it has suffered a separation. "That 'other' installed in the self thus establishes the permanent incapacity of the self to achieve self-identity; it is as it were already disrupted by the Other; the disruption of the Other at the heart of the self is the very condition of the self's possibility" (Butler 27).

8. It is important to differentiate Roughead's version of the case with a more historically accurate version recounted in Lillian Faderman's *Surpassing the Love of Men*. In Faderman's version, the teachers are finally vindicated because (and this is what makes this case significant for a historiography of lesbian identity) the judge refused to accept the possibility of sexual love between two *middle-class* women. As Faderman recounts, "The judges were most swayed in their judgements by their unwillingness to believe that women above the lower class were sexual creatures, that they would willingly indulge in sexual activity for the gratification of their own appetites and not for the sole purposes of procreation" (149).

9. Roughead's version of the Drumsheugh case is recounted in Bernard F. Dick's *Hellman in Hollywood*. For a detailed and insightful historical analysis of this case, see Lillian Faderman, *The Scotch Verdict* (1983).

10. In her appearance before the HUAC, Hellman refused to participate in the committee's ongoing witch-hunt saying, " I can not and will not cut my conscience to fit the fashion of the times."

11. According to Lillian Faderman, lesbian schoolteachers were of particular interest to the FBI "vice" squads operating in the 1950s. See *Odd Girls and Twilight Lovers*.

12. Butler's strategy for dismantling hegemonic gender categories can be seen as a practical and strategic manipulation of Barthes's conception. In her discussion of the categories that have operated as "regulatory regimes" over the lives of gays and lesbians, she promotes an exploitation of faultlines within categorizations and cultural constructs (Barthes's seams) and sees them as possible "rallying points for a certain resistance to classification and identity as such" (Butler 16). As she further explains in "Imitation and Gender Insubordination":

> For being "out" always depends to some extent on being "in"; it gains its meaning only within that polarity. Hence being "out" must produce the closet again and again in order to maintain itself as "out." In this sense, outness can only produce a new opacity; and *the closet* produces the promise of a disclosure, that can, by definition, never come. Is this infinite postponement of the disclosure of gayness . . . to be lamented? Or is this very deferral of the signified to be *valued* as the site for the production of values, precisely because the term now takes on a life that cannot be, can never be, permanently controlled? (16)

13. A brief reminder of the plot is in order: Two friends from college, Martha Dobie and Karen Wright, run a school for girls. One particularly naughty and downright mean girl, Mary, accuses the women of being lovers in revenge for their frequent punishments of her. She whispers this prevarication to her grandmother, Mrs. Tilford, while she is being driven back to the school after having (again) run away. The

grandmother soon arranges for all of the parents to withdraw their girls from the school, resulting in its downfall.

14. De Lauretis suggests in her article in *How Do I Look* that the lesbian subject position is created in just those confusions of identity that create what she calls a "space of excess and contradiction." A viewer could easily conceive of Karen in just such a space, especially at the end of the movie, when her "true" sexual identity is seemingly clarified for her on-stage audience, but becomes more confused for the actual film audience by her actions after Martha's admission and at the funeral. These two scenes and the way in which they further position Karen in the faultlines of sexual categorization for the film audience will be discussed in the following paragraphs.

15. Lillian Faderman, however, suggests quite a different interpretation of Karen's behavior at the funeral: "Karen's love for Martha and her tacit rejection of Cardin in this last scene hint distinctly at the possibility that Martha's confession has led Karen to her own self-realization which she is better equipped to handle than Martha" (Faderman in Weiss 69).

16. This image has been used countless times in Anglophone literature. Some more popular and familiar examples are *Hamlet* and *Paradise Lost*.

References

Barthes, Roland. *The Pleasure of the Text*. New York: Hill and Wang, 1986.

Butler, Judith. "Imitation and Gender Insubordination." In *Inside/Out: Lesbian Theories, Gay Theories,* ed. Diana Fuss. New York: Routledge, 1991.

De Lauretis, Theresa. "Film and the Visible." In *How Do I Look: Queer Film and Video,* ed. Bad Object-Choices. Seattle, Wash.: Bay Press, 1991.

D'Emilio, John. *The Making of a Homosexual Minority: 1940–1970*. Chicago: University of Chicago Press, 1983.

Dick, Bernard F. *Hellman in Hollywood*. New York: Harper and Row, 1982.

Faderman, Lillian. *Odd Girls and Twilight Lovers*. New York: Columbia University Press, 1991.

———. *Scotch Verdict*. New York: Morrow, 1983.

———. *Surpassing the Love of Men*. New York: Morrow, 1981.

Fuss, Diana. *Essentially Speaking: Women, Nature and Difference*. New York: Routledge, 1989.

Hadleigh, Boze. *The Lavender Screen*. New York: Carol Publishing Group, 1993.

Review of *The Children's Hour,* dir. William Wyler. *New York Times,* 15 March 1962, 28.

Rich, Adrienne. "Compulsory Heterosexuality and the Lesbian Existence." In *The Signs Reader: Women, Gender and Scholarship,* ed. Elizabeth Abel and Emily K. Abel. Chicago: University of Chicago Press, 1983.

Roughead, William. *Bad Companions*. Edinburgh: W. Green & Son, 1930.

Russo, Vito. *The Celluloid Closet*. New York: Harper and Row, 1981.

Weiss, Andrea. *Vampires and Violets: Lesbians in Film*. New York: Penguin Books, 1992.

Wright, William. *Lillian Hellman: The Image, the Woman*. New York: Simon and Schuster, 1986.

Zimmerman, Bonnie. "Seeing, Reading, Knowing: The Lesbian Appropriation of Literature." In *(En)Gendering Knowledge: Feminists in Academe,* ed. Joan E. Hartman and Ellen Messer Davidow. Knoxville: University of Tennessee Press, 1991.

LIBERALISM, LIBIDO, LIBERATION
Baldwin's *Another Country*

William A. Cohen

WHEN JAMES BALDWIN'S third novel, *Another Country,* was published in 1962, it was met with outrage and disappointment by nearly every major reviewer in the New York literary scene. *Another Country,* most reviewers felt, failed to fulfill the promise of Baldwin's first novel, *Go Tell It on the Mountain* (1952), and his by then famous essays on race relations in the United States.[1] (His second novel, *Giovanni's Room* [1956], was to most critics so foreign in location and so aberrant in subject matter that it practically did not count in an assessment of his reputation.)[2] To many reviewers in the mainstream press, the new novel seemed too unforgiving in its judgment of white, middle-class liberalism, too shrill and dogmatic in its presentation of racism, and too ready to endorse alternative, bohemian—especially homosexual—lifestyles. To African-American critics, the novel was neither sufficiently focused on black experience nor compelling as political analysis, for it appeared more interested in the salvation of individual characters than radical social change.[3]

Baldwin wrote from the unique position of a Harlem boy become literary celebrity, a critic of American social relations expatriated to France, an unabashedly gay man in a culture apprehensive about unorthodox sexuality. From his dissident perspective on American society, Baldwin composed a novel that so threatened and offended reviewers, many thought him to have lost his artistic gifts. The critics were unprepared to accept the novel's radical presentation of race and sexuality in contemporary America, yet faced with a work whose style and setting they could easily assimilate (in some cases even identify with), they could not entirely dismiss this promising writer.[4]

What the reviewers for the most part failed to notice was that the novel itself had already anticipated the racial and sexual terms in which their most persistent critiques were leveled. For the story proceeds through an unfolding series of crises, self-consciously staging conflicts among characters in terms of structural and social power relations, principally along axes of gender, race, and sexuality. *Another Country* not only maps its characters against these social indices but, more remarkably, also explores the ways in which vectors of power relations themselves interact—crosscutting, supporting, contradicting,

and displacing one another—in constituting the relationships among individual characters.

For all his attention to the social categories that structure personal relationships, however, Baldwin nonetheless maintains a liberal faith in the power of individuals to overcome "external" forces such as racial or sexual conflict. "A genuine human relationship" or "the liberating possibility of love," he claims, can transcend divisive conflict, for "the suffering of any person is really universal," "the Negro is like anybody else, just like everybody else."[5] By tracing the complex relations among the antinomies male/female, white/black, and heterosexual/homosexual through the novel, I want in what follows to put these generalizations to the test. While Baldwin endorses an ideology of individual self-empowerment, he also extends this liberalism past its usual boundaries, interrogating its limits. Yet if the novel finally conceives its utopia in chiefly private, individual terms, we will want to ask how different its fantasy is from the traditional liberalism that undergirds it.

Another Country responds in varying ways to the different aspects of "normativity" which typically constitute the subject of liberalism and which liberalism in turn has implicitly ratified. Gender, for Baldwin, comprises a rigidly fixed, virtually incontestable axis of difference. In this sense he diverges little from the mainstream of traditional humanism; conventional gender roles thus appear practically naturalized in the novel. Sexuality, however, is at the other extreme, for the male characters, at least, shift seemingly at will between heterosexual and homosexual options, to the extent that "gay" and "straight" barely constitute identities, let alone political positions. Instead, sexuality seems simply to be determined by the gender of a man's immediate sexual partner. Baldwin imagines race to be located along the continuum that has a relatively inflexible conception of gender on one end and a rather fluid notion of sexuality on the other—for race is the terrain of the contest between the social construction of difference and individual self-determination.

The novel presents so many permutations of race, gender, and sexuality in so deliberate, even schematic a way, that the absence of certain other combinations is itself significant. We will need to consider what Baldwin cannot imagine as well as what he treats explicitly in order to account fully for the power relations that structure the narrative. The relative rigidity of gender relations, for instance, conceived as a realm distinct from sexuality, precludes a representation of *female* homosexuality: The roles open to women in the world of this novel rarely allow for relations independent of men, and the fixedness of women's place forecloses their access to the range of sexual options that men have.[6] Further, the narrative almost entirely occludes relationships between black characters, for its aim is to challenge what gets constituted as "society"—implicitly white—by contesting that formulation from within, rather than by conveying the specificity of black experience (as Baldwin had done in his first novel). Finally, we will want to ask why the figure for Baldwin's self-representation—the gay black man—is so determinedly written out of the work that, he insisted, he "*had* to write."[7]

ANOTHER COUNTRY takes place in the mid-1950s in New York, much of it in bohemian nightclubs and jazz bars in Greenwich Village and Harlem.[8] Baldwin could not have selected settings more racially integrated and sexu-

ally permissive in the period ("this was the Village—the place of liberation" [29]), and consequently the focus on racism and sexism stands out all the more clearly. He also could not have chosen a location more aware of its own literary cachet: As one critic wrote shortly after the novel's publication, "This is *the* novel of contemporary New York."[9]

At the beginning of *Another Country,* Rufus Scott, a black jazz musician in his late twenties, finds himself destitute and delusional. The narrative follows Rufus as he struggles to account for his condition and descends into depression, until, eighty pages into the book, he commits suicide by jumping off the George Washington Bridge. As the novel opens, Rufus is wandering in desperation, recalling his last lover, a southern white woman named Leona. Baldwin portrays the violence that structures this relationship—Rufus ultimately beats Leona into a state of physical and mental debility—as both sexually and racially motivated. Shortly after they meet, Rufus says to Leona:

> "Didn't they warn you down home about the darkies you'd find up North?"
> She caught her breath. "They didn't never worry me none. People's just people as far as I'm concerned."
> And pussy's just pussy as far as I'm concerned, he thought. (17)

In response to the white racial domination that surrounds him, Rufus punishes Leona; yet he does so in particularly sexual ways, transforming the generalized social force of racial conflict into an immediate performance of misogynistic violence. Leona consistently responds with the inadequate language of white liberalism:

> "Rufus," Leona said—time and again—"ain't nothing wrong in being colored."
> Sometimes, when she said this, he simply looked at her coldly, from a great distance, as though he wondered what on earth she was trying to say. His look seemed to accuse her of ignorance and indifference. (49)

Rufus's relationship with Leona demonstrates the failure of love to overcome racial barriers—the incapacity of a liberal white sentiment to respond adequately to radical black consciousness—and acts out this failure in the specifically gendered form of violence against a woman. Racial conflict is enacted as gender warfare in part because gender categories are so unchallenged in the novel as to serve as the stable battleground in the contest over racial positions.

The most fully developed interracial relationship in the novel, however, significantly alters these terms, recombining them in a potentially successful (if only somewhat less turbulent) relation. Shortly after Rufus's death, his best friend, Vivaldo Moore, a struggling novelist of working-class Italian-Irish origin, becomes romantically involved with Ida Scott, Rufus's younger sister, herself a talented jazz singer. The combination of personalities and positions—a white man and a black woman—eventually proves more durable than the relationship between Rufus and Leona, yet along the way, Ida and Vivaldo replay many of the same debates. At one point Vivaldo wants to use

Ida as an affront to his conservative, working-class mother, intending to bring home "a colored girl . . . [as] but one more attempt on his part to shock and humiliate his family" (235). Ida refuses any part in this "kindergarten drama" and a fight develops: "'I've been living in this house for over a month and you *still* think it would be a big joke to take me home to see your mother! Goddammit, you think she's a better woman than I am, you big, white, liberal asshole? . . . Or do you think it would serve your whore of a mother right to bring your nigger whore home for her to see?'" (237). For Vivaldo, Ida is different from the black prostitutes he frequented in Harlem prior to meeting her because of the emotional bond between them; by contrast, she recognizes the racially prescribed role she plays, merely acting out the part of "nigger whore" for him.

Vivaldo nonetheless maintains his faith in the capacity of "love" to overcome the wrongs done by a history of racism, as he muses over Ida in naïve, romantic tones: "Oh, Ida, he thought, I'd give up my color for you, I would, only take me, take me, love me as I am! Take me, take me, as I take you" (260). The two positions confront each other again when Ida complains of the way Eric Jones, Rufus's white ex-lover, used her brother sexually, just as Vivaldo is using her:

> "I'm black, too, and I know how white people treat black boys and girls. They think you're something for them to wipe their pricks on.". . .
> "After all this time we've been together," he said, at last, "you still think that?"
> "Our being together doesn't change the world, Vivaldo."
> "It does," he said, "for me."
> "That," she said, "is because you're white." (273)

Ida's understanding of the structural, racial dimension to her relationship with Vivaldo powerfully confronts his liberal white humanist claims for individual love.[10]

By contrast with Rufus and Leona, who end up respectively dead and institutionalized, Vivaldo and Ida build a relationship that endures; the note of compromise that closes it at the end of the novel proposes the triumph of "love" over the barriers of racism. Yet this couple's resistance, on the one hand, to the misogyny of the Rufus-Leona relation and its reliance, on the other, on a certain indeterminacy of male sexuality indicate something more than a simple resolution of the race debate on one side or the other. For it is only through the achievement of an accord over racial tension that the possibility of a mutual heterosexual relationship can come about. If the Rufus-Leona combination demonstrates that the negative valence of gender difference—misogyny—absorbs and expresses racial discord, then Vivaldo and Ida's relationship correspondingly suggests that a heterosexual woman can achieve independence only by virtue of a peace worked out on racial terms. In both cases, gender relations are mediated through conceptions of race; women's autonomy and self-determination in the novel is only available—and valued—insofar as it arises from negotiations in the arena of race. In this sense, the novel transforms and narrows its consideration of both racism and racial equality by locating them in the gendered terms of the heterosexual relationships.

As if to demonstrate the impossibility of equity for noninterracial heterosexuality, Vivaldo's other straight relationship, with a white woman named Jane, is disastrous. Jane functions explicitly as a source of racial conflict for the men rather than, like Ida, as a link between them. At one point she provokes a violent bar fight over racial issues (32–35) and later taunts Vivaldo for his involvement with a "spade chick" (251–52). Even in this intraracial relationship, race remains a central point of contention; and in the same way that racial negotiation generates a certain gender balance between Vivaldo and Ida, the racial violence entailed in the Vivaldo-Jane pairing corresponds to, indeed produces, a virulently misogynistic representation of the racist woman. Through Rufus's imagination she is described:

> Even [Vivaldo's] affair with Jane was evidence in his favor, for if he were really likely to betray his friend for a woman, as most white men seemed to do, especially if the friend were black, then he would have found himself a smoother chick, with the manners of a lady and the soul of a whore. But Jane seemed to be exactly what she was, a monstrous slut, and she thus, without knowing it, kept Rufus and Vivaldo equal to one another. (36)

Transforming the divisive racial terms of the conflict that Jane provokes into misogynistic ones, Rufus can characterize her as "a monstrous slut."

If Vivaldo loves Ida because she, unlike the other black women he has known, is not a prostitute, Ida virtually implicates herself as one, suggesting a black woman can have no other relation to a white man, until she and Vivaldo reach their final compromise. Ida has an affair with Steve Ellis, a manipulative white television producer who advances her singing career in exchange for the liaison. Though the situation torments her, until the novel's end (when she confesses to Vivaldo) her tactic is to take the white man for whatever he can give her. She ends up the victim of both racial and sexual domination and can find her way out of the situation only by posing the two systems against each other. The threat, moreover, comes not only from the white man but from black men as well: At a gig Ellis has arranged for her, Ida is insulted by a black male musician, a friend of her late brother's, who whispers:

> "You black white man's whore, don't you never let me catch you on Seventh Avenue, you hear? I'll tear your little black pussy *up*." And the other musicians could hear him, and they were grinning. "I'm going to do it twice, once for every black man you castrate every time you walk, and once for your poor brother, because I loved that stud." (357)

Masculine racial anger (the black man's hatred of the white man) is again transvalued as sexual violence (the threat of rape) and the black woman finds herself under assault on both grounds.

The novel ultimately presents Ida's relationship with Vivaldo as a haven from this brutality, but one scarred and hardened by the visitation of social violence upon the individual. At the end, the novel suggests that, on the basis of this relationship, Ida will relinquish her automatic condemnation of white people, while Vivaldo correspondingly has his consciousness raised

about racial strife: "Her long fingers stroked his back, and he began, slowly, with a horrible, strangling sound, to weep, for she was stroking his innocence out of him" (362). Ida herself never had much innocence to lose, because, being black and female, she always knew the violence of structural oppression. But by negotiating a peace on racial terms, she begins to have some measure of autonomy as a woman as well.

For all of Ida's racial independence and self-determination, however, the novel's single scene between two women shows racial division precluding a coalition on the basis of gender. Cass Silenski is the novel's other major female character: A friend of Rufus's and Vivaldo's, she is a white woman married to a commercially successful (but artistically bankrupt) novelist, Richard, and the mother of two boys. Like Ida, she confronts questions of women's dependence and white privilege; she learns from both Ida and Eric about the structural dimension to her own oppression but is unable finally to respond to it fully, in part because in this novel gender on its own does not supply sufficient leverage for "liberation." Early in the story, Cass argues against both Richard's and Vivaldo's white liberalism: She rejects her husband's characterization of Rufus ("all of you made such a kind of—*fuss*—over him . . . just because he was colored" [93]), and to Vivaldo's frustrated question—"They're colored and I'm white but the same things have happened, really the *same* things, and how can I make them know that?"—Cass responds, "But they didn't . . . happen to you *because* you were white. They just happened. But what happens up here [in Harlem] . . . happens *because* they are colored. And that makes a difference" (99).

Yet by the time Cass is alone with Ida, she has retreated to the jejune liberal position that she earlier criticized. Ida berates Cass:

> "*You* don't know, and there's no way in the world for you to find out, what it's like to be a black girl in this world, and the way white men, and black men, too, baby, treat you. You've never decided that the whole world was just one big whorehouse and so the only way for you to make it was to decide to be the biggest, coolest, hardest whore around, and make the world pay you back that way.". . .
>
> "How *can* we know it, Ida? How can you blame us if we don't know? We never had a chance to find out. . . . There were hardly any colored people in the town I grew up in—how am I to know?" (293)

Through one of the novel's many transformations of the terms of one system of power relations into those of another, Ida attempts to convey to Cass the consciousness she has developed about gender oppression through her understanding of racism, implying that the two systems are analogous.[11] Yet Cass cannot see past the racial difference between them to the possibility of a female or feminist alliance. At this point in the novel, Ida is on her way to visit Ellis, with whom she is having an affair; and Cass is on her way from Eric, with whom *she* is having an affair. The two infidelities run in tandem (in one scene, each serves as an alibi for the other to the men being duped), but while Ida's affair serves to confirm modes of racial and sexual oppression, Cass's functions at least potentially to liberate her from a marriage stifled by rigidly oppressive gender roles. Ida continues to educate Cass about gender

inequalities by using racial terms, letting her know what "a poor white woman can still do":

> "You *can* suffer, and you've got some suffering to do, believe me. . . . You stand to lose everything—your home, your husband, even your children.". . .
> "I'll never give up my children," she said.
> "They *could* be taken from you."
> "Yes. It *could* happen. But it won't.". . .
> "It happened," said Ida, mildly, "to my ancestors every day." (296)

That home, husband, and children constitute "everything" for Cass is made clear early on, when she says to Richard, "You *are* my life—you and the children. What would I do, what would I be, without you?" (93). The possibility of something else—represented as desire outside of marriage—is what opens Cass's consciousness to the limitations of her role as wife and mother.

As if by analogy with her earlier discussions of racial inequality, Cass articulates the asymmetry that structures gender relations in general. In response to Richard's taunt, "'I don't believe all this female intuition shit. It's something women have dreamed up,'" she responds: "'But *I* can't say that— what men have "dreamed up" is all there is, the world they've dreamed up *is* the world'" (94–95). And when she considers his response to her affair, she says, "'If *he* were leaving *me,* if he were being unfaithful to *me*—unfaithful, what a word!—I don't think I'd try to hold him that way. I don't think I'd try to punish him. After all—he doesn't belong to me, nobody *belongs* to anybody'" (339). Of course Cass *does* effectively belong to Richard, and this discovery both impels and is confirmed by her relationship with Eric. That Richard responds violently to her admission of the affair—he hits and curses her, threatening to take away the children—only confirms for the reader Cass's realizations about gender inequities.[12]

Despite the implication that Cass develops a protofeminist consciousness from her affair and from Richard's reaction to it, however, she remains fully determined by her status as wife and mother. The infidelity finally functions to secure her only more firmly in that capacity, for she enters into the affair feeling that she is no longer sexually desirable ("I don't know if Richard loves me any more or not. . . . He hasn't touched me in, oh, I don't know how long" [232]), and when she confesses to him, she does so intending to save, not to destroy, their marriage: "I have to tell you because we can never come back together, we can never have any future if I don't" (314). Furthermore, even in the midst of the affair, Cass continues to be described in maternal images. Her mothering "instinct" enables her to nurture Rufus, Ida, and Vivaldo throughout the story; and in a novel full of explicit sexual scenes, her romance with Eric reads more like an oedipal fantasy than a love affair driven by insuperable passion. In contrast to the physical intensity of Vivaldo and Ida's first sexual episode (147–53) and the climactic sexual scene between Vivaldo and Eric later in the novel (321–34), Cass and Eric's encounter is virtually devoid of sexual physicality:

> He looked up at her, looking upside down, so that he was for her at that moment both child and man, and her thighs trembled. . . . He

turned and held her beneath him on the bed. Like children, with that very same joy and trembling, they undressed and uncovered and gazed on each other. . . . She watched his naked body as he crossed the room to turn off the lamp, and thought of the bodies of her children. . . . He took her like a boy, with that singlemindedness, and with a boy's passion to please: and she had awakened something in him, an animal long caged, which came pounding out of its captivity now with a fury which astounded and transfigured them both. Eventually, he slept on her breast, like a child. (246–47)

Sex itself is elided in this passage, as the encounter almost parodically dramatizes an oedipal model of heterosexual desire. Given that Eric is otherwise gay, moreover, and that Cass is so coded as maternal, the scene partakes of the stereotypical image of the gay son's relation to the "smothering mother."

Cass is thrown back into her traditionally structured marriage, and the novel finally turns away from her, relegating her to a cautionary tale. In her last scene, a parting with Eric, she realizes that "it's too late," that she is "trapped," and she speaks fatalistically: "We think we're happy. We're not. We're doomed" (341–42). From Eric's point of view, her situation is equally hopeless:

A sorrow entered him for Cass stronger than any love he had ever felt for her. . . . He wished that he could rescue her, that it was within his power to rescue her and make her life less hard. But it was only love which could accomplish the miracle of making a life bearable—only love, and love itself mostly failed; and he had never loved her. (340)

After Rufus's, Cass's struggle against a system of domination is the least successfully resolved in the novel. One has little hope that she can do more than attenuate the violence in her marriage, for the gender-determinism of her role is not significantly challenged. The relevant heterosexual comparison is Ida and Vivaldo's relationship, and there the fact of racial difference is what *produces* the potential for greater balance in gender terms. Yet the novel also offers a kind of mirror image of the interracial heterosexual relationship in the form of the *non*interracial *homo*sexual relation, the other interaction that Baldwin can portray as successfully resolved. And like the relationships that challenge traditional gender roles, those that cross normative sexual boundaries—that is, the gay male relations—are in a constant struggle against conflict.

IF THE RIGIDITY of gender relations in *Another Country* can be contested only when mediated through the relatively more negotiable sphere of race, then racial arrangements themselves, I will argue, are opened to further "liberation" when filtered through the fantasy of a sexuality (implicitly male) that is wholly private and volitional. While gender, that is to say, narrows and particularizes the novel's racial negotiations, sexuality conversely broadens and universalizes them. Ultimately the central male characters in the novel—Rufus, Vivaldo, and Eric—are completely triangulated, and in turning to their complex interrelations across normative lines of race and sexuality, we

can locate Baldwin's major claims about the socially redemptive power of "love."

The novel's attitude toward homosexuality at first glance appears self-contradictory: On the one hand, it offers an idyllic representation of a specific gay relationship, that of Eric and Yves; on the other, it portrays homosexual men in general as detestable. Looking first at the general case, we can note the portrayal of gay men as a class of people.

> Coming toward them, on the path, were two glittering, loud-talking fairies. [Eric] pulled in his belly, looking straight ahead. . . . The birds of paradise passed; their raucous cries faded.
>
> Ida said, "I always feel *sorry* for people like that."
>
> Ellis grinned. "Why should you feel sorry for them? They've got each other." (222–23)

Beyond Eric's apparent anxiety, Baldwin makes no attempt to ironize or disavow his characters' disapproval of generic "fairies"; indeed, the narrator's use of such terms tends, rather, to ratify the characters' sentiments. The disjunction becomes even sharper when, just before the novel's two principal male characters have sex, Eric—who eventually becomes the gay spokesman for Baldwin's humanist values—describes for Vivaldo the two bars on his street:

> One of them's gay . . . and what a cemetery *that* is. The other one's for longshoremen, and that's pretty deadly, too. The longshoremen never go to the gay bar and the gay boys never go to the longshoremen's bar—but they know where to find each other when the bars close, all up and down this street. It all seems very sad to me, but maybe I've been away too long. *I* don't go for back-alley cock-sucking. *I* think sin should be fun. (281)

Eric's irony bespeaks Baldwin's attitude toward sex in general: He celebrates it only when a vehicle for transmitting knowledge and love, and castigates it when motivated by anything else—especially material profit.[13] The denunciation of loveless sexual encounters between men in particular might be unremarkable were it not for the fact that such activity tends to define and condemn the anonymous gay figures as a class. (By contrast, for instance, the Harlem prostitutes are partially vindicated by their racial motives.) We will see that, as much as Eric emancipates other characters from sexual categories, he can do little for these nameless, detested "gay boys" and longshoremen.

We can explain the apparent contradiction between the novel's approbation of the individual gay man and its reproach of the class he represents if we understand Baldwin to be making a distinction between those who make love and those who have sex. This potentially punitive dichotomy is enabled by Baldwin's imagination of sex as an act that is always personal, never political. The novel most explicitly pits "despised and anonymous" homosexual activity against the kind of revelatory sexual encounters in which Eric specializes through the latter's disapproving musings over the "ignorant army" of closeted men. These men have a sexual need:

which they spent their lives denying . . . and which could only be satisfied in the shameful, the punishing dark, and quickly, with flight and aversion as the issue of the act. . . . Something had been frozen in them . . . so that they could no longer accept affection, though it was from this lack that they were perishing. The dark submission was the shadow of love—if only someone, somewhere, loved them enough to caress them this way, in the light, with joy! (179–80)

Though it might be appropriated for gay liberation as a call to come out, this passage does not, in context, constitute an incitement to self-empowering identification; rather, it is a humanistic plea that sex be "meaningful," and that its meaning be universal and beneficent.[14]

If sex "in the light, with joy" delivers the individual consciousness in *Another Country,* then even for the otherwise straight man, sex with another man—if he's the right man—can be liberatory. Vivaldo is ostensibly and overtly heterosexual, yet a number of incidents suggest the instability of this "identity." He recounts to Cass how once, when he was a kid "on the streets of Brooklyn," he and six friends "drove over to the Village and . . . picked up this queer" (97), then raped, beat, and abandoned him to die. Another passage charts Vivaldo's frustration with white heterosexuality as he moves progressively toward interracial homosexuality. First, he vividly imagines a repulsive sexual encounter between a man and a woman in the apartment across the street from his, explicitly substituting these anonymous figures for himself and a lover in his past: "The best that he had ever managed in bed, so far, had been the maximum of relief with the minimum of hostility" (115). From this disenchantment with white women he moves to memories of his encounters with black prostitutes in Harlem, then to recalling his relationship with Rufus—erotically charged, but racially and sexually blocked: "He had insisted that he and Rufus were equals. They were friends, far beyond the reach of anything so banal and corny as color. They had slept together, got drunk together, balled chicks together . . . once or twice the same chick— why? And what had it done to them? . . . They never really talked about it" (116). From this homosocial bonding over the shared heterosexual encounter with a woman, Vivaldo passes to more overtly homoerotic memories of an occasion when, once in the army, he and "a colored buddy" got drunk and compared their genitals, ostensibly for the benefit of a woman with them, "but also [for] each other. . . . It was out in the open . . . and it was just like his, there was nothing frightening about it" (116–17).

Eventually Vivaldo's simultaneous desire for and fear of sex with a black man becomes explicitly associated with Rufus. In Vivaldo's mind his inability to express this desire is partially responsible for his friend's suicide. Shortly before having sex with Eric, Vivaldo confesses to him something he "never told to anybody before" about the last time he saw Rufus:

I looked at him, he was lying on his side, his eyes were half open, he was looking at me. I was taking off my pants, Leona was staying at my place and I was going to stay there, I was afraid to leave him alone. . . . I had the weirdest feeling that he wanted me to take him in my arms. And not for sex, though maybe sex would have happened. I had the feeling that he wanted someone to hold him, to hold him, and that, that

night, it had to be a man. I got in the bed and I thought about it and I watched his back, it was as dark in that room, then, as it is in this room, now, and I lay on my back and I didn't touch him and I didn't sleep. . . . I still wonder, what would have happened if I'd taken him in my arms, if I'd held him, if I hadn't been—afraid. I was afraid that he wouldn't understand that it was—only love. Only love. But, oh, Lord, when he died, I thought that maybe I could have saved him if I'd just reached out that quarter of an inch between us on that bed, and held him. (288–89)

The barriers between himself and Rufus are too great for Vivaldo to overcome, but the scenario with Eric is clearly meant to recapitulate, and allow Vivaldo to work through, the missed opportunity with Rufus: "It was as dark in that room, then, as it is in this room, now," and the quarter-inch between Vivaldo and Rufus is reproduced, on the following page, in the present scene: "Here Vivaldo sat, on Eric's bed. Not a quarter of an inch divided them" (290). Vivaldo's confession not only functions to absolve him of guilt for his part in Rufus's death but also works as a form of semiconscious seduction for Eric. As Vivaldo later wakes from a dream of being both threatened and embraced by Rufus, he finds that it is "Eric to whom he clung, who clung to him. . . . Immediately, [Vivaldo] felt that he had created his dream in order to create this opportunity; he had brought about something that he had long desired" (322). Vivaldo replays his desire for Rufus in his desire for Eric, but now with a difference—or rather, now *lacking* a difference—of race.

Vivaldo's sexual experience with Eric is cathartic not only in the way it enables him to work through his guilt about Rufus but in terms of his own self-understanding as well. Baldwin envisions this sexual climax as a coming-into-consciousness for Vivaldo, though it is a revelation he achieves neither through an understanding of oppressive social relations nor, as anachronistic post-Stonewall language would have it, by "questioning his sexuality." Indeed, even as it threatens to destabilize his sexual identity, the incident helps to shore up Vivaldo's "essential" heterosexuality: "He knew that he was condemned to women. What was it like to be a man, condemned to men? He could not imagine it and he felt a quick revulsion, quickly banished, for it threatened his ease. But at the very same moment his excitement increased: he felt that he could do with Eric whatever he liked" (324–25).

The homosexual experience, then, is simultaneously organized in two contradictory ways for Vivaldo: One is wholly discontinuous from heterosexual intercourse, given the gender identity of the partners ("It was strangely and insistently double-edged, it was like making love in the midst of mirrors"), while the other simply substitutes the "passive" partner for a woman. Vivaldo explicitly "feminizes" himself, both noting the difference from heterosexual intercourse—here, by conjuring up the absent female figure—and imagining how it would feel to *be* a woman:

This was as far removed as anything could be from the necessary war one underwent with women. He would have entered her by now, this woman who was not here, her sighs would be different and her surrender would never be total. Her sex, which afforded him his entry, would nevertheless remain strange to him, an incitement and an anguish, and

an everlasting mystery. . . . Now, Vivaldo, who was accustomed himself to labor, to be the giver of the gift, and enter into his satisfaction by means of the satisfaction of a woman, surrendered to the luxury, the flaming torpor of passivity, and whispered in Eric's ear a muffled, urgent plea. (324–25)

Even as Vivaldo finds himself "condemned" to heterosexuality, the "excitement" of his "plea" is, significantly, not about penetrating another man but about being penetrated by him. For this scene partakes of two fantasies at once: One, the gay man's fantasy, that the straight man will beg to be penetrated by him; and two, the straight man's fantasy, that the desire to be penetrated can nonetheless serve to confirm his heterosexuality. It matters that Vivaldo is penetrated not only as a radical affront to the normative sexual practice of the putatively straight man, but, in Baldwin's terms, because a heightened consciousness on all levels enters him through the sexual act.

This consciousness entails a crossing of more than the hetero/homo line, for in having sex with Eric, Vivaldo collapses a whole series of identifications. He fantasizes himself not only as a woman, but now making love to Rufus, now *being* Rufus, being made love to by Eric: "Rufus had certainly thrashed and throbbed, feeling himself mount higher, as Vivaldo thrashed and throbbed and mounted now." The identification also extends to Ida, for even though earlier when "he tried to think of a woman[,] . . . he did not want to think of Ida," at the climax "he remembered how Ida, at the unbearable moment, threw back her head and thrashed and bared her teeth. And she called his name. And Rufus? Had he murmured at last, in a strange voice, as he now heard himself murmur. *Oh, Eric. Eric*" (324–25). This sexual connection generates an orgasmic concatenation of identities, whereby Vivaldo conceives of himself as simultaneously gay and straight, male and female, white and black—to the extent that his own voice, speaking the names of his lovers, is alienated from him. The experience unsettles his identity in terms of gender and sexuality; that it constitutes for him "another mystery, at once blacker and more pure" (324) suggests it breaks down racial categories as well. This is, as Vivaldo imagines elsewhere, "a region where there were no definitions of any kind, neither of color, nor of male and female" (255).

If the sexual encounter between Vivaldo and Eric disrupts the whole series of binaries that have hitherto structured power relations in the novel, where does this disintegration lead? It clearly does not move into what we might now term identity politics, nor does it tend in the opposite direction, toward a sustained, transgressive destabilization of identity itself. Instead, taking "love" as the revolutionary act, this disordering sexual experience enables Vivaldo provisionally to escape limiting categories, even as, in the process, it reconstitutes him as transcendent liberal subject. Vivaldo is "educated" by Eric as he has been by Ida, but where the latter instructs him in the social blockage to emotional/sexual fulfillment, the former exposes him to the "liberating" possibilities of "love":

He felt fantastically protected, liberated, by the knowledge that . . . no matter what happened to him from now until he died, and even, or per-

haps especially, if they should never lie in each other's arms again, there was a man in the world who loved him. All of his hope, which had grown so pale, flushed into life again. He loved Eric: it was a great revelation. But it was yet more strange and made for an unprecedented steadiness and freedom, that Eric loved him. (326)

Sex with another man does not function to categorize Vivaldo as "gay" because such a sexual taxonomy, for Baldwin, is always limiting. Instead, as "a great revelation," this sexual act raises his consciousness in an ostensibly universal and "human" way, emancipating him from the constraints of social classifications. For Vivaldo's sexual experience with a white man enables him, almost magically, to return, now well adjusted, to a relationship with a black woman.

As the straight, white male protagonist is the character most capable of learning such lessons, we may begin to inquire about the exclusions upon which this consciousness is predicated. Interracial homosexuality entails too much difference for Vivaldo, so sex with Rufus remains for him only phantasmatic—indeed, Rufus himself must be eliminated, inhabiting the book for the most part only as a ghostly presence. By deflecting and dividing his desire between a black woman and a white man, however, Vivaldo overcomes the "impossibility" of sex with Rufus. The novel's central, unaccomplished pairing of Rufus and Vivaldo, which is mediated and bisected by both Ida and Eric, refracts and complicates the by now familiar "between men" structure that Eve Kosofsky Sedgwick has described. For Vivaldo to have sex with Rufus would transgress normative barriers, both racial and sexual; Ida functions as the transitional figure for race, then, while Eric is the conduit for sexuality. By the logic of the novel, in other words, interracial homosexuality requires two figures for mediation.[15]

If the notion of "too much difference" bounds and organizes the story's relationships, then the implicit normative subject for Baldwin, as for traditional liberalism, remains straight, white, and male. This reasoning explains why the character most challenged by "difference" is Vivaldo, while those who "educate" him are Ida and Eric.[16] (The other straight, white men, however—Richard and Ellis—Baldwin presents as despicable, not only because they are unwilling to learn from "difference," but because they uncritically exploit the power they hold by virtue of their gender, race, and sexuality.) The novel parcels out difference—racial difference to a straight woman, difference in sexual orientation to a white man—while it cannot portray a black couple, gay or straight, a lesbian of any color, or a gay black man: These figures retain too little common ground with the normative subject. The explanation for these absences may lie in the metonymic nature of desire in this text, which flows by transpositions and displacements through one character into another. Were these absent figures made present in the novel, they could at no point establish a love-relation with the usual liberal subject, the straight white man, because they are too "distant" from him on the metonymic chain. Consequently, they are written out of the love stories.

This logic of displacement finds symbolic expression quite directly through the novel's representation of jewelry. When he was in love with Rufus, Eric "had had a pair of cufflinks made for Rufus, for Rufus's birthday,

with the money which was to have bought his wedding rings: and this gift, this confession, delivered him into Rufus's hands. Rufus had despised him because he came from Alabama; perhaps he had allowed Eric to make love to him in order to despise him more completely" (43). Much later, when Eric first observes Ida, he notices:

> On the little finger of one hand, she wore a ruby-eyed snake ring; on the opposite wrist, a heavy, barbaric-looking bracelet, of silver. . . . [Her] earrings were heavy and archaic, suggesting the shape of a feathered arrow: *Rufus never really liked them.* In that time, eons ago, when they had been cufflinks, given him by Eric as a confession of his love, Rufus had hardly ever worn them. But he had kept them. And here they were, transformed, on the body of his sister. (211)

The cufflinks literalize a linkage between genders, races, and sexualities. They begin as wedding rings, for a marriage Eric forgoes in favor of Rufus, and thus signify a crossing from heterosexual to homosexual. Yet the racial difference they also cross, in passing from Eric to Rufus, produces enmity, not amorousness, as Rufus tortures his white lovers. When they pass from Rufus to Ida, they set off not only her blackness—she is described here and elsewhere as if, in the eyes of white men at least, she were an African princess—but her femininity as well, for the cufflinks have now become earrings. Thus, while they indicate the failure of Eric's love for Rufus, they also affirm the *intra*racial, cross-gender connection between Rufus and Ida. (So does another piece of jewelry—the snake ring, also a gift from Rufus, which Ida twists around her finger, as if to invoke Rufus, in virtually every scene in which she appears.) However implausible it may be for Eric to recognize, across a crowded bar, cufflinks from years before melted down and recast as earrings, it is their value precisely as links across bodies that matters.[17]

If Baldwin attempts to contest and expand liberalism's traditional borders in terms of both race and sexuality (as the case of Vivaldo makes clear), it remains for us to articulate the important senses in which those challenges differ from each other. Having examined the ways in which questions of race and sexuality trouble—even as they enable—Vivaldo's desire, we can now turn to the redemptive figure of sexual enlightenment, Eric. Like Vivaldo, Eric has experienced a sexual "failure" with Rufus, but while the former moves on primarily to a relationship with a black woman, the latter takes a white male lover—Yves, with whom he has been involved during a three-year sojourn in France.[18] Like Vivaldo, also, Eric has in the past had an obsession with black men. In fact, the explanation offered for his alienation from his native Alabama is his double identification with black people and stereotypical gay male behaviors:

> Part of Rufus's great power over him had to do with the past which Eric had buried in some deep, dark place; was connected with himself, in Alabama, *when I wasn't nothing but a child;* with the cold white people and the warm, black people, warm at least for him. . . .
> [He stood] before his mirror by night, dressed up in his mother's old clothes or in whatever colorful scraps he had been able to collect, posturing and, in a whisper, declaiming. (165, 170)

Eric's identification simultaneously across race lines and against sexual norms is the first sign of his incipient consciousness; it is advanced through his love, while an adolescent, for a black teenager, LeRoy. The latter, knowing that he will suffer more for their relationship than Eric will, suggests once again the social blockage to love:

> "I guess you know, now," LeRoy said . . . "what they saying about us in this town.". . .
>
> "Well, if we've got the name, we might as well have the game is how I see it. I don't give a shit about those people, let them all go to hell; what have they got to do with you and me?". . .
>
> "You a nice boy, Eric, but you don't know the score. Your Daddy *owns* half the folks in this town, ain't but so much they can do to you. But what they can do to *me*—!" And he spread his hands wide. (175)

Like Cass and Vivaldo, Eric responds with ineffective claims for humanism and individual love to black characters' arguments about the social constitution of racial barriers. But where the novel's heterosexual relationships mostly work to reinforce racial impediments, the homosexual connection magically produces "a healing transformation" in racial terms as well. Despite the interdiction of Eric's relationship with LeRoy, they make love; afterwards, Eric is "frightened and in pain and the boy who held him so relentlessly was suddenly a stranger; and yet this stranger worked in Eric an eternal, a healing transformation. . . . That day was the beginning of his life as a man. What had always been hidden was to him, that day, revealed" (176). Eric's "revelation" is given as the core value in the book, and it is something he can pass on, sexually, to other characters, as if he has shamanistic powers. Through sexual meetings, he endows Cass with the capacity to assert herself in her marriage, Vivaldo the power to overcome his guilt about Rufus and to build a relationship with Ida; Eric himself has the most idyllic relationship in the novel, with Yves. It is the promise of this final relationship that ends the novel, on a note of extraordinary optimism, as Yves flies into New York to join Eric.

Baldwin conceives of the special knowledge that Eric divines from his encounters with LeRoy and Rufus as universal, for even if it belongs particularly to the gay man in a homophobic society, it is also clearly generalized to black people in racist America and to women in patriarchy. This consciousness receives its most straightforward articulation as follows:

> His life, passions, trials, loves, were, at worst, filth, and, at best, disease in the eyes of the world, and crimes in the eyes of his countrymen. There were no standards for him except those he could make for himself. There were no standards for him because he could not accept the definitions, the hideously mechanical jargon of the age. He saw no one around him worth his envy, did not believe in the vast, gray sleep which was called security, did not believe in the cures, panaceas, and slogans which afflicted the world he knew; and this meant that he had to create his standards and make up his definitions as he went along. It was up to him to find out who he was, and it was his necessity to do this, so far as the witchdoctors of the time were concerned, alone. (181)

As the representative of the margins of society, one who must "make up his definitions as he goes along" and yet seems wholly untroubled by this position, Eric is the redemptive figure in the text, facilitating, directly or indirectly, all of the other relationships, and speaking at once for all "alterity."[19] Yet Baldwin's effort to assign universal value to Eric's enlightened views requires some explanation, not only because, as the contemporary criticism demonstrates, assigning the role of redeemer and mediator to a gay man was largely incomprehensible to Baldwin's readers, but also because any such universalizing gesture must be suspect in a text so given to charting desire and domination that is shaped by particular social forces.[20]

WHY, THEN, DID BALDWIN give the privileged place in his novel to a gay white man? Why does he alone rise above the conflicts and antipathy that divide the other characters? On one level, it may simply be that he speaks, by analogy, for all marginalized people. Baldwin recognized that oppressed people understand far more about their oppressors than the latter know of themselves: "If you want to know what's happening in the house, ask the maid. . . . In this extraordinary house [of American society], I'm the maid."[21] Ida expresses the same sentiment repeatedly, claiming and demonstrating a far greater knowledge of white society than white people; yet her voice is always positioned against another in debate while Eric's alone is validated as uncontested truth.

This argument for analogy, however, fails to explain why Baldwin's two kinds of analysis seem to stand in for each other, why the racial critique rebounds upon the sexual and vice versa. Returning to our earlier conceptualization of the three axes of power relations (gender, race, and sexuality) as occupying different places on a continuum that has rigid social determinism on one end and fluid individual volition on the other, I suggest that the critique Baldwin wanted to make about race he could only express fully in terms of sexuality. By 1962, that is, in the face of increased black activism and demands for civil rights, it would have seemed disingenuous for Baldwin to claim that individual love could conquer racial discord. Yet he was so deeply committed to the idea of individual freedom and the expression of "love" over and across structural boundaries that he sought to convey this sentiment, not directly in terms of race, but deflected onto the more readily privatized terms of sexuality.

This is not to say that the novel's treatment of sexuality is simply a cover for an analysis of race; rather, it is to suggest that for Baldwin all desire would ideally be free of social constraints. While desire for him was clearly motivated along racial lines (Rufus and Ida have a "need" for white lovers, Eric and Vivaldo a "need" for blacks), sexuality, for men at any rate, was in his mind beyond social determination and, therefore, exemplary. For Baldwin, sexuality occupied the realm of the indisputably private, allowing a voice for individual desires to transcend social barriers. If only from the reviews, which were horrified at the frank representation of homosexuality, we know he was overly optimistic on this point, and in the thirty years since the book's publication the gay liberation struggle has demonstrated just what kinds of social pressure sexual "choice" exerts and endures. For while Baldwin's novel carefully articulates different axes of power relations, the places these axes occupy on the spectrum are in no way immutably fixed—indeed,

they shifted rapidly in the years immediately after the book's publication. The historical moment in which these formulations could be crystallized was an extremely brief one. That moment required both the visibility of America's volatile race relations and a modicum of tolerance for the representation of non-normative sexuality; it also necessarily antedated the women's movement and Stonewall, whereby gender and sexuality began to enter the domain of popular politics.

Some readers accurately registered the way in which *Another Country* confronted liberal white America with the contradictions in its values—as no less staunch a defender of these ideals than Norman Podhoretz realized shortly after the novel was published. The now-prominent spokesman for neoconservative values fully recognized the challenge that the book presented in an article, "In Defense of James Baldwin," which he wrote, he states, in order to "venture a step or two in the direction of literary justice to a new novel that seems to me to have been maltreated in an appalling way." Podhoretz claims that "Baldwin's intention is to deny any moral significance whatever to the categories white and Negro, heterosexual and homosexual" and that for him "the only significant realities are individuals and love." This is, "after all, only a form of the standard liberal attitude toward life . . . [held by] most liberal and enlightened Americans." Yet Baldwin "holds these attitudes with a puritanical ferocity, and he spells them out in such brutal and naked detail that one scarcely recognizes them any longer—and one is frightened by them, almost as though they implied a totally new, totally revolutionary conception of the universe."[22] "One" is indeed frightened by them if one is a straight white man, for Baldwin clearly intends not to abandon liberal ideology but to demand the rights it claims to guarantee him. Baldwin was a fierce advocate of these supposedly inalienable rights; and while his polemic finally endorses individual values ("love"), it does so only by radically exposing the limits of liberalism, insistently traversing the racial and sexual lines that have historically bounded it. The novel confronts liberal ideology not finally in order to undermine its bases but instead to pose a significant challenge by working within its own terms, transforming them into a "totally new, totally revolutionary conception."

Yet if *Another Country* ultimately remains committed to a liberal humanist ideology of salvation and love—however "revolutionary" its revision of these terms—what blindspots does its adherence to this ideology entail? It can only rarely conceive of gender as a category of oppression, because male and female roles are so inflexible—unless the subject is a black woman or a gay man, though that only proves the point, since it demonstrates that gender as such provides no leverage. Sexuality is equally unavailable as an arena of political contention, since it is relegated to a thoroughly private realm. As the place of individual liberation, sexuality is thus inconceivable as a site of power struggle in its own right; gay men per se are consistently belittled as "fairies" and "queers," while "gay" and "straight" seem hardly to constitute identities for the male characters (most of whom are finally "bisexual"). The novel's political polemic is forceful on issues of racial conflict, even as this point is made *through* gender and sexuality. Yet its resistance to what I have termed "too much difference" requires it narrowly to insist that "black" signify "straight," that "gay" signify "white," and that traditional gender roles go largely unchallenged. Finally, the universalizing maneuver whereby Eric's

consciousness of gay oppression comes to stand in for all other modes of sub-jugation not only obscures the specificity of power relations structured by sexuality but elides the different and often contradictory concerns of people who feel themselves, as Baldwin might say, to be "outsiders."

As we move beyond considering *Another Country* in the terms it derives from liberal ideology, we can also understand the ways in which the novel's utopia itself derives from certain social exigencies. It is now clear just how closeted the pre-Stonewall setting of Baldwin's novel is: There is no coming out of the closet because there is nowhere to come out to. Sexuality was, therefore, "perfectly" private—it had not yet found a public voice—and it is for this reason that Baldwin's fantasy of *racial* mixing and equality (which had, by this period, certainly gone public) was everywhere deflected onto sexual dynamics. To explore racial conflict *as* sexual was to bring it to the most private, individual terms Baldwin could imagine; it was to fantasize a relation between people nowhere impeded by an imbalance of power or inequality. Yet the impossibility of representing a person simultaneously gay and black signals the crisis of this structure: To be both, like Baldwin himself, was to find oneself impelled contradictorily by both individual volition and social forces. That *Another Country* cannot sustain a gay black subject—the one we might expect from so outspoken a gay black writer—bespeaks the liability of remaining within a liberal humanist ideology, however insistently it is extended. The transposition of racial conflict onto private sexual terms, and of gay issues finally onto an all-white, all-male terrain, makes it clear just how unrepresentable the gay black man, or the lesbian of any race, was and in many ways continues to be.

Notes

For contributing to this essay at the various stages of its composition, I wish to thank Christopher Haines, Elizabeth Young, Elizabeth Abel, Carolyn Dinshaw, D. A. Miller, Laura Green, and Frank K. Saragosa. This essay originally appeared in *Genders,* no. 12 (Winter 1991); copyright © 1991 by the University of Texas Press.

1. For a study of *Another Country*'s critical reception and a powerful defense of the novel against its detractors, see Mike Thelwell, "*Another Country:* Baldwin's New York Novel," in *The Black American Writer,* vol. 1, ed. C. W. E. Bigsby (Deland, Fla.: Everett/Edwards, 1969), 181–98. For a summary of reviews and criticism, see also Daryl Dance, "James Baldwin," in *Black American Writers: Bibliographical Essays,* vol. 2, ed. M. Thomas Inge et al. (London: Macmillan, 1978), 73–120, esp. 94–97.

2. On the general critical silence that met *Giovanni's Room,* see Dance, "James Baldwin," 91. Thelwell, "*Another Country,*" notes that the earlier novel "had been writ-ten in France, set in France, and had been widely . . . [treated as a mere] tour de force, a kind of minor aberration. The second 'serious' work was still to come, and this was of course *Another Country*" (182–83).

3. Eldridge Cleaver's notorious attack on the novel suggests the profound homophobia that motivated a radical black response. In describing the central black male character in the novel, Cleaver writes:

> Rufus Scott, a pathetic wretch who indulged in the white man's pastime of committing suicide, who let a white bisexual homosexual fuck him in his ass, and who took a Southern Jezebel for his woman, with all that these tortured relationships imply, was the epitome of a black eunuch who has completely submitted to the white man. (*Soul on Ice* [London: Jonathan Cape, 1968], 107)

See also Robert A. Bone's vitriolic censure of the book in "The Novels of James Baldwin," *Tri Quarterly,* 2 (Winter 1965): 3–20.

4. It is difficult to determine how the "reading public" took the book and dubious to judge its public reception by what the critics said. Thelwell attributes the negative reviews in part to a snowball effect—"a few widely read early reviews tend to influence the attitudes and vision of the writers who grind out subsequent commentary, so an escalation of opinion takes place" ("*Another Country,*" 185)—and more significantly to the direct assault that the white, male, heterosexual, bourgeois reviewers felt (though could not acknowledge) from the book. It did sell remarkably well, although this in itself says nothing about *how* it was read, as Hoyt W. Fuller explains in "Contemporary Negro Fiction" (in Bigsby, *The Black American Writer,* 229–43): "*Another Country* is in fact an incredibly misunderstood book, certainly maligned for the wrong reasons—those reasons being its blunt treatment of interracial and homosexual relationships—and probably, with its all but phenomenal sales, also read for the wrong reasons" (235). The issue of *who* was reading the novel is suggested by John S. Lash, "Baldwin beside Himself: A Study in Modern Phallicism," in *James Baldwin: A Critical Evaluation,* ed. Therman B. O'Daniel (Washington, D.C.: Howard University Press, 1977), 47–55: "[Baldwin's] latest novel, *Another Country,* is widely praised by college students, popular critics, and lay readers as something of an event in modern American fiction" (47); these readers must be distinguished from the literary-critical and book-review establishments that derided the novel.

5. The quotations are from, respectively, Brian Lee, "James Baldwin: Caliban to Prospero" (in Bigsby, *The Black American Writer,* 169–79), 174; Thelwell, "*Another Country,*" 192; Baldwin, "The Negro in American Culture" (Nat Hentoff's interview with Baldwin and others; in Bigsby, *The Black American Writer,* 79–108), 80; and Baldwin, "Disturber of the Peace: James Baldwin" (an interview with Eve Auchincloss and Nancy Lynch; in Bigsby, *The Black American Writer,* 199–215), 214. In "James Baldwin: The Political Anatomy of Space" (in O'Daniel, *James Baldwin,* 3–18), Donald B. Gibson writes that the novel's

> assumptions about the basic nature of the social problems it confronts give rise to a societal analysis essentially conservative in character. It assumes that large-scale social problems, such as racial oppression and its resulting social manifestations, are the result of limitations within the psyches of individuals rather than of the dynamics of contending social forces. Hence, the responsibility for social problems lies with the individual, be he oppressed or oppressor, victimizer or victim. (10)

6. On the asymmetrical interrelation of different axes of power relations in general, and gender and sexuality in particular, see Eve Kosofsky Sedgwick, "Across Gender, across Sexuality: Willa Cather and Others," *South Atlantic Quarterly,* 88, no. 1 (Winter 1989): 53–72. On the "heterosexual matrix," by which the diacritical terms "male" and "female" presuppose and ossify an implicit homo/heterosexual binary, see Judith Butler, *Gender Trouble* (New York: Routledge, 1990).

7. Thelwell, "*Another Country,*" 183.

8. One chapter—Book 2, Chapter 1—is set in France and relates Eric's leave-taking with his lover, Yves, and his return to New York. The clue to the date comes in this chapter: Yves has a "twenty-one-year-old face" and "when the Germans came to Paris" (the occupation was in 1940) he "had then been five years old"; thus, the scene takes place in 1956. James Baldwin, *Another Country* (New York: Dell, 1962), 159; all further references will be made parenthetically to this edition and all italics appear in the original.

9. Thelwell, "*Another Country,*" 184.

10. On the relation between love and social conflict in Baldwin's work, Gibson, "James Baldwin," writes: "Baldwin believes that the injustices committed by groups against other groups, and individuals against other individuals, come about because individuals do not know themselves, cannot be honest with themselves or others, and do not possess, therefore, the capacity to love. The idea of love is central

to Baldwin's thinking and lies at the heart of his system of values" (11). For more on Baldwin's insistence on love as *the* redemptive value, see his *Nothing Personal* (with photographs by Richard Avedon; New York: Atheneum, 1964). For Baldwin, love functions as a specifically individual value, yet for all this position's passionate idealism, it can be seen to verge on an improbable faith in the promise of liberal individualism:

> I have always felt that a human being could only be saved by another human being. . . . For, perhaps—perhaps—between now and that last day, something wonderful will happen, a miracle, a miracle of coherence and release. And the miracle on which one's unsteady attention is focussed is always the same, however it may be stated, or however it may remain unstated. It is the miracle of love, love strong enough to guide or drive one into the great estate of maturity, or to put it another way, into the apprehension and acceptance of one's own identity. For some deep and ineradicable instinct—I believe—causes us to know that it is only this passionate achievement which can outlast death, which can cause life to spring from death. (n.p.)

11. Indeed, Lorelei Cederstrom ("Love, Race and Sex in the Novels of James Baldwin," *Mosaic,* 17, no. 2 [Spring 1984]: 175–88) argues that for Baldwin, "sexual politics and racial politics have the same patterns" and that he demonstrates that the two are intricately related and derive from the same sources" (176). Although Baldwin certainly shows the different political arenas to be related, he portrays them not as equivalent but as having a much more complex interconnection, whereby the terms of one are displaced onto or transvalued as those of another. Further, while Cederstrom's rebuttal of previous critics' explicit homophobia is salutary, it places her argument in the insidiously heterosexist position of having to claim that "it is a misreading of Baldwin's revolutionary sexual message to see this as an advocacy of homosexuality" (183). Although I concur that "ultimately, Baldwin advocates a new definition of sexuality, based on equality between the sexes and the races, as well" (184), the only idyllic relationship that Baldwin can imagine in *Another Country* is a white homosexual one, and the novel's particular sexual and racial parameters virtually doom any other pairing to failure.

12. As Richard's violence reaches a pitch, his fantasy about Cass's sex with Eric takes on specifically antigay terms: "'*Now* she worries about the children!' He pulled her head forward, then slammed it back against the chair, and slapped her across the face, twice, as hard as he could. The room dropped into darkness for a second, then came reeling back, in light; tears came to her eyes, and her nose began to bleed. 'Is that it? Did he fuck you in the ass, did he make you suck his cock? Answer me, you bitch, you slut, you *cunt!*'" (316). Richard's imagination of Cass and Eric's affair is gay coded—he envisions anal and oral sex—and he implicitly draws on a homophobic castigation of Eric even as he finally humiliates Cass by defining her as nothing other than female sexuality. That his homophobia corroborates misogyny is also apparent when Richard projects himself into their affair: Responding to Cass's claim, "I know [Eric] better than you do," he says, "I guess you *do*—though *he* may have preferred it the other way around. Did you ever think of that?" (315).

13. See, for instance, the descriptions of Rufus's self-degrading attempt to prostitute himself to a white man (40–43); Vivaldo's accounts of visiting prostitutes in Harlem (57–60, 85); Ida's opportunistic affair with Ellis; and Eric's disavowal, upon meeting Yves, of a "merely" sexual interest: "He wanted Yves to know that he was not trying to strike with him the common, brutal bargain; was not buying him a dinner in order to throw him into bed" (185).

14. Echoing Eric's denunciation of nonspecific homosexuals, though in even more disturbing tones, Baldwin writes in an essay on Gide:

> The really horrible thing about the phenomenon of present-day homosexuality, the horrible thing which lies curled like a worm at the heart of Gide's trouble and his work . . . is that today's unlucky deviate can only save himself by

the most tremendous exertion of all his forces from falling into an underworld in which he never meets either men or women, where it is impossible to have either a lover or a friend, where the possibility of genuine human involvement has altogether ceased. When this possibility has ceased, so has the possibility of growth. (*Nobody Knows My Name* [New York: Dial, 1961], 160–61).

15. While we might from another angle be tempted to see Rufus as the medium of connection between the two white men, the relationship between Vivaldo and Eric is clearly instrumental, not determining, in the novel's plot. Rufus's death enables their union, but that bonding itself points back to him as the object of their common desire, not as the intermediary upon whose elimination they depend. While the model of the doubled triangle—Rufus and Vivaldo mediated on the one hand by Ida, on the other by Eric—suggests one way of understanding the novel's resolution of "impossible" interracial homosexuality, we will still want to be cautious of equating the mediating work done by the black woman with that of the gay white man.

16. It is particularly significant that Vivaldo constitutes the normative liberal subject, since he forms the subjective center of the novel—not only as the character who has the most to learn, but because he is identified with Baldwin's own artistic vocation. Well into the story's exposition, a reflexive passage about Vivaldo's novel-writing states:

> He did not seem to know enough about the people in his novel. They did not seem to trust him. They were all named, more or less, all more or less destined, the pattern he wished them to describe was clear to him. But it did not seem clear to them. . . . With the same agony, or greater, with which he attempted to seduce a woman, he was trying to seduce his people: he begged them to sur-render up to him their privacy. (111)

The sexual analogue to writing is seduction, and this passage promises that sexual revelations will coalesce with those of characterological subjectivity.

17. If the cufflinks symbolize the transformations from one social axis to another, they also suggest how inextricably interrelated these systems of difference are. Having introduced the third term, sexuality, to the race/gender dynamic, we can reexamine some of the scenes cited earlier, which now appear more complicated. Black characters' racial consciousness, for instance, sometimes obscures questions of sexuality, as in the scene in which Ida's understanding of the racial aspects of desire occludes the homo/hetero difference ("black boys *and* girls" [273]). Similarly, Rufus virtually equates his two lovers, even though one is female and the other male—for both, more importantly for him, are white southerners:

> When Eric was gone, Rufus . . . remembered only that Eric had loved him; as he now remembered that Leona had loved him. He had despised Eric's man-hood by treating him as a woman, by telling him how inferior he was to a woman, by treating him as nothing more than a hideous sexual deformity. But Leona had not been a deformity. And he had used against her the very epithets he had used against Eric, and in the very same way. (44)

Rufus's racial rage conceals the difference between heterosexual and homosexual relations, for in both cases he articulates this hostility in misogynistic terms. At other points, homosocial bonds subtend the movement whereby racial anger is transformed into misogyny. Thus, with the same gesture that they repudiate Jane's racial divisive-ness by castigating her in gender terms, Rufus and Vivaldo shore up the bond be-tween themselves: "Jane seemed to be exactly what she was, a monstrous slut, and she thus, without knowing it, kept Rufus and Vivaldo equal to one another" (36). Likewise, in giving racial violence a gender valence, the black musician who insults Ida invokes a homosocial bond with Rufus: "Because I loved that stud" (357). These additional complications testify to the insistence with which the novel interweaves the three axes and which the analysis of necessity has separated out.

18. Although Yves, plotted along the novel's most explicit binaries, is gay, white, and male, he nonetheless occupies a relation of alterity to Eric by virtue of both his foreignness and his lower-class origin. National and class axes of power, however, are far less operative in this novel than those of gender, race, and sexuality; Baldwin treats the former set of concerns more fully in the relation of the poor Italian, Giovanni, to the middle-class would-be straight American protagonist, David, in *Giovanni's Room*.

19. That Baldwin intends Eric's self-knowledge as a model for all oppressed people is made clear by his use of virtually the same phrasing in a description elsewhere of black consciousness: "To become a Negro man, let alone a Negro artist, one had to make oneself up as one went along" (*Nobody Knows,* 232).

20. Just as Baldwin analogizes racial difference to sexuality, allowing the latter to act as voice for the former, so Steven Epstein, in "Gay Politics, Ethnic Identity: The Limits of Social Constructionism," *Socialist Review,* 17 (May–August 1987): 9–54, convincingly demonstrates how contemporary gay politics is often organized around an ethnic identity model. While race and sexuality certainly exhibit similarities in both the novelistic and theoretical formulations, both Baldwin and Epstein fail to address adequately the question of people who simultaneously occupy both categories: Thus, Rufus drops out of the novel (and desire becomes either homosexual or interracial) and the gay "ethnic" person rarely appears in Epstein's article.

21. Hentoff, "Negro," 98. Elsewhere Baldwin states:

> One cannot understand where Negroes are today, without understanding twice as much about where white people are. . . . There is no Negro problem, there is a white folks problem. . . . The form and content of oppression are reflections of the fears and needs of the oppressor. To survive the oppressed must understand and use these. (Thelwell, "*Another Country,*" 197)

22. Norman Podhoretz, "In Defense of James Baldwin," originally published in *Show* magazine; reprinted in Podhoretz, *Doings and Undoings* (New York: Farrar, Straus, 1964), 244–50.

12
■
THE QUEER FRONTIER

Blake Allmendinger

IN AN ESSAY ON James Fenimore Cooper published in *Studies in Classic American Literature* (1923), D. H. Lawrence formally recognized a special love between men. Lawrence claimed that the friendship between Natty Bumppo and Chingachgook constituted a "new human relationship"—one that was "deeper than fatherhood, deeper than marriage," "deeper than the deeps of sex," as he enthused.[1] Beginning in the 1950s, Leslie A. Fiedler, who was indebted to Lawrence, wrote about the pervasiveness of male same-sex relationships in Western American literature. However, while seeming to celebrate the homosocial and homoerotic, Fiedler inadvertently revealed his own homophobia. By defining frontier alliances between white men and Indians such as Natty Bumppo and Chingachgook—between "civilization" and "savagery"—as "sexless and holy" relationships, Fiedler stigmatized unions that were not strictly celibate.[2] If platonic friendships were examples of "innocent homosexuality," as Fiedler maintained, then sexually consummated relationships must be guilt-ridden, impure, and debased by comparison.[3]

Fiedler claimed that the Western glorified pure, same-sex love.[4] For Fiedler though, "the West" was a loose term that signified any unsettled region existing outside society, and the Western was broadly identified as any work dealing with white men who fled from society and established interethnic frontier fraternities.[5] Hence, for Fiedler, the Western included nontraditional and nonregional works, such as Huckleberry Finn's adventures with Jim and Ernest Hemingway's short stories dealing with Indians, which were set in the South and in the northern Midwest, respectively.

Fiedler's definition of the Western is idiosyncratic, somewhat unconvincing, and vague, as definitions of the Western historically tend to be. Just as we argue today whether the West is a place or a process, a state of mind, or simply a misleading and imprecise term, so we continue to debate whether Westerns can be classified and judged according to a single formula. Films by John Ford; pulp fiction by Zane Grey and Louis L'Amour; heterogeneous works by Walter Van Tilburg Clark, E. L. Doctrow, and others—How can we identify what these Westerns all have in common?

The presence of male same-sex relationships may not serve as a litmus test, but these relationships occur more frequently, consistently, and explicitly in Westerns than they do elsewhere in literature. At the heart of most Westerns are male friendships and rivalries, both of which constitute complex love-hate relationships. The association between a white man, who represents "civilization," and a black man or American Indian, who represents "savagery," serves as the model for same-sex relationships. Occasional variations only reinforce this basic unchanging paradigm. Sometimes, for instance, a white man identifies with another white man who—by virtue of his comparison with the racialized and socially ostracized "other"—also represents "savagery." Together, the white man and his seducer, the outlaw, enjoy a same-sex relationship, a potentially dangerous transgressive love, outside the realms of society.

THE VIRGINIAN, one of the early prototypes of the Western and one of the best-selling novels of 1902, features two white men who adopt transgressive identities in the process of enacting a same-sex relationship. While one man becomes "black," at least metaphorically, the other one imagines himself as a woman attracted to the racial "other" and consumed by forbidden desire. As the novel begins, the narrator arrives in Wyoming to visit his old friend, Judge Henry, who owns a large cattle ranch. Judge Henry has sent one of his ranch hands, the Virginian, to meet the train at the station and to escort the narrator back to Sunk Creek. Stepping onto the platform, the narrator observes the Virginian teasing an elderly bachelor who has suddenly decided to marry. Mentally comparing the Virginian, a virile young man, with the bridegroom-to-be, the narrator comments, "Had I been the bride, I should have taken the giant."[6] In the cowboy's "face, in his step, in the whole man, there dominated a something potent to be felt, I should think, by man or woman," he reasons (6).

The bride in this scene becomes the unnamed narrator, whose anonymity throughout the text facilitates his shift in identity. Assuming the role of the cowboy's romantic companion, the narrator imagines himself in a hypothetical western marriage of males. Later, when the cowboy woos the schoolmarm and, on one occasion, shyly offers Molly a smile, the narrator claims that, "had I been a woman, [I would have let him] do what he pleased" (157). How could Molly resist such a seductive entreaty, he pleads with the audience? "I cannot tell you, having never (as I said before) been a woman myself" (160). Although he reminds the audience of his gender repeatedly, instead of soothing the reader's anxiety he disrupts the narrative—like Shakespeare's lady, by "protesting too much" and inserting an unnecessarily obvious parenthetical clause.

By moving from civilized eastern to primitive frontier society, the narrator trangresses boundaries and breaches social decorum, entering into a symbolic interracial, homoerotic relationship with another ostracized male. The enigmatic Virginian—the archetypal cowboy, the outcast, the loner—like the narrator, has no given birth name, no social identity, and only one physical attribute that the narrator comments on. His black hair (18) inspires a nickname that emphasizes the Virginian's uniqueness. "Who is that black man?" asks Molly, when the black-haired "stranger" appears at a dance sponsored by the local community (71). Even on the frontier, where men and

women live in isolation from established society, the "black man" exists in his own, separate sphere. Compared to other exiles, transplants, and emigrants, the Virginian seems different, and his difference seems suggestively savage, transgressive, demonic. Like other men, the narrator respects and fears the Virginian, a dangerous opponent who guns down his enemies. Like "other" women, however, the narrator finds himself attracted to the darkness that wards off his rivals. Acknowledging the Virginian's strange aura, which both alarms and seduces him, the narrator calls his "black" love the "devil" (21).

In Jack Schaefer's *Shane* (1949), the same-sex love object is just as effectively demonized. The Western hero, dressed in symbolic black, is an outcast like Cain, a roaming killer who strikes fear in the heart of Western communities. When the Starretts asks Shane to help them fight a cattleman who wants to seize their small farm for grazing land, the outlaw comes to the poor family's aid. In the process of defending the Starretts, the gunfighter inspires the son's undying worship, the father's grudging affection, and the wife's secret love. While saving the family, Shane almost destroys it, initiating a romantic rivalry.

In order to preserve the family, Shane denies his feelings for Marion and displaces his feelings for Joe. Promising to love her platonically, as he does Joe and Bob, Shane says to Marion: "Could I separate you in my mind and [still] be a man?"[7] Paradoxically, Shane must deny his heterosexual attraction to Marion in order to preserve his own code of manliness. Meanwhile, Schaefer considers, but finally refutes, the idea that the hero's friendship with Joe might be homosexual. In one scene, the men compete with each other to remove a stump from Joe's land. The stump simultaneously unites Shane and Joe, who join in the task of removing it, and separates the two men, who engage in a contest to see who can lift his end first. In the middle of the ordeal, Joe looks across the tree stump at Shane, as if there were "some unspoken thought between them that bothered him" (24), but at the end of the day, with the work now completed, the two men "looked up and their eyes met and held." Although the silence that greets them when they lay down their axes is both "clean and wholesome" (26), the sounds of grunting and "blowing" (25), the squatting and thrusting which the men perform audibly, and the "sucking" noise that the stump makes when it releases its roots from the soil (24), seemingly articulate something the two men can't say.

The bond between Shane and Joe is tested and strengthened by their mutual affection for Marion. The task of removing the stump merely redirects the men's sexual energy. When Marion comes outdoors to model a hat, she only briefly distracts the two laborers. "[S]top bothering us. Can't you see we're busy?" says Joe, who then goes back to work (20). The triangular relationship among the three characters generates what Eve Kosofsky Sedgwick has called "homosocial desire."[8] In the process of competing for Marion, Shane and Joe establish an erotic rivalry that binds them to each other as well as to the woman they love. Unlike the narrator in *The Virginian,* who imaginarily impersonates the woman whom the cowboy desires, Shane and Joe use Marion as a medium through which to channel their own same-sex love.

The mediating presence of women enables readers to interpret male same-sex relationships as manifestations of homosocial desire. In the absence of women, however, certain acts intervene, filtering male same-sex relationships and thus removing the tainted suggestion that these dangerous

friendships are sexual. Violent acts of disruption in Westerns always function cathartically, first dramatizing intimate, complex relations between heroes and villains and then climactically purging them, thus terminating relations that might have become homosexual by means of a deadly fistfight, shoot-out, or hanging.

In *The Virginian,* the hero hangs Steve for rustling Judge Henry's stock. After the hanging, which Steve endures silently, the Virginian breaks down and cries, overcome by remorse for having killed his best friend. "It was the first [sob] I had ever heard from him," the narrator writes. "I had no sooner touched him than he was utterly overcome. 'I knew Steve awful well,' he said" (250). This scene not only reveals that the hero has feelings for Steve; it suggests that the two men enjoyed an exclusive relationship. The reader learns that Steve called him "Jeff" (264), a name that no one else (not even Molly) knows. The Virginian's friendship with Steve—and his association with the narrator, who is privileged to hear the intimate confession that was intended for Steve—distinguish the Virginian's same-sex friendship from his relations with Molly, which never achieve a similar emotional expressiveness, passionate depth, or intensity.

The hanging precipitates—and also resolves—the crisis at the center of this same-sex relationship. Steve, the cattle rustler, is the cowboy's personal friend and at the same time his professional enemy. Forced to punish the criminal, the Virginian demonstrates how much he cares for Steve in the process of killing him. His sorrow over the death of his former companion enables the hero to finally confess the emotions that he could never acknowledge to Steve. The hanging, a retributive act of violence, leads to an indirect admission of love (addressed to the third-party narrator); at the same time, it makes the reciprocation of feeling between the lover and his love object no longer possible. The imposition of punishment—the lynching of a cowboy for having stolen a ranch owner's stock and the perceived justice of that act in a vigilante society—cancels out the hypothetical impropriety of the Virginian's affection for Steve. Sacrificing his best friend would seem to prove his emotional invulnerability. It suggests that the Virginian is "hard, isolate, stoic," like other mythic figures in American literature whom D. H. Lawrence identifies.[9]

In the case of Shane's fistfight with Chris, a violent crisis also leads to a subdued denouement. In a saloon brawl, the hero beats up one of the cattle-man's hands, who has attempted to terrorize the Starretts into leaving their land. After pummeling the cowboy into a state of unconsciousness, Shane lifts "the sprawling figure up in his arms." Carrying the body to one of the tables, he gently "set it down, the legs falling limp over the edge." Using a bar-tender's rag, he "tenderly cleared the blood from the face. He felt carefully along the broken arm and nodded to himself at what he felt" (61–62). Although Shane now feels compassion for Chris, the language used to describe that compassion also neuters the love-object. Shane lavishes care not on a man but on an ungendered object—on "it," not on Chris; on "the face," not on "his face." The words "he felt" begin and end the last sentence. But instead of lending emphasis, the repetition creates ambiguity. At first, Shane physically (clinically, unemotionally) "felt" Chris's arm, examining his oppo-nent for injuries. After touching the wounded man, however, Schaefer indi-

cates that Shane "felt" something else, either unexpressed sorrow or unspoken sympathy.

If Shane's emotional response to this violent encounter is controlled or subdued, his physical actions during the encounter are explicitly and erotically charged. After the fistfight with Chris, Shane wrestles three more of Fletcher's men. Choreographed as a perverse kind of foreplay, the match simulates castration and graphic acts of arousal. After kneeing one of Fletcher's men in the groin (71), Shane escapes the embrace of another man who "hugs" him too tightly (72), who engorges Shane, causing him to rise "straight and superb, the blood on his face bright like a badge" (74). At the end of the scene, Shane stands free and alone, erect with his gun cocked: "the man and the tool, a good man and a good tool," finally safe from assault (118).

One might expect Westerns to give audiences "masculine" heroes with whom to identify, since their audience comprises primarily heterosexual males. Instead, although they exhibit some "macho" tendencies, heroes are actually more dandified and effeminate than most other characters. The typical hero—a killer, an outcast, a loner—may exist on the outside, but in the process of protecting "civilization" from "savagery," he is often absorbed by society. The traditional villain, however, has an unregenerate status that codes him as "masculine." He is crude, ungroomed, and uncivilized, whereas the hero, in his role as protector or rescuer, possesses at least a rough sense of decorum and romantic chivalry. The Virginian, for example, decorates his hatband with flowers when he pays court to Molly (84). After observing that he wears a petunia in his hatband and grooms himself carefully (4), Marion asks Shane about the latest fashions in town. "You're the kind of man [who] would notice them" (11).

In spite of each man's refinement, no one questions the Virginian's or Shane's masculinity. Violence simultaneously consummates and terminates their same-sex relationships. At the same time, it confuses and clarifies their own sexuality. Victories over their enemies signify that the heroes are physically stronger than their seemingly more masculine foes. In the aftermath of their triumphs, however, the heroes also reveal themselves as delicate and emotionally sensitive characters.

EARLY WESTERNS, such as *The Virginian* and *Shane,* feature homosocial relationships that become erotically charged. More recent experimental works, in the process of straying from formula, explore the extent to which these relationships become overtly sexual. In these works, the hero's orientation, his relations with men, and his status in society are more complexly analyzed. Here, although the hero is often portrayed sympathetically, he is stigmatized by society because of his sexual activities or because of some equal "crime."

In the 1940s, Jean Genet began writing about similarities between homosexuals and criminals, noting that both groups of men are traditionally scorned by society. (The temporary sexual liaisons that homosexuals and criminals sometimes establish in prison only serve to express the deeper sense of alienation that the two groups share philosophically.)[10] Genet's theory—that gay men bear a criminal stigma, a liminal status in mainstream society—anticipates Leslie A. Fiedler's idea that men, if they consummate

same-sex relationships, are "guilty" of having committed improper acts. In the 1950s, when Fiedler's work first achieved prominence, artists began more frequently casting Western heroes as sexually ambiguous, socially marginal characters. Although heroes in the past had been portrayed as outsiders, they had often been romanticized because of their liminality and eventually reintegrated within their communities. Now they were permanently exiled, having broken certain sexual taboos.

Gore Vidal's teleplay, *The Death of Billy the Kid* (1955); the subsequent feature film, entitled *The Left-Handed Gun* (1958); James Leo Herlihy's novel, *Midnight Cowboy* (1965); and the film of the same name (1969) all depict their protagonists as male hustlers and/or repressed homosexuals.[11] *In Cold Blood* (1966), Truman Capote's best-seller, offers perhaps the most complex example during this period of "queer frontier" literature. *In Cold Blood* reconstructs the crimes of Perry Smith and Dick Hickock, two small-time convicts who become famous mass murderers. In 1959, while serving time for theft in the Kansas state prison, Dick learns that his cellmate once worked for a farmer named Clutter. When he hears that Clutter stores his money at home in an office safe, Dick imagines the secluded farm as the perfect site for a robbery. After his release, Dick contacts Perry, a former inmate now on parole, and the two men make plans. On the night of November 14, they break into the Clutter household, look in vain for the safe, slit Clutter's throat in frustration, and then kill his wife, son, and daughter. Three years later, Dick and Perry are tried and convicted of first-degree murder. On April 14, 1965, after three years of Supreme Court appeals, the men finally hang.

In Cold Blood echoes the Western in certain characteristic details. The Clutter farm is situated in westernmost Kansas, not far from Dodge City, where Wyatt Earp and Bat Masterson once sent men to their graves.[12] Curly and Dewey, the FBI agents who arrest Dick and Perry, are respectively known for being a quick "draw" and for rounding up cattle thieves.[13] Somewhat facetiously, Capote notes that the hangman who executes Dick and Perry wears a green cowboy hat (378, 380).

In addition to exploiting recognizable settings and leitmotifs, *In Cold Blood* resembles the Western, according to Leslie A. Fiedler, because it features an interracial, same-sex relationship.[14] However, the union between Dick, who is white, and Perry, who is half Cherokee Indian, is more "perverse" than the simple friendship between Natty Bumppo and Chingachgook. Despite protestations of innocence—"I'm a normal," Dick claims repeatedly (111, 128)—the ex-convict would rather rape Clutter's daughter than rob Clutter's home. Perry, a paranoid schizophrenic and repressed homosexual, also unconvincingly defends his normality. Referring to his time in the merchant marines, he says: "I wouldn't roll over," although "the queens wouldn't leave me alone" (156). Their sexual abnormalities and their criminal status as killers link Dick and Perry together in a same-sex union of miscreants.

Although they never have intercourse, the two men enjoy a relationship that appears homosexual.[15] Perry admires Dick because he seems "pragmatic," "practical," "masculine" (27, 57). "That Dick had been married— married twice—and had fathered three sons was something he envied. A wife, children—those were experiences 'a man ought to have'" (117). While Dick packs a gun, Perry strums a guitar and projects femininity. His tiny feet

belong in a "lady's dancing slippers" (26). His eyes, "with their moist, dreamy expression," seem "rather pretty" (189). His handwriting, with its "feminine flourishes" (169), and his tendency to lisp (202) with a darting "pink" tongue (254), cause women to question his manliness. Dick's mother tells an FBI agent that she always loathed Perry. "No, sir, I wouldn't have him in the house. One look and I saw what he was. With his perfume. And his oily hair. It was clear as day where Dick had met him," she says, condemning Perry for being an ex-convict and/or an effete homosexual (194).

Dick and Perry are equally stigmatized because of their criminal actions and "perverse" sexuality. Dick calls his coconspirator "honey," "baby," and "sugar" (26, 60, 106). By fatal coincidence, Clutter mistakes the two men for his wife when he hears noises downstairs. "Is that you, honey?" he says, echoing one of the terms of endearment that the two men bestow on each other (268). On their way to the Clutter farm, Dick and Perry behave like "two dudes" on a "date" (44). But their date with death results in a marriage between two hardened killers. (In the 1967 film adaptation, Dick jokes: "I'm the best friend you got." Perry: "'Til death do us part?" Dick: "All we need is the ring, sugar.")[16] After the killings, Dick forges checks in order to buy Perry clothes, telling the clerk at one men's store that Perry is about to get married and that Dick has agreed to pay for "what you might [call] his— ha-ha—trousseau" (115). At the small county courthouse, the two reenact their relationship (284). In the "men's" cell, Dick reads men's magazines. In the "women's" cell, Perry flips through *Good Housekeeping,* buffs his nails, and combs his "lotion-soaked" hair (286). While the cells divide Dick and Perry, the labeled compartments symbolically unite the two criminals, stereotyping the men as gendered partners in crime.

Although he was "aggressively heterosexual," Capote stated in interviews, Dick found himself attracted to Perry because of his friend's violent tendencies.[17] In the novel, a story that Perry narrates about having killed a black man named King persuades Dick that the two men would make great accomplices. King, who once lived with Perry in a Las Vegas boarding house, had done "roadwork and other outdoor stuff—he had a good build." Every time he passed by King's door, Perry saw the man lying naked in bed, reading "cowboy junk." Aroused by this exhibition in some dangerous way, Perry invited King to go for a drink with him. Instead, stopping his car in the desert, he says that he suddenly attacked King and left him on the roadside to die. "Maybe nobody ever found him. Just buzzards," he says somewhat boastfully (132). In the tradition of Westerns (or "cowboy junk," as Perry calls it derisively), the killing eliminates, not only King, but the threatening homosexual love object whom King represents. However, at the same time that the killing ends a complex connection with King, it initiates an even more problematic friendship with Dick. Perry lies about having killed King, as he later admits to authorities. By portraying himself as a cold-blooded, "masculine" criminal, Perry hoped to seduce Dick, he says (131).

However, events finally force Perry to prove he can kill. At the Clutter farm, although Dick picks up a knife, he hesitates to slit Clutter's throat. Perry grabs the knife and screams, "All right, Dick. Here goes." Explaining that "it was something between me and Dick," Perry says his threat was a test. "I meant to call his bluff, make him argue me out of it" (276). Instead,

realizing that the man he has idolized is afraid to kill Clutter, Perry also discovers that he, who has lied about having killed King, can prove himself by sacrificing four people now. In an "exclusive" interview, Dick later confessed that he felt the need to test his bravado:

> When I got into that house I was going to show who was boss. Although my partner had never said so I knew he was thinking I didn't have the guts to go through with it. . . . What would my partner think if I chickened out? These thoughts raced through my mind.[18]

Dick's manhood is challenged by his refusal to commit violent acts. In a reversal of roles, the "effeminate" Perry succeeds where the "macho" Dick fails. Perry now understands that, instead of being "pragmatic" and "virile," Dick is "pretty weak and shallow," "a coward" (292).

Analyzing the events at the Clutter farm, a doctor at the Menninger Clinic who specializes in forensic psychiatry, claimed that Clutter's death, the first murder, was the only one that mattered to Perry, at least psychologically (338). Clutter, an older man and an authority figure in Holcomb society, represented the father with whom Perry had shared a love-hate relationship. After the separation of his parents (a rodeo cowboy and a full-blooded Cherokee Indian), Perry had gone to live with his father. But when his father had threatened to shoot him one day, in the midst of an argument, Perry had abruptly left home (158). Eventually, the abused boy developed his father's quick temper. His temper, in turn, may have triggered his violent assault on the Clutters. "I thought [Clutter] was a very nice gentleman. . . . I thought so right up to the moment I cut his throat," Perry testified (275).

The murder, therefore, reconstructed while at the same time revising acts from his past. (The psychiatrist believed that Perry killed Clutter in order to reverse the fact that Perry's father once almost shot him.) In the same complex fashion, Perry uses violence both to distance himself from Dick and to draw himself more deeply into a love-hate relationship. By murdering Clutter, Perry hopes to shame Dick, calling attention to his ruthless audacity and Dick's false bravado. But instead of distinguishing them from each other, the murder and the subsequent killings make the two men accomplices. Regardless of who killed the family, the law holds both men responsible. The criminal acts link Dick to a cold-blooded murderer. Unable to escape his fate, which Perry has effectively sealed, Dick finds himself stuck with an unwanted "wife" (244).

BECAUSE OF THEIR DIFFERENCES, the white man and colored man, in the frontier tradition, represent two distinct worlds, racially coded as "civilization" and "savagery." Because of their same sex, however, these types also share similarities. Thus, Dick and Perry—as white man and half-breed, as man and "wife"—serve as two halves of one pair. As mirror images of each other, they reverse but reflect one identity. In their adjoining cells, Dick and Perry—different yet double, individual yet joined—seem like strange "Siamese twins" (355).

Narcissistic tendencies hint at their preference for same-sex relationships. "Every time you see a mirror you go into a trance. . . . Like you was

looking at some gorgeous piece of butt," Dick teases Perry (26). The repressed homosexual also gazes at "sweaty studies" of men in weight-lifting magazines (204). Capote suggests that this activity allows Perry to redirect his libido. Because Perry, the weight lifter, sees his own muscled form reflected in images, the magazines take on the same masturbatory function as soft-core pornography.[19]

After killing the Clutters, Dick and Perry escape and drive down to Mexico. In Acapulco, they spend time with Otto, a wealthy gay tourist, and his Mexican gigolo. Otto sketches Dick, while he lies in the nude, in exchange for money and favors that the host lavishes on his two new acquaintances (140). Like Perry, who identifies himself in the pages of weight-lifting magazines, Dick narcissistically transforms himself into a series of eroticized images. Replacing The Cowboy (as Otto nicknames the gigolo), Dick becomes a paid "cowboy" substitute, honoring his end of an unseemly transaction by striking a nude, "macho" pose.

Robert Warshow suggests that "a certain image of man" expresses itself in most Western films. Audiences like to see how a man looks "when he shoots or is shot. A hero is one who looks like a hero," Warshow contends.[20] In Westerns, heroes function, not as unique individuals, acting out their personal histories, but as archetypes, working out our shared mythic destiny. When we identify with heroes, we narcissistically project ourselves into those roles, doing so with some degree of self-consciousness. *In Cold Blood* observes Dick and Perry acting those parts, not so successfully, although just as self-consciously. Dick plays the "cowboy" while Perry flexes his muscles, gazing into the mirror to see if he looks like a "man." (Perry's screen persona, Robert Blake, reflects his counterpart's qualities. Blake interprets Perry as a sensitive psychopath, a variation on the misfits and rebels that James Dean and Marlon Brando made popular. Like Perry, Blake has Brando's squat legs and well-muscled torso, his soft skin, a curly forelock, and melting, dark eyes—all of which hint, more strongly than in the case of Brando, at a potential bisexuality.) If Dick and Perry were "gay," their assumptions of stereotypical heterosexual roles (their "voguing") might seem subversive or camp. But since Dick and Perry are "straight"—in their own minds, at least—their modeling represents a serious and sincere form of flattery. Dick and Perry aspire—and fail—to become icons of "pure" masculinity.

The friends both sport tattoos. Although these signs are intended to signify a man's masculinity, Capote believes that they actually camouflage a man's insecurity. After writing *In Cold Blood,* Capote said in an interview: "I have seldom met a murderer who wasn't tattooed. Of course, the reason is rather clear; most murderers are extremely weak men who are sexually undecided and quite frequently impotent."[21] Whether Capote's generalization is psychologically valid or not, his characterization of Dick and Perry supports his hypothesis. When Dick and Perry gaze into mirrors and view their tattoos (42, 26), it is unclear whether they see colorful scars that acknowledge their initiation into tough prison gangs or cosmetic ornaments that enhance them romantically. Dick and Perry reflect provocative, but ambiguous, images. They undermine, while attempting to reinforce, representations of "straight" sexuality. For instance, when Perry buys a pair of dark glasses, "fancy ones" with "mirrored lenses," Dick seems uncomfortable. He

feels embarrassed to be seen with someone who wears "that kind of flit stuff," he says. Clearly, when he looks in his friend's mirrored lenses, Dick sees himself unexpectedly (128–29).

While researching and writing *In Cold Blood,* Capote tried to suspend judgment and sympathy. But in spite of his later claims that he had kept himself "out of it," Capote grew fond of the two men over the course of six years.[22] Between 1959 and 1965, Capote interviewed the men hundreds of times and painstakingly studied their histories. The two men became "very good friends of mine (I mean . . . very close friends, very very close intimates in every conceivable way)," he conceded.[23] "It wasn't a question of my *liking* Dick and Perry. . . . That's like saying 'Do you like yourself?' What mattered was that I knew them, as well as I know myself," he maintained.[24]

Because the two men looked alike, in certain ways felt the same, and shared the same destiny, Capote identified with Perry especially. Both men were social misfits who had come from broken families and foster homes; both were superstitious, boyish, and short; both were artists (a writer and a would-be musician, respectively). Harper Lee—who came to interview subjects, take notes, and keep her friend Capote company—remembered the time at the county courthouse when Capote first noticed Perry's short legs. "Look, his feet don't touch the floor!" Capote exclaimed, as Perry sat patiently, waiting to be arraigned by the judge. Although Lee thought to herself, "This is the beginning of a great love affair," she later understood the relationship between Capote and Perry to be more complex. Each man "looked at the other and saw, or thought he saw, the man he might have been," explained Lee.[25] While Perry had the self-destructive criminal tendencies that Capote (the drug addict, the alcoholic) also exhibited, Capote represented the successful artist and practicing homosexual, whom Perry both aspired to be and feared he might one day become.

Sigmund Freud has argued that narcissism plays a role in determining certain same-sex relationships. According to Freud, a man who seeks other men may be yearning, on some deeper level, to embrace his own self-reflection.[26] Although Capote and Perry never consummated their relationship sexually, their bond certainly seemed homosexual. Their tendency to find themselves drawn to, and at the same time repulsed by, facets of themselves that they saw in each other gave the friendship an intense, self-absorbed quality.

Capote loved Perry and, at the same time, craved his demise. In choosing his title—a grim double entendre—Capote assumed that just as the two men had murdered the Clutters, in cold blood, so the law would execute them. But the Supreme Court appeals, which lasted three years, postponed the men's execution date. Eager to deliver the book to his publisher, Capote waited for Dick and Perry to die so he could write his conclusion. After the third appeal failed, Capote resisted the temptation to celebrate. He wrote to a friend: "I've been disappointed so many times I hardly dare hope. But keep your fingers crossed." When Dick and Perry tried to contact Capote to see if he could help them win a reprieve, the author refused to answer their telephone calls or respond to their messages. In the meantime, he outlined the book's ending, planning to fill in the details once the two men had hanged. "Hope this doesn't sound insane, . . . but the way I've constructed things, I

will be able to complete the entire manuscript within hours after [the execution]. Keep *everything* crossed."[27]

In the Western tradition, Perry's death, which was staged as a hanging, finalized the relationship between the outlaw/half-breed and his white male counterpart. Minutes before dying, in the courtyard at the Kansas state prison, Perry surprised Capote by asking to speak to him. In a farewell speech, he forgave Capote for not having answered his messages. "Good-bye. I love you and I always have," he said lispingly. Capote remembered the scene in an interview. "I was standing there at the foot of the gallows. There were about fifty people surrounding me. They couldn't hear what he said to me because he was whispering. I was very upset." "I didn't love [Dick or Perry], but I had a great understanding for both of them, and for Perry I had a tremendous amount of sympathy," he said, qualifying his feelings in retrospect.[28]

The friendship between Capote (the representative of "civilization") and Perry (the unredeemed "savage") resembles other same-sex relationships in frontier American literature. At the same time, it suggests a correspondence between homosexuality and criminality, which exists outside as well as within the Western tradition. Capote, the self-destructive gay writer, and Perry, the convicted mass murderer, share their "guilty" love secretly, in an intimate moment, in a whispered confession that prison officials and public spectators cannot hear. This episode reenacts a familiar Western scenario. Here, as in *The Virginian,* violence acts as a catalyst, forcing the victim to realize that he loves his own executioner. At the same time, the executioner, who loves his victim but will not save his life, belatedly expresses his feelings by mourning the absent beloved. Before the hanging, Capote restrains himself as Perry confesses his love. ("I spent the entire two days before the execution throwing up . . . but somehow when the time came I got myself together and went there and spoke to [him].")[29] After the hanging, however, the stoic who passively willed Perry's death now feels implicated, guilty, regretful. Perry's death, for which Capote feels partly responsible, causes the author to mourn and do penance. At the height of his success, after publishing *In Cold Blood,* the writer begins to act self-destructively, turning more frequently to narcotics and alcohol. Capote the narcissist, having eliminated his love object, tries to kill himself too. "It really killed me. I think, in a way, it *did* kill me," he said in an interview, explaining how the emotional crisis exhausted him.[30]

While it is true that Westerns privilege male friendships and rivalries, minimizing the roles played by female characters, Westerns also restrict men by qualifying the nature of their same-sex relationships. Leslie A. Fiedler and Jane Tompkins suggest that men escape to the wilderness in order to free themselves from the civilizing influence of women.[31] Seeking out each other's company, men form alternative relationships outside the bounds of society. However, although they have complex interactions, men cannot express themselves sexually. If they coupled, their same-sex domestic partnerships would resemble the civilized unions with women—the "marriages"—that they seek to avoid.

Westerns, which are concerned almost exclusively with the actions and feelings of men, by definition possess homosocial and homoerotic components. Actual homosexual behavior, however, appears only in Western send-ups and parodies. Members of the singing Village People perform as

cowboys and Indians. In leather bars, men wear Western clothes, enacting self-conscious fantasies. The Waco Kid and his black male lover ride into the sunset at the end of *Blazing Saddles* (1974), a Western film farce. An artist covers John Wayne's mouth with red lipstick and produces "camp" art.

Capote never acknowledged having borrowed from Westerns in order to create an artistic hybrid. Having claimed that *In Cold Blood* was the first nonfiction novel, Capote was forced to deny his indebtedness to other genres in American literature. In private life, however, he demonstrated an awareness of Westerns, one which was informed by his sly sense of humor. Near the end of his life, having concluded a love affair, Capote entered Roosevelt Hospital. Although depressed, and addicted to narcotics and alcohol, he still had his razor-sharp wit. Because he dreaded publicity, Capote adopted a pseudonym. Recalling the friendship between Theodore Roosevelt and a certain renowned Western artist and acknowledging that he had come here after ending a same-sex affair, Capote facetiously signed Owen Wister's name in the register. (The doctor attending him, thinking that Capote had written *The Virginian*, innocently asked for his autograph.)[32]

In Cold Blood has more in common with Westerns than the author's superficial acquaintance with Wister might indicate. Separately and together, as members of a same-sex relationship, Dick and Perry resemble mythic archetypes in frontier American literature. (Like other members of their generation, however, Dick and Perry are decidedly antiheroic, thus resembling actors James Dean and Sal Mineo more than Natty Bumppo and Chingachgook.) The book's resemblance to Westerns, rather than its uniqueness as a nonfiction novel—its familiarity, rather than its bizarre topicality—partly explains why *In Cold Blood* remains enormously popular. At the same time, however, *In Cold Blood* flirts with Western conventions. With a text that acknowledges a homoerotic friendship between two hardened criminals, and a subtext that reveals a narcissistic attraction between the author and one of his characters, *In Cold Blood* explores male homosexuality more boldly than any previous Western-themed literature.

Notes

1. Lawrence, *Studies in Classic American Literature* (rpt.; Harmondsworth, U.K.: Penguin, 1983), 59.

2. Fiedler, *Love and Death in the American Novel* (New York: Criterion, 1960), 210. See also Fiedler, "Come Back to the Raft Ag'in, Huck Honey!" (1955), in which Fiedler defines male same-sex relationships in nineteenth-century American literature as examples of "chaste male love" (in *The Collected Essays of Leslie Fiedler*, vol. 1 [New York: Stein and Day, 1971], 144).

3. Fiedler, *Love and Death in the American Novel*, 539.

4. Ibid. Fiedler also uses the term "Western" to describe this literary phenomenon in *The Return of the Vanishing American* (rpt.; New York: Stein and Day, 1969), 21, 24.

5. Fiedler, *Love and Death in the American Novel*, 210.

6. Wister, *The Virginian* (rpt.; New York: Signet, 1979), 3. Subsequent references to this edition appear in the text.

7. Schaefer, *Shane* (rpt.; New York: Bantam, 1983), 104. Subsequent references to this edition appear in the text.

8. Sedgwick, *Between Men: English Literature and Male Homosocial Desire* (New York: Columbia University Press, 1985), 21.

9. Lawrence, *Studies in Classic American Literature,* 68.

10. The comparison of homosexuals with criminals occurs throughout Jean Genet's literature. See, for example, Genet, *The Thief's Journal,* trans. Bernard Frechtman (rpt.; New York: Grove, 1964), 9–10, 149, 171, 243. See also Edmund White's biography, *Genet* (London: Chatto and Windus, 1993), 38, 197–99, 291.

11. For an interpretation of Billy the Kid as a "repressed homosexual," see Stephen Tatum, *Inventing Billy the Kid: Visions of the Outlaw in America, 1881–1981* (rpt.; Albuquerque: University of New Mexico Press, 1985), 139.

12. Gerald Clarke, *Capote: A Biography* (New York: Simon and Schuster, 1988), 320.

13. Capote, *In Cold Blood* (rpt.; New York: Signet, 1980), 102, 382. Subsequent references to this edition appear in the text.

14. Fiedler, *The Return of the Vanishing American,* 14.

15. In an interview, Capote later clarified that "there was no homosexual relationship between Hickock and Smith; Perry once had an affair with a man and had definite homosexual fixations, but he had nothing to do with Hickock; they were completely frank about such matters and would have told me like a shot." (See Eric Norden, "Playboy Interview: Truman Capote," *Playboy,* 15 [March 1968]; reprinted in M. Thomas Inge, ed., *Truman Capote: Conversations* [Jackson: University Press of Mississippi, 1987], 130).

16. In *Cold Blood,* dir. Richard Brooks, with Robert Blake and Scott Wilson (Columbia, 1967).

17. George Plimpton, "The Story behind a Nonfiction Novel," *New York Times Book Review,* (16 January 1966; reprinted in Inge, ed., *Truman Capote,* 60.

18. Richard Eugene Hickock, as told to Mack Nations, "America's Worst Crime in Twenty Years," *Male,* December 1961; reprinted in Irving Malin, ed., *Truman Capote's "In Cold Blood": A Critical Handbook* (Belmont, Calif.: Wadsworth, 1968), 10.

19. For an analysis of weight-lifting as a means of deflecting and redirecting male homosexual tendencies, see Mark Simpson, *Male Impersonators: Men Performing Masculinity* (London: Cassell, 1994), 32.

20. Warshow, "Movie Chronicle: The Western," in Jack Nachbar, ed., *Focus on the Western* (Englewood Cliffs, N.J.: Prentice-Hall, 1974), 56.

21. Norden, "Playboy Interview," 131. In another interview, Capote said: "Most people who are tattooed, it's a sign of some feeling of inferiority, they're trying to establish some macho identification for themselves." (See Lawrence Grobel, *Conversations with Capote* [New York: Plume, 1985], 126).

22. Capote, "Preface," in *Music for Chameleons* (rpt.; New York: Signet, 1981), xviii. See also Grobel, *Conversations with Capote,* 116.

23. Haskell Frankel, "The Author," *Saturday Review* 49 (22 January 1966); reprinted in Inge, ed., *Truman Capote,* 71.

24. Jane Howard, "How the 'Smart Rascal' Brought It Off," *Life,* (18 February 1966; reprinted in William L. Nance, *The Worlds of Truman Capote* (New York: Stein and Day, 1970), 72.

25. As quoted in Clarke, *Capote,* 326.

26. It is not my intention to explore or debate Freud's ideas in this essay. On the relationship between male homosexuality and narcissism, see Sigmund Freud, "The Sexual Aberrations" (1905), in James Strachey, trans. and ed., *Three Essays on the Theory of Sexuality* (rpt.; New York: Basic Books, 1962), 11 n, 12 n; Freud, "On Narcissism: An Introduction" (1914) and "Instincts and Their Vicissitudes" (1915), in James Strachey, trans., *The Standard Edition of the Complete Psychological Works of Sigmund Freud,* vol. 14 (rpt.; London: Hogarth, 1957).

27. As quoted in Clarke, *Capote,* 352–55.

28. As quoted in Grobel, *Conversations with Capote,* 118.

29. Shana Alexander, "A Nonfictional Visit with Truman Capote," *Life,* (18 February 1966); reprinted in Kenneth T. Reed, *Truman Capote* (Boston: Twayne, 1981), 103.

30. As quoted in Clarke, *Capote,* 398.

31. Fiedler, *Love and Death in the American Novel,* 210; Jane Tompkins, *West of Everything: The Inner Life of Westerns* (New York: Oxford University Press, 1992), 66.

32. Jack Dunphy, *"Dear Genius . . .": A Memoir of My Life with Truman Capote* (New York: McGraw-Hill, 1987), 25.

236
∎
Blake
Allmendinger

13

■

PRODUCING IDENTITY
From *The Boys in the Band* to Gay Liberation

William Scroggie

Stonewall

For many gay men and lesbians, Stonewall has taken on mythic stature. The Stonewall Inn riots of June 1969 have come to signify the birth of gay liberation, the moment when homosexuals began to fight for their rights and come out of the closet. In our common sense of "gay history," Stonewall has become invested with meaning. For many gay historians, it represents a key shift, what John D'Emilio calls "a historic rupture" (107). After Stonewall, we are told, the "New Homosexual was born" (Teal 24). From one contemporary vantage point, Stonewall marks the emergence of gay identity.[1]

To what extent do we see a "new" homosexual subject at this time? I propose that this period marks a rupture in the signification of homosexuality. Instead of tracing this to the Stonewall riots as a specific historical "event," I consider "Stonewall" as just one text within a larger cultural rupture. Rather than seeing gay identity as something "suppressed" before Stonewall, and thus liberated by the riots and the political movement that followed it, I see gay identity as semiotically produced in this period. The Stonewall period is important because it is a moment of rupture in the discourse of homosexuality that allowed for "new" representations of homosexuality within the culture. This is not to say that the production of gay identity as a "new" representation of homosexuality should be understood as liberatory, despite the political functions it has served. Gay identity is merely another way of representing homosexuality.

From 1968 through 1972, the signification of homosexuality shifted rapidly. The critical reception of Mart Crowley's *The Boys in the Band* provides a particularly compelling example of this phenomenon. When Crowley's play opened in New York in spring 1968, it was immediately hailed as a breakthrough in the representation of homosexuality. *New York Times* theater critic Clive Barnes said, "The play is by far the frankest treatment of homosexuality I have ever seen on the stage. . . . [It] takes the homosexual milieu, and the homosexual way of life, totally for granted and uses this as a valid basis for human experience" (48). Writing in February 1969 for the *Los Angeles*

Advocate (later the *Advocate*), Mel Holt said the play "strips away the facade, revealing the core of man's nature" (3).

The rave reviews did not last long. In 1971, gay liberationist Dennis Altman called *The Boys in the Band* "Crowley's portrait of unredeemed misery," and complained that not all homosexuals were "corrupted by self-hate" (36). In 1972, another gay liberationist, Peter Fisher, provided a similar critique. Noting the original reception, he wrote, "*The Boys in the Band* was seen as a breakthrough by many people, but it presents a stereotypical picture of unhappy people unable to come to terms with themselves" (203). In the years since, many critics have been equally dismissive of both the play and subsequent 1970 film.[2] For example, in a recent essay, Joe Carrithers complains that "Gay viewers may search for a positive depiction of their lives, the diversity of their lives, but that search will be in vain" (65).[3]

The play and movie's critical reception testifies to the shifts that have occurred in the signification of homosexuality and the possibilities for representation. Thus, I would argue that the critical "bashing" of the play and film are due to a shift in the cultural signification of homosexuality and changing expectations/demands for its representation. As a critical strategy, analyzing whether or not *Boys* represents positive images of homosexuals is not only disingenuous but misdirected, for it ignores the text's importance. It is my contention that once we get away from positive/negative considerations, we can see how *Boys,* like other texts from this period, participates in producing new representations of homosexuality that lead toward our contemporary common sense of identity.

To this end, this essay examines the representation of homosexuality in the Stonewall period with the goal, not of passing some kind of political judgment, but, I hope, of providing new insights into the changing discursive constructions of homosexuality—from theories that represent homosexuality as pathological to humanist notions of homosexuality as defining the self and then to social constructionist theories that destabilize sexual categories. In the texts that I examine contradictions emerge that point to the competing constructions of homosexuality that have structured the ways in which it is understood in our society. At the same time, we can see the continual development of an identity discourse and a reliance on its fundamental presuppositions, namely, that homosexuality defines subjects and that it can be the basis around which these subjects structure their lives.

Challenging Pathology

One of the most significant shifts that occurred in the signification of homosexuality in the late 1960s was the rejection of its association with pathology. Throughout much of the 1950s and 1960s, the prevailing opinion of the medical establishment, and certainly the field of psychoanalysis, was that homosexuality was a developmental maladjustment or illness.[4] As of 1962, the pathological theory of homosexuality was so commonly held by psychoanalysts that one leading proponent, Irving Beiber, was able to state unequivocally: All *psychoanalytic* theories assume that adult homosexuality is psychopathologic and assign differing weights to constitutional and experiential determinants. All agree that the experiential determinants are in the main rooted in childhood and are primarily related to the family" (18).

However, the challenge to psychoanalysts like Bieber began to be mounted with increasing frequency by the late 1960s, particularly by sociologists.[5] In her 1968 essay, "The Homosexual Role," sociologist Mary McIntosh argues for an understanding of homosexuality outside of psychoanalytic models which position it as a developmental maladjustment or illness. She wants sociologists to see "homosexuals as a social category, rather than a medical or psychiatric one" (192). As part of her critique of psychiatric understandings, McIntosh questions the efficacy of attempting to locate the causes of homosexuality and argues that too much of the examination of homosexuality has been in the "study of its etiology" (183). She claims that this interest reflects the assumption that homosexuality is a developmental abnormality and demonstrates the extent to which "psychologists and psychiatrists have been involved as diagnostic agents in the process of social labelling" (184).

McIntosh, in an early constructionist argument, reconfigures the prevailing understandings of homosexuality by representing it as "social role" rather than a "condition" (189). By defining homosexuality as a role, McIntosh allows for an articulation of the homosexual as a social subject who can be represented outside of a medical discourse. She shifts the focus away from the psyche of the subject and back onto society, allowing homosexuality to be theorized in new ways and according to a different logic. Her argument anticipates later theories that understand homosexuality as "a social concept disguised as a biological phenomenon" (Beaver 101).

McIntosh's essay also anticipates the way in which homosexuality would be discussed by the gay liberationists of the early 1970s. Like these liberationists, she critiques the culture's rigid binary classification of heterosexual/homosexual. According to McIntosh, homosexual difference, rather than reflecting real difference in sexual behavior, is largely the result of social pressures to classify people as belonging to distinct types, which results in these types becoming "polarized, highly differentiated from each other" (184). Although McIntosh does not develop any political critique of such a process, her argument is inherently a social critique. The implications of McIntosh's critique are destabilizing, for, according to her logic, if homosexuality is a social role then so is heterosexuality, and both are unstable and changeable.

Despite the fact that McIntosh does not argue for an understanding of homosexuality as an identity, her essay does reveal the pressure that a discourse of identity was beginning to exert on the discourse of pathology in this period. In fact, her argument could be called a reaction to the construction of homosexuality as both a pathology and as an identity. This is apparent in her critique of what she calls the commonly held notion that homosexuality is a "condition characterizing certain persons" (182). Her use of the word "condition" is noticeably unstable in the essay. While it points to a psychological condition on the one hand, it is also said to characterize persons "in the way that birthplace or deformity might" (182). Further, she claims that there exists a belief that there are two kinds of people in the world: homosexuals and heterosexuals" (182). McIntosh's various definitions of "condition" are revealing precisely because from our vantage point they seem contradictory. To characterize by birthplace is far from the same as characterizing by a deformity. Similarly, to say that there are two kinds of

people is far different from saying that there are people with healthy sexuality and people with unhealthy sexuality. These various definitions reveal competing understandings of homosexuality. Her examples of birthplace and of "two kinds of people" hint at a paradigm of identity, while "deformity" suggests pathology and a very different psychological paradigm. Although McIntosh does not advance a theory of identity, she recognizes its growing currency and indirectly opens a space for it since once homosexuality begins to be represented outside of a medical/psychiatric discourse, a "new" kind of social subjectivity is possible.

Like McIntosh, social psychiatrist Martin Hoffman reconfigures the signification of homosexuality. Hoffman's three-year sociological study of homosexual men in San Francisco (1965–1968), *The Gay World: Male Homosexuality and the Social Creation of Evil,* is an attempt to "know" the homosexual. The result is a narrative of homosexuality that is deeply contradictory. On the one hand, he relies on old scripts, which construct a pathological subject, while on the other, he writes a narrative with a new, social subject at odds with the old. Here, old constructions are apparent in his reliance on developmental theories of homosexuality that represent it as an abnormality, whereas new constructions are seen in his deployment of an identity paradigm.

The Gay World produces a paradigm of identity in several ways. First, by rejecting pathological theories (albeit inconsistently), Hoffman's book leaves a space for a social identity. For Hoffman, pathological theories of homosexuality reflect social values. As he says, "if homosexuality is considered a pathology it is because it is discouraged" (133). Hoffman recognizes that constructions of homosexuality are culturally determined. The assumed "normalcy" of heterosexuality is "because heterosexuality is encouraged and because homosexual behavior is discouraged" (133). Hoffman does not take for granted that homosexuality is a mental illness and critiques those psychoanalysts of the 1960s who began with this assumption.

Hoffman's "definition" of homosexuality also leaves room for the representation of a new kind of homosexual identity. By defining homosexuality as a "sexual object choice," Hoffman sets up a seemingly neutral signification. For Hoffman, all sexuality is learned. As he says, "People learn sexual behavior just as they learn any other form of complex activity" (37). He believes that the child begins life with an undifferentiated sexual potential" (123) and "sexual object choice" is the result of a "subtle interaction which goes on between the child and significant persons in his environment" (124). On one level, Hoffman attaches no value judgment to sexuality—both homosexuality and heterosexuality are understood as learned behaviors, and both are possible paths of sexual development. The narrative of sexual development is not preordained and Hoffman suggests that homosexuality is not necessarily an aberration.

The strategy of *The Gay World,* particularly its reliance on individual "profiles" and its description of a "gayworld," represents homosexuals as a particular community with a discreet lifestyle. Hoffman describes the gay bars, baths, sections of beaches, parties, and circles of acquaintances that structure the lives of the homosexual men he "studied." Although he condemns the "lifestyles" of many of the men he discusses, he nonetheless represents a homosexual identity. Like McIntosh, he describes a social identity in that it is shaped by the larger culture and is susceptible to change.

The representation of homosexuality as a social identity is most clearly invoked when Hoffman argues that homosexuals are an oppressed minority. By the end of his book, he writes that one can view "the homosexual community as a minority group subject to the same kinds of problems which other minority groups experience" (190). Thus, the problems of the gay world are explained as a result of the oppression of this minority. By this logic, homosexuals are persecuted because of their identity, just as women or African-Americans might be. The prescription for the end to the "pathology" of the gay world is to "view homosexuals as a minority group, and begin to seriously consider giving them full legal rights and social privileges" (200). To the extent that Hoffman represents homosexuals as members of a minority, he takes homosexuality out of the realms of behavior and psychological condition.

However, the representation of a "new" homosexual identity in Hoffman's book still bears traces of the "old" pathological constructions. His insistence on understanding the causes of homosexuality creates a narrative of etiology at odds with his nonpathological narrative. Hoffman devotes an entire chapter to an investigation of psychological and developmental explanations for homosexual behavior, setting out a number of possible "scripts" for its development, from sibling rivalry to castration anxiety. These narratives serve to reinscribe homosexuality within a medical discourse which understands it as "abnormal."

The contradictions in Hoffman's text again surface in his definition of homosexuality. Is it a behavior or a category of person? At the same time that homosexuality is described as a learned behavior, a sexual object choice, and a "variation in the sexual impulse" (201), Hoffman says that the word "homosexual" describes "individuals, not just acts" (31). Although Hoffman does not believe that sexual orientation (as he sometimes calls it) is innate, he does speak specifically of a homosexual identity. Unlike the heterosexual, he argues, the homosexual can "define himself as a homosexual and can make this identity the center of his own self-concept and of his behavior" (153). Further, this identity ties him to a community of homosexuals "who will have something in common with him which is real and very intrinsic to their own being" (153). Exactly what this "real and very intrinsic" something is remains a bit unclear. Still, Hoffman here constructs homosexuality as an identity around which a life can be structured.

Hoffman's text produces a series of tensions. He represents homosexuality as a social identity at the same time as he attempts to explain its etiology according to psychoanalytic models, which, historically, have been used to explain it as abnormal sexual development. In an attempt to reconcile this apparent contradiction, he shifts the "diagnosis" from homosexuality as pathological to the gay world as pathological. Although this shift is important in that it opens a space for new representations of homosexuals that are not necessarily pathologic, it nevertheless indicates that there is something "wrong" with the behavior of homosexuals. In a similar way, his representation of homosexuals as a minority is at odds with his investigation of the etiology of homosexuality. It is hard to imagine him investigating the etiology of race or gender in the same way that he does homosexuality. His attempt to answer why subjects are homosexual serves to undercut their status as a legitimate minority group. Hoffman is not unaware of the dilemmas in his text

and the competing discourse of homosexuality in the culture. As he acknowledges at one point: "To describe homosexuality as morally evil is unfashionable. And yet the alternative, considering it as a legitimate way of life for some people, is simply not palatable to very many. Hence, the popularity of the disease concept" (196).

Identity Effects

Mart Crowley's, *The Boys in the Band,* a drama about seven homosexual friends who gather for a birthday party, could be said to ask the question, Who is the homosexual? The play answers this question by representing homosexuality as a "personal" identity within a humanistic discourse of "the self." This representation is a significant development in that homosexuality is understood as defining "who the characters are." However, the text's representation of this personal identity remains tied to pathological constructions, particularly in its emphasis on developmental psychology and inferiority. The play positions homosexuality as a problem of "coming to terms with the self" and puts forward a rather conventional narrative of self-discovery. This narrative fails to resolve the "problem" of homosexuality, and is repeatedly complicated and undercut by the simultaneous representation of homosexuality as more than a personal issue. In many ways, the discourse of *The Boys in the Band* can be considered as transitional to the extent that it draws on both pathological theories and the later gay liberationist discourse which understands homosexuality in political and social terms. The result is a decidedly conflicted representation. Unable to contain the signification of homosexuality within the discourse of the personal, the text cannot satisfactorily resolve its "coming to terms" narratives, nor represent homosexual identity without grappling with the ways in which it is socially constructed. The play's representation of homosexuality provides the terms of its own deconstruction.

As part of its attempt to "know" the homosexual, *Boys* looks for the causes and origins of homosexuality and attempts to construct an explanatory narrative. Like other texts from the late 1960s, *Boys* explores the etiology of homosexuality. In so doing, it relies on developmental narratives which represent homosexuality as an abnormality. None of the characters in the text can construct a self-concept devoid of pathology. Despite this, the deployment of psychoanalytic theories of homosexuality is noticeably ambivalent. The play reveals the instability of these theories at the same time as it invokes them. The developmental "story" is put forward, while the text allows for the possibility of its deconstruction.

Beginning with the opening scene, the play positions homosexuality within a medical discourse. In the play's second line, Donald tells Michael, "The doctor canceled!" (7), indicating that Donald suffers from a "condition" warranting medical attention. In their subsequent conversation, both Donald and Michael reveal that they are in analysis due to problems which seem to be related to their sexuality. Donald informs Michael that he is depressed and that even after much analysis, he's "not that well yet" (8). As he begins to elaborate on what he has learned from his analysis, he provides a developmental profile that sounds very much like those which position homosexuality as a developmental maladjustment. He tells Michael:

Naturally, it all goes back to Evelyn and Walt. . . . I've realized it was always when I failed that Evelyn loved me the most—because it displeased Walt, who wanted perfection. And when I fell short of the mark she was only too happy to make up for it with her love. So I began to identify failing with winning my mother's love. And I began to fail on purpose to get it. (12–13)

Although Donald does not specifically link his homosexuality to his childhood, he does provide an explanation of his development which emphasizes closeness to the mother and a distance from the father—classic components of psychoanalytic explanations of a homosexual boy's development. For example, in Hoffman's recounting of psychoanalyst Irving Bieber's theory of the causes of homosexuality, we see parallels with Donald's explanation:

> Beiber's characteristic homosexual-producing mother is over-close and over-intimate with her son. She is very much afraid of losing the son and thus is possessive, and this possessiveness results in a kind of demasculinization of him. She favors that son who is later to become a homosexual over her other children and often over the husband as well, and encourages an alliance with him against the father, so that the son is alienated from masculine identification. . . . The son develops a submissiveness and a tendency to worry about displeasing his mother. (Hoffman 148)

Michael's childhood story is even more strikingly in line with the prevailing psychoanalytic theories of male homosexuality. He tells Donald:

> my Evelyn refused to let me grow up. She was determined to keep me a child forever and she did one helluva job of it. And my Walt stood by and let her do it. . . . She made me into a girl-friend dash lover. . . . *And Walt let this happen.* . . . I can't tell you the thousands of times she said to me, "I declare, Michael, you should have been a girl." And I guess I should have—I was frail and pale and bleached and curled and bedded down with hot-water bottles and my dolls and my paper dolls. . . . She bathed me in the same tub with her until I grew too big for the two of us to fit. She made me sleep in the same bed with her until I was fourteen years old. (16–17)

According to Michael's narrative, the "cause" of his homosexuality can be traced to his developmental history. As a result of his dysfunctional upbringing, he is, in his own words, a "goddamn cripple" (17), a phrase that clearly situates him within a medical discourse. The play, then, provides an explanation of the etiology of homosexuality that configures it as a neurosis resulting from childhood experiences. Like Donald's account, Michael's narrative "fits" Bieber's theory—and even corresponds in one additional way: "often the sleeping arrangements are atypical and the son and mother sleep together until well into adolescence" (Hoffman 148)).

These developmental narratives, however, are far from stable within the text. We are left to wonder how much credence we are to give Michael

and Donald's own understandings of their homosexuality. At the same time as the play offers their explanations, it suggests that these narratives do not provide any real "truth." Donald's assertion, "Naturally, it all goes back to Evelyn and Walt," emphasizes that this type of explanation has become clichéd by the time of the play. Michael's reply, "Naturally. When doesn't it go back to Mom and Pop. Unfortunately, we all had an Evelyn and Walt" (12), casts further doubt on how seriously we are to take this explanation since everyone could be said to be a product of their childhood development. Both Michael and Donald recognize that blaming the parents is a bit too easy. As Michael says, "Christ, how sick analysts must get of hearing how mommy and daddy made their darlin' into a fairy" (13). Michael does blame his parents, and he ultimately gives a long speech doing just this. However, he concludes this speech with a qualification: "I know it's easy to cop out and blame Evelyn and Walt and say it was *their* fault. That we were simply the helpless put-upon victims. But in the end, we are responsible for ourselves" (17). What are we to make of this? Both characters cast doubt on the easiness of psychoanalytic explanations, but they lack any way to explain the origins of homosexuality that does not understand it as a pathology. The conclusion of their conversation once again undercuts these explanations, trivializing their psychoanalytic discussion. After both Donald and Michael's long speeches, the play reverts back to a camp tone as Michael announces in a Bette Davis voice, "I adore cheap sentiment" (18), suggesting that Donald and Michael haven't really discovered or revealed anything in their discussion. The need to know the etiology of homosexuality cannot be satisfactorily answered by either the characters or the text.

If the signification of homosexuality cannot be contained with a pathological discourse, what other options does the play suggest? One possibility the play offers is that homosexuality is an identity. Clearly, homosexuality defines subjects in the play. It is crucial to the characters' self-concepts and their concepts of each other. Just as the opening discussion between Michael and Donald introduces a pathological discourse, it simultaneously introduces a discourse of identity. Within the opening moments of the play, the characters' homosexuality is repeatedly reiterated. For example, Donald teases Michael, saying, "you're the type that gives faggots a bad name," while claiming, "I am a model fairy" (15). In a more serious assertion later in the play, Harold arrives at Michael's home and announces, "What I am, Michael, is a thirty-two-year old, ugly, pock-marked Jew fairy" (63). Noticeably, "fairy" is the key defining noun here, taking precedence over all of Harold's other self-description. Homosexuality more than describes a characteristic of the characters, it is equated with a "truth" about them. We see this rather clearly in Hank's explanation of his relationship with his ex-wife and his present lover, Larry. Hank says, "I really and truly felt that I was in love with my wife when I married her. It wasn't altogether my trying to prove something to myself. I did love her and she loved me. But . . . there was always that something there" (110). He adds, "And then there was a time when I just couldn't lie to myself any more" (110). In the play, homosexuality is understood as intrinsic to who the characters are. As Emory says, "I've known what I was since I was four years old" (110).

In the terms of the play, homosexual identity is something that is "there," waiting to be discovered and come to terms with. This discovery is a

central concern of the text. For example, Michael's former college roommate, Justin, is said to have "eventually found out who he was and what he was": a homosexual (122). The play's "mystery"—whether Michael's college friend, Alan, is a closet homosexual—drives the final action and reinforces an understanding of homosexuality in terms of identity. Michael reads (or perhaps misreads) Alan's emotional breakdown on the phone and reluctance to leave the party as signs of Alan's "true" identity. As he presses Alan to reveal himself, he goads him, saying: "He knows very, very well what a closet queen is. Don't you, Alan?" (120). Michael accuses Alan of being unable to "face the truth about [himself]" (122), but Alan denies the charge and seemingly "proves" his heterosexuality by calling his wife and telling her that he loves her. Whether or not Alan is a "closet queen" remains unclear, but the mystery emphasizes the need to know and define. If the play resists knowledge of Alan's sexual identity, it does not hedge about Michael's. In one of the play's least ambivalent speeches, Harold tells Michael, "You are a sad and pathetic man. You're homosexual and you don't want to be . . . but you always will be homosexual. . . . Until the day you die" (125). According to this speech, then, homosexuality is a "truth" that cannot be resisted by the subject. One either is or is not a homosexual, and if one is a homosexual, one best accept it. Importantly, the play never contradicts this stance.

To the extent that *The Boys in the Band* represents homosexuality as a personal subjectivity, the play suggests that it is a problem with which the characters must come to terms. The obstacles to personal "growth and fulfillment" are understood as something the individual subject must and can overcome. Such humanism inevitably reproduces the existing social formation and ideology. The "coming to terms with oneself" narrative in *The Boys in the Band* deflects the social critique which the play simultaneously broaches. This humanist "strategy" of representation should not surprise us. In fact, the text demonstrates that homosexual identity can only be built from the available discourse.

The humanist discourse is problematic since the text makes clear that the characters' difficulty in constructing a homosexual identity has everything to do with the invisible norm of heterosexuality that underlies notions of self and identity in our society. How can the characters accept "who they are," their homosexual identity, when that identity does not signify a valid basis of self-conception within the culture? Thus, the play raises the question of whether it is possible for homosexuals to construct a "healthy" identity within American society circa 1968.

Because of the representational bind in which the text finds itself, the resolutions of the various "coming to terms" narratives are unsatisfactory and inadequate. Personal subjectivity cannot be separated from social subjectivity and the play's attempt to do so produces contradictory identity effects and competing narratives of sexuality. If we trace the "coming to terms" narrative for several of the play's characters, we can see how its logic breaks down.

Michael, the play's central character, provides one of the best examples of this narrative failure. From the beginning of the play, the text represents homosexuality as his problem. Throughout the play he struggles to come to terms with it, with limited success. His notion of a homosexual identity is informed by a discourse of disease and sin. Not surprisingly, he has difficulty

constructing a positive sense of self out of this discourse. Even at age thirty, Michael remains racked by guilt over his homosexuality. He explains to Donald what he feels like after a typical night of drinking and cruising: "Icks! Anxiety! Guilt! Unfathomable guilt—either real or imagined—from that split second your eyes pop open and you say, 'Oh, my God, what did I do last night!' and ZAP, Total recall!" (23). The next morning he is left asking, "Was I too bad last night? Did I do anything wrong? I didn't do anything terrible, did I?" (23). Following the logic of the coming to terms with self narrative, Michael's problem in the play is resolving his guilt. However, he faces significant obstacles in this process, including his Catholicism and his construction of homosexuality as a developmental abnormality. The events of the play trigger his return to drinking and, as Harold says, "Guilt turns to hostility" (111). His destructiveness, both to himself and to others, can be seen as a product of this guilt. Michael, like all social subjects, has internalized society's norms and values.

Even the most hopeful reading reveals that Michael makes little progress coming to terms with himself. At the end of the play, as he collapses into Donald's arms, he laments, "If we . . . if we could just . . . not hate ourselves so much. That's it, you know. If we could just learn not to hate ourselves so very much" (128). Donald replies, "Inconceivable as it may be, you used to be worse than you are now" (128). Michael challenges Donald in return: "You've got a long row to hoe before you're perfect, you know" (128). Their conversation suggests that it is not possible to come to terms with the self when that self is constructed as sick or a sinner.

Donald's "failure" to construct a "healthy" homosexuality, like Michael's failure, reveals how sexual identity is bound up in larger issues of self and identity in our society. Specifically, the play foregrounds the ways in which the heterosexual/homosexual binary is equated with other binaries, including the legitimate social subject/illegitimate social subject. In the play, Donald's homosexuality leads him to feel that he is disqualified from participation in bourgeois subjectivity. To some extent, he is correct in this assumption. Unlike Michael, who tries desperately to participate in bourgeois subjectivity, Donald relegates himself to the margins. As he says, "Failure is the only thing with which I feel at home" (13). Accordingly, Donald quit his Ivy League college, found the lowest-paying job possible, and has withdrawn from the world. His self-imposed exile could be read as a rejection of the values of dominant society. However, it seems more of a retreat than a challenge. Michael, for one, reads this retreat as Donald's own fault, telling him, "Nobody holds a gun to your head to be a charwoman. That is, how you say, your neurosis" (14). Donald, like the other characters, can only construct a homosexual identity from within the discourse of this particular historical moment. Thus, his "failure" is really the discursive failure of homosexuality to signify what gay liberation might call "gay pride." By the end of the play, neither Donald nor Michael have resolved their problems. In the end, character does not triumph over social conditions and we are left to question whether the attempt is pointless in the absence of cultural change.

The failure of all the characters to come to terms with themselves within this humanist narrative logic reveals the inability of the available discourse to support a representation of homosexual identity that allows for

"positive" self-concepts. The play persistently suggests that what is needed is a construction of self that could allow for something like "pride" and "self-esteem," concepts that would be invoked with the rise of gay liberation. Yet, the characters fail to construct their homosexuality in these terms, suggesting that the construction of a "positive" sense of self is not simply a matter of the will of the individual, but is, in fact, tied to the social formation.

The representation of Hank and Larry, the one couple at the party, also reveals the extent to which the possibilities for the representation of homosexuality are culturally determined. The play's representation of their relationship demonstrates the social pressures that construct a "good" sexual subjectivity. Larry's promiscuous sexual behavior could be said to stand in the way of he and Hank achieving what Hoffman might call a happy, adjusted sexuality. The text suggests that Larry's inability to commit to Hank fully and his credo of "I've got to have 'em all" (107) is an acting out of society's stereotype of the promiscuous male homosexual, and thus the problem which Larry needs to overcome. Once again, such a reading is inadequate since the play simultaneously exposes that the very notion of coming to terms with the self and achieving a healthy sexuality means reconciling the self to social norms and rules. As homosexuals, these characters are already outside of dominant sexual ideology, regardless of their particular lifestyles. Therefore, they are cut off from any socially sanctioned notion of "happiness" and "well-adjusted" sexuality. The text exposes that playing by the rules of proper sexual conduct is not the answer. Although Hank appears to be the "correct" alternative to Larry, there is much about his representation that is problematic. In fact, he is shown to be uptight, overly concerned with keeping up a straight front, and prone to jealousy. His conventionalism and respect for social norms lead to a failed straight marriage and his late "coming out," not exactly signs of good "adjustment."

In the end, the characters' attempts to come to terms with themselves are shown to be inadequate, and it is evident that homosexual identity cannot be contained within the realm of the personal. As the play itself demonstrates, homosexual identity is as much social as personal, and the characters' attempts to construct a positive sense of identity will fail unless this is recognized. Although the play never fully embraces a social critique, it suggests the need for social and political change and anticipates an identity politics that would come during the gay liberation period.

For example, Michael develops an increasing "political" awareness as the play progresses and moves from a rather conciliatory stance vis-à-vis straight society to a much more challenging position. In Act I, he is markedly conciliatory. He rationalizes remaining closeted to his straight friend, Alan, when he tells Donald: "Some people *do* have different standards from yours and mine, you know. And if we don't acknowledge them, we're just as narrow-minded and backward as we think they are" (20). His fear of coming out is justified in terms of protecting Alan. As he tells his friends later, "It's not that I care what he would think of me, really—it's just that *he's* not ready for it. And he never will be" (27). His friends seem dubious about this justification, so Michael clarifies his position: "you have to admit it's much simpler to deal with the world according to it rules and then go right ahead and do what you damn well please" (28). Despite the fact that Michael speaks of himself as having "come out," he still operates according to the rules of the closet.

Michael's stance is critiqued at various moments, both directly and indirectly. As he explains to his friends why he is reluctant to come out to Alan, their reaction is noticeably skeptical. Emory doubts that Alan doesn't already know the truth, while Larry questions Michael's notion of being fair to Alan, asking, "Whatever's fair" (28). Yet, no one launches a full-scale argument against him. It is Michael who first begins to question his logic more fully. When Alan arrives at Michael's and passes judgment on the various guests, Michael's desire to play by the world's rules weakens. When Alan reveals his distaste for Emory, saying, "He's like a . . . butterfly in heat! . . . He probably wanted to dance with you! [Pause] Oh, come on, man, you know me—you know how I feel—your private life is your own affair," Michael becomes increasingly angry (50). He replies, "[Icy] No. I don't know that about you" (50).

Thus, the closing conflict of Act I, when Alan lashes out at Emory for his effeminacy, serves as a test of Michael's construction of homosexuality. The conflict demonstrates that Alan's credo that what goes on in private is a private affair is not enough. Tolerance for homosexuality is only skin deep. Further, it shows that Michael's attempt to play by the straight world's rules doesn't work. Alan's facade of tolerance evaporates when Emory refuses to downplay his effeminacy (and his sexuality). Alan lashes out: "Faggot, fairy, pansy . . . queer, cocksucker! I'll kill you, you goddamn little mincing swish! You goddamn freak! FREAK! FREAK!" (57). As Alan attacks Emory, any possibility for heterosexual/homosexual harmony based on tolerance disappears. Michael is immobilized by the violence that erupts, and it is clear that playing by the rules is ineffective. He "Walks over to the bar, pours a glass of gin, raises it to his lips, downs it all" (59). Michael's return to drinking is the result of forces from the outside world (i.e., Alan's attack), and thus the play suggests that the oppression of homosexuals and homosexual self-destruction will continue until people like Michael challenge the cultural construction of homosexuality.

The second act provides a more forceful critique of Alan and straight attitudes as Michael becomes less and less conciliatory. As Michael's impatience with Alan escalates, and as his drinking frees his tongue, he begins to attack Alan's attitude and he rejects his earlier statements which advocated shielding Alan from the truth. Michael's coming out to Alan anticipates a "central strategy of the gay movement" where "confronting others with one's homosexuality came to be viewed as the principal way for gay individuals to bring about social change," while secrecy was seen as "an indicator of self-oppression and as one of the major reasons for the ongoing oppression" of homosexuals (Cain 31). Michael seems to realize this, when he says of Alan, "That type refuses to understand that which they do not wish to accept. They reject certain facts. And Alan is decidedly from The Ostrich School of Reality" (*Boys* 93). Alan must be forced to confront these "facts" and he resists, saying: "No! I don't want to hear it. It's disgusting!" (109). As a stand-in for the straight audience, Alan is to be challenged and educated. Michael indicts Alan's willful ignorance, saying, "My what an antiquated vocabulary you have. I'm surprised you didn't say sodomite or pederast. [A beat] You'd better let me bring you up to date" (120). However, just what is finally accomplished by this education is unclear. Although Alan tells Emory, "I'm

sorry for what I did before," the significance of this resolution is undercut by Michael's cutting retort, "Christ, now you're both joined at the hip! You can decorate his home, Emory" (118) Further, Michael's attack on Alan's "vocabulary" comes after the apology. When Alan leaves at the end of the play, it is doubtful that he is any more enlightened. Further, Michael's articulation of an identity politics fails to result in any "new" sense of self. In fact, the play resorts back to a personal discourse which emphasizes the importance of healing the self, instead of healing society. By the end of the play, Michael is trying not to hate himself, rather than arguing for social change.

The play's equivocal social critique can also be seen in the representation of Larry's sexual ethos. Larry's discourse anticipates a sexual politics which becomes increasingly widespread in subsequent years. He refuses to live according to the sexual rules of bourgeois society, insisting, "I am *not* the marrying kind, and I never will be" (107). Whereas Hank wants sexual fidelity in their relationship, Larry wants "Respect—for each other's freedom. With no need to lie or pretend" (116). He tells the guests at the party, "It's my right to live my sex life without answering to anybody—Hank included! And if those terms are not acceptable, then we must not live together. Numerous relations is a part of the way I am!" (112). Larry's discourse is decidedly out of register with the rest of the text and must, therefore, be contained. The threat of Larry's sexual ethos is subverted by representing his "philosophy" as really an excuse for behavior that the play attempts to position as a product of his lack of coming to terms with himself. Thus, his jealousy of Hank's flirtation with Alan can be read as revealing that he does not really believe what he preaches and the text undercuts any sense that Larry's sexual philosophy might serve as the basis for a "new" homosexual identity. In the end, Larry's ethos cannot be reconciled within the narrative of coming to terms which drives the text and is rejected.

As an alternative to a full-scale social critique, the play puts forward a decidedly humanist credo, which fails to address the political issues that the play raises. This credo is perhaps most clearly articulated in Harold's assertion, "In affairs of the heart, there are no rules!" (65). This version of "to each his own" deflects attention from the extent to which sexuality is governed by strict social rules.[6] Further, it denies that homosexuality is more than an "affair of the heart." In fact, it contradicts the logic of the text which has shown not only that homosexuality defines subjects, but that these subjects are produced within the culture according to the "rules" of the available discourse. Harold's credo enacts the same contradictory logic that we see throughout *Boys*. That is, it pleads for tolerance of homosexuality from within a humanist discourse that is fundamentally homophobic. Thus, when Emory tells Alan that what Hank and Larry are doing upstairs in the bedroom is "not hurting anyone," his argument operates within the discourse of the dominant culture which denies that sexuality is social issue (119). He is wrong; what they are doing does threaten the ideology of dominant society, as does the play itself. Even the representation of homosexuality as a personal identity destabilizes heterosexuality's claim to identity. Thus, the play does mark an important development in the representation of homosexuality, despite its failure to fully articulate a social critique and the play's seeming acceptance of homosexuality's "lesser" status in the homosexual/heterosexual binary.

Homosexuality and the Public Imagination

The shifting signification of homosexuality that is apparent in *The Boys in the Band,* is equally apparent a year later, this time in the mainstream publication *Time*. In October 1969, just a few months after the Stonewall riots and the formation of the Gay Liberation Front, *Time* magazine devoted seven pages of the "Behavior" section to an article entitled, "The Homosexual: Newly Visible, Newly Understood" and two accompanying pieces. The section reveals how different representations of homosexuality were intersecting and competing within dominant culture. A crisis in representation results, causing cultural "discomfort" and threatening hegemonic understandings of homosexuality. When homosexuality is made visible, as in the *Time* article and increasingly in the culture of the late 1960s, it causes a disruption which must be contained. Thus, *Time*'s text is particularly interesting, not only because it provides such a clear example of the instability of the signification of homosexuality, but also because it reveals the cultural "need" to know and contain homosexuality. The *Time* article both resists representing homosexuality as an identity and simultaneously produces this identity as an effect of its attempt to know the homosexual subject. A series of contradictions results in the text.

Despite the fact that the article concludes that homosexuality is a psychological maladjustment, it begins by discussing homosexuals as a community. The first paragraph offers a portrait of a homosexual drag ball in San Francisco, suggesting (albeit stereotypically) that homosexuals have their own culture. The unidentified author notes that homosexuals "throw public parties, frequent exclusively 'gay' bars (70 in San Francisco alone), and figure sympathetically as the subjects of books, plays and films" ("The Homosexual" 60). Homosexuals are represented as a category of persons with a specific social identity at the same time as the text refuses to sanction this identity.

The article constructs homosexuality as a developmental "problem," but it also represents alternative constructions. The author argues that "most experts now believe that an individual's sex drives are firmly fixed in childhood" (61). Blamed on upbringing or social selection, homosexuality is defined as a "condition," "preference," or "hang-up." In fact, a great deal of space is given over to a discussion of its etiology—most of which relies on the theories of psychoanalysts who understand homosexuality as a developmental maladjustment. However, this discussion is overtly contradicted by a "typology" of homosexuals which creates one category called "the adjusted" (63). Further, the author (echoing Hoffman's argument in *The Gay World*) blames some of the problems of homosexuals, such as maintaining relationships, on "social pressures" (63). Needless to say, these different claims are never reconciled.

In another contradictory move, the article's discussion of the "new militancy" of homosexuals serves to configure homosexuals not as people suffering from a pathological condition, but as an oppressed minority (60). As the author notes, "Encouraged by the national climate of openness about sex of all kinds and the spirit of protest, male and female inverts have been organizing to claim civil rights for themselves as an aggrieved minority" (60). The discussion of the gay liberation movement which follows emphasizes the ways in which homosexuals have appropriated the discourse of other oppressed minorities to fight for "their" rights. The author, although clearly

unsympathetic to the movement, ends up foregrounding the disjuncture between the ways many homosexuals conceptualize themselves and his or her own conceptualization of homosexuality as a condition. The article highlights the instability of the culture's notion of homosexuality. The author notes this situation, writing: "Though they still seem fairly bizarre to most Americans, homosexuals have never been so visible, vocal or closely scrutinized by research" (60). The article's own scrutiny is complicated by this new visibility and politicalization. In order to provide a portrait of homosexuality circa 1969, the text is forced to discuss homosexuality in terms that contradict a pathological discourse. Thus, we obtain a discourse on identity appearing alongside a discourse of disease.

Despite its title claim that homosexuals are "newly understood," homosexuality is far from understood in any consistent way here. This is revealed, not only in the lead article, but also in the two accompanying pieces that offer (1) personal stories of "Lives in the Gay World" and (2) a discussion of whether homosexuality is a mental illness conducted by a group of "experts." *Time*'s tactic of presenting competing viewpoints only further serves to emphasize the lack of cultural consensus on what homosexuality is. What we end up with are very different notions. The discussion "Are Homosexuals Sick?" is particularly revealing. Of the eight experts, including an anthropologist, sociologist, gay leader, minister, and psychoanalyst, only the psychoanalyst, Dr. Charles Socarides, argues that homosexuality is a pathology. The other experts position homosexuality in quite different terms. Sociologist Lionel Tiger argues that "To pick on homosexuals . . . as on Communists or Moslems . . . is to shortchange their option for their own personal identity" (66). The minister, Rev. Robert Weeks, argues that society should accept "the totality of sexuality," and gives an example of a gay couple he knows who are happy and very much in love" (66–67). The panelists critique Socarides' claims that homosexuality is an "illness" and that "a human being is sick when he fails to function in his appropriate gender identity" (66–67). Sociologist John Gagnon points out, "We should not get hung up on the 20th century nuclear family as the natural order of man" (67). Further, several panelists suggest that if homosexuals have problems it is due to social attitudes "which are poisonous to the individual's self-esteem and self-confidence" (67). With the exception of Socarides' opinions, the reader is left with a sense of homosexuality that allows for a conception of it as a viable personal and social identity. Although *Time*'s section attempts to contain the signification of homosexuality, it cannot. A new discourse is emerging within the culture and within the text.

The Future of Identity

By the early 1970s, this new discourse became more fully articulated. Gay liberation articulates a politics of identity in a way that *The Boys in the Band* only flirts with. Gay liberation texts (for example, Dennis Altman's 1971 *Homosexual Oppression and Liberation* and Peter Fisher's 1972 *The Gay Mystique: The Myth and Reality of Male Homosexuality*) represent a homosexual subject without relying on psychoanalytic constructions, or for that matter, discourses of morality. A new discourse has emerged which constructs a social subject oppressed by society. The "problem" of homosexuality is seen as a social one and both texts argue for social and political change.

By 1971–1972, it is clear that the paradigm of identity has gained considerable cultural currency as a mode of understanding homosexuality, particularly within the homosexual subculture. Although Gay Liberationists did not necessarily embrace identity as a way of understanding homosexuality, they continually invoked a minoritizing discourse and produced what we might think of today as a politics based on homosexual identity. Just as the Stonewall era discourse was contradictory, so is the discourse of homosexuality in the Gay Liberation period: on the one hand many Gay Liberationists reject rigid notions of homosexual/heterosexual subjects, while on the other hand, they could be said to represent homosexuality as an identity. In the end, Gay Liberationist texts, like those of the Stonewall period, participate in the production of identity. Their critiques of identity cannot overcome the pressure for identity that their conceptions of sexuality exert.

No Easy Answers

Throughout this essay I have focused on *how* various texts have produced identity rather than why this production occurred. It has been my hope to avoid "grand explanatory systems" that might attempt to answer *why* identity has emerged as our collective sense (Sarup 59). I *have,* however, attempted to address not only how identity has been produced, but also how it has functioned. In the Stonewall period and today, identity serves multiple functions, many of which are contradictory. For those defined as homosexual, the identity paradigm can serve a political function. That is, by representing homosexuals as an oppressed minority (like African-Americans or women), various political and social demands can be made—from legal rights to cultural representation. Both a politics of sameness and a politics of difference work within the logic of identity: homosexuals can assert their equal rights and status, as well as their claims to a specific community and culture. According to this same logic, the dominant culture can invoke the binary pair of difference/sameness for its purposes. For example, an identity paradigm allows homosexuals to be included or excluded on the basis of "sexuality."

Identity works within dominant ideology. It maintains the distinction between homosexual and heterosexual which existed before the Stonewall period (although, perhaps, structured according to a different logic) and may, in fact, reinscribe heterosexuality as the dominant term in the heterosexual/homosexual binary. Further, identity can function within the humanist discourse of the "self." Thus, it works in accordance with the prevailing modes within which subjectivity is understood in our culture.

In the end, my analysis cannot answer why knowledge has been organized in such a way that identity is produced. Nor can it answer whether identity is politically effective or even whether it represents the "truth" of "who we are." However, it is my hope that this analysis provides an alternative way of analyzing identity, moving away from whether or not "we" (gays, lesbians, queers, theorists, etc.) should embrace identity and toward a fuller consideration of the ways in which identity structures the contemporary representation of homosexuality. Will identity continue to structure the representation of homosexuality? The recent deployment of the term "queer" presents an interesting test to the extent that it marks a conscious rejection of rigid understandings of sexual identity. Just as the challenge to such rigid

demarcations by some gay liberationists was unable to fully break with the logic of identity, it will not be easy for "queer" to destabilize our cultural common sense of identity.

Notes

1. I treat only gay male identity here so as to provide the specificity that my analysis requires. It is my contention that an understanding of lesbian identity requires attention to the specificity of women's historical place in American culture. Thus, to investigate the construction of lesbian identity, one must examine the women's movement, the social status of women, female gender roles, the construction of female sexuality, and similar topics.

2. Although the play and film are certainly different "texts," I risk grouping them together here because the film recreates the entire play's text and cast. With the exception of an opening montage sequence and the relocation of one "scene," the action and setting are identical. Of course, the differences between experiencing a play and a film should not be ignored.

3. In another critique, Vito Russo (in his 1981 study of homosexual representation in the movies, *The Celluloid Closet*) admits the movie's cultural importance, yet concludes, "The film presented a perfunctory compendium of easily acceptable stereotypes . . . and lots of zippy fag humor that posed as philosophy" (175).

4. For further examples of the pathological theory of homosexuality, see the following: Albert Ellis, *Homosexuality: Its Causes and Cures* (New York: Lyle Stuart, 1965); Peter Wyden and Barbara Wyden, *Growing Up Straight: What Every Thoughtful Parent Should Know about Homosexuality* (New York: Stein and Day, 1968); Judd Marmor, ed., *Sexual Inversion: The Multiple Roots of Homosexuality* (New York: Basic Books, 1965); and Donald J. West, *Homosexuality* (Chicago: Aldine Publishing Company, 1967).

5. Certainly there were those "experts" in the late 1950s and early 1960s who didn't subscribe to the pathological theory. One of the most important and influential was Dr. Evelyn Hooker who published an important study, "The Adjustment of the Male Overt Homosexual," *Journal of Projective Techniques*, 21 (1957): 18–31. However, the exponents of non-pathological theories remained in the minority.

6. This approximates what Judith Butler describes when she says that the performance of identity "maintains the illusion of identity which serves to regulate sexual desire. The politics are displaced from view" (337). See Judith Butler, "Gender Trouble, Feminist Theory and Psychoanalytic Discourse," in *Feminism/Postmodernism*, ed. Linda Nicholson (New York: Routledge, 1989).

References

Altman, Dennis. *Homosexual Oppression and Liberation*. New York: Avon Books, 1971.

Barnes, Clive. "Review of *The Boys in the Band*." *New York Times*, 15 April 1968, 48.

Beiber, Irving. *Homosexuality: A Psychoanalytic Study*. New York: Vintage Books, 1962.

Beaver, Harold. "Homosexual Signs (In Memory of Roland Barthes)." *Critical Inquiry*, 8, no. 1 (Autumn 1981): 99–119.

The Boys in the Band. National General, 1970.

Butler, Judith. "Gender Trouble, Feminist Thory and Psychoanalytic Discourse." In *Feminism/Postmodernism*, ed. Linda Nicholson. New York: Routledge, 1989.

Cain, Roy. "Disclosure and Secrecy among Gay Men in the United States and Canada: A Shift in Views." *Journal of the History of Sexuality*, 2, no. 2 (1991): 25–45.

Carrithers, Joe. "The Audience of *The Boys in the Band*." *Journal of Popular Film and Television*, 23, no. 2 (Summer 1995): 64–70.

Crowley, Mart. *The Boys in the Band*. New York: Farrar, Straus and Giroux, 1968.

D'Emilio, John. *Making Trouble: Essays on Gay History, Politics. and the University.* New York and London: Routledge, 1992.

Fisher, Peter. *The Gay Mystique: The Myth and Reality of Male Homosexuality.* New York: Stein & Day, 1972.

Hoffman, Martin. *The Gay World: Male Homosexuality and the Social Creation of Evil.* New York: Basic Books, 1968.

Holt, Mel. "His *Boys in the Band.*" *Los Angeles Advocate,* February 1969, 3.

McIntosh, Mary. "The Homosexual Role." *Social Problems,* 16: 182–192.

Russo, Vito. *The Celluloid Closet: Homosexuality in the Movies.* Rev. ed. New York: Harper and Row, 1987.

Teal, Donn. *The Gay Militants.* New York: Stein and Day, 1971.

MYRA BRECKINRIDGE
AND THE PATHOLOGY OF HETEROSEXUALITY

Douglas Eisner

IN GORE VIDAL'S 1968 novel, *Myra Breckinridge,* the title character is on a mission that she hopes will save humanity from itself:

> [Myra] is a creature of fantasy, a daydream revealing the feminine principle's need to regain once more that primacy she lost at the time of the Bronze Age when the cock-worshipping Dorians enslaved the West, impiously replacing *the* Goddess with a god. Happily his days are nearly over; the phallus cracks; the uterus opens; and I am at last ready to begin my mission which is to re-create the sexes and thus save the human race from certain extinction.[1]

To "re-create the sexes," she must destroy men's power, symbolized by their penises ("the phallus cracks"). This will have the added benefit of lowering the population by making it impossible for men to impregnate women, thereby saving the planet from mass starvation. The plot of the novel, however, is more narrowly focused. Myra, née Myron, Breckinridge is seeking her part of a family inheritance from her uncle, Buck Loner, who owns an acting school in Hollywood. While she engages in her legal maneuvers, she teaches Posture and Empathy at the school and obsesses on Rusty and his girlfriend, Mary-Ann Pringle, with whom she ultimately falls in love. For Myra the personal *is* political. Talking about her two young protégés, she writes: "Rusty's desire to have sex only with girls and Mary-Ann's desire to have at least four children the world did not need might be considered proof that our society is now preparing to kill itself by exhausting the food supply and making nuclear war inevitable" (*MB* 122). Her memoir recounts her joint effort to save the world from itself and to get her inheritance, both of which are made possible through the transformation of male bodies.

Myra Breckinridge's publication in 1968 is emblematic of the prominent societal forces of the decade: "the civil rights and antiwar and countercultural and women's and the rest of that decade's movements forced upon us central issues for Western civilization—fundamental questions of value, fundamental divides of culture, fundamental debates about the nature of the good life."[2]

These central issues included the nature of American power and imperialism, the nature of social oppression and violence, and the effects these had on American's sexual mores. The social movements of the 1960s argued that America's existing institutions were corrupt and sought to revolutionize America's central values and structures.

Along with these movements, the weakening of obscenity laws by the Supreme Court, the approval and marketing of the birth control pill, the proliferation of material about male and female homosexuality, the blurring of gender lines in fashion and advertising, and the new marketing niche called "swingers" opened up new spaces for sexual and gender expression.[3] In particular, homosexuals increasingly understood themselves as part of a gay community, as opposed to the popular belief that gay men and lesbians were isolated and lonely.[4] Homosexuality was further "popularized" and commodified in the proliferation of the rhetoric of camp, whose tenets Susan Sontag attempted to summarize in her 1964 essay, "Notes on Camp."

Both of these trends—leftist critiques of power and the popularization of a gay rhetoric—opened up new spaces for understanding homosexuality, and "sexual perversion" in general, providing a "hip" space for these representations. *Myra Breckinridge* is the result of the collusion of these two seemingly unconnected popular discourses of the 1960s: the leftist critique of power and the camp aesthetic. As such, it represents the almost perfect foreshadowing of the Gay Rights movement—an effort to thrust queer desire into the center of American politics—arguing that sexuality is as much about power as it is about personal expression.

In his essays from the 1960s, Vidal asserts that power is the mechanism by which all action occurs: "[P]ower *is* an end to itself, and the instinctive urge to prevail the most important single human trait, the necessary force without which no city was built, no city destroyed."[5] These urges are capricious and individualistic: "World events are the work of individuals whose motives are often frivolous, even casual." Vidal is particularly concerned with how American historians, sociologists, and leaders evade this central issue; instead they assert a "bland benevolence" for the rise of power, the desire to "do good" or to provide for the masses. And although Vidal does see a certain benefit in this ("it is certainly better to be non-ruled by mediocrities than enslaved by Caesers"), he warns that the persistent denial of the dark side of human nature makes us vulnerable to dictatorship: "we have been made vulnerable not only to boredom, to that sense of meaningless which more than anything else is characteristic of our age, but vulnerable to the first messiah who offers the young and bored some splendid prospect, some Cesarean certainty" (*HDS* 73–74).

In these essays, Vidal reflects a position developed by student radicals of the decade. The inaugural document of the New Left, the 1962 Port Huron Statement, written by members of the Students for a Democratic Society (SDS) argued that "Although mankind desperately needs revolutionary leadership, America rests in national stalemate, its goals ambiguous and tradition-bound instead of informed and clear, its democratic system apathetic and manipulated rather than 'of, by, and for the people.'"[6] It argued that this had happened because the managerial style of politics had alienated leaders from the people which in turn produced a system of alienation between men [*sic*] in all areas of society. The meritocracy of the university and of industry

had caused Americans to be alienated from their own labor, and from their own learning. The bulk of the statement analyzed various aspects of American society and public policy, and formulated a radical politics that would have "the function of bringing people out of isolation and into community."[7] The main focus for many youth movements became the war in Vietnam which in turn would focus attention on America's seeming dream of global empire. The Port Huron Statement focused on anticommunism, deterrence, poverty, and racism as symptoms of a severely disturbed United States and an imperial intention that alienated Americans from their own government.[8]

This analysis of power that SDS popularized was developed further by other radical groups during the sixties. The women's movement, for example, developed a critique of power to explain women's oppression. Betty Friedan's 1963 book, *The Feminine Mystique,* outlined the ways in which women in the 1950s lost their independence, sense of purpose, and sense of themselves. Friedan argued that woman must overcome the limited roles that society (men) allows her to play: "She must create, out of her own needs and abilities, a new life plan, fitting in the love and children and home that have defined femininity in the past with the work toward a greater purpose that shapes the future."[9] By the late 1960s and early 1970s, feminists had continued this critique of patriarchy to include a call for revolution to overthrow men's power. For example, Kate Millett's *Sexual Politics* argued that sexuality, particularly heterosexual coitus, "serve[d] as a model of sexual politics on an individual or personal plane."[10] Expanding on Charlotte Bunch's notion that "there is no private domain of a person's life that is not political and there is no political issue that is not ultimately personal,"[11] Millett argued that the definition of politics had to be expanded to recognize that politics "refer[red] to power-structured relationships, arrangements whereby one group of persons is controlled by another."[12] For Millett, sexuality was the key to understanding the way power is exercised in a democracy: "However muted its present appearance may be, sexual dominion obtains nevertheless as perhaps the most pervasive ideology of our culture and provides its most fundamental concept of power."[13] Like Vidal, Millett connects politics to power to sexuality. She understands sexuality as one way (the key way) in which power is exercised. Through the naturalization of theories of biological, psychological, sociological, and anthropological superiority of men over women, men's sexuality is privileged over women's, and the exercise of male sexuality is always privileged over the exercise of female.

These movements, as well as others like the Black Power Party and El Movimiento, held parallel views about the exercise of American power and its manifestations in personal lives, and called for a restructuring of American society. Their views circulated both among radicals and in the general culture. Vidal takes up and shapes these ideas in most of his writing during the decade culminating in *Myra Breckinridge.* In his 1968 essay, "Manifesto and Dialogue," he describes the effects of overpopulation: sickness, famine, violence, pollution. He places the blame for this squarely on the United States:

> But because the West's economy depends upon more and more consumers in need of more and more goods and services, nothing will be done to curb population or to restore in man's favor the ecological

257

■

Myra
Breckinridge
and the
Pathology
of Hetero-
sexuality

balance. Present political and economic institutions are at best incapable of making changes; at worst, they are prime contributors to the spoiling of the planet and the blighting of human life. It could be said that, with almost the best will in the world, we have created a hell and called it The American Way of Life. (*HDS* 319–20)

As a solution he proposes that we "reorganize society," which among other things would limit births by law and make these births anonymous; use American food surplus to feed the poor, American and non-American; make air and water pure by banishing the automobile and putting most factories underground; and break up cities into smaller units (*HDS* 321). One of his main goals is to separate families from sexual desire because since our culture connects the two, "normal sexual response" (which for Vidal means universal bisexuality) must always be diverted into reproduction: hence, the overpopulation problem (*HDS* 321). He admits that his plan will probably never go into effect because it will be resisted powerfully by the powers that be.

Vidal is well aware of the hostility a discussion of the intersection of sexuality and power elicits. In his essay, "Women's Liberation Meets Miller-Mailer-Manson Man" (1971), Vidal points out that the response feminists have elicited showed the effects of power on gender relations: "The hatred these girls have inspired is to me convincing proof that their central argument is valid. Men do hate women . . . and dream of torture, murder, flight" (*HDS* 390). In this essay, Vidal reaffirms his position: that feminists have proven that men oppress women, that one of the effects of this is a hyper-masculinity that enforces this oppression, and that this system needs to be overthrown, not just because women should be freed from this oppression and not just because men and women need to be liberated from narrow sexual expression, but because: "we are breeding ourselves into extinction" (*HDS* 402). In other words, a feminist revolution will liberate the sexes not just from their gender and sex roles, but from sexual reproduction itself.

The various strands of his critique are fused in *Myra Breckinridge*. Myra connects beauty, desire, and power explicitly, arguing that when faced with and desiring beauty, men (she is really only concerned with men) are helpless. For example, this is from the opening chapter:

> I am Myra Breckinridge whom no man will ever possess. Clad only in garter belt and one dress shield, I held off the entire elite of the Trobriand Islanders, a race who possess no words for "why" or "because." Wielding a stone axe, I broke the arms, the limbs, the balls of their finest warriors, my beauty blinding them, as it does all men, unmanning them in the way that King Kong was reduced to a mere simian whimper by beauteous Fay Wray whom I resemble left three-quarter profile if the key light is no more than five feet high during the close shot. (*MB* 3)

It is not only that she was able to conquer them with her beauty, but that the conquering of these men was an unmanning, a breaking of their balls. Faced with her body and her beauty, all men are helpless; their desire does them in. Their desire gives Myra power, which is meaningful only if it can be wielded over sexed creatures, and it is not about a specific sexual act, but rather about

the desire to have sex. One can achieve power if one can make someone do something sexually that they do not want to do.

Myra believes that her own power alone is able to overcome the perverse American sex/gender system that she attributes to Freud's effect on Western culture:

> I say *normal* human response, realizing that our culture has resolutely resisted the idea of bisexuality. We insist that there is only one *right* way of having sex: man and woman joined together to make baby; all else is wrong. Worse, the neo-Freudian rabbis . . . believe that what they call heterosexuality is "healthy," that homosexuality is unhealthy, and that bisexuality is a myth despite their master Freud's tentative conviction that all human beings are attracted to both sexes. (*MB* 86)[14]

259
■
Myra
Breckinridge
and the
Pathology
of Hetero-
sexuality

According to Myra, "many women lead perfectly contented lives switching back and forth from male to female with a minimum of nervous wear and tear" (*MB* 86). Men, on the other hand, find this difficult, making them the problem. Men, even "swingers," must "appear to accept without question our culture's myth that the male must be dominant, aggressive, woman-oriented" (*MB* 90). Since Myra sees this as a myth, only a mythic creature, such as herself, can change it, hence her project. She also realizes that the time is right for changing the myth since:

> Today there is nothing left for the old-fashioned male to do, no ritual testing of his manhood through initiation or personal contest, no physical struggle to survive or mate. Nothing is left him but to put on clothes reminiscent of a different time; only in travesty can he act out the classic hero who was a law unto himself, moving at ease through a landscape filled with admiring women. Mercifully, that age is finished. . . . The roof has fallen on the male and we now live at the dawn of the age of Woman Triumphant, of Myra Breckinridge! (*MB* 57)

The fact that there are even "swingers," men who will have sex with anyone, shows Myra that a new age is dawning. When she goes to an orgy and sees men and women engaging in all sorts of sexual behaviors, she realizes that times have changed, that some men now understand that they are "socially and economically weak, as much put upon by women as by society" (*MB* 90). For contemporary reviewer Margot Hentoff, the novel's publication, itself, was a sign that society was changing. Hentoff pointed out that while Vidal's interests had not really changed, *Myra Breckinridge*'s popularity was due, in part, to the fact that his interests had become mainstream, that gender blending was all the rage, that everyone was becoming and doing everything, and that Vidal was "walking on the waters of polymorphous perversity and sexual revolution."[15]

The focus of Myra's realignment becomes her student, Rusty, whom she ultimately rapes. She chooses Rusty because he shows no interest in her, but primarily for what he represents:

> Rusty is a throwback to the stars of the Forties, who themselves were simply shadows cast in the bright morning of the nation. Yet in the age

of the television commercial he is sadly superfluous, an anachronism, acting out a masculine charade that has lost all meaning. That is why, to save him (and the world from his sort), *I must change entirely his sense of himself.* (*MB* 117, Vidal's italics)

To change his sense of himself is to "free" him from his ardent heterosexuality and his desire to reproduce. Like her creator, Myra believes that our unmitigated desire to procreate will be humanity's undoing: there are so many people that we will not be able to feed them all; this fact and the proliferation of weaponry proves that humanity is on a suicide course (*MB* 120–21): "Death and destruction, hate and rage, these are the most characteristic of human attributes, as Myra Breckinridge knows and personifies but soon means, in the most extraordinary way, entirely to transcend" (*MB* 117–18). To survive, "efforts must still be made to preserve life, to change the sexes, to re-create Man" (*MB* 123). As it becomes clear during Rusty's rape, the transformation of man requires violence and essentially means turning back the clock, and making men boys again: "I was reducing his status from man to boy to child to—ah, the triumph!" (*MB* 137).

When Myra rapes Rusty, his transformation is not just a sign of the changing social order, it is also a sign of Myra's deific power: "The sense of power was overwhelming. I felt as if, in some way, it was I who controlled the coursing of the blood in his veins and that it was at *my* command that the heart beat at all. I felt that I could do anything" (*MB* 138). This sense of complete control over another person underlies how Myra's desires are little different from the desires of many of Vidal's other main characters—complete power over others. Her final triumph is both orgasmic and religious: "shouting with joy as I experienced my own sort of orgasm. . . . I was one with the Bacchae, with all the priestesses of the dark bloody cults, with the great goddess herself for whom Attis unmanned himself. I was the eternal feminine made flesh, the source of life and its destroyer" (*MB* 150). As she remakes man (Rusty), she rises to another sphere.

Interestingly, during the moment of her triumph, she gives us two other motivations for Rusty's rape: "'Now you will find out what it is the girl feels when you play the man with her'" (*MB* 149) and "I had avenged Myron" (*MB* 150). These comments underline two curious thematic lapses in the novel, lapses that become more important as the novel continues. Myra's realignment of the sexes is really a realignment of men. Women remain free from responsibility for humanity's pending doom. After this rape and Rusty's subsequent alliance with Letitia Van Allen, Myra turns to Mary-Ann, but with the girl, Myra is extremely passive—a very strange behavior considering what we have seen up to then. While a rape of Rusty is essential to the transformation of society, a transformation that, Myra has claimed, is essential to keep humanity alive, a subsequent rape of Mary-Ann is unfathomable. Similarly, the idea of a revenge for Myron underlines the deeply personal agenda from which this rape derives, but which Myra is practically silent about until now. If the personal is political for Myra, the political is quite personal as well. Myron's surfacing at this point foreshadows the ways normative heterosexuality will reassert itself at the end of the novel—a heterosexuality that will require an inviolate Mary-Ann.

There is always the question of how seriously we are supposed to take Myra's project and Rusty's rape. Since its original publication, *Myra Breckinridge* has been understood as camp, a style of artistic production that came from the gay community, and was first systematically written about by Susan Sontag in her essay, "Notes on Camp" (1964).[16] Sontag defines camp as the "love of the unnatural: of artifice and exaggeration" (275) and that "the androgyne is certainly one of the great images of Camp sensibility" (279).[17] Camp "is the attempt to do something extraordinary. But extraordinary in the sense, often, of being special, glamorous" (284). Camp "is the glorification of 'character'" and character is "understood as a state of continual incandescence—a person being one, very intense thing" (285–86). Camp "refuses both the harmonies of traditional seriousness, and the risks of fully identifying with extreme states of feeling" (287). Camp "incarnates a victory of 'style' over 'content,' 'aesthetics' over 'morality,' of irony over tragedy" (287). By this definition, *Myra Breckinridge* is certainly participating in Camp. In this sense, Rusty's rape, which, in terms of content, could be seen seriously, is played as comedy. It is not the fact that she rapes him, but how she does it. The whole novel is in quotation marks, an in-joke between Myra/Vidal and the reader. *Myra Breckinridge* succeeds because of its ability to plug in to this now popularized discourse.

Sontag recognizes but underplays the relationship between camp and homosexuality: "The peculiar relation between Camp taste and homosexuality has to be explained. . . . Camp taste . . . definitely has something propagandistic about it. . . . Homosexuals have pinned their integration into society on promoting the aesthetic sense. Camp is a solvent of morality. It neutralizes moral indignation, sponsors playfulness" (290). However, a number of recent critics have taken Sontag to task for this article, pointing out how she sanitizes the queer experience, objectifies camp as an object, or even erases the queer subject.[18] Indeed, Sontag is simply reacting to an already popular aesthetic form that pervaded the mid-1960s but derived from the gay and lesbian community and thrived in cities (New York, San Francisco) where there were large concentrations of homosexuals. Sontag's piece brought this awareness to a larger audience. However, in so doing she erased both the political and historical ramifications of camp.[19]

Recent writers, responding to Sontag and others, have sought to embed the political and the queer back into camp, from which they never left. Arguing against Sontag's notion that camp is simply aesthetic, they argue "Camp is political; Camp is solely a queer (and/or sometimes gay and lesbian) discourse; and Camp embodies a specifically queer cultural critique."[20] In a recent article, Cynthia Morrill writes that when queer subjects realize that their desire is unrepresentable, since representation is dependent on reinforcing compulsive reproductive heterosexuality, queers find themselves "hurled out of representation." Since they can only express themselves through representation, they must reincorporate themselves into the dominant order. This process is Camp.[21] Morrill sees camp as an effect of homophobia. She invokes Barthes's notion of *jouissance,* "a condition of representation that hurls the subject outside of the ties of dominant discourse by unsettling, among other things, his or her historical, cultural, and psychological assumptions."[22] For Morrill, camp is a form of *jouissance* because it marks

261

■

Myra
Breckinridge
*and the
Pathology
of Hetero-
sexuality*

the destabilization of representational strategies, a destabilization necessary because of the queer's hurling outside it: "a queer discourse that results from un-queer proscriptions of same-sex desire."[23] Camp's style is the way it is because it is expressing the essential morality of the queer experience, that gender enforcement is a violence particularly wrought upon queers. Camp is important, not only because it expresses an essential positionality in Western culture, but also because its style shows that gender should be a game, something we play at: "Camp is the safety valve that can keep any gender activism from becoming fanaticism."[24] Camp allows us to not take ourselves too seriously while exposing the violence and oppression implicit in all gender enforcement.

Myra Breckinridge is extreme, florid, and absurd "in a special playful way" (Sontag 288). Myra allows Vidal to explore his serious social project in a less threatening, comic way. It also allows for the articulation of queer desire despite the way "the existence of transgendered people—people who exist sexually for pleasure, and not procreation—strikes terror at the heart of our puritanical Eurocentric culture. Vidal positions Myra as the voice and agent of doom for the traditional American male."[25] The novel was so troubling that it had to be understood as a joke or pathological.[26] As Sontag points out: "Camp taste is by its nature possible only in affluent societies, in societies or circles capable of experiencing the psychopathology of affluence" (289). The society itself is pathological, Sontag claims, that makes camp possible; the novel is evidence of this pathology and much like the rhetoric of the new Left, this pathology is understood as inherent to the society: "I discussed every society's *secret* drive to destroy itself and whether or not this was a good thing" (*MB* 122).

To call Rusty's rape camp is to attest to both the violence of queer representation and the violence of gender conformity. To unman Rusty requires a violent act because his own masculinity is so embattled: "the last bastion" (*MB* 139). More important, however, this violence is conjoined with humor to undercut the violence. Are we supposed to be offended or amused, repulsed or turned on?

In particular Myra's florid, over-the-top style—a constant in the novel—allows for the violence of the scene to go from the real to the surreal and, ultimately, the comic:

> The total unveiling of the buttocks was accomplished in an absolute, almost religious, silence. They were glorious. . . . A tiny dark mole on one cheek. An angry red pimple just inside the crack where a hair had grown in upon itself. The iridescent quality of the skin which was covered with the most delicate pale peach fuzz, visible only in a strong light and glittering now with new sweat. I could smell his fear. It was intoxicating. (*MB* 134)

Myra relishes each and every detail, focusing on imperfections and disjunctions: "[The testicles] were all that I could desire. The penis, on the other hand, was not a success" (*MB* 145). She glories in Rusty's fear, his resistance, his panic. The scene is both sadistic—"I took the measuring stick and with a great cracking sound struck his right thigh" (*MB* 141)—and comic—"Delicately I took one of his nipples in the tongs. He shrank from me, but the

tongs pursued" (*MB* 138). Rusty's evasions are both funny and touching: "When I turned back to my victim, I was surprised to find him sitting up on the table, poised for flight. He had trickily used the turning of my back to restore his shorts to their normal position. . . . He was not going to surrender the last bastion without a struggle" (*MB* 139). Ultimately, we are left in a state of ambivalence, which perhaps is the essential end result of camp since queer desire can never be fully represented, given narrative constraints. This representation of violence is camp because of both its absurdity and eroticism. It allows for both attraction and repulsion, blurring the boundaries between forms of desire and violence. It blurs the boundary between different "types" of people, including who Myra actually is.[27] For Myra, boundaries are meaningless and her rape of Rusty is an attempt to destabilize gender roles. Her rhetoric, however, is part and parcel of this attempt. It is not just that she is raping him, but also that the rape is an incongruous humorous performance, it "has the effect of pointing out a wide field of normalization . . . as the site of violence,"[28] or as Myra puts it, it allows Rusty to "find out what it is the girl feels when you play the man with her" (*MB* 194).

Rusty's rape embodies both Myra's heterosexually oriented desire and her female revenge on men, but Myra's body is ever-changing. Myra's desire for Rusty and then for Mary-Ann underlines the instability of certain forms of desire in the novel even as it stabilizes others. In particular, the "queer" desire that Morrill wants to see in camp representations hovers around the edges of the novel, suggested, but always rejected, while "straightness" always seems able to find a place in which to exert its power. In some ways, this relationship underlines Vidal's idea that "Power" never gives up easily, but it is interesting that in Vidal's really quite radical novel, compulsive heterosexuality is still able to prevail; it reasserts itself through the unchallenged gender performance of Mary-Ann and, ultimately, through the reemergence of Myron through another act of violence.

After Rusty's rape, Myra turns her attention to her personal goal of getting Myron's inheritance. Despite the hype of this book, Myra's transsexuality is only hinted at in the first half of the novel: "I exist entirely outside the usual human experience . . . outside and yet wholly relevant for I am the New Woman whose astonishing history is a poignant amalgam of vulgar dreams and knife-sharp realities (shall I ever be free of the dull lingering pain that is my peculiar glory, the price so joyously paid for being Myra Breckinridge)" (*MB* 4). However, as the reference to Myron in the rape sequence suggests, Myra is, to a certain extent, always Myron. It is as the transformed man that Myra most severely undercuts patriarchy. Myra materializes her own social critique, and her real opponent is not Rusty, but Uncle Buck.

Uncle Buck is a paragon of straightness and maleness who is interested only in money and sex. His frequent massages by a "nurse," his sexual interest in Myra, and his determined effort to keep his money no matter whom he exploits (Myra, his students) make him the perfect foil for Myra's shenanigans. Although Myra seeks to undermine the reproductive imperative and its reinforcement of family connections, she is not immune to the importance of having family connections to get power and influence. Buck has, not only half an inheritance that was Myra's mother-in-law's/mother's, he also has access to Hollywood, about which Myra is obsessed. Consequently, she uses her connections with him to get what she wants, although she could care less

about him: "He means to cheat me out of my inheritance while I intend to take him for every cent he's got, as well as make him fall madly in love just so, at the crucial moment, I can kick his fat ass in" (*MB* 18). Family is a tool Myra will use to reach her ultimate goals, not a tool of affection.

Myra's characterization of Buck is accurate; he does plan on cheating her out of her inheritance:

> Flagler and Flagler will be notified first
> thing tomorrow morning and told to examine with a fine tooth comb the deeds to this property and also to make a careful investigation of one Myra Breckinridge widow and claimant and try to find some loophole as I have no intention at all of letting her horn in on a property that I myself increased in value. (*MB* 22)[29]

Like Myra, Buck wonders, "what is the true Myra Breckinridge story that is the big question" (*MB* 20). Besides her claims on him, he is most interested in her body:

> she came sashaying into the office
> with her skirt hiked up damn near to her chin at least when she sits down she is a good looking broad but hoteyed definitely hoteyed and possibly mentally unbalanced I must keep an eye on her in that department but the tits are keen and probably hers and I expect she is just hungering for the old Buck Loner Special. (*MB* 21)

It is her body, however, that will ultimately betray him.

Myra's greatest triumph is not her rape of Rusty, but the revelation of her "truth" in the form of her body that allows her to get the money she desired, resulting in a moment of American capitalism at its finest. Following numerous meetings with Buck Loner, and after trying to convince him that she was Myron's wife, Buck and his lawyer, Flagler Junior, confront her with the fact that there is no evidence of Myron's death:

> she says I quote Randolph I guess this is the moment of truth unquote and he nods and allows that maybe shes right and then so help me god she stands up and hikes up her dress and pulls down her goddam panties and shows us this scar where cock and balls should be and says quote Uncle Buck I am Myron Breckinridge unquote. . . .
> Im Myra Myron is dead as a doornail why when I lost those ugly things it was like a ship losing its anchor and Ive been sailing ever since havent I Randolph free as a bird and perfectly happy in being the most extraordinary woman in the world unquote well what can you say to that question mark I said nothing but just handed her the check. (*MB* 182–83)

The scars are evidence of her transformation, evidence of the fact that she is Myra *and* Myron; she can use her family privilege to get the money she

deserves. The perverted sex/gender system of Myra/Myron works to undercut the familial patriarchal system because the system has no way of understanding this transformation other than a legitimization of itself which in turn legitimizes Myra's claim. Her body becomes her claim and her truth. Although she cannot "describe for you *exactly* what my body is like" (*MB* 10), her body acts as the text in this instance, revealed, not through Myra's queer, camp language, but through Uncle Buck's stream of consciousness, a language that asserts its claim on reality both through its form and through its claim to normative sexuality and patriarchy. Myra's body legitimizes her claim to family/capitalist privilege even as it mocks that privilege.

265
■
Myra
Breckinridge
and the
Pathology
of Hetero-
sexuality

Myra's interactions with Buck underline the effects her restructured body could have on dominant patriarchal legitimacy. However, as the rhetoric surrounding her rape of Rusty suggests, she hopes that it will not just be property claims that are turned over to her new mythic body, but that male heterosexual bodies will be transformed themselves. This project seems to go awry as the novel progresses. The rape does not have the immediate effect on Rusty that Myra had hoped. Rather than being unmanned, Rusty becomes a violent heterosexual lover, eventually becoming a "complete homosexual" (*MB* 212), which seems just as perverse in Myra's original formulation of her mission. He becomes just as monosexual at the end as he was in the beginning.

Myra's most successful transformation, in fact, has been herself, but ultimately her project fails. She realizes that her rape of Rusty has not just changed his sexual desire, but her own:

> To my astonishment, I have now lost all interest in men. I have simply gone past them, as if I were a new creation, a mutant diverging from original stock to become something quite unlike its former self or any self known to the race. All that I want now in the way of human power is to make Mary-Ann love me so that I might continue to love her—even without possessing her—to the end of my days. (*MB* 192)

To diverge from the original stock is to both stop desiring men, and also to stop desiring possession, to somehow liberate humanity from the necessary connection between power and desire. However, Mary-Ann appreciates Myra's feelings while rejecting her because she is a woman; dominant gender construction reasserts itself through Mary-Ann. Has Myra realigned the sexes? Is it possible to do so, one individual at a time? For Myra, this dilemma is frustrating, not only because her desire is being thwarted, but because she has no weapons in her arsenal to deal with female power. In exercising power over Rusty, she had used forms of power recognizable in patriarchy in the form of rape. In other words, she uses the patriarchal privilege that rape represents to destroy that privilege. However, how is she to undercut women's position in patriarchy? This is the problem that ultimately undermines her project: "For what purpose have I smashed the male principle only to become entrapped by the female? Something must be done or I am no longer triumphant, no longer the all-conquering Myra Breckinridge . . . whisper her name! Sympathetic magic must be made. But how?" (*MB* 196)

The sympathetic magic ends up being a reassertion of the male hetero-
sexual principle against which she has been arguing, just as Myra, a trans-
formed homosexual man, is herself transformed into a heterosexual man.
Myra's story is framed by her two alternative male selves. Through this
transformation—homosexual Myron to Myra and then to heterosexual
Myron—Vidal explores the way in which power seems always able to
reassert itself. Despite his and Myra's call for a transformation of society, the
normative sex/gender system is able to reassert its dominance. Dominant
society's pathology, Vidal suggests, is so constitutive of the possibilities for
narrative, particularly narrative closure, that radical action is already, and
always, impossible to sustain.

Myra's mission is to get revenge on men for their abuses of Myron. She
tells us that while Myron was sometimes masculine, his "feminine aspects of
his nature were the controlling ones. . . . He wanted men to possess him
rather than the other way around. He saw himself as a woman, made to suf-
fer at the hands of some insensitive man" (*MB* 76). Myron's notion of
women, then, was essentially conventional; women were made to suffer and
were made to be possessed. However, his understanding of the effect of this
behavior emphasized his own power. As a biological male, performing as a
traditional woman, he was "able to take from Woman her rightful pleasure—
not to mention the race's instrument of generation—became a means of exer-
cising power over *both* sexes and, yes, even over life itself!" (*MB* 77). More
important:

> [Myron] was never drawn to homosexuals. In fact, once the man *wished*
> to penetrate him, Myron lost interest for then he himself would be-
> come the thing used, and so lose the power struggle. What excited him
> most was to find a heterosexual man down on his luck, preferably
> starving to death, and force him to commit an act repugnant to him
> but necessary if he was to be paid the money that he needed for sur-
> vival. (*MB* 77)

Myron shares Myra's desire to demean men—to force them to do things that
are repugnant as a way of destroying masculinity. Ultimately, Myron felt he
failed because while living, he could never become what he wanted to be,
"an all-powerful user of men" (*MB* 78), due to the fact that some men would
always resist. Furthermore, Myron would never use his penis: "Myron's sex-
ual integrity required him to withhold that splendid penis" (*MB* 77), be-
cause of its biological nature, its claim to reproduction. Myra, however, can
use a dildo to overcome men's resistance, which then makes forcible rape
possible. So Myron transforms his body into Myra, or, in other words, the
homosexual Myron, whom we never actually meet and who has no sense
of camaraderie with other homosexuals, is transformed into the heterosex-
ual Myra.

Myra's desire for Mary-Ann implies that she is becoming a lesbian and,
like earlier, the homosexual body must be expunged. She writes: "Imagine
my consternation when, once again, she said what she truly felt (and what I
have known all along but refused to let myself admit even to myself): 'If you
were only a man, Myra, I would love you so!' (*MB* 192). Unlike Rusty,
whom she violently transforms, Mary-Ann's resolute heterosexuality is

never challenged. The rigidity of Mary-Ann's conception of gender and sexuality is then structurally embedded in the novel in the form of the final deus ex machina, a hit-and-run car accident, which has the effect of transforming Myra back to Myron. As the new Myron, however, he becomes completely conventional; his sex is realigned back to his born one, but now he has lost his homosexual tendencies, married Mary-Ann, and settled down to "live a happy and normal life, raising dogs and working for Planned Parenthood" (*MB* 213). Myron still sympathizes with Myra's efforts to stop reproduction; ultimately, however, the sexes are aligned in a standard heterosexual couple.

267
■
Myra
Breckinridge
and the
Pathology
of Hetero-
sexuality

Although we do not know who was actually driving the car, structurally, the accident works to whip us back into the real world—to remind us that Myra's kind of behavior will never go unpunished. In her initial entry following the accident, writing in a drugged state, Myra's paranoia reminds us that much is at stake: "What have I told them? Did I reveal the secret of human destiny to the enemy? I pray not. But only a careful questioning of my captors will be able to set my mind at rest. If I *have* told them all, then there is no hope for the coming breakthrough" (*MB* 198). The doctors are the enemy trying to undo Myra's work, which they eventually succeed in doing: "Where are my breasts? *Where are my breasts?*" (*MB* 210). Heterosexually gendered normativity ultimately prevails because no matter how radical the gender move is, radical queer sexuality can never be sustained. This is to say that despite Vidal's belief that the entire culture is sick and self-destructive, he can still not find a way of *narratively* stabilizing homosexuality, homosexuals, or queer desire in a productive relationship that links power and desire in the way that he can with heterosexuality. Here, I would argue, emerges the necessity for camp in the novel. The novel really only represents heterosexuality: Myra has sex with Rusty; Myron marries Mary-Ann. However, through its camp conventions the novel queers these heterosexual acts, reminding us of the queers who exist in its margins—and who must be erased by the end. The novel, then, is queer while stabilizing normative sexuality.

The restructuring of society to diffuse the power and violence in America championed by the new social movements of the 1960s was embraced by the radicalized gay movement after the Stonewall Riots in 1969. New York City's Gay Liberation Front (GLF), for example, printed the following statement of purpose in the New Left newspaper, *RAT:*

> We are a revolutionary group of men and women formed with the realization that complete sexual liberation for all people cannot come about unless existing social institutions are abolished. We reject society's attempt to impose sexual roles and definitions of our nature. We are stepping outside these roles and simplistic myths. We are going to be who we are. At the same time, we are creating new social forms and relations, that is, relations based upon brotherhood, cooperation, human love, and uninhibited sexuality.[30]

The GLF called for a complete transformation of sexual social institutions as a sign of sexual liberation. Similarly, the Gay Revolution Party's manifesto argued that "the end of classes and castes, and even the survival of human life, depend on the total destruction of the caste system which has made women objects for straight men and made gay people the outcasts of

society."[31] Arguing that being gay is "a process of attaining mutual and equal social and sensual relationships among all human beings," it called for the destruction of all structures of hierarchy and oppression through the rewriting of gender norms, so that gender itself becomes a meaningless category.[32] The gay radicals of 1969–1970 equated their struggle with the other radical struggles—race, gender, third world, anti-imperialist—that were active during the late 1960s:

> We see the persecution of homosexuality as part of a general attempt to oppress all minorities and keep them powerless. . . . Therefore we declare our support as homosexuals or bisexuals for the struggles of the black, the feminist, the Spanish-American, the Indian, the hippie, the young, the student, the worker, and other victims of oppression and prejudice.[33]

Students for a Democratic Society (SDS), the feminist movement, the Black Power movement, and the Gay Liberation Front all argued that the United States had a basic sickness that upheld forms of violence and oppression, thereby disconnecting Americans from their basic humanity. They called for close scrutiny of social and political norms, and the feminists and gay and lesbian radicals argued that the sex/gender system was at the heart of the sick society.

For Vidal, this emphasis on equal rights and minority status was (and is) ridiculous.[34] However, *Myra Breckinridge* anticipates much of this gay and lesbian radical rhetoric. The novel is aware of the impossibility of representing homosexuality and queer desire because of the violent way they are repressed, even as it attempts to do so through camp. America is sick and self-destructive. The symbol of this sickness is not the usual homosexual figure, but rather the repression of the homosexual and queer desire. Heterosexuality itself becomes the mechanism of continuing this pathology as it continually reasserts itself through the apparatus of social institutions (the novel, the hospital, the law, education) and the apparatus of narrative, which requires a happy ending and can only be satisfied with a happy, heterosexual pairing. I suppose we should be happy that Myra is not completely destroyed, as she would be in a standard narrative; rather she lurks behind the new heterosexual Myron, ready to reassert herself in the novel's sequel, *Myron*. Although she has been "hurled out of representation," her project of making it impossible for people to reproduce manifests itself in Myron's fake genitalia, underlining the fact that society will reinforce normative heterosexuality at all costs, even if it means resting on fake equipment.

Notes

1. Gore Vidal, *Myra Breckinridge and Myron,* with new introduction (1968; rpt., 1971; New York: Vintage, 1986), 6–7. All subsequent references to this book will be in the text with the abbreviation *MB.*

2. Todd Gitlin, *The Sixties: Years of Hope, Days of Rage* (1987; rpt., New York: Bantam, 1993), xiv.

3. John D'Emilio, *Sexual Politics, Sexual Communities: The Making of a Homosexual Minority* (Chicago: University of Chicago Press, 1983), 129–39; James Kent Willwerth and Stefan Kanfer, "Rebels and Swingers," in *Sex in the '60s: A Candid Look at the Age of Mini-Morals,* ed. Joe David Brown (New York: Time, 1968), 25–36.

4. D'Emilio, *Sexual Politics,* 140–44.

5. *Homage to Daniel Shays: Collected Essays 1952–1972* (New York: Random House, 1972), 73. Unless otherwise noted, citations to Vidal's essays are in this volume and all further references will be in the text and abbreviated *HDS.*

6. Quoted in James Miller, *"Democracy Is in the Streets": From Port Huron to the Siege of Chicago* (New York: Simon and Schuster, 1987), 330.

7. Ibid., 333.

8. Ibid., 339–73.

9. Betty Friedan, *The Feminine Mystique* (1963; rpt., New York: Dell, 1983), 338.

10. Kate Millett, *Sexual Politics* (Garden City, N.Y.: Doubleday, 1970), 23.

269
■
Myra
Breckinridge
and the
Pathology
of Hetero-
sexuality

11. Quoted in William H. Chafe, *The Unfinished Journey: American* [sic] *since World War II,* 2nd ed. (New York: Oxford University Press, 1991), 335.

12. Millett, *Sexual Politics,* 23.

13. Ibid., 25.

14. This quotation connects *Myra Breckinridge* to Vidal's earlier novel, *The City and the Pillar,* which he rewrote and republished in 1965. In the Afterword to this version, he writes:

> most homosexualists [his word for homosexuals who identify as such] marry and become fathers, which makes them, technically, bisexuals, a condition whose existence is firmly denied by at least one school of psychiatry on the odd ground that a man *must* be one thing or the other, which is demonstrably untrue. Admittedly, no two things are equal, and so a man is bound to prefer one specific to another, but that does not mean that under the right stimulus, and at another time, he might not accommodate himself to both. (*The City and the Pillar Revised: Including an Essay, "Sex and the Law" and "An Afterword"* [New York: E. P. Dutton, 1965], 246.)

One possible way of understanding *Myra Breckinridge* is as a novelistic effort to elucidate this afterword which in turn was a response to the decade of approbation *The City and the Pillar*'s publication brought on. Vidal purposely did not allow advance copies of *Myra Breckinridge* to be released to reviewers, knowing that the novel would be a best-seller if reviewers did not have the opportunity to trash the novel for moralistic reasons. By the time reviews were published, it was already a best seller, and of the major literary review journals only the *New York Times,* in keeping with tradition, attacked the novel. For Vidal's account of this, see his introduction to the 1987 reprint of *Myra Breckinridge and Myron.* The *Times* originally published a negative review (Elliott Fremont-Smith, "Books of the Times: Like Fay Wray if the Light Is Right," *New York Times,* 3 February 1968, natl. ed., 27), but when faced with the novel's popularity, published a more positive review in the "Sunday Book Review" (James MacBride, "What Did Myra Want," *New York Times,* 18 February 1968, sec. 7, 44–45).

15. "Growing Up Androgynous," *New York Review of Books,* 10 (9 May 1968), 32–33.

16. For good accounts of the effect this essay had on American culture, see Andrew Ross, *No Respect: Intellectuals and Popular Culture* (New York: Routledge, 1989), 135–70; and Andy Medhurst, "Batman, Deviance, and Camp" (1991), reprinted in *Signs of Life in the U.S.A.: Readings on Popular Culture for Writers,* ed. Sonia Maasik and Jack Solomon (Boston: Bedford Books, 1994), 323–38.

17. "Notes on Camp" is collected in Susan Sontag, *Against Interpretation* (1966; rpt., New York: Anchor, 1990). All page references will be made in the text.

18. See for example, the articles in Moe Meyer, ed., *The Politics and Poetics of Camp* (London: Routledge, 1994), especially Meyer's Introduction, pp. 1–22, and Cynthia Morrill's, "Revamping the Gay Sensibility: Queer Camp and *Dyke Noir,*" pp. 110–29. All but one of the articles in this volume reference Sontag's article which, if nothing else, signifies the importance of it in the American imagination. See Gregory W. Bredbeck, "B/O—Barthes's Text/O'Hara's Trick," *PMLA,* 108, no. 2 (1993):

268–82, for an earlier article that points out the evasive strategy of defining camp as a sensibility. An even earlier attempt to reclaim camp from Sontag's formulation can be found in Jack Babuscio, "Camp and the Gay Sensibility," in *Gays and Film,* ed. Richard Dyer (London: British Film Institute, 1980), 40–57. See also the articles in David Bergman, ed., *Camp Grounds: Style and Homosexuality* (Amherst: University of Massachusetts Press, 1993).

19. Meyer, Introduction, 7–8.

20. Ibid., 1.

21. Morrill, "Revamping the Gay Sensibility," 112.

22. Ibid., 118.

23. Ibid., 119.

24. Kate Bornstein, *Gender Outlaw: On Men, Women and the Rest of Us* (New York: Routledge, 1994), 138.

25. Ibid., 78.

26. See for example, Elliot Fremont-Smith's *New York Times* review. For a good overview of the negative critical reception of *Myra Breckinridge,* admittedly from an unsympathetic critic, see William F. Buckley, Jr., "On Experiencing Gore Vidal," *Esquire,* 72, no. 2 (1969): 108–13.

27. Robert F. Kiernan, *Gore Vidal* (New York: F. Ungar, 1982), 97–98.

28. Michael Warner, ed., Introduction to *Fear of a Queer Planet: Queer Politics and Social Theory* (Minneapolis: University of Minnesota Press, 1993), xxvi.

29. Uncle Buck's sections are transcriptions of recording disks. Vidal writes these scenes with no punctuation or hyphenation to reflect its recording technology. This alternative form of representation, in which we are privy to his editing (he periodically tells the transcriber to delete sections, gives paragraph and punctuation delineation, etc.) is in marked contrast to Myra's obsession with form. Because Vidal writes this section in a formalistic way, I have tried to recreate the form.

30. Reprinted in D'Emilio, *Sexual Politics,* 234.

31. In Karla Jay and Allen Young, eds., *Out of the Closets: Voices of Gay Liberation* (New York: Douglas, 1972), 343.

32. Ibid., 342.

33. North American Conference of Homophile Organizations: Committee on Youth, "A Radical Manifesto" (xerographic copy, 28 August 1969).

34. Vidal has consistently distanced himself from the gay rights movement, and has refused to call himself a homosexual, since he believes strict homosexuality is as aberrant as strict heterosexuality. Vidal's most recent statement about his sexuality, a subject that he has never been willing to talk about much, can be found in *Palimpsest: A Memoir* (New York: Random House, 1995): "I was obliged to face the fact that I was never going to be make the journey from homoerotic to homosexual and so I was never going to be able to have anything other than one-sided passing sex" (131).

CONTRIBUTORS

BLAKE ALLMENDINGER is professor of English at the University of California, Los Angeles. He is the author of *The Cowboy: Representations of Labor in an American Work Culture* (Oxford, 1992) and *Ten Most Wanted: The New Western Literature* (Routledge, 1998), as well as coeditor of *Over the Edge: Remapping the Boundaries of Western Experience* (California, 1998).

DAVID BERGMAN is the author or editor of more than a dozen books, including *Gaiety Transfigured,* a *Choice* Outstanding Book of the Year. He is winner of the George Elliston Poetry Prize for *Cracking the Code.* His latest book of poetry is *Heroic Measures.* He is editor of the *Men on Men* series. A professor of English at Towson University, he directs its program on cultural studies.

JOSEPH BRISTOW is professor of English at the University of California, Los Angeles. His recent books include *Effeminate England: Homoerotic Writing after 1885* (Columbia, 1995) and *Sexuality* in the New Critical Idiom series (Routledge, 1997). He is currently completing a study of sex and sexuality in Victorian poetry to be published by Cambridge.

WILLIAM A. COHEN is assistant professor of English at the University of Maryland. He is the author of *Sex Scandal: The Private Part of Victorian Fiction* (Duke, 1996) and numerous articles.

FRANCESCA COPPA is assistant professor of English at Muhlenberg College. She writes on modern British drama and is completing a book on Joe Orton.

KELLY CRESAP recently completed his Ph.D. in English from the University of Virginia. His dissertation is titled "Warhol and the Art of Cultivated Postmodern Naïveté."

DOUGLAS EISNER is teaching at Fullerton College after earning his Ph.D. at the University of California, Riverside. He has published articles on twentieth-century gay literature and contemporary popular culture. He is working on a book-length project on anxieties about masculinity in Cold War American literature.

YVONNE KELLER is visiting assistant professor of women's studies at Miami University, Ohio. She has taught at the University of Cologne, Germany. She recently received her Ph.D. in the history of consciousness program at the University of California, Santa Cruz. She is completing a book manuscript on lesbian pulp novels of the fifties and early sixties in literary and historical contexts.

RICARDO L. ORTÍZ is assistant professor of Latino studies in the English department at Georgetown University. "L.A. Women" is part of an ongoing study of Los Angeles literary and cultural history, tentatively titled *Reading John Rechy Reading L.A.*

JENNIFER A. RICH is a Ph.D. candidate in English literature at the Graduate Center, City University of New York. She is the editor of *Found Object* and teaches at Marymount Manhattan College.

WILLIAM SCROGGIE received his Ph.D. in English from Indiana University. His dissertation is titled "Gay Male Identity and the Politics of Representation." He is currently an editor for the Mazer Corporation.

ANN SHILLINGLAW is a doctoral candidate in English at Loyola University, Chicago, where she is completing a dissertation on Oscar Wilde's fiction. She received a B.A. from Lake Forest College and a M.A. from Syracuse University, where she studied under Raymond Carver. Shillinglaw's interests include nineteenth-century literature and also popular culture, especially film and television of the 1960s. She recently published her essay "Mister Ed Was a Sexist Pig" in *The Journal of Popular Culture* (1997).

PATRICIA JULIANA SMITH is postdoctoral lecturer in English at the University of California, Los Angeles, where she teaches twentieth-century British literature, and gay and lesbian studies. She is the author of *Lesbian Panic: Homoeroticism in Modern British Women's Fictions* (Columbia, 1997) and coeditor of *En Travesti: Women, Gender Subversion, Opera* (Columbia, 1995). She is at work on a book tentatively titled *The Permissive Society in Postimperial British Literature and Culture.*

LAURA WINKIEL recently received her Ph.D. from the department of English at the University of Notre Dame. Her dissertation is "'Forever Forward . . . Backward Never!!!': Rhetorics of Transformation in Twentieth-century Manifestoes and Novels." Her dissertation has been awarded several fellowships, including an American fellowship from the American Academy of University Women. She has been a research fellow at the Center for the Humanities at Wesleyan University and recently has published an article on Djuna Barnes in the *Journal of Modern Literature.*